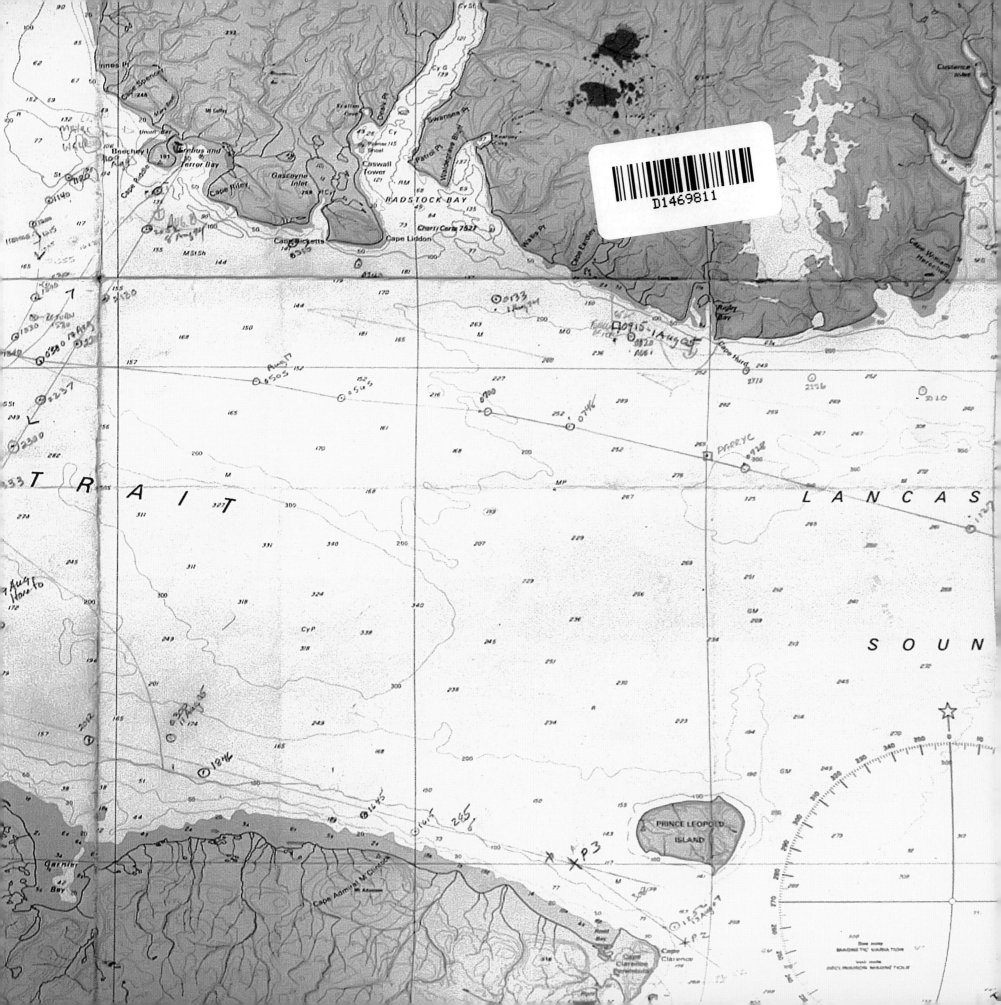

Over the Horizon

EXPLORING THE EDGES OF A CHANGING PLANET

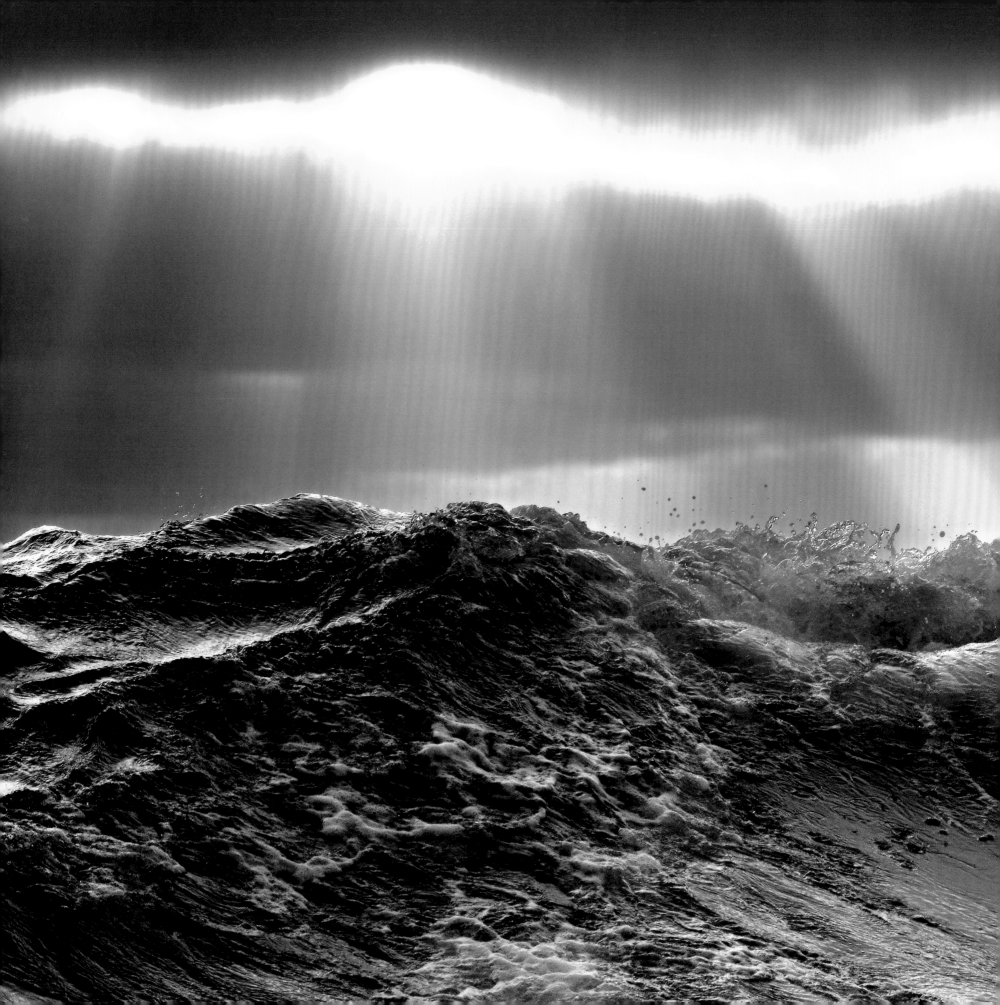

OVER THE HORIZON

EXPLORING THE EDGES OF A CHANGING PLANET

DAVID THORESON

www.davidthoreson.com

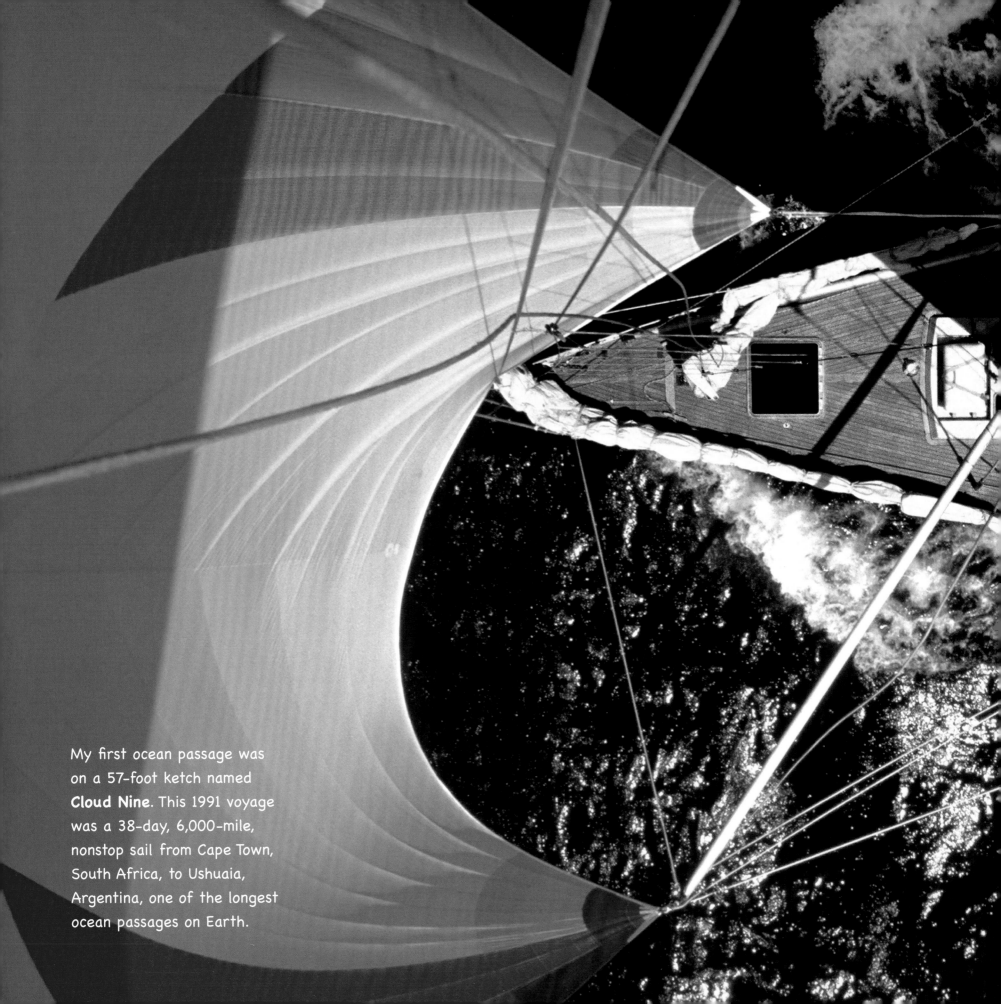

My first ocean passage was on a 57-foot ketch named **Cloud Nine.** This 1991 voyage was a 38-day, 6,000-mile, nonstop sail from Cape Town, South Africa, to Ushuaia, Argentina, one of the longest ocean passages on Earth.

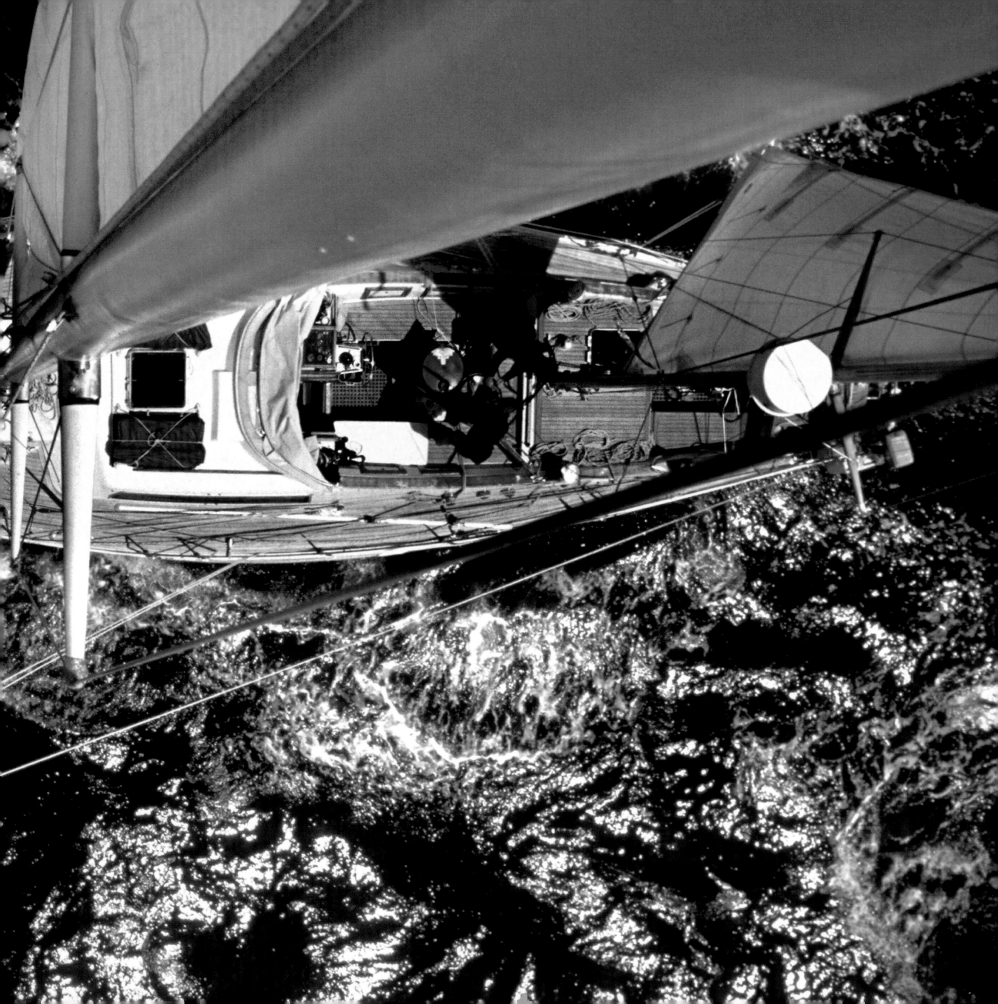

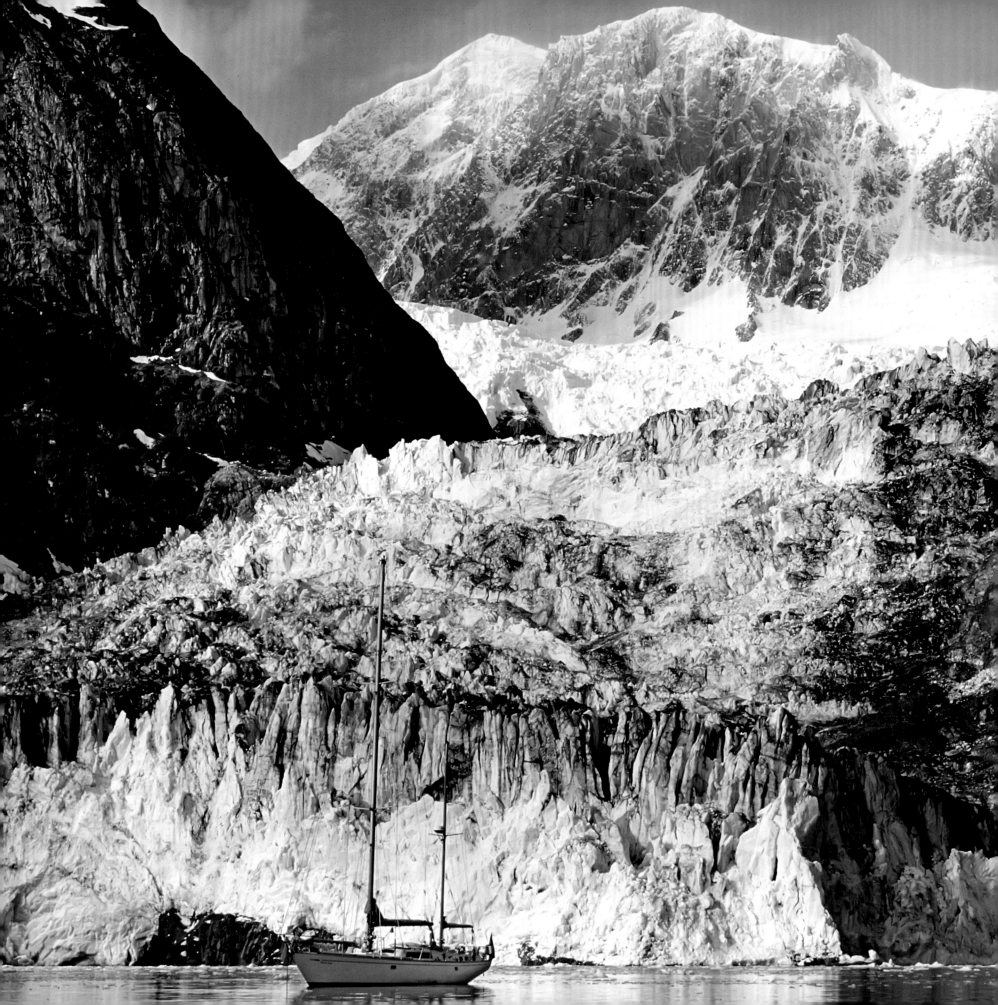

"In spite of all the severe living conditions, there was a romance and charm about the life which is hard to describe in a way to make it attractive to anyone who has not actually lived through it. Those of us who know by personal experience just what this life was like have a very fond recollection of it. ... The hardships fade away while the romance and the attractiveness of those days strengthen with the years as they pass."

**– Isaac Norris Hibberd,
"Sixteen Times Round Cape Horn"**

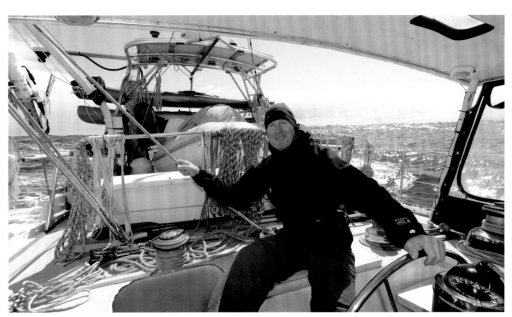

Cloud Nine, left, anchored in a deep Chilean fjord in 1991. I revisited the site later in my sailing career. Above: I manned the helm of the research sailboat *Ocean Watch* in the North Pacific Ocean in 2010.

OVER THE HORIZON

EXPLORING THE EDGES OF A CHANGING PLANET

DAVID THORESON

WWW.DAVIDTHORESON.COM

FOREWORD BY DAVID ROCKEFELLER JR.

This book combines photography with in-the-moment journal entries
and current thoughts on climate and what exploration truly means in the 21st century.
This is a lifetime of work and a very personal journey of discovery.

First Edition © 2016 Blue Water Ventures LLC • ISBN 978-0-9965257-1-8

Mark Hirsch Publishing, 52 Means Drive, Suite 114C, Platteville, WI 53818

563-590-2710 • markhirschpublishing@gmail.com • **Printed in China**

BOOK DESIGN AND PHOTO EDITING BY TOM WALLACE • COPY EDITING BY KATHE CONNAIR

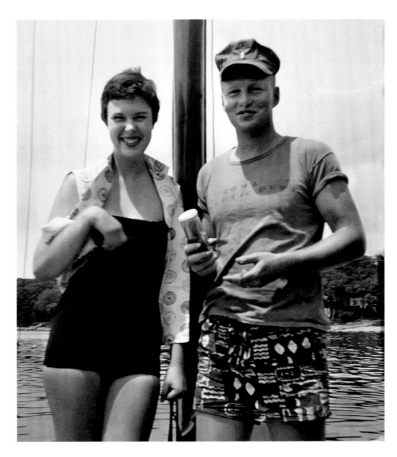

This book is dedicated to my parents, Judy and
Richard Thoreson. My mother taught me to
love, protect, and enjoy the water, and my father
gave me the discipline of a Marine Corps officer
combined with the spirit and heart of an artist.
Thank you both for giving me the freedom
to explore life my way.

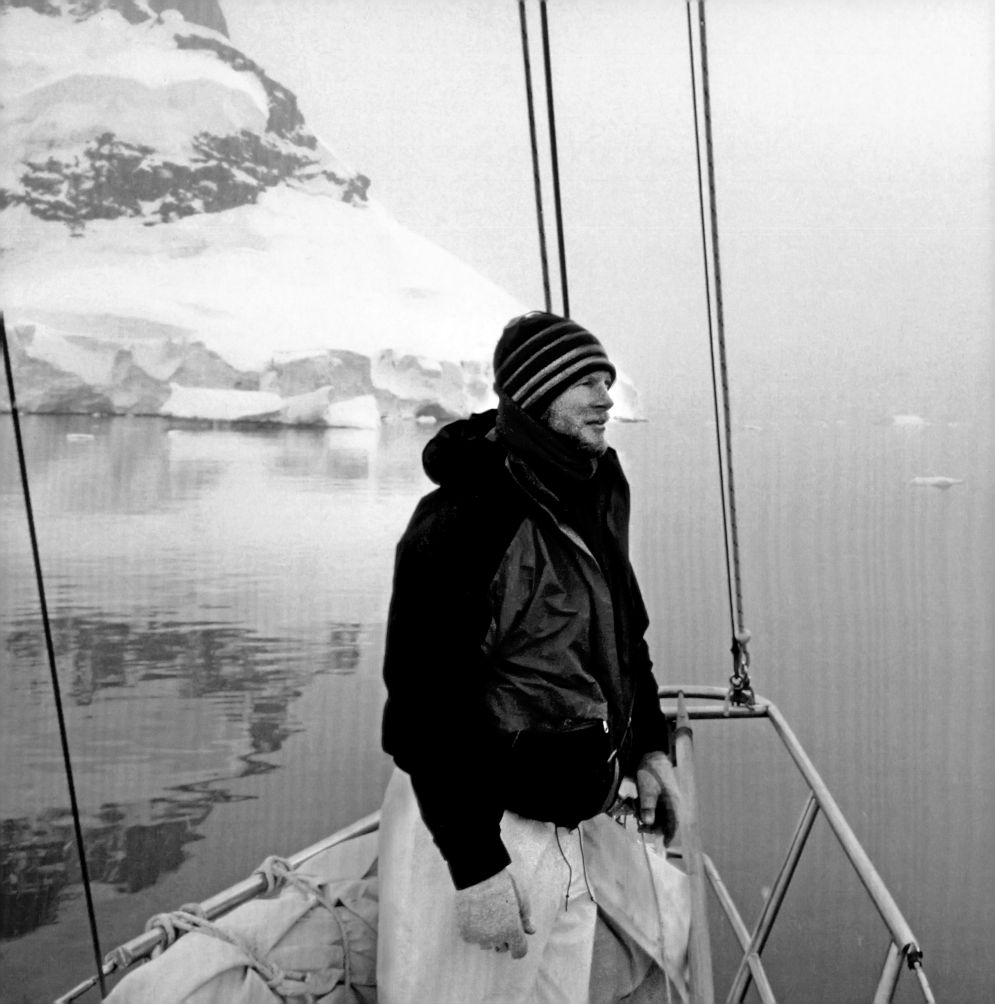

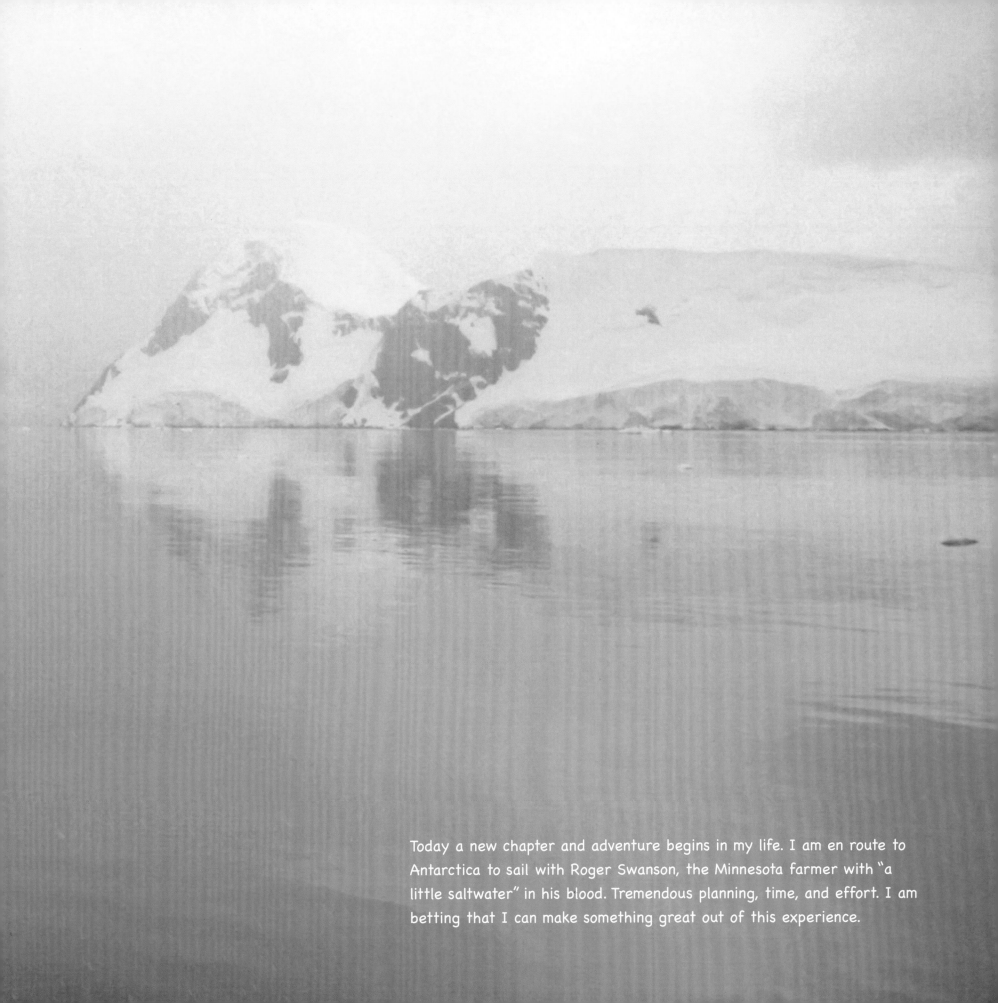

Today a new chapter and adventure begins in my life. I am en route to Antarctica to sail with Roger Swanson, the Minnesota farmer with "a little saltwater" in his blood. Tremendous planning, time, and effort. I am betting that I can make something great out of this experience.

CONTENTS

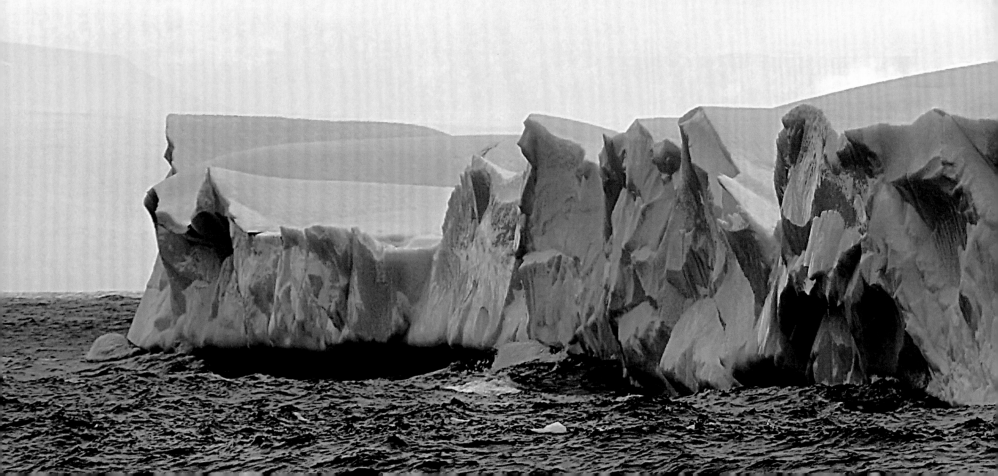

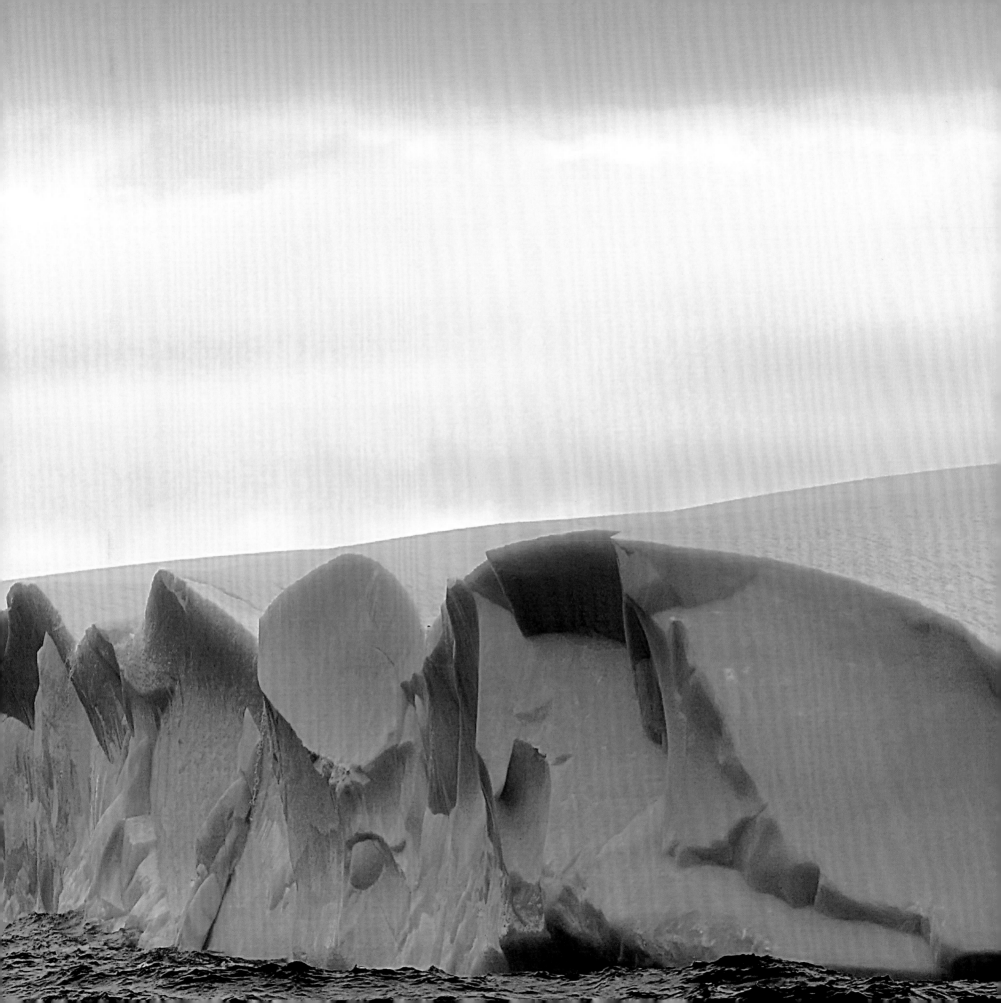

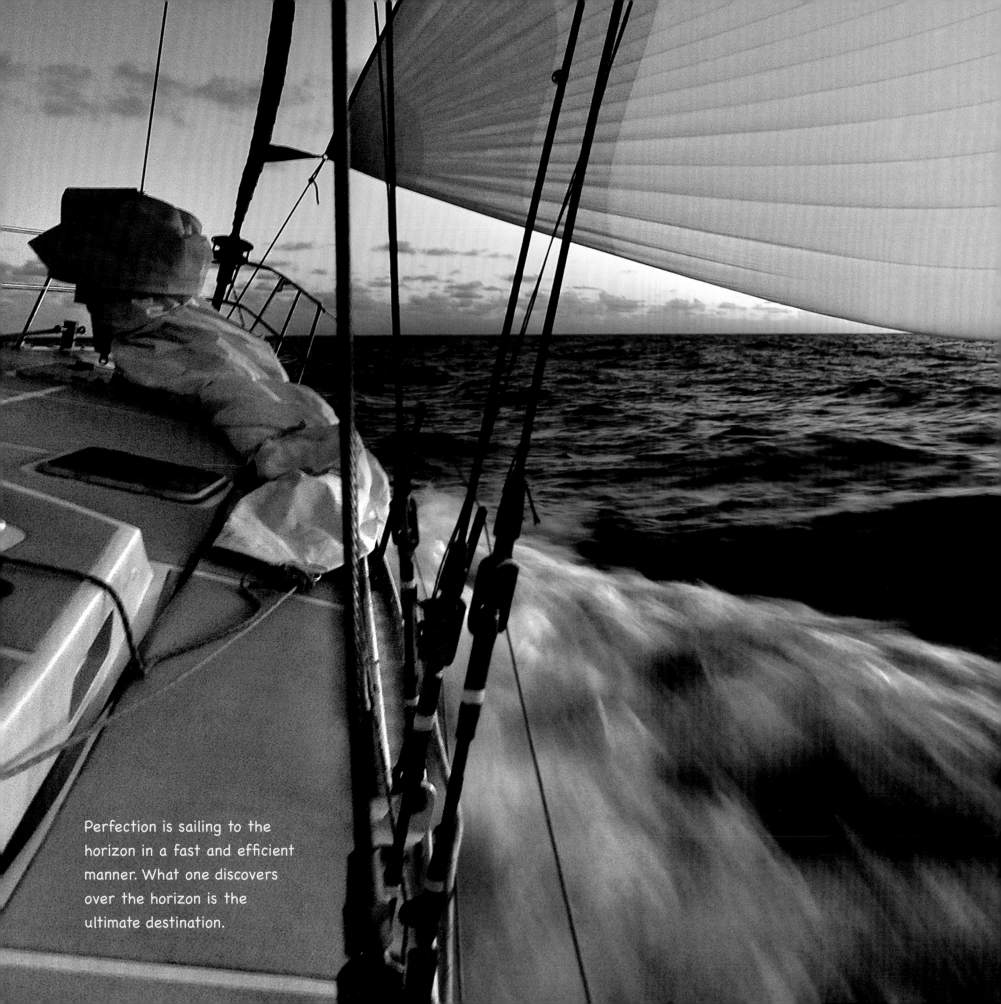

Perfection is sailing to the
horizon in a fast and efficient
manner. What one discovers
over the horizon is the
ultimate destination.

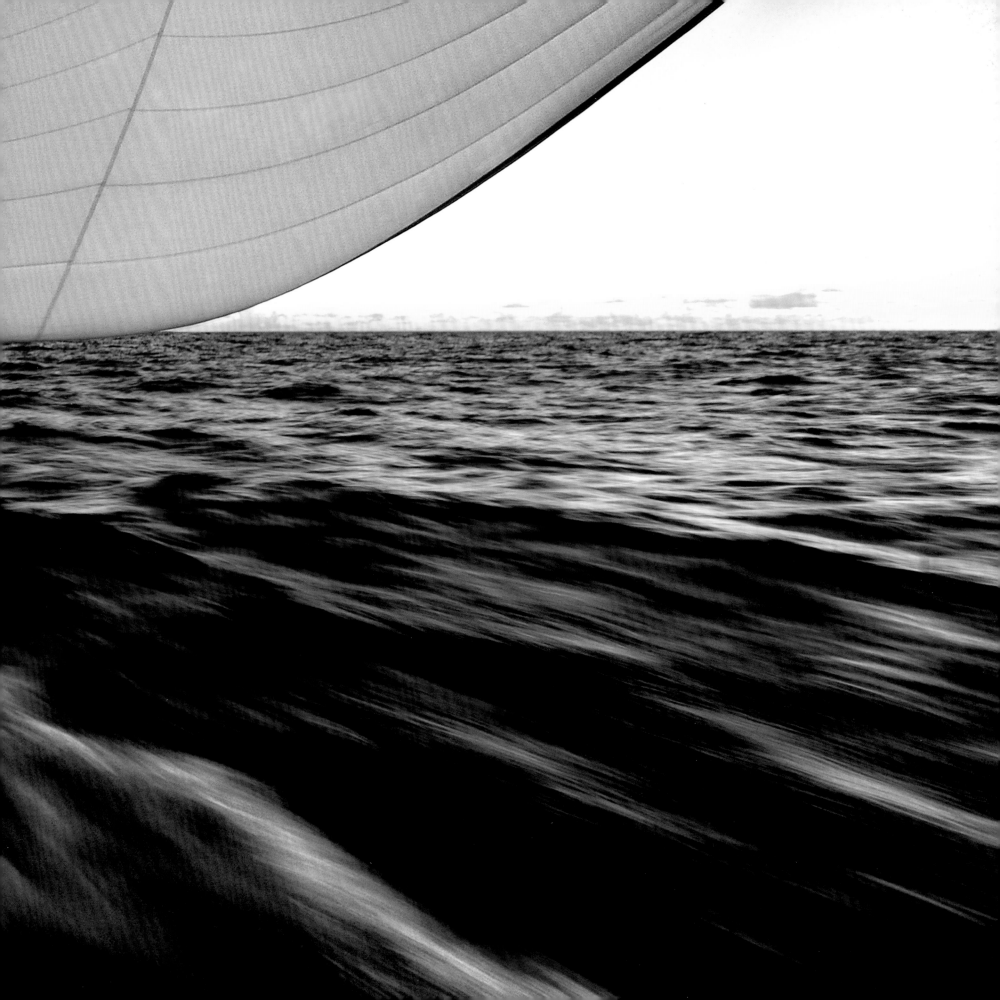

FOREWORD

By DAVID ROCKEFELLER JR.

I discovered late in life that the oceans need as much protection as the land does. My service on the Pew Oceans Commission at the beginning of this century led me to understand that the serene surface of the seven seas belied the damaging changes which had occurred beneath them. Acidification, warming, pollution, plastics — all but the last are very hard for the casual observer to see or measure.

My own history as a conservationist began with my love of hiking in the mountains of Maine and Wyoming. I learned to appreciate what Acadia and Grand Teton National Parks had done to protect and preserve these natural landscapes along with the fauna and flora that inhabit them.

In the 1990s I served as Citizen Chair of the National Park Foundation and was treated to a survey of our nation's most spectacular parks. And after leading a sailing expedition across the Gulf of Alaska, I came to appreciate the amazing conjunction of land and sea in that wild place of grizzlies and salmon. As a result, I agreed to join the Board of the Alaska Conservation Foundation, and I traveled there twice a year from New England for meetings with the best of Alaska's conservation community.

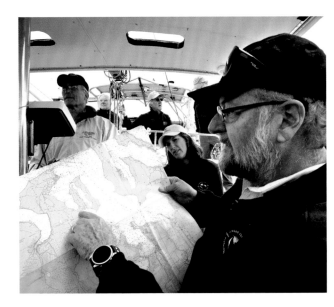

"The goal of this expedition is to build broad awareness among everyday citizens of the precipitous changes occurring throughout the world's oceans and the impact these changes have on various ecosystems and human life."

– David Rockefeller Jr.

David Rockefeller Jr. studied a chart near Port Townsend, Wash., and, right, sailed the magnificent Chilean fjords during the 2009-10 Around the Americas circumnavigation of North and South America. He seeks to promote conservation and sustainability within the yachting community.

After serving on the Pew Commission, I founded Sailors for the Sea to educate and activate the recreational boating community on behalf of healthy oceans. Twelve years later, we now have offices in Newport, R.I.; Portugal; Japan; and — later this year — in Chile. We plan to reach a million recreational boaters a year.

Sailors for the Sea's most ambitious project occurred in 2009-10 when we helped to sponsor Around the Americas, a 28,000-mile sailing circumnavigation of the American continents for the purpose of conducting scientific experiments in the ocean and educating people, young and old, at 50 stops along the way.

This is how I met David Thoreson, who — along with Captain Mark Schrader and fellow sailors Herb McCormick and David Logan — was onboard *Ocean Watch* for the entire 13-month journey. I was lucky enough to be a guest sailor with them during their two-week rounding of Cape Horn and the Chilean archipelago. We encountered four gales over that 600-mile stretch in open waters as well as in more protected channels.

David Thoreson belongs to a rare breed of adventurers with the eye of an artist and the ear of a historian. He is articulate, courageous, and highly creative. It is very rare to experience exploration "firsts" in this modern era, but David has achieved this status by sailing the Arctic's Northwest Passage in both directions.

The world needs people like David Thoreson who have the daring and imagination to visit some of the most remote and beautiful and vulnerable portions of our planet and then to transmit images and stories of those places that encourage others who will never go there to protect them. It takes the John Muirs, Ernest Shackletons and Doug Tompkinses of the world to illustrate the beauty of what is distant from our urban maelstroms yet deserves our protection.

"I founded Sailors for the Sea to educate and activate the recreational boating community on behalf of healthy oceans. We plan to reach a million recreational boaters a year."

– David Rockefeller Jr.

The Around the Americas journey began in the summer of 2009. We sailed *Ocean Watch*, a 64-foot, cutter-rigged steel sloop refit with scientific instrumentation, satellite communication, and carbon kayaks to explore distant fjords. Above left, David Rockefeller Jr. addressed an audience in Port Townsend, Wash., at the conclusion of the voyage.

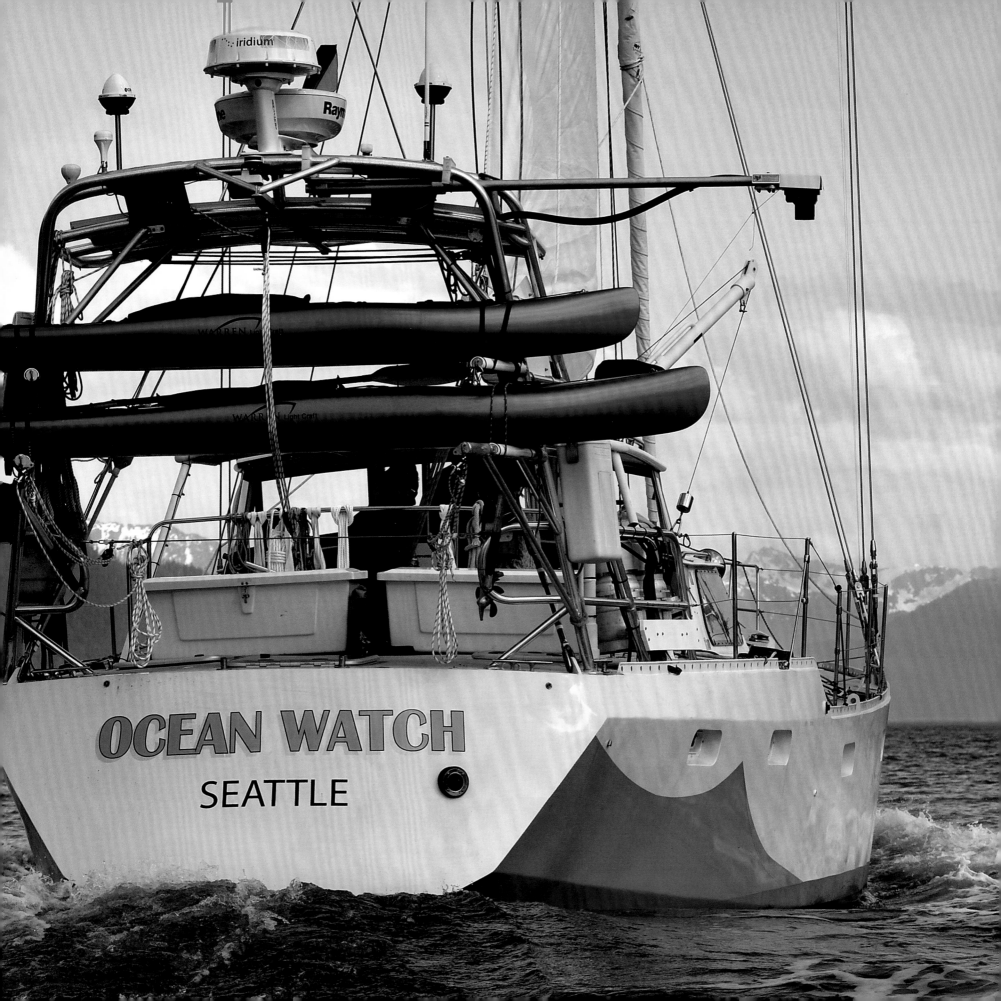

INTRODUCTION

By HERB MCCORMICK

Up ahead on the horizon, pack ice was all I could see — a cold, white and seemingly impenetrable wall that couldn't have been more daunting or intimidating. Aboard the 64-foot cutter *Ocean Watch*, several hundred miles north of the Arctic Circle, we closed in on the chilled, compact settlement of Barrow, Alaska, the northernmost city in the United States. Bound for the fabled Northwest Passage, our first major obstacle was literally directly in our path.

Herb McCormick was elated to be sailing around Cape Horn. He hails from what is arguably the sailing capital of the United States: Newport, R.I., right.

Yet, despite our immediate predicament, I felt calm, even confident. And perhaps the major reason for my peace of mind was our mate David Thoreson, stationed high aloft in the rigging of our sailboat, armed with binoculars and his camera — always with his camera. Scouting the leads, or routes, through the icy floes, pointing the way forward, and shouting down instructions, Thoreson was a veteran of these waters. His presence, knowledge, and easy demeanor were all reassuring; he'd been this way before.

Weeks earlier, in preparation for the ice, David had advised: "Patience. We'll have to be patient. We won't decide when we can move up north. The ice will." Now on his third attempt at the Passage — turned back the first time, successful the second — he knew what he was speaking about. And he was right.

With David's constant input, over the next several tense hours our crew on *Ocean Watch* safely negotiated the hazardous seas and dropped the anchor off Barrow, the first real test of the trip passed with flying colors. Before the summer of 2009 was over, the Northwest Passage was in our wake, and *Ocean Watch* had successfully completed the first west-to-east

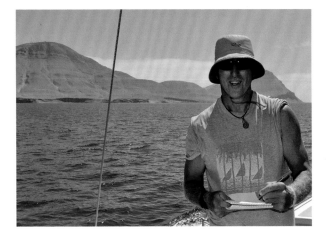

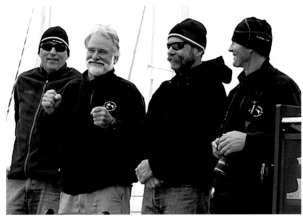

"Along with skipper Mark Schrader and first mate Dave Logan, the other permanent Ocean Watch *crew members, David and I had forged a bond that will never be broken. The four of us had started the journey as pals, as friends. We came back as brothers."*

– Herb McCormick

transit of the legendary waterway by an American vessel in a single season.

The historic voyage of *Ocean Watch* was a scientific and environmental expedition called Around the Americas. Beginning and ending in Seattle, the 13-month, 28,000-nautical-mile adventure served as a vehicle to bring awareness to significant ocean conservation issues, including the effects of the changing climate. It was also an incredibly unique undertaking. Many mariners have sailed around the world on the traditional route following the trade winds on a course more or less parallel to the Equator, traveling from east to west. But only a handful of sailors have done it from north to south. Ours was a very, very rare circumnavigation — a vertical one.

As the expedition's full-time photographer and writer, respectively, David and I chronicled the journey at every step along the way, including filing daily blog entries. It was quite easily the most rewarding collaboration of my professional life. Around every bend, it seemed, there was anoth-

er interesting, important story waiting to be told. And with David, oftentimes we reached that same conclusion simultaneously, without a word spoken between us. As journalists and colleagues, we were firmly on the same page. It was fantastic.

With the Northwest Passage behind us, in a rising gale and dodging icebergs, *Ocean Watch* set sail south from Baffin Island down the coast of Labrador to Newfoundland. After several days of staunch northerly winds, which built up seas occasionally cresting at well over 30 feet, that 1,800-nautical-mile passage proved to be the windiest, wildest sleigh ride of the entire trip. Professional marine photographers agree that capturing the raw fury of a raging ocean storm from the deck of a yacht is practically impossible. For David, whose breathtaking images of those dramatic moments at sea are lasting and indelible, it was just another day at the office.

Down the Eastern Seaboard, across the Equator, and into the Southern Hemisphere we sailed. En route to Rio de Janeiro, nego-

tiating the huge bump of the Brazilian coastline, which juts far eastward into the South Atlantic, we endured the hottest, most miserable stretch of the journey. But the payback was well worth it, for once into the steadily pumping westerly breezes in the so-called Roaring Forties — the 600-nautical-mile band of latitude between 40 and 50 degrees South — *Ocean Watch* enjoyed the fastest, crispest, most beautiful sailing conditions of the entire voyage. And like the majestic, soaring albatrosses he freeze-framed in flight, and the colorful penguin colonies he visited and chronicled in the windswept Falkland Islands, David was precisely in his element. Plus, the best day of the whole circumnavigation was just ahead.

For sailors, Cape Horn — the southernmost tip of land on a desolate island off the far coast of South America — has been called "the Mount Everest of offshore sailing." After battling a series of

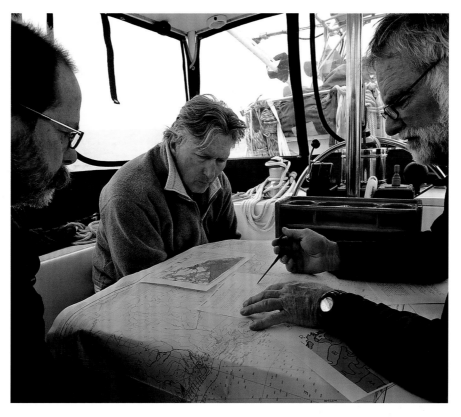

Above, from left, Dave Logan, Herb McCormick, and Captain Mark Schrader studied ice charts during the Around the Americas expedition. At left, top, McCormick took notes aboard *Ocean Watch*, and below, he stood with Schrader, Logan and me.

northwesterly gales, *Ocean Watch* approached it on a cold January morning in an extremely unusual easterly breeze. The weather was dank and gray, and the famous edifice of the Horn was shrouded in a foreboding cloak of fog and mist. In other words, it was perfect.

"Well," said David, "it looks like a Cape Horn day." It surely did.

With the favorable east winds, we set *Ocean Watch's* billowing spinnaker and executed a textbook rounding of the cape. For all of us aboard,

it was one of the most thrilling experiences of our sailing lives.

From the Horn, we pointed *Ocean Watch's* bow north toward Seattle. In the weeks that followed, we faced strange, disturbing El Niño conditions off the stark coast of Peru.

David and I scuba dived with hammerhead sharks and sea turtles in the brilliant Galapagos Islands. Together, we all sailed under San Francisco's iconic Golden Gate Bridge, once again flying our spinnaker. And then, finally, we sailed up Puget Sound and into Seattle, from which we'd departed more than a year earlier. The journey of a lifetime was complete.

Along with skipper Mark Schrader and first mate Dave Logan — the other permanent *Ocean Watch* crew members — David and I had forged a bond that will never be broken. The four of us had started the journey as pals, as friends.

We came back as brothers.

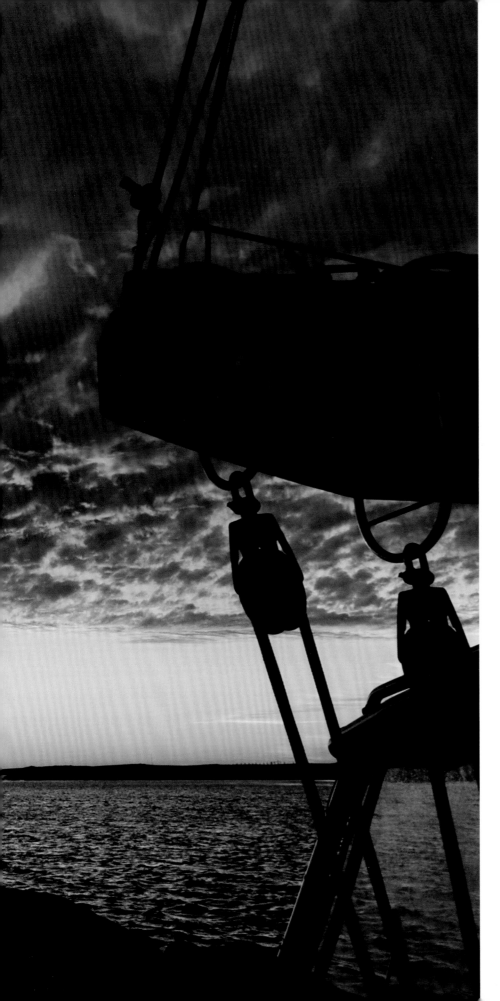

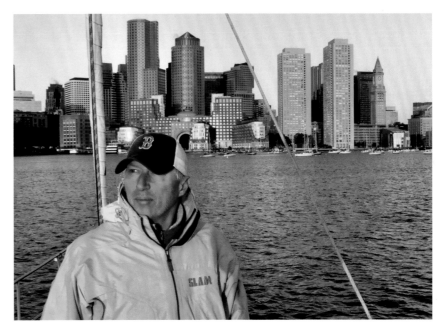

"Almost four months ago, the 64-foot cutter Ocean Watch *left Seattle heading due north, for parts mostly unknown. In the days before departing, on countless occasions, we were asked our route, what the plan was. I can't speak for the entire crew, but I could never actually bring myself to say 'around the Americas.' At the time, the notion seemed so audacious, so ludicrous, that I couldn't fathom it. So my answer never varied: 'We're headed to Boston. Look, if we even get to bloody Boston, that will be a miracle. Ask me again in Boston.' And then, in the wee hours of the morning, there it was: Boston."*

– Herb McCormick

Herb McCormick looked over the horizon in the Falkland Islands before *Ocean Watch* departed for Cape Horn. An insufferable Red Sox fan, he enjoyed passing the time on watch "discussing" sports teams and their hometowns.

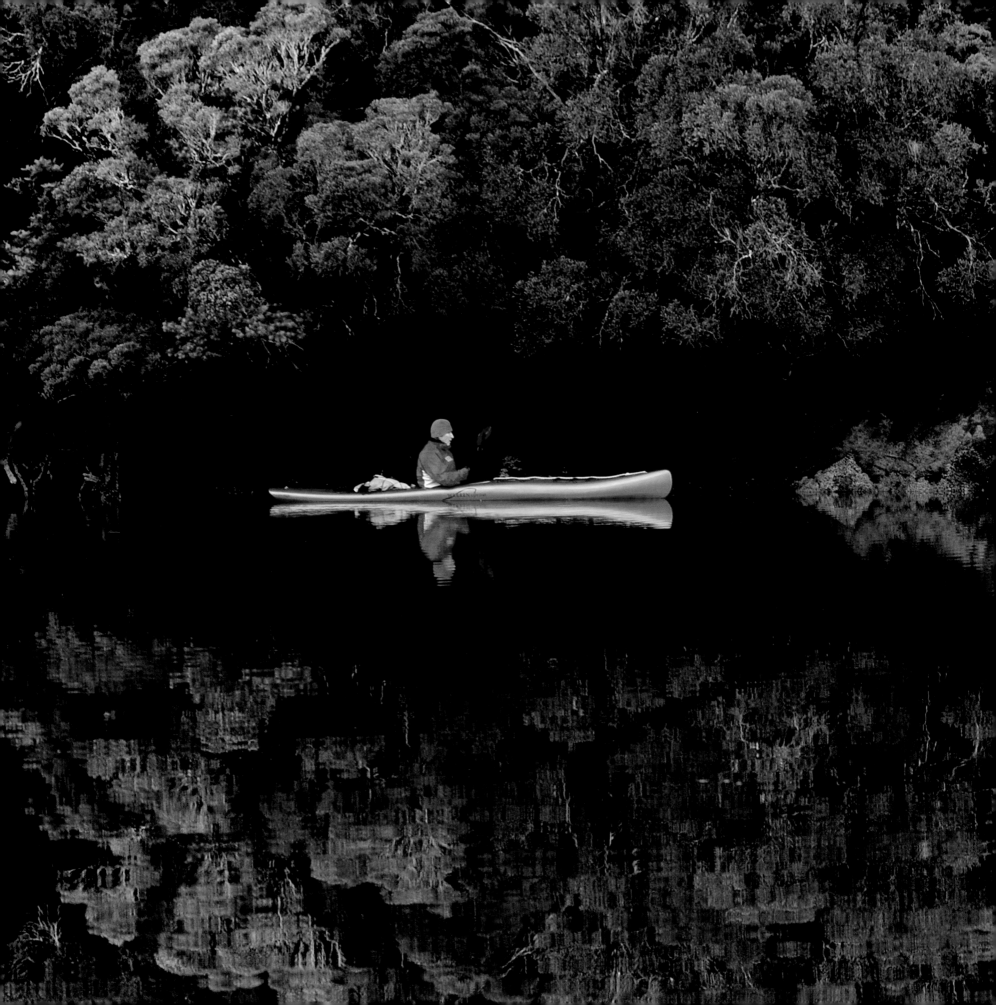

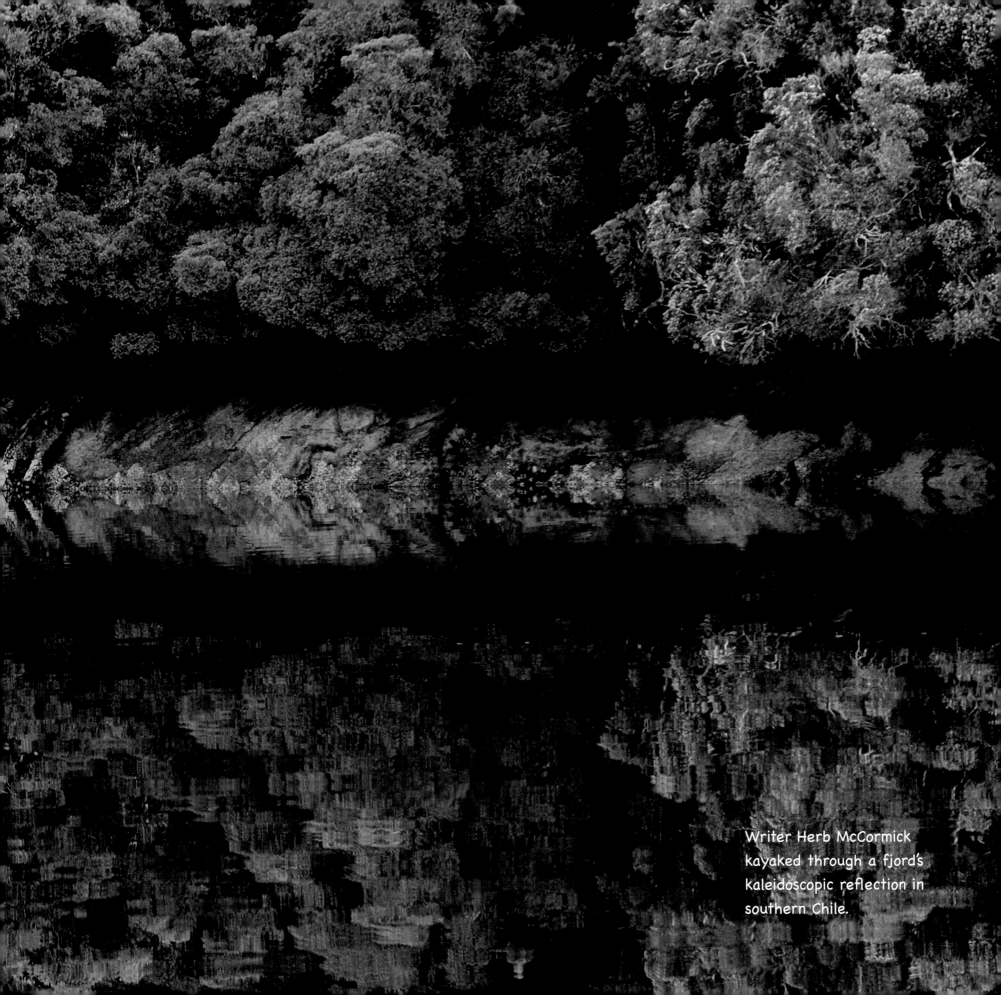

Writer Herb McCormick kayaked through a fjord's kaleidoscopic reflection in southern Chile.

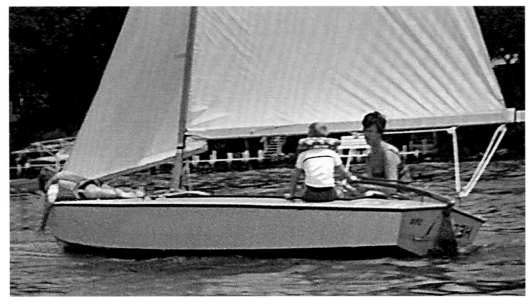

My mother, Judy Thoreson, taught me to sail on a sturdy, 16-foot boat used for training on inland lakes. The Iowa Great Lakes are glacial gems hidden amid Midwestern farm country.

A SAILOR FROM OKOBOJI, IOWA

I grew up in northern Iowa, and my home port is Lake Okoboji. That is not as surprising as it may seem. Set in plains gouged out by a receding ice sheet some 14,000 years ago, Okoboji is a beautiful glacial lake and a logical start to my interest in climate change. One of the Iowa Great Lakes, it is about one-tenth the size and depth of Lake Superior, but a good training ground nonetheless.

My mother taught me to sail here, starting with a little X-boat named *Help*. The word was written upside-down on the stern, just in case she capsized. Early

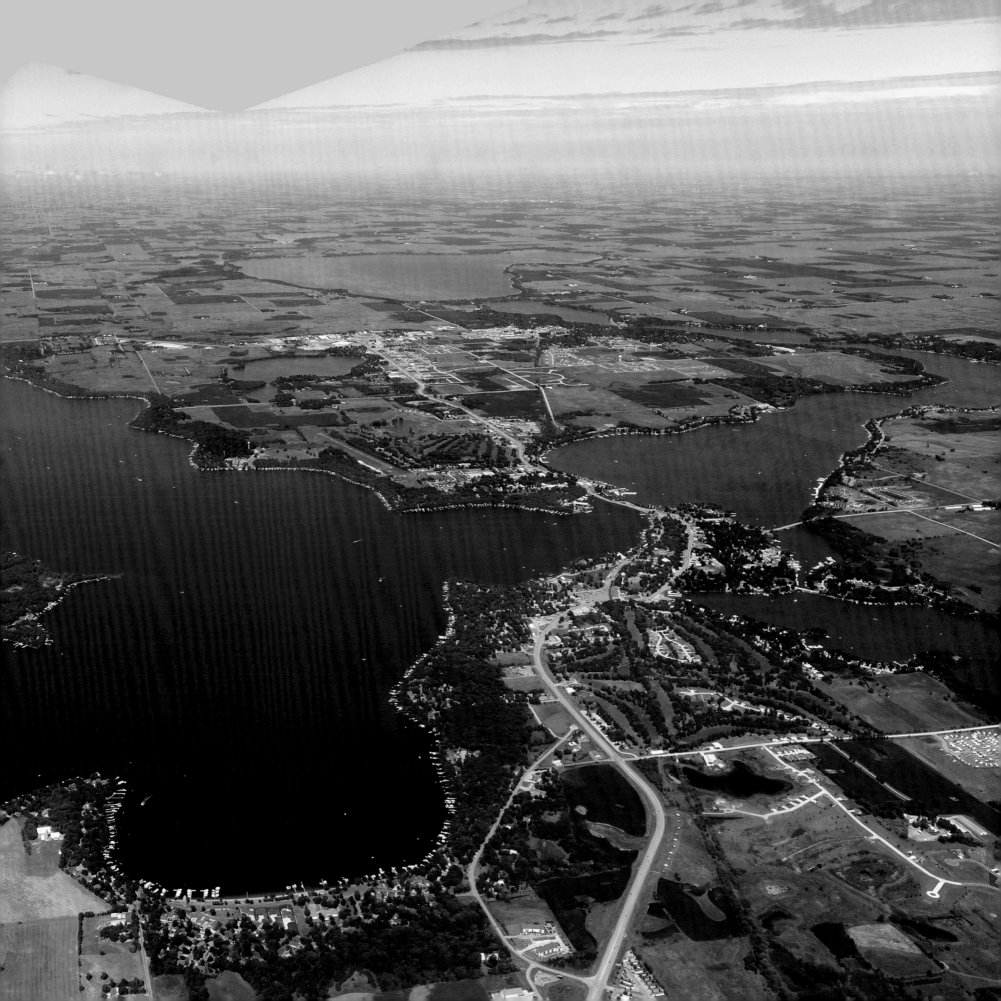

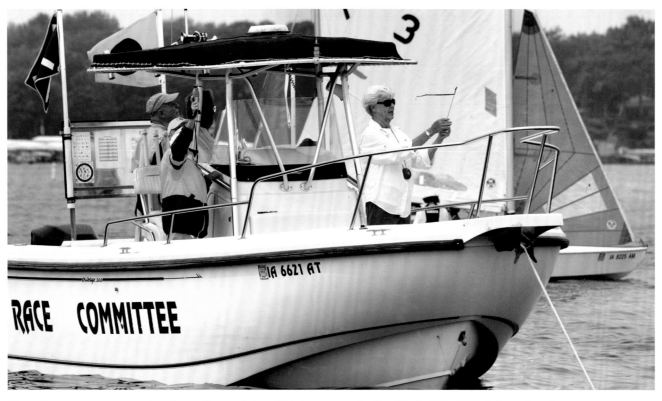

My mother was once a great racing sailor, and she still judges races for the Okoboji Yacht Club. I continue to race scows, including MC 2181 shown at right, in the 2014 Inland Lakes Yachting Association Championships held on West Lake Okoboji.

on, that was a regular occurrence amid the very windy plains. Those challenges proved to be good practice for dealing with big air days on the seas later in life. As I got older and more experienced, Mom taught me to race as well, and I eventually became a very competitive racing sailor, with strong finishes in national championship regattas. But more than that, I discovered I loved being out in the basic elements of wind and water. I will never tire of the exhilarating feeling of using the wind to propel myself.

With these experiences, I was constantly distracted and frequently in trouble in school. I preferred to be outside, even if it was just to do chores at home. On long, hot summer days, it took hours to mow our large yard, and with each row I would escape to dreams of far-flung adventures on a sailboat, plowing a vast expanse of water.

How do you make a dream like that real? There is no textbook. I'm from Iowa and I wanted to sail the world's oceans. I began by traversing vast expanses of land, all the

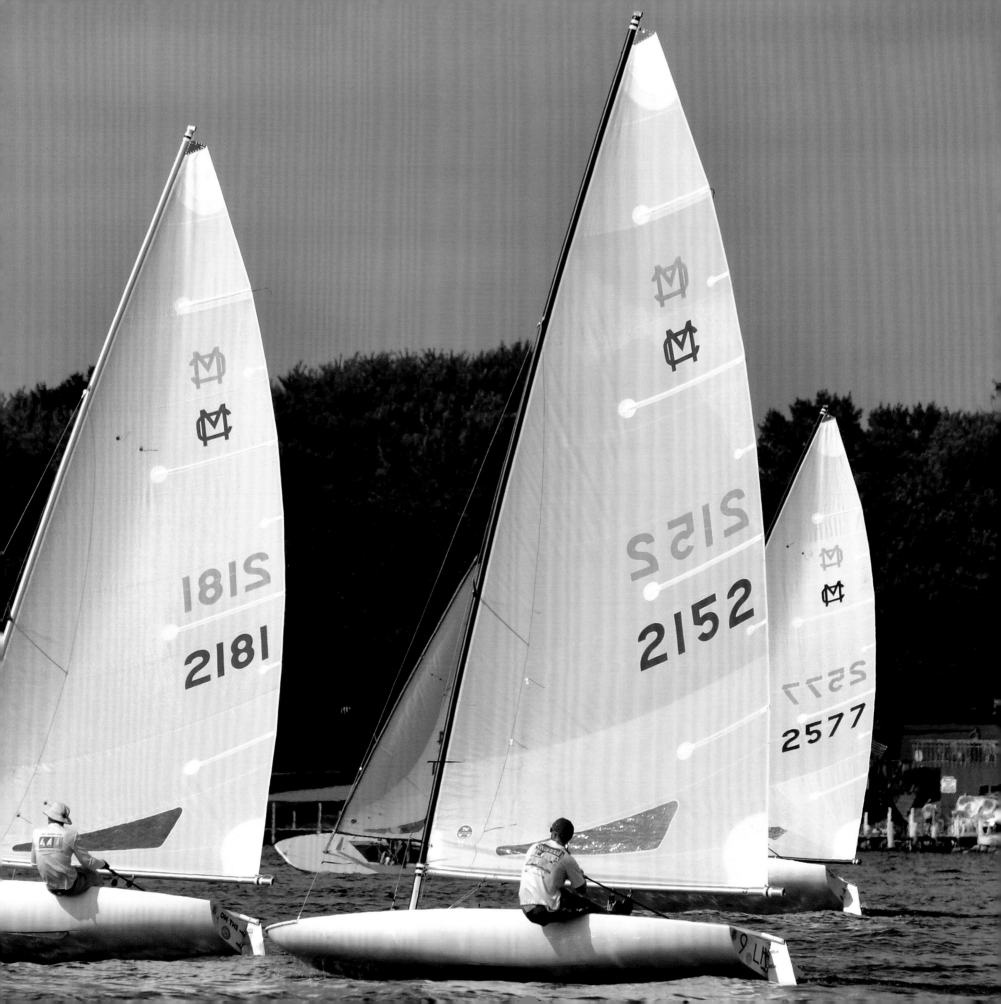

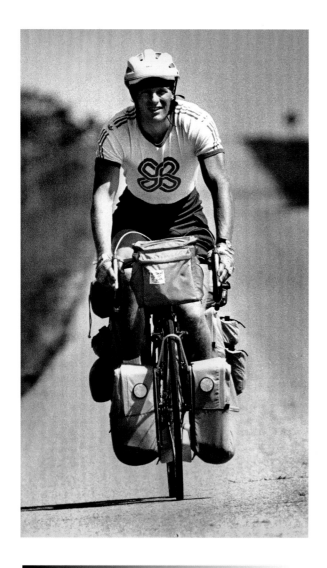

JOURNAL • JULY 8 • 1986

MUNISING • MI

I was thinking tonight of this mental vs. physical thing and the stage I'm in right now. I really need to push the physical while young and still can. Let the mental side keep developing as my young physical being slowly falls by the side.

while honing my skills as a photographer.

After college, unable to make a career choice, I took off on epic bicycling, hiking, and climbing adventures. The South Pacific called: New Zealand, Fiji, Australia. But those far-flung places made me realize how little I knew about my own country. I biked 8,000 miles across the eastern United States, and then I went west, where I climbed and mountain-biked extensively.

While moving slowly through the world, whether on the seat of my bike, the soles of my shoes or a balky bus, I discovered that the link between recreation in the outdoors and conservation runs very deep. The more people I engaged when recreating, the deeper I moved into a conservation mindset. There was a growing community of people who, like me, felt a deep passion and respect for the outdoors and wanted to protect natural resources. I had found a new home.

I eventually chose outdoor photography as my profession. I became a contract photographer for the National Park Service and later started my own gallery and freelance photography business. I found that I am drawn not only to the natural world's extreme physical challenges, but also to its mental and spiritual rewards. I never tire of viewing and photographing the horizon. The search for

Above left: I biked 10,000 miles across the United States in 1986-87. At right: In 1990, armed with cameras, mountain bike and climbing gear, I logged another 10,000 miles in my 1965 VW microbus. Near Moab, Utah.

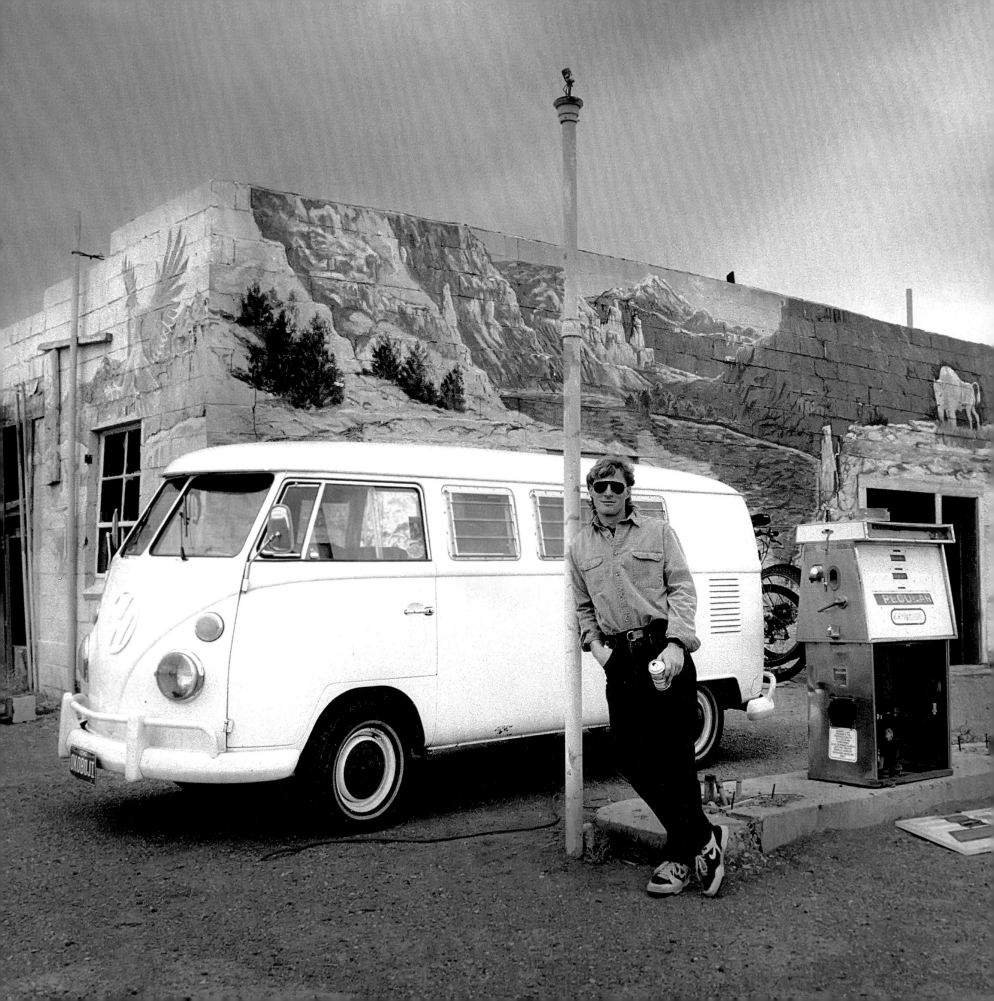

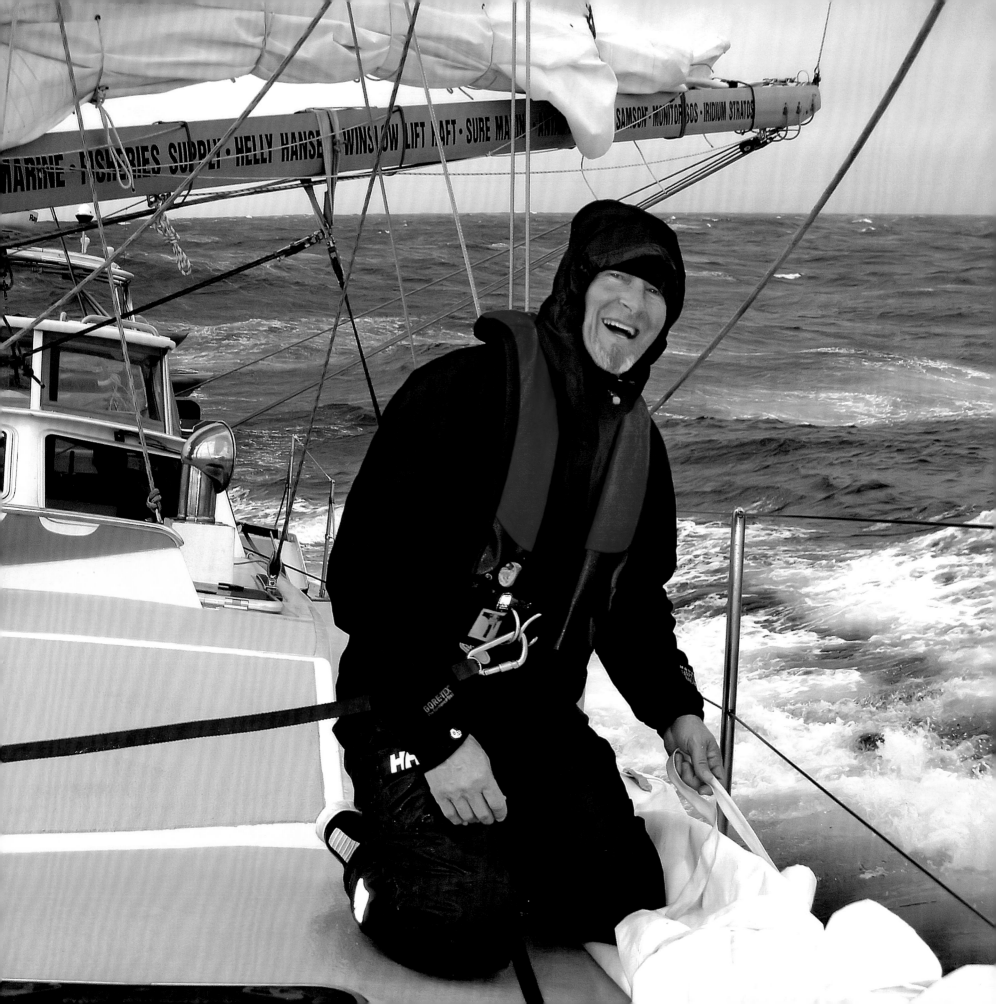

new images, new horizons, matched up perfectly with my dream to sail the world's oceans.

Roger Swanson, a fellow sailor from the Midwest, helped me follow my dreams all the way into the Arctic Ocean's infamous Northwest Passage. The first time was in 1994, but we were unable to complete the voyage because of heavy pack ice, a condition that had thwarted explorers for centuries. I returned for a record-setting 2007 sail through the Passage from east to west, and in the process became an eyewitness to planetary change. The ice had literally disintegrated. Our vessel sailed through, never touching a piece of it.

That voyage was the galvanizing event that glued together all my years of random adventures. The Earth's environment was changing rapidly, and I was in the Arctic to see it happening. The experience convinced me to find meaning, in addition to thrills, in my exploits.

What I have to share with you is more art and story-telling than science, but I am here to testify about what is occurring at the extreme ends of the Earth. Now, like the proverbial canary in a coal mine, I am sounding an alarm from the epicenter of climate change. What a time to have become an explorer!

Windy, frigid conditions are all in a day's work when sailing the high latitudes of the Earth's oceans, as in the Labrador Sea, at left. Right: I joined the Around the Americas expedition of 2009-10 to help document the plight of our oceans.

JOURNAL • SEPTEMBER 7 • 2007

NOME • ALASKA

Will the Northwest Passage remain ice-free? Probably not every year, but the trend appears to be in place for continued opening for longer periods, as warming land and seas make it more difficult for multi-year ice to form. Anyone interested in this issue should take a good, long look at what is happening around the poles.

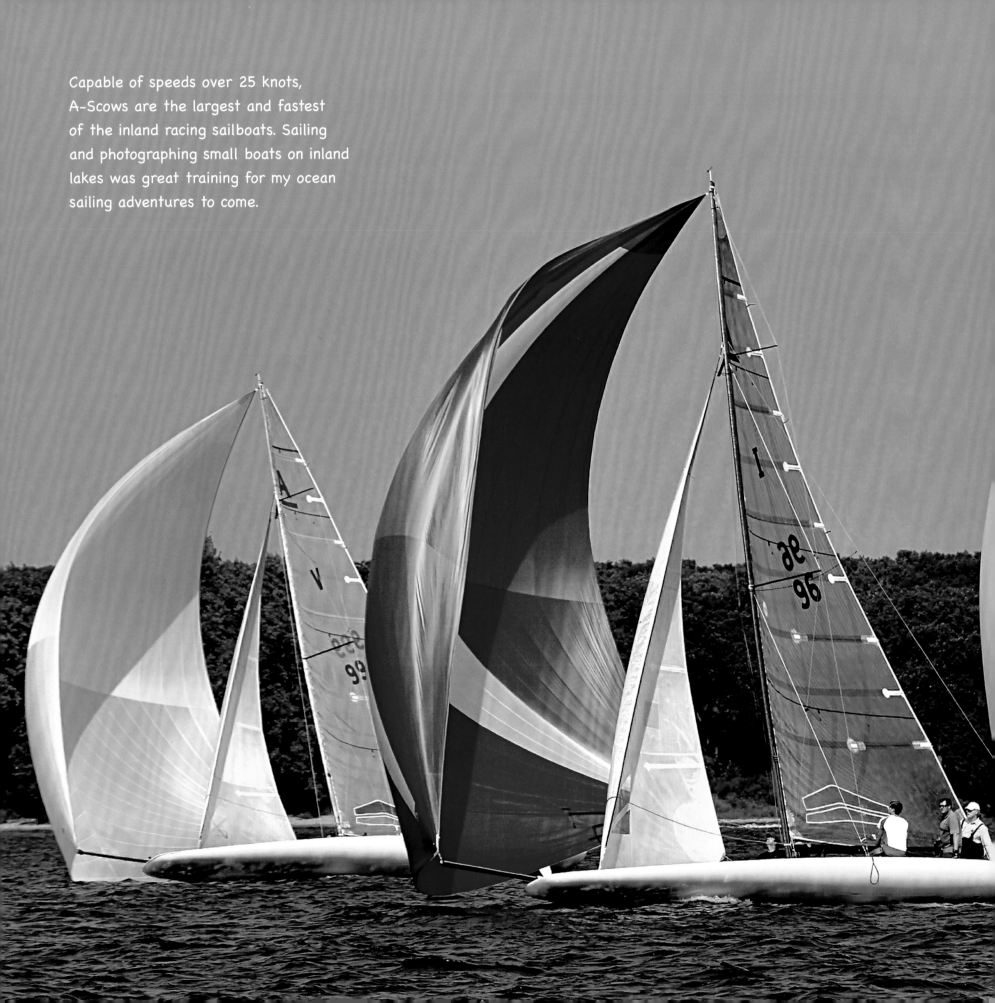

Capable of speeds over 25 knots,
A-Scows are the largest and fastest
of the inland racing sailboats. Sailing
and photographing small boats on inland
lakes was great training for my ocean
sailing adventures to come.

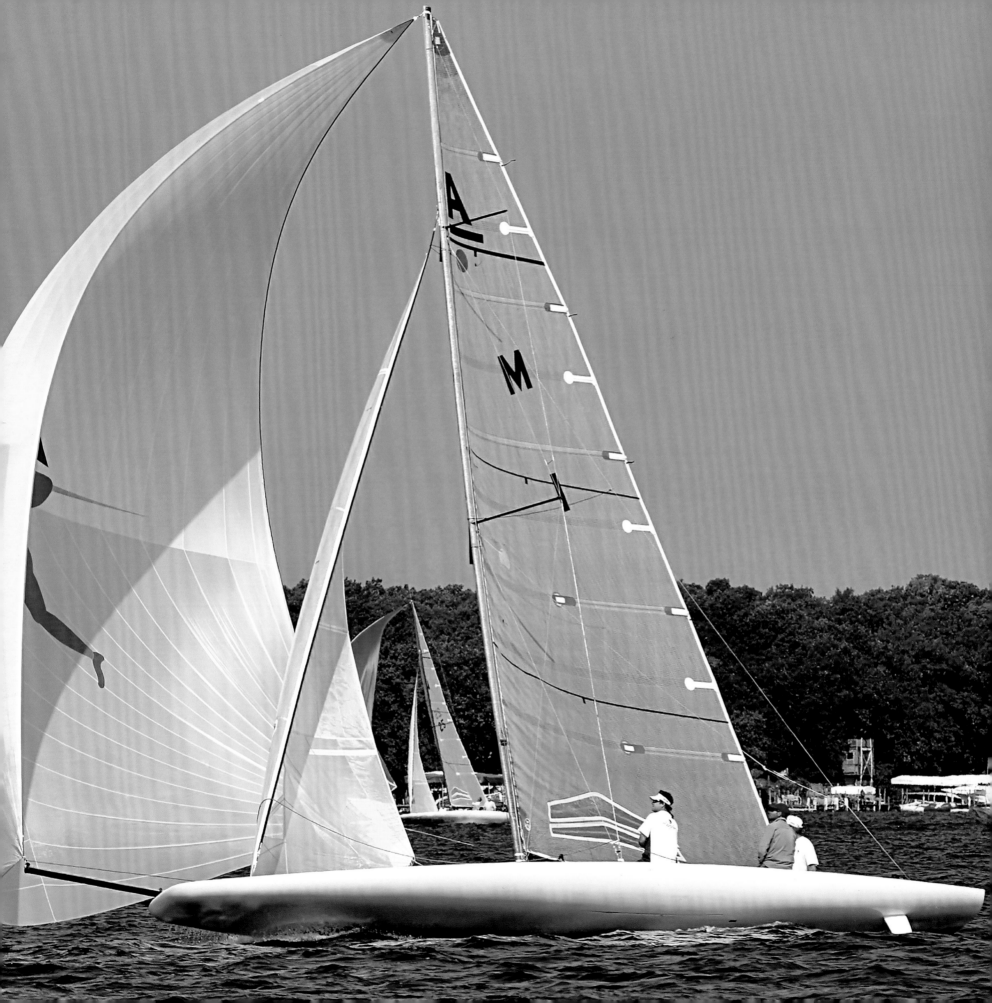

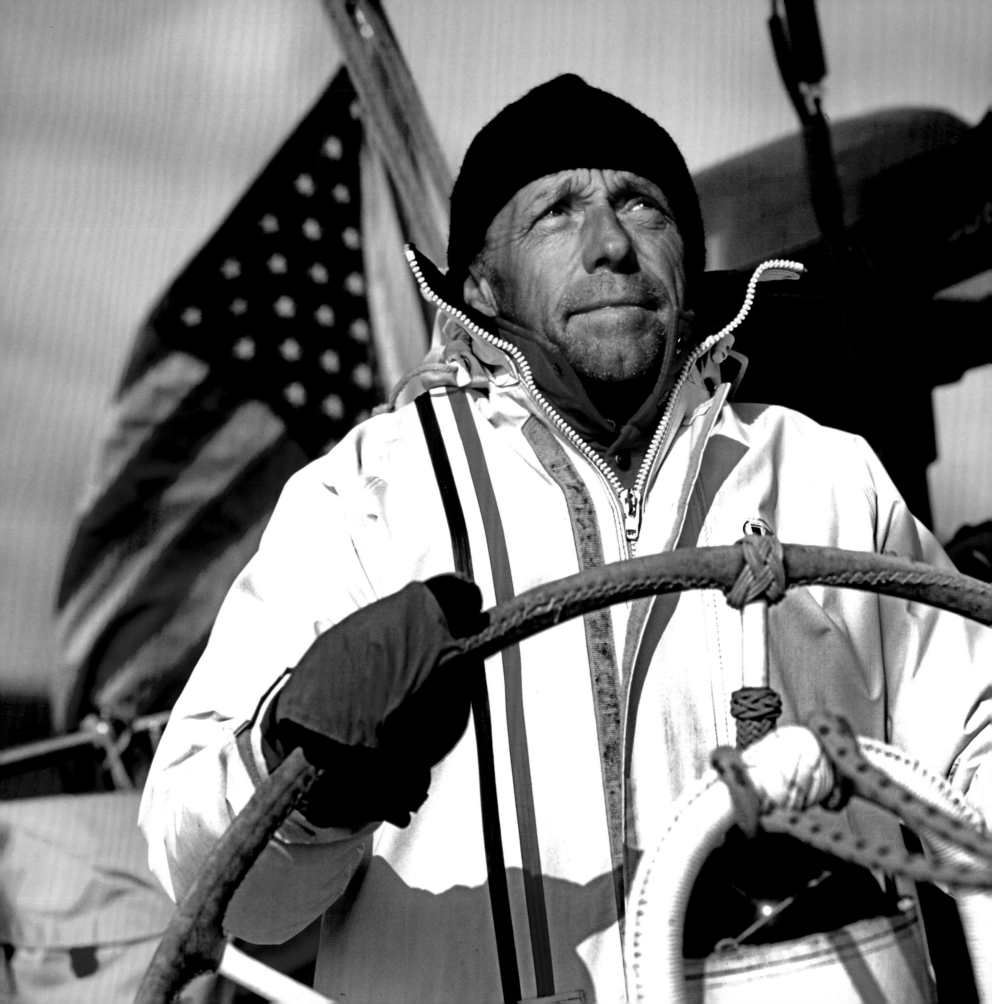

MENTOR AND FRIEND ROGER SWANSON

"Travel is the realm of the improbable adventure, the quick fix, the ship passing in the night. It entitles you to meet interesting people whom you would otherwise never meet, even if you laid traps or advertised for them."
– Lawrence Millman, "Last Places"

People constantly ask me how I began my ocean sailing career. The answer is easy: I met a hog farmer, and the rest is history. I met my mentor, Roger Swanson, 35 miles from Lake Okoboji on his century farm in southern Minnesota. The retired naval seaman's home port was Dunnell, population 165.

Roger, both intelligent and methodical, seemed to have all the best attributes for a life spent at sea. In addition to being able to handle the day-to-day rigors of farming, he had an innate curiosity. He invented several successful products, including the fiberglass truck topper, and with his father had perfected a method of cracking safes, among other (legal) pursuits. But when he lost his first wife to illness, their daughter, Lynne, challenged him on his 50th birthday to "sail around the world like you always said you would do." What followed is one of the great sailing stories of all time.

Roger sold his business and purchased *Cloud Nine*, a 57-foot Bowman ketch. She became a legend. According to Cruising World magazine in 2014, "the top American

Captain Roger Swanson safely navigated through the Drake Passage to the Antarctic Peninsula in 1992, perhaps the toughest stretch of water on Earth.

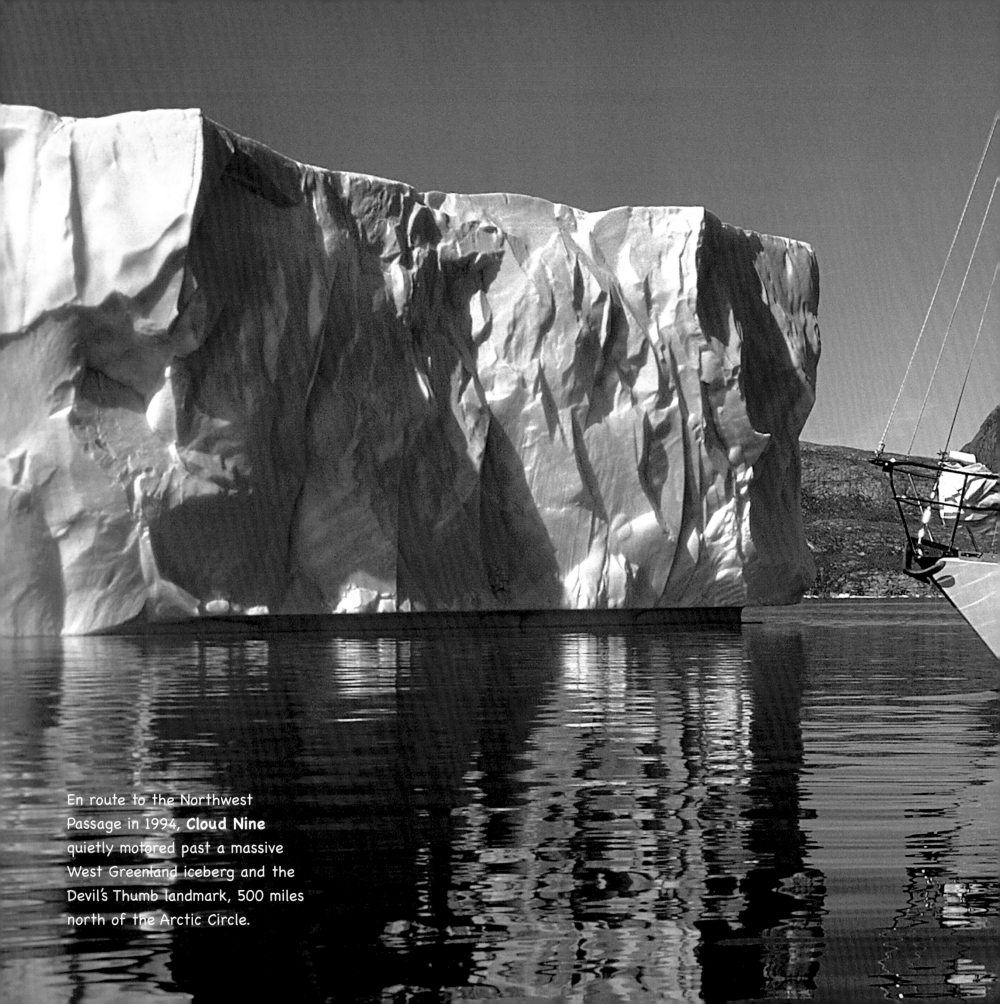

En route to the Northwest Passage in 1994, **Cloud Nine** quietly motored past a massive West Greenland iceberg and the Devil's Thumb landmark, 500 miles north of the Arctic Circle.

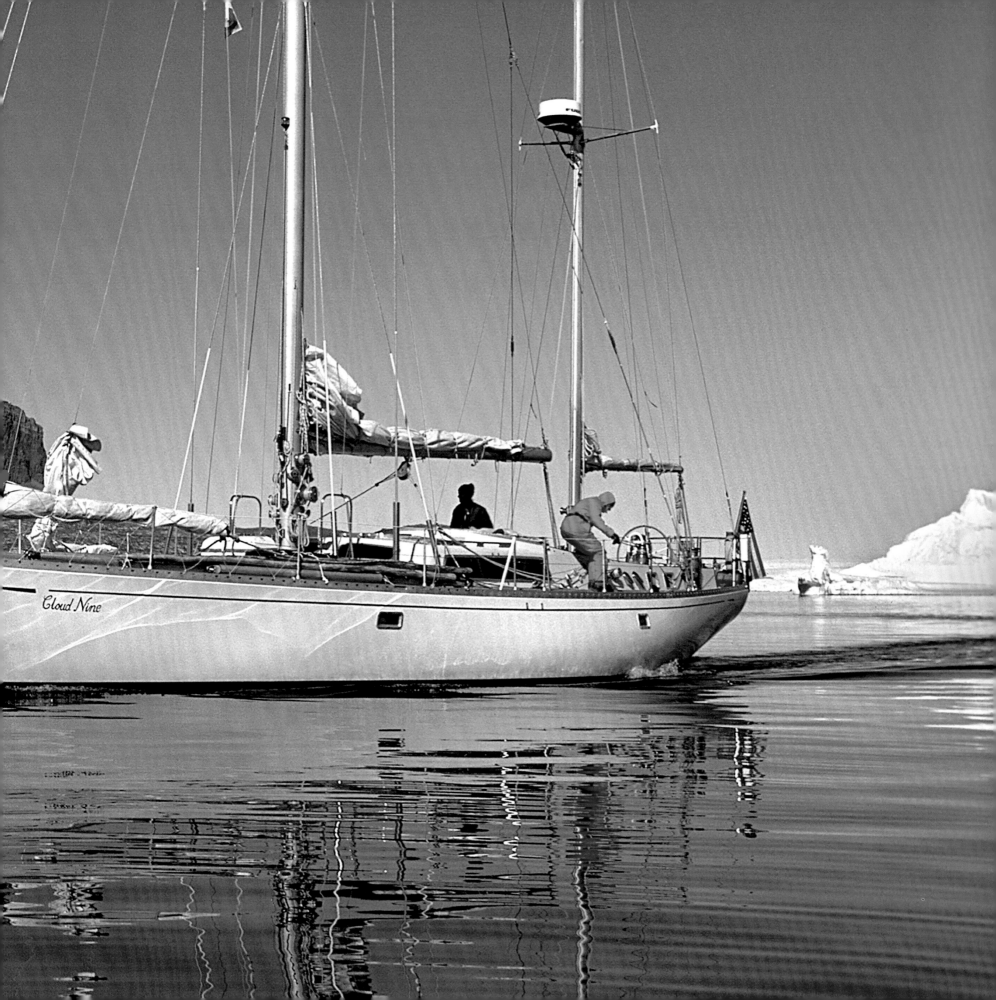

Cruising Yacht in history may well have been Roger Swanson's *Cloud Nine*."

In 1981, Roger and his two sons, Steven and Philip, made a 28-month, 37,000-mile circumnavigation of the world. (Lynne was too seasick to complete the voyage.) Roger went on to make two more circumnavigations (the last with his wife, Gaynelle Templin). He logged 220,000 nautical miles over 40 years and took 310 different people to sail the world's oceans during his career. I was fortunate enough to be one of them, beginning in 1991. I sailed with Roger on three Atlantic crossings (once below the Antarctic Circle) and twice to the Arctic, including the successful transit of the Northwest Passage.

Roger received the Cruising Club of America's prestigious Blue Water Medal in 2000 and was named the "preeminent American offshore voyager of the last three decades." Captain Swanson was a good mentor, indeed.

On Christmas Day 2012, at the age of 81, Roger sailed over his last horizon. In a final update to my blog covering the Northwest Passage, I wrote: "It is with a very heavy heart that I post tonight. My friend and blue-water sailing mentor, Roger Swanson, has passed into the deep after a hard-fought battle with illness. Roger was a great mind, strategist, and adventurer.

"Because of his willingness to accept 'greenhorns' on his sailing vessel, hundreds of lives were changed forever, including mine. I sailed seven times with Roger and nearly 40,000 nautical miles. By seeing the remote regions of the world by sailboat, and working hard to get there, I was privileged to experience the environment in a unique and nuanced manner that shaped my life and views of the ecology and climate forever.

"Roger opened doors that only he could have opened. There will never be another one like him. Fair breezes, Captain. Godspeed, and thank you always for taking me to the sea."

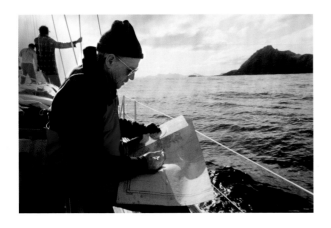

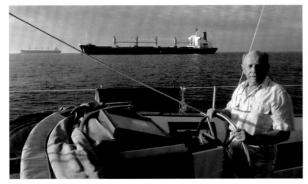

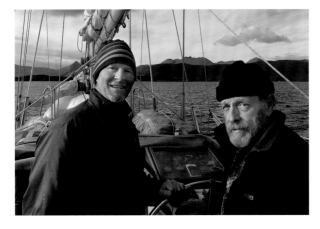

Captain Roger Swanson adapted to any sea, whether navigating around Cape Horn, maneuvering through busy shipping lanes or keeping a steady helm on sleep-deprived nights in Antarctica. I was very honored to sail with Roger through the Northwest Passage in 2007.

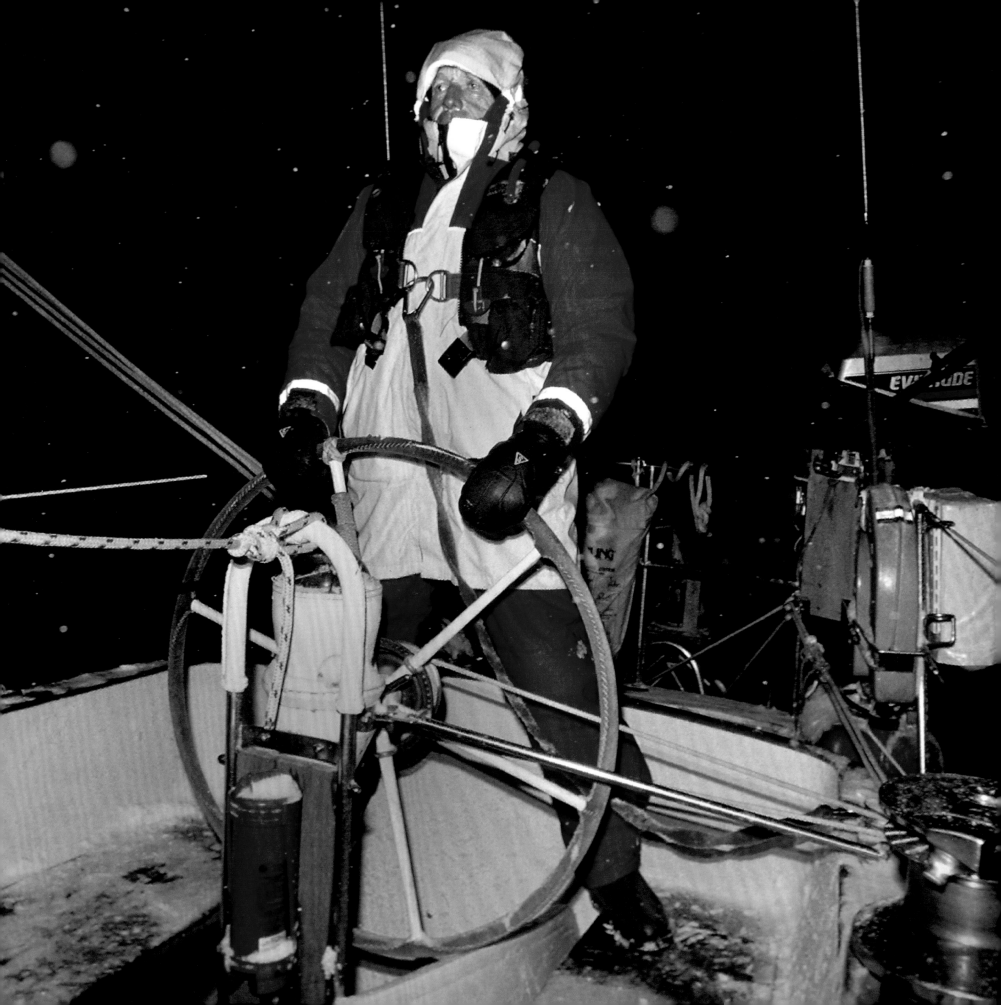

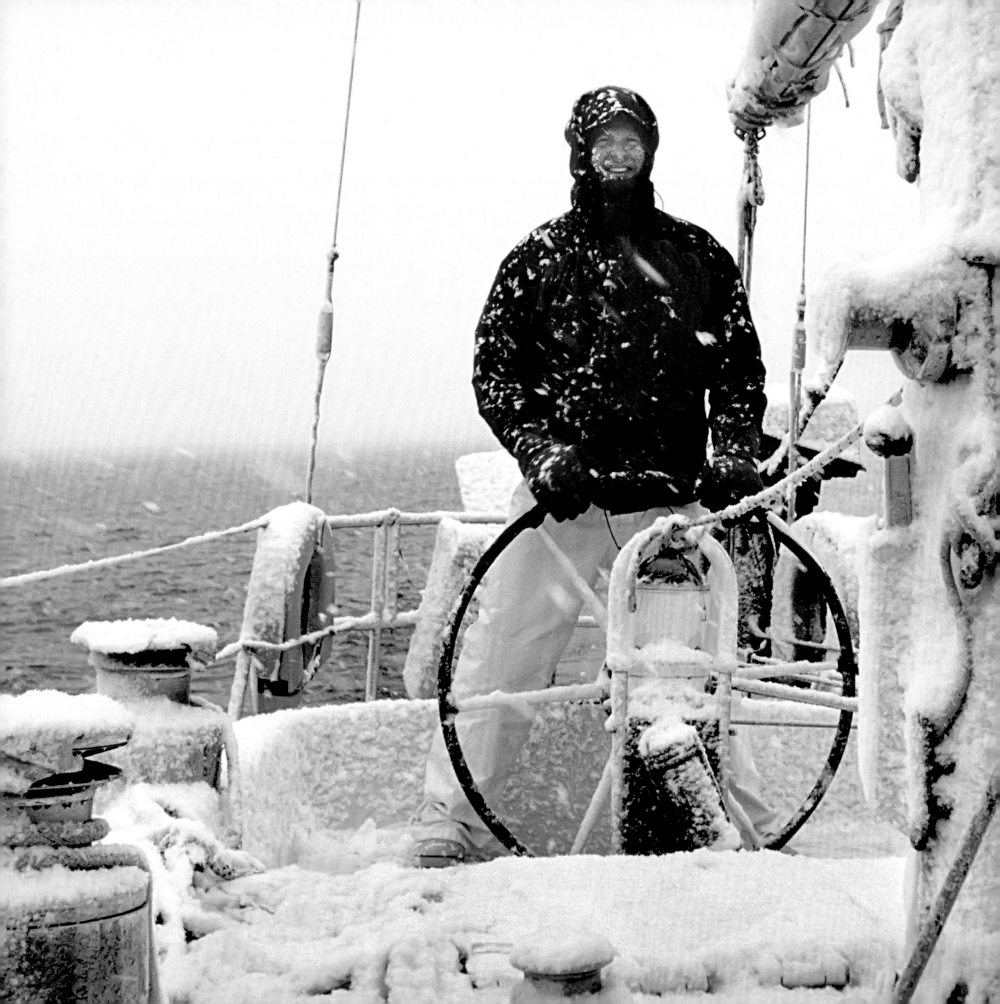

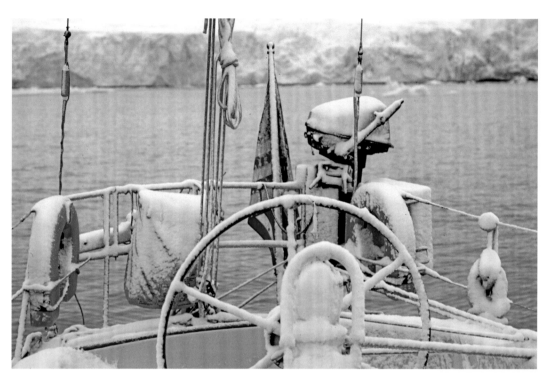

Out on the big seas, Captain Roger Swanson introduced me to the powerful weather systems that drive the Earth's climate. Above: After getting pummeled by storms near the Antarctic Circle, *Cloud Nine* rested at Palmer Station, a U.S. research station.

LEAVING DORIAN BAY • ANTARCTICA

It is snowing as hard as I have ever seen it snow, and we are sailing through slush. I cannot ever recall a more uncomfortable stretch of bad weather, combined with stress, in my life. In fact, there has never been a more challenging set of circumstances. I know this has made me a stronger person, and I can face life with a renewed sense of confidence. I also learned that I can take a hell of a lot of punishment and still keep an optimistic attitude. Lastly, I know I want to do more sailing, which I find very enjoyable and a wonderful way of existence. Now it is time to finish the Drake Passage and head back to Cape Horn.

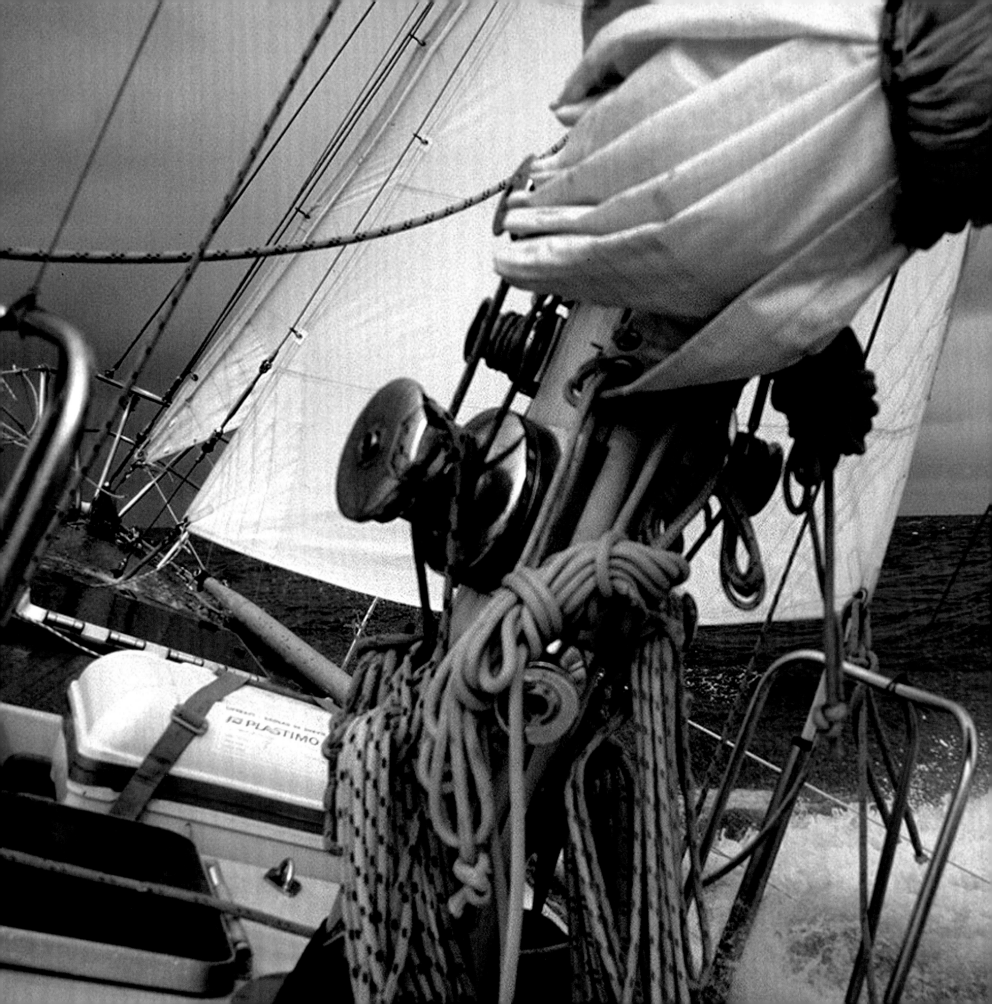

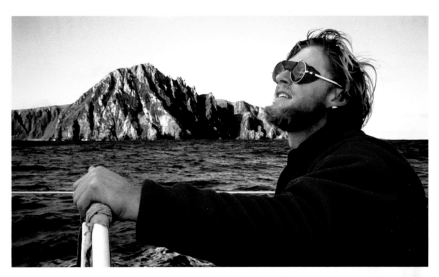

I was at the helm as *Cloud Nine* sailed around Cape Horn on the return from Antarctica in 1992. Left: We had left Cape Horn to starboard weeks before and slowly sailed south into the cold and dangerous Drake Passage.

DRAKE PASSAGE • SOUTHERN OCEAN

Cape Horn and the Drake Passage wasted little time rearing their ugly heads and spitting at us. Of all possible wind schemes, we get headwinds out of the south gusting to 45 knots. This is an indescribable experience. I feel anxious, excited, and scared. You definitely know you are alive out here. Every sense is tested. Many thousands of sailors have died in these waters, and it is nothing to take lightly. Death seems always very close at hand.

Captain Roger Swanson demonstrated his celestial navigation skills in the Southern Ocean. Together we sailed to Antarctica in 1992 as *Cloud Nine* became one of the first small vessels to sail below the Antarctic Circle.

OFFSHORE ANTARCTIC PENINSULA

Very long watch, cold feet, and exhausted. There were definitely icebergs all over the place today. We passed 8-10 very large icebergs, many smaller bergs and the always dangerous "bergy bits." We are 100 miles from the Antarctic Circle. Everyone's tense. Our engine is not operating correctly. Today was pretty nice, actually, but not a lot of wind to sail. Moving slowly but surely to the South. Just passed by an iceberg that must have been 400 feet high. Incredible.

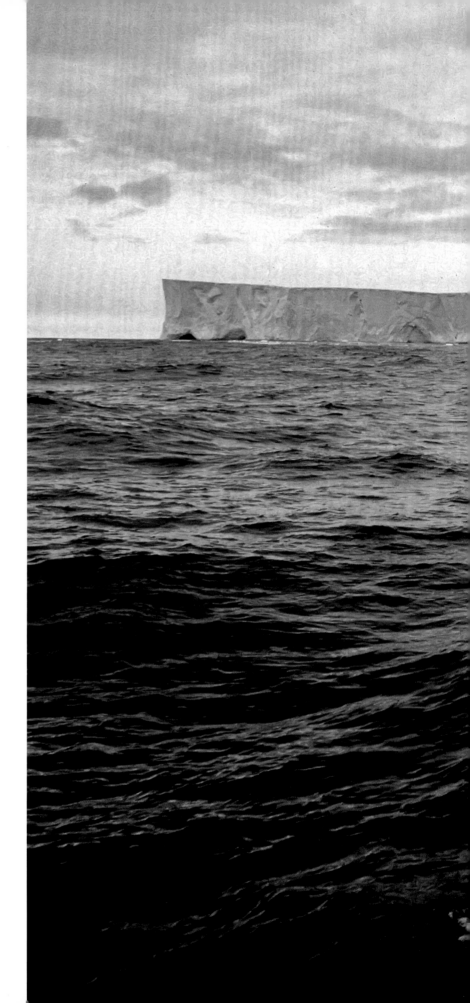

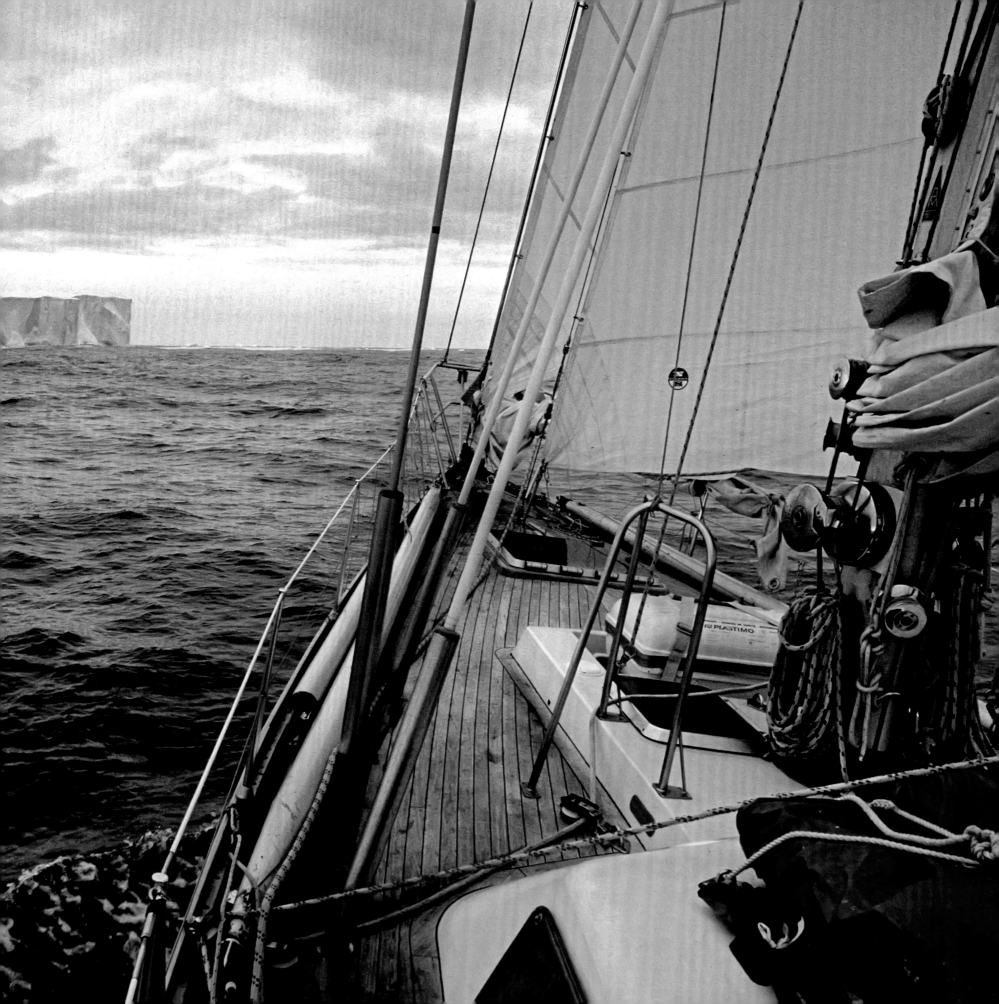

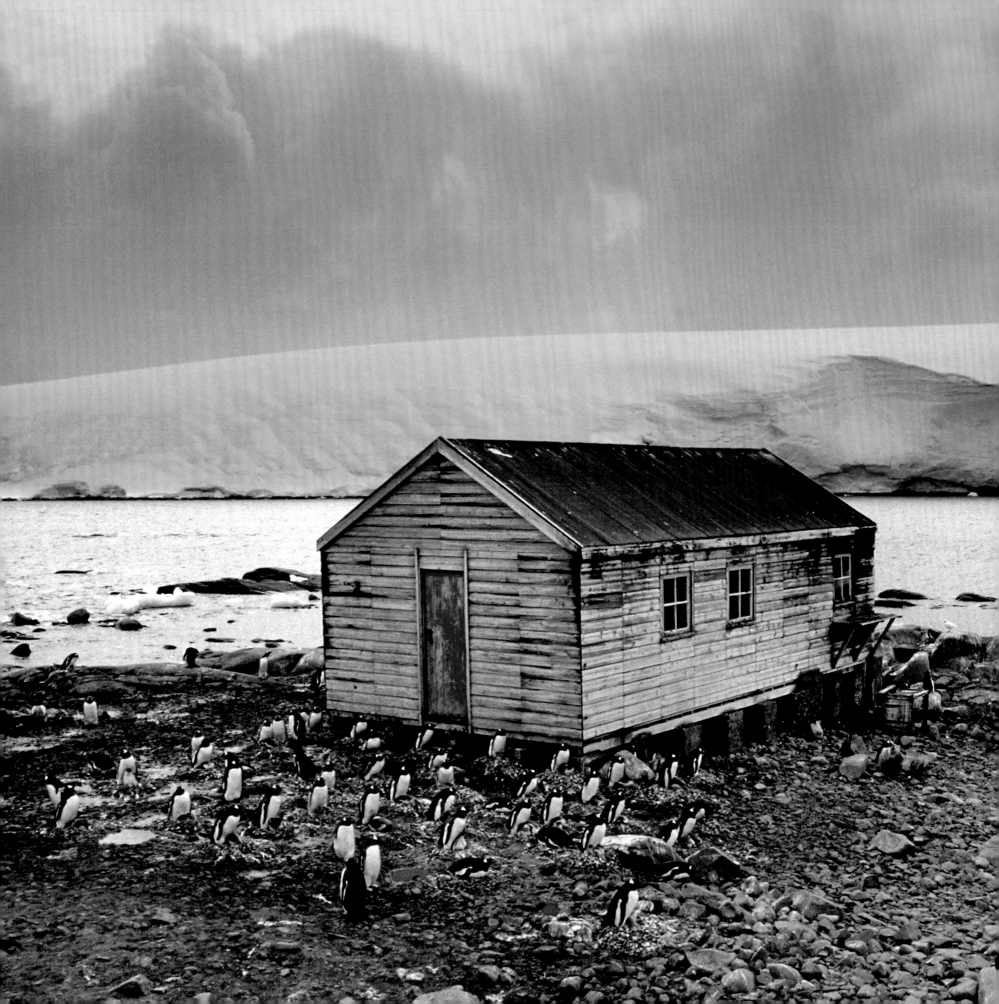

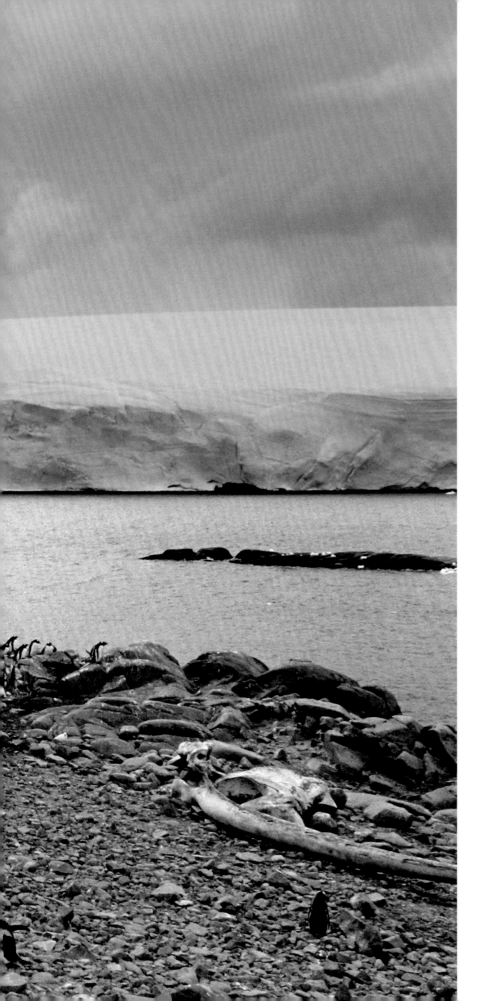

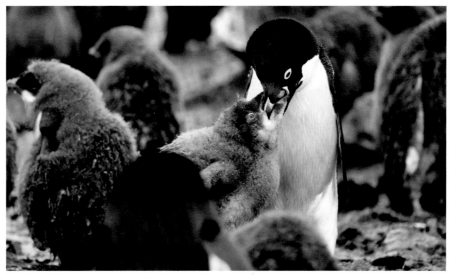

The warming of the Antarctic Peninsula threatens Adelie penguins, which feed their young by regurgitation. Left: A nesting colony of gentoo penguins has taken over Port Lockroy, which was once a British scientific base.

DORIAN BAY · ANTARCTICA

Earlier in the day we visited Port Lockroy, an abandoned British scientific base. We enjoyed seeing the old dilapidated huts with food stores still inside and the gentoo penguin colony outside. Dorian Bay was absolutely beautiful. We even had blue skies for a short time. Pristine snow-capped peaks in the distance. Antarctic white — nothing else like it on Earth. The incredible beauty of Antarctica finally showed through the sullen overcast veneer.

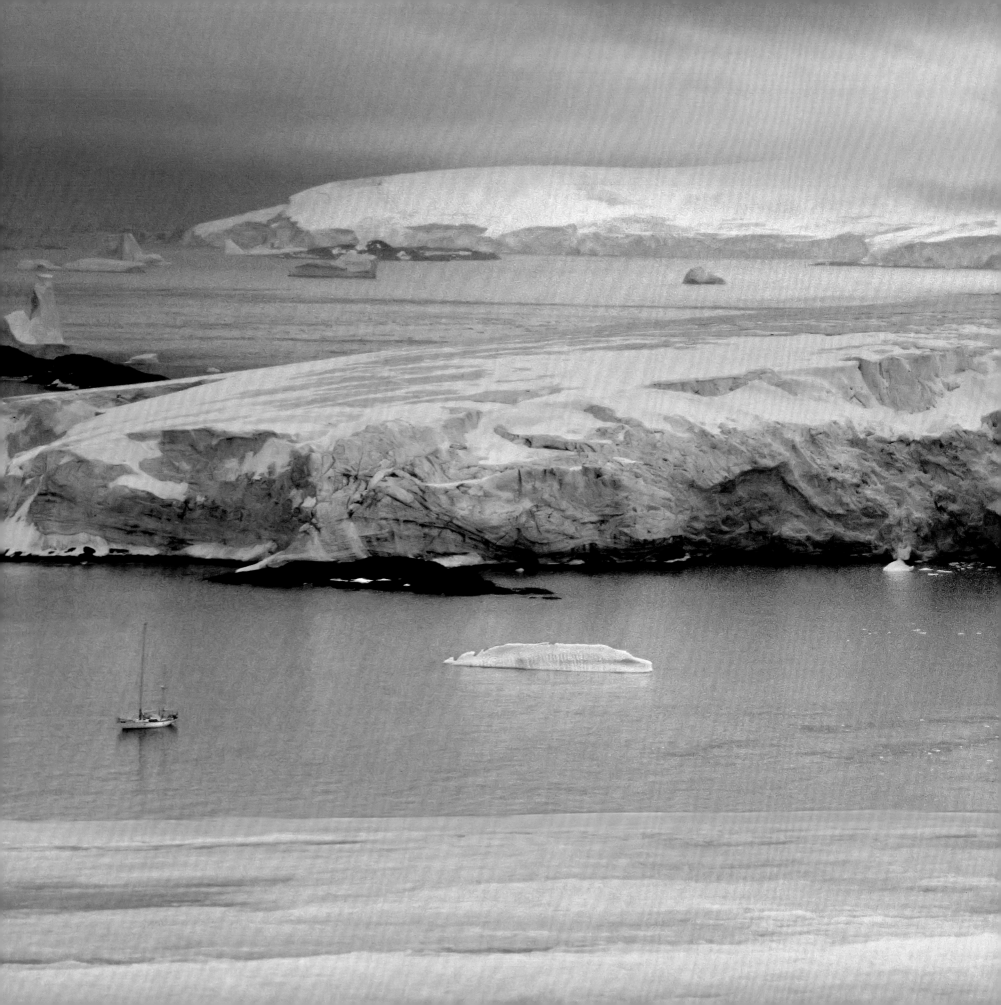

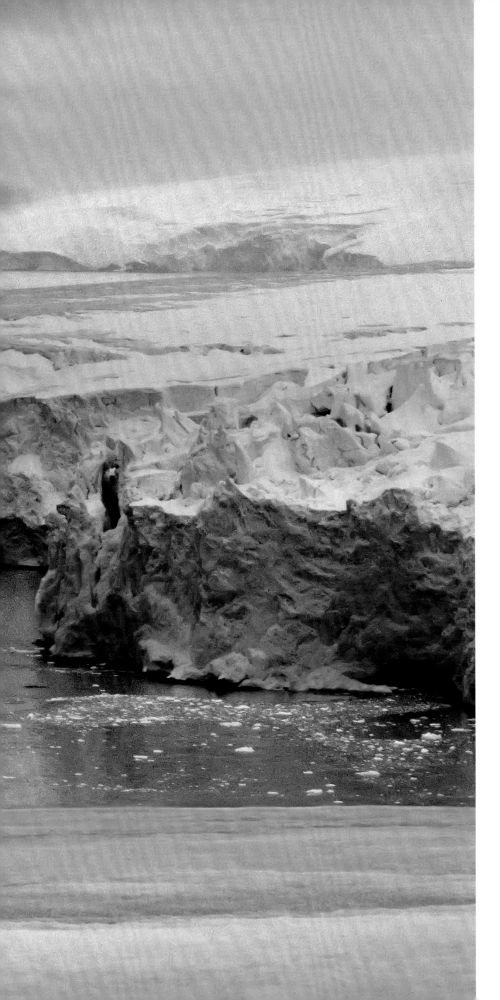

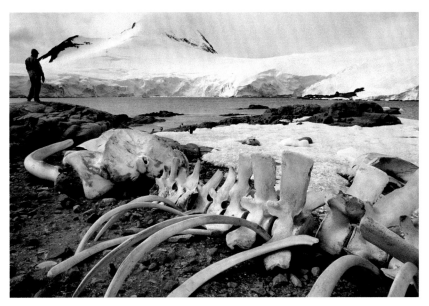

Cloud Nine anchored near Palmer Station in 1992 near the calving front of a massive glacier in Antarctica. Thoughts and conversation soon turned to an attempt of the Northwest Passage. Above: The crew of *Cloud Nine* explored a humpback whale skeleton at an abandoned whaling site near Port Lockroy.

JOURNAL • JANUARY 30 • 1992

DORIAN BAY TO DRAKE PASSAGE

I can sense the Drake now, and it seems to sense us. Another pawn to toy with. Early morning hours. Dark. Motoring out of here in somewhat rough and confused seas. Not very nice out. Fog, sleet, and 34°F. Still icebergs roaming around, which is quite disturbing. One is now off our port bow. I am growing weary of these mammoth ice hulks. Hoping today brings us some wind and possibly more favorable sailing conditions. We deserve it. Not even one full day of sun in the last three weeks. Not fair.

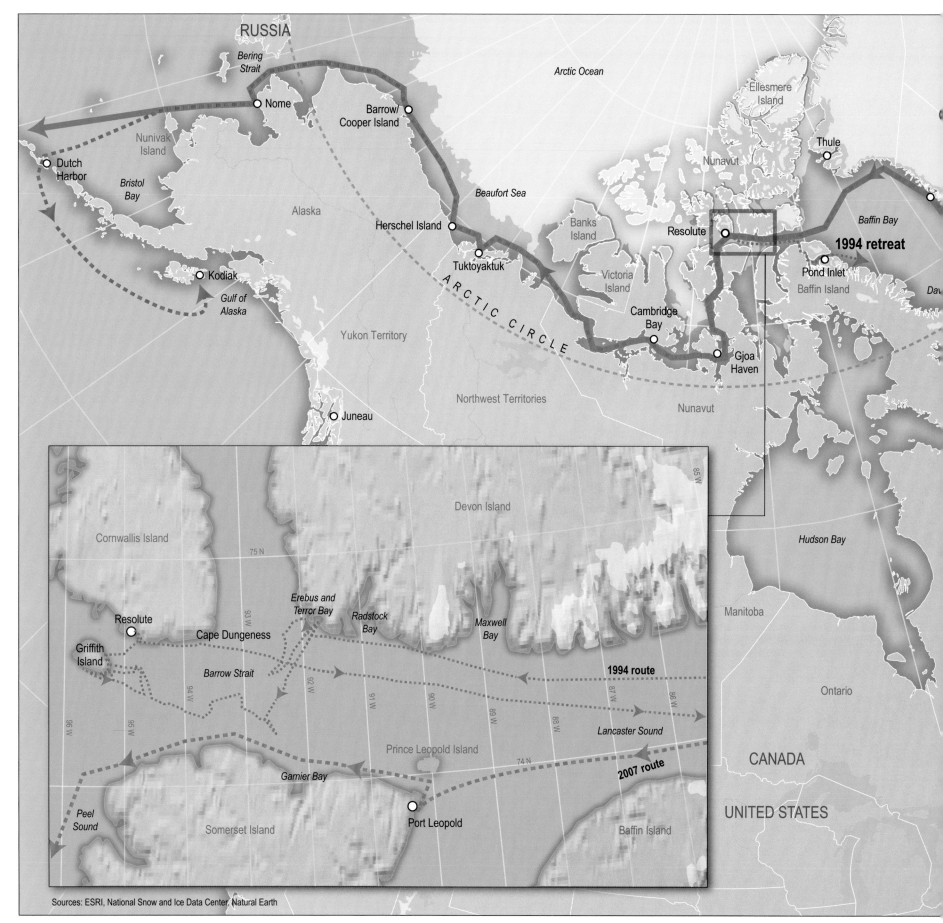

Sources: ESRI, National Snow and Ice Data Center, Natural Earth

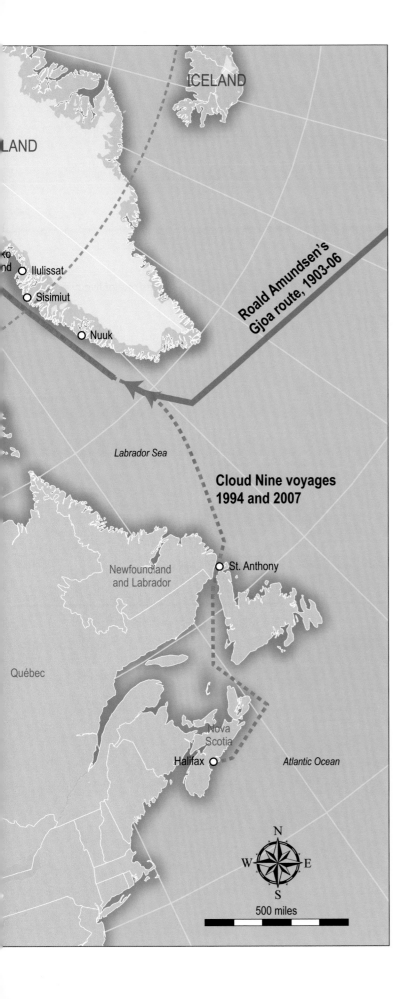

THE NORTHWEST PASSAGE, 1994

ON THE TRAIL OF AMUNDSEN

In 1994, I joined Captain Roger Swanson and the crew of *Cloud Nine* again, this time for an attempt to transit the Arctic's Northwest Passage. This would prove to be another fascinating, and humbling, adventure adding to my understanding of a changing planet.

For centuries, European explorers had sought a shorter trade route to lucrative markets in the Far West than sailing around the great Southern Capes. Many attempts were made to find a sea route through the Arctic Ocean, but most voyages heading east from Europe ended in peril and gut-wrenching death. Vessels became surrounded by unending pack ice, or frozen seawater, and could not escape the frigid grasp of the Northwest Passage.

Roald Amundsen was the first to navigate the Passage, taking almost four years, from 1903 to 1906. The Norwegian established the classic route and, along with his North and South Pole exploits, entered the record books as possibly the most decorated explorer of all time. Belgian Willy de Roos was the first sailor of the modern era to transit the Passage, successfully completing it in 1977.

From the Atlantic, the journey bends north, with the current, along the west coast of Greenland and over the Arctic Circle. The route then turns west and crosses Baffin Bay and enters the channels of the Canadian Arctic along the northern coast of North America. The treacherous journey eventually turns south and heads through the Bering Strait, aiming for

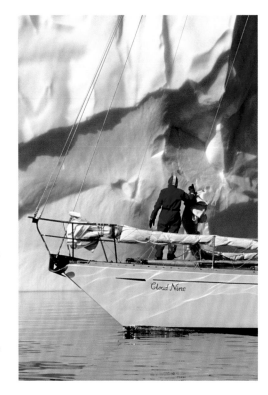

I was one of five crew members to join Captain Roger Swanson on *Cloud Nine* for a 1994 attempt at a Northwest Passage. Right: Refrozen meltwater created a blue streak through an iceberg near Disko Island off Greenland's west coast.

the warmer waters of the Pacific.

Cloud Nine departed from Newfoundland in 1994 and entered the treacherous North Atlantic Ocean en route to Greenland. We retraced countless European explorers' routes dating back to the 16th century, hoping to become the first American vessel to complete the east-to-west route.

Taking time to explore Greenland's rugged western coastline as ice cleared to the north, we stopped and reprovisioned in small, remote villages. We also hiked to glaciers such as Jakobshavn, the most productive glacier in the Northern Hemisphere, accounting for about 10 percent of all of Greenland's icebergs.

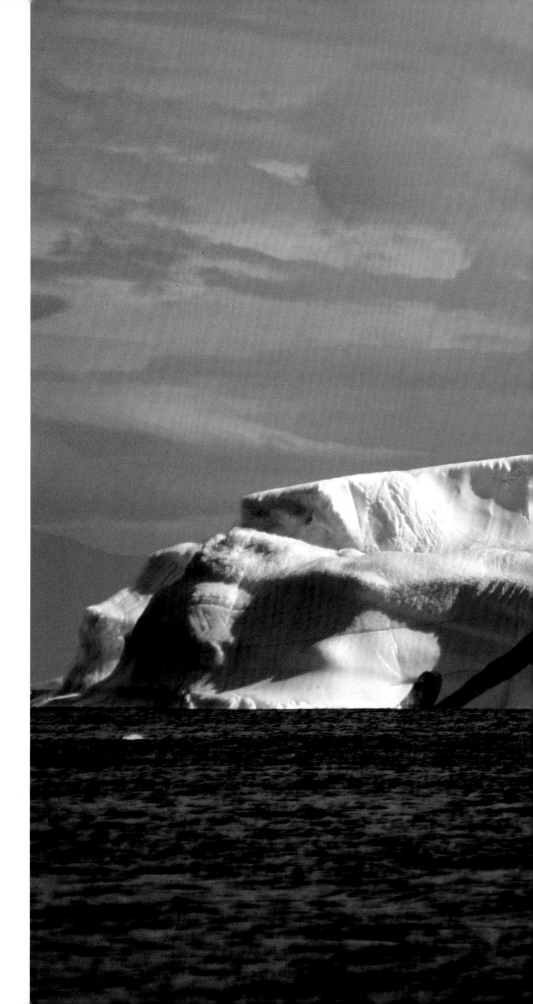

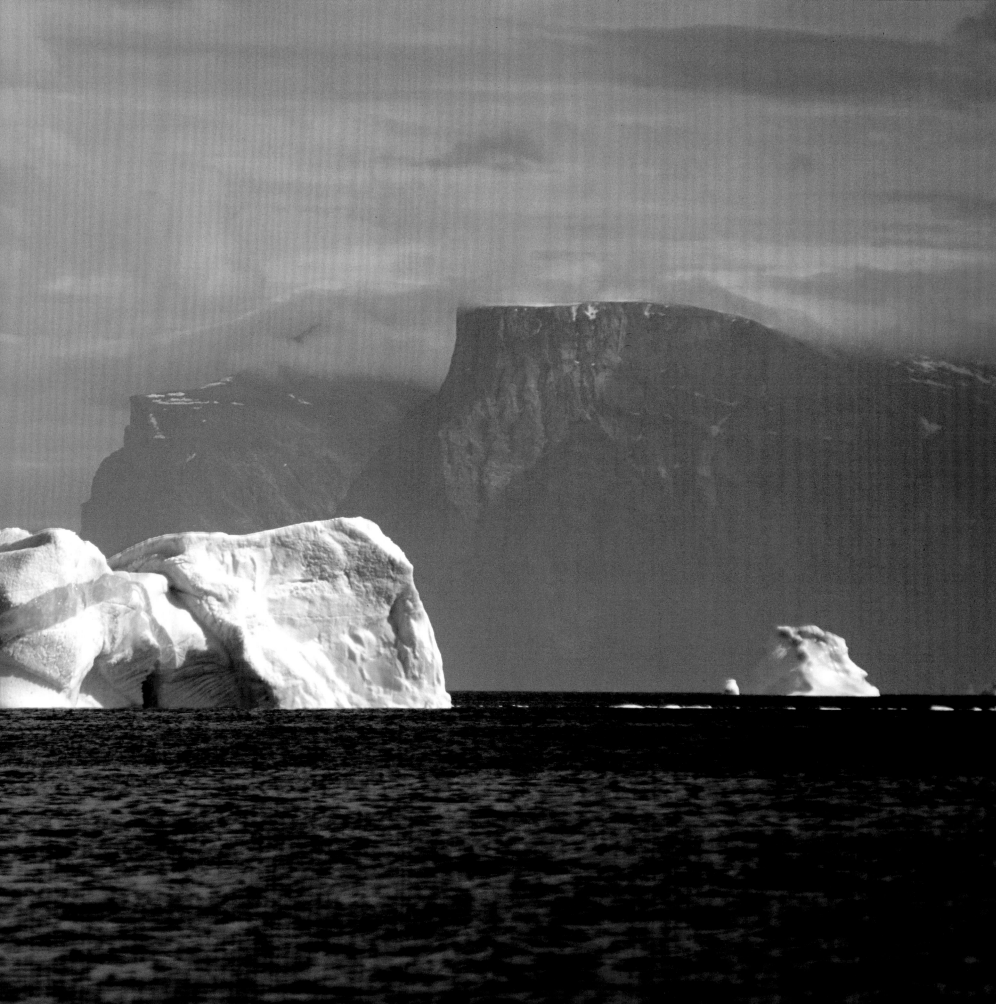

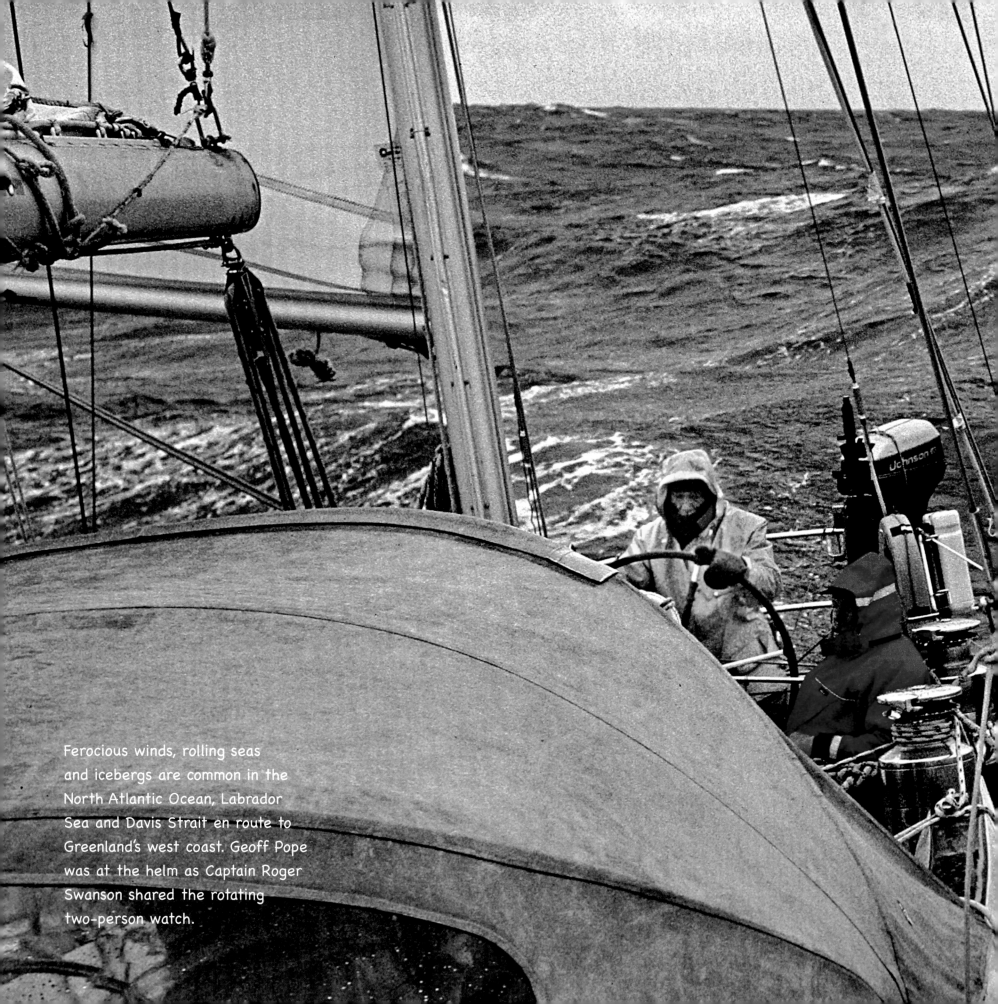

Ferocious winds, rolling seas and icebergs are common in the North Atlantic Ocean, Labrador Sea and Davis Strait en route to Greenland's west coast. Geoff Pope was at the helm as Captain Roger Swanson shared the rotating two-person watch.

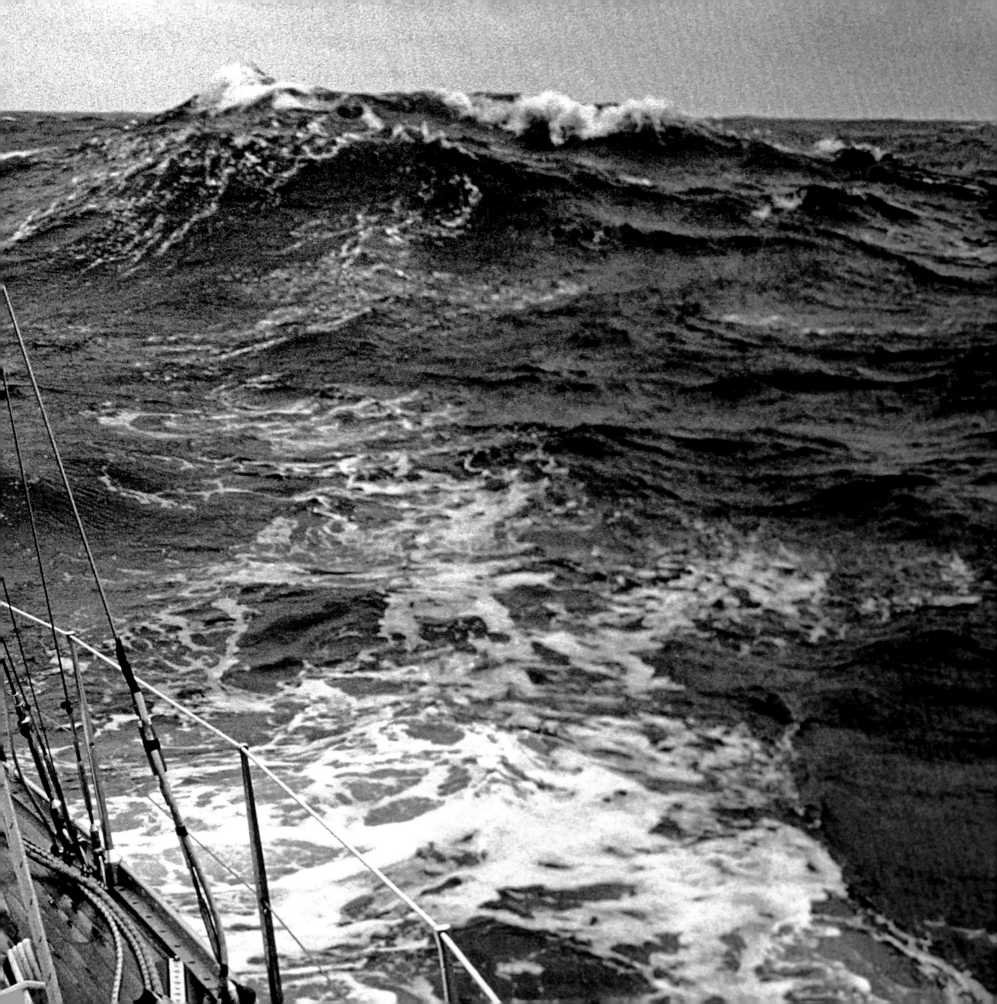

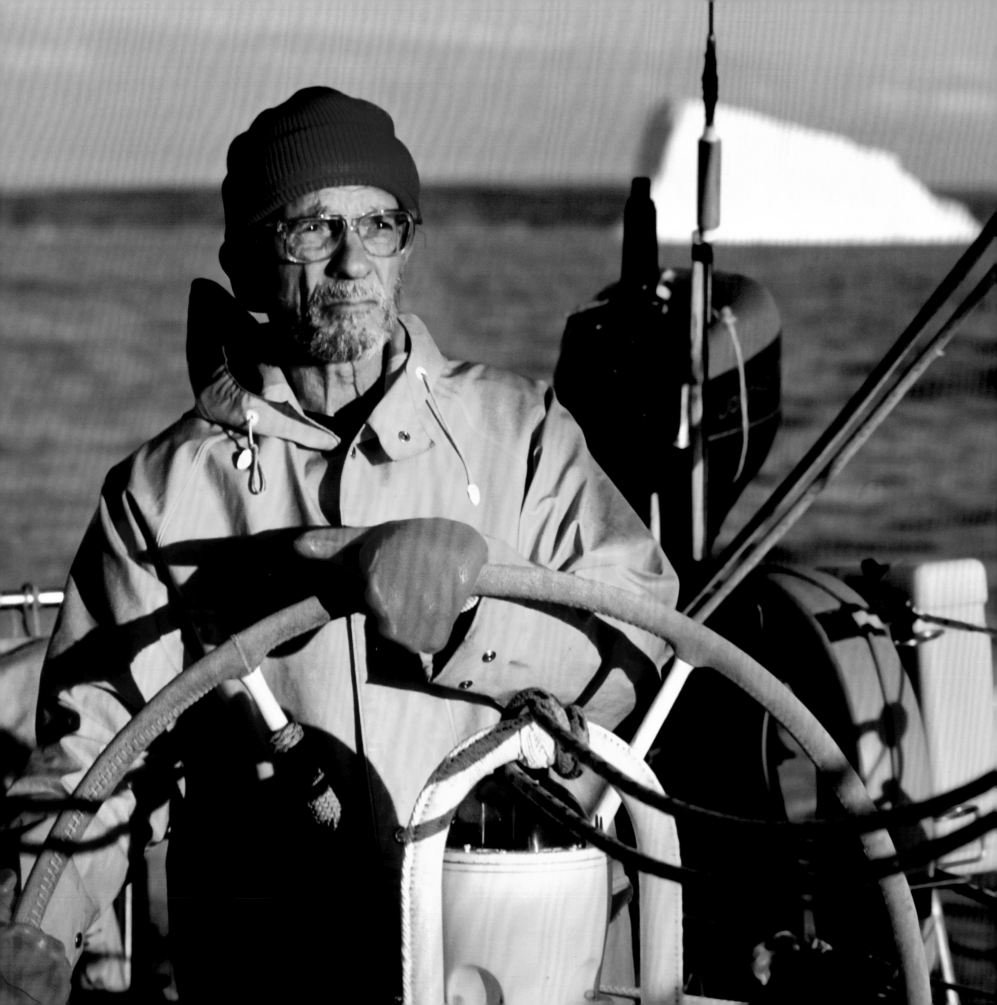

GEOFF POPE: A SURVIVOR FINDS LASTING FRIENDSHIP

Geoff Pope, a spry 81-year-old from Excelsior, Minnesota, was my watch partner and a book unto himself. In our hours together, he told me about his exploits aboard *Sheila Yates*. Named after his daughter, she was built in Nova Scotia by old-school craftsmen, for an old-school sailor.

In 1989, Geoff and his crew had left his beloved Lake Superior and headed out the St. Lawrence Seaway to the North Atlantic for his first transatlantic crossing. They were near Cape Farewell in southern Greenland when the vessel became engulfed in fog. There was a building gale, and they were trapped between huge plates of ice. They had no hope of getting out. They were seven dead men.

The weather was too severe for Greenland Command to send help by air or sea. Maydays. No reply. No help. No hope. Then, a million-to-one shot in the dark: A final call on the VHF radio, with its limited range, located a fishing trawler. She was headed across the Atlantic to the Faroe Islands with her catch from the season. The vessel was named *Kubiak*, captained by David Fancy. Her crew ventured into the deadly ice and rescued the seven men from *Sheila Yates*. They did everything possible to safeguard Geoff's vessel, including sustaining damage to the bow of the *Kubiak*, which later needed 70 tons of new steel for repairs. *Sheila Yates* sank in 600 fathoms after taking a relentless pounding in a northeast gale. But her men were safe.

Geoff Pope sailed *Cloud Nine* along Greenland's west coast. He once held the record for the longest portaged canoe trip ever accomplished, more than 7,000 miles from New York City to Nome, Alaska, in 1937.

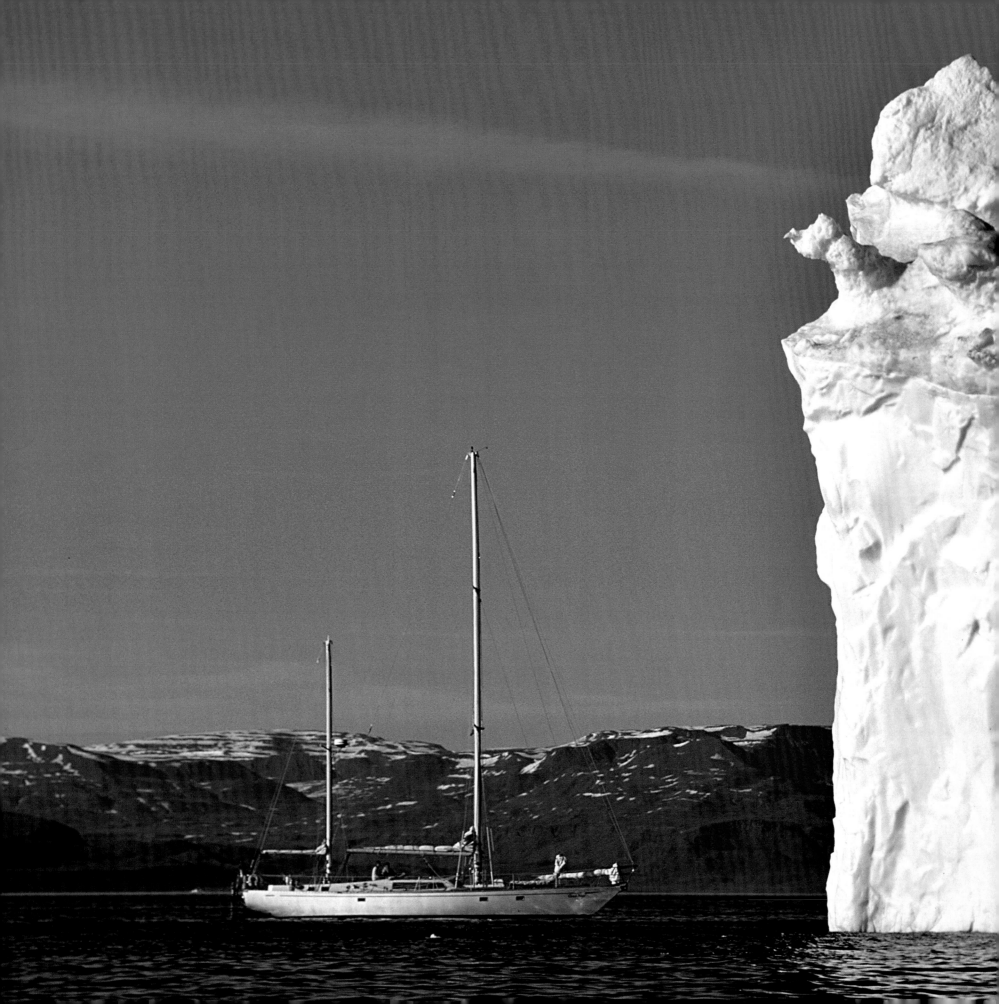

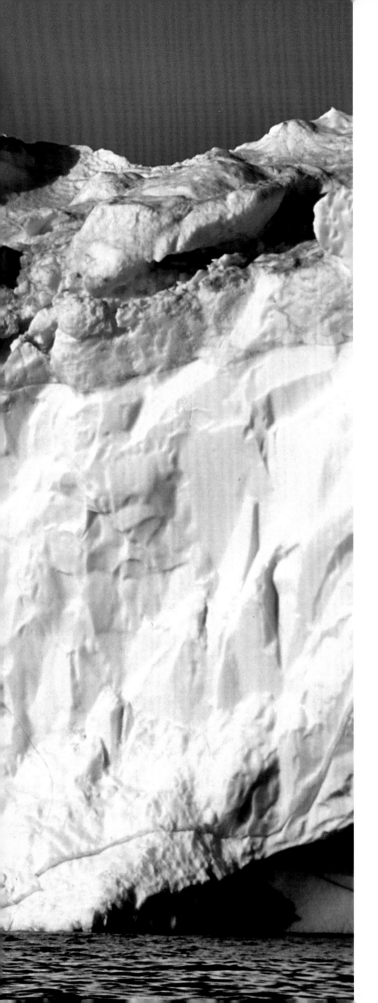

As Geoff watched his dream go down in the cold and unforgiving North Atlantic, he formed a bond with *Kubiak* crew member Hans Peter Petersen (HP, for short), whose wife, Liss, and 4-month-old daughter were also onboard.

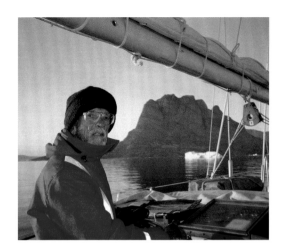

Now with *Cloud Nine*, Geoff arranged to meet HP in Sisimiut, Greenland, in 1994. It was very touching to see Geoff reunited with the Petersens, who by then had two children. Geoff gave them stuffed polar bears that he'd had to stow in his berth because our quarters were so tight. Liss, in return, presented Geoff with her handiwork, a cross-stitch map of Greenland.

Geoff passed away in 2005, at age 92, but I will always remember these simple yet powerful moments.

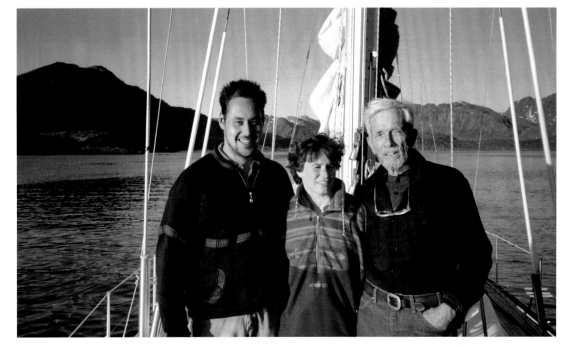

Cloud Nine passed towering icebergs as it traveled north near Greenland. Above: Geoff Pope steered us into Uummannaq, Greenland. He was happy he could reunite with HP and Liss Petersen in Sisimiut.

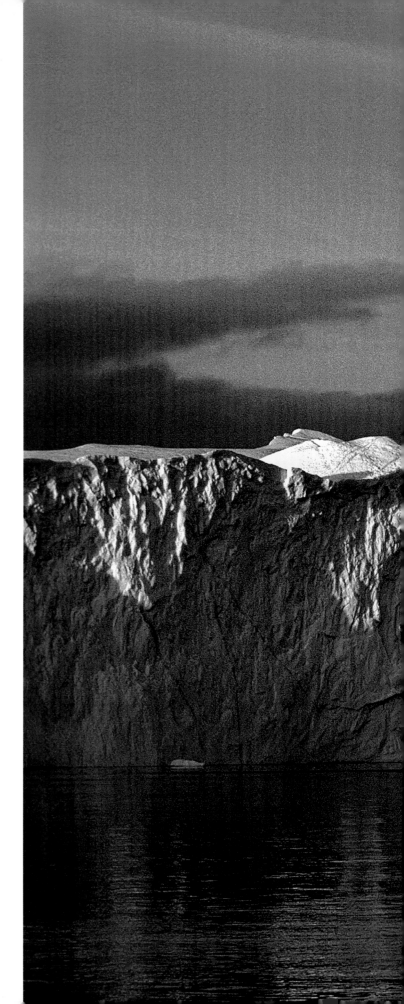

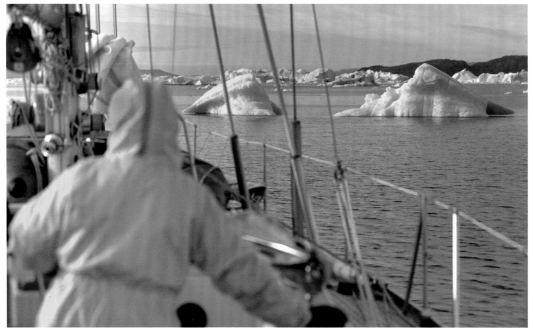

Cloud Nine and crew methodically ventured north along the rugged coast of Greenland, waiting for ice to clear out of Baffin Bay. Ice recedes from the coast with the warm northerly flowing current. We visited Jakobshavn Glacier, the most prolific glacier in the Northern Hemisphere. It produces roughly 10 percent of Greenland's icebergs, including, possibly, the iceberg that sank the *Titanic*.

JOURNAL · JULY 8 · 1994

JAKOBSHAVN GLACIER · WEST GREENLAND

Roger and I left around 2130 hours for our midnight hike in the 24-hour light. Perfect conditions for our hike. The walk was short but strenuous, especially with about 40 pounds of camera gear. Past the cemetery and down the valley. The glacier was visible the whole time. Words cannot ever begin to tell the story of what we witnessed. Massive mountains of ice as far as we could see. The ice fjord is 5 kilometers wide and 1,100 meters thick and moves 30 meters daily toward the sea.

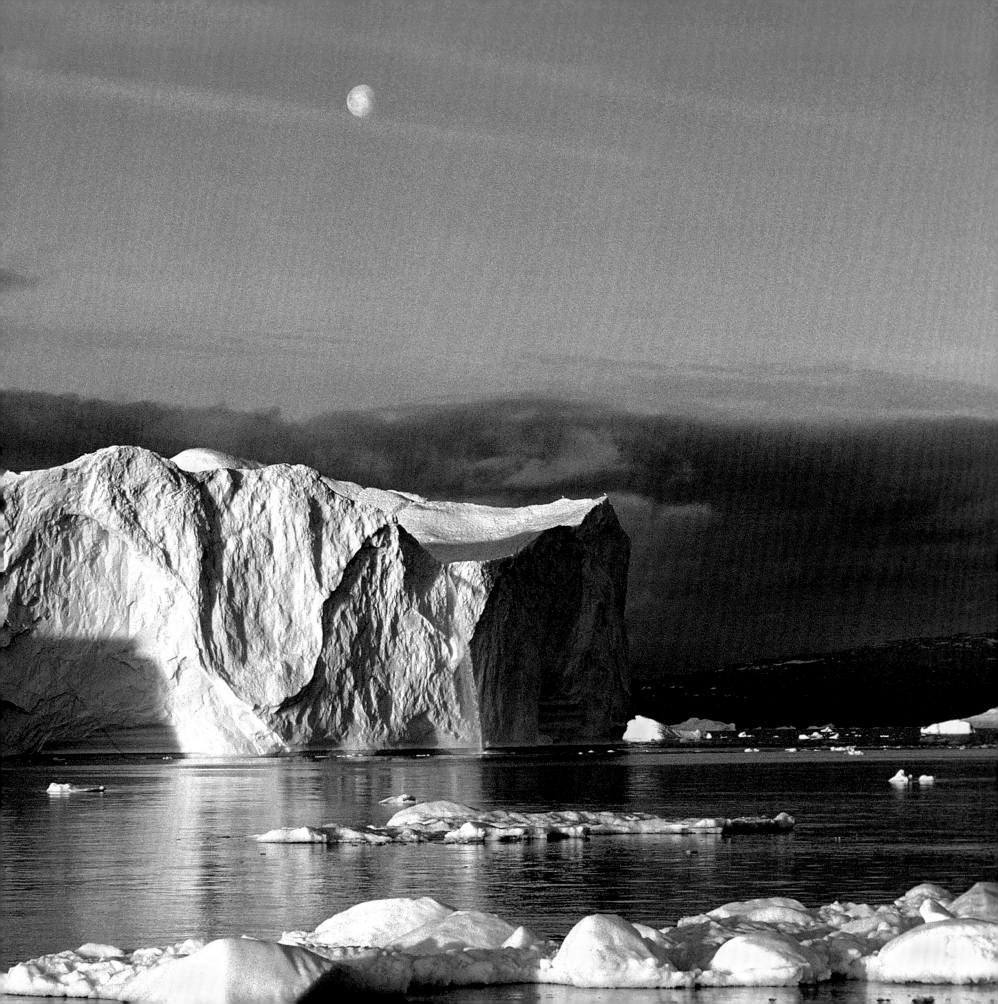

A row of red houses along Greenland's coast added a spark of color to an otherwise monochromatic landscape. Crossing Baffin Bay, 500 miles north of the Arctic Circle, was treacherous, but *Cloud Nine* perfectly handled the rough seas and sailed past sections of lurking pack ice. Favorable breezes let us proceed west into the Canadian Arctic.

JOURNAL • JULY 29 • 1994

BAFFIN BAY

We split the pack ice. Pure magic. Dumb luck, made luck, deserved luck, what the hell, lots of planning and some luck. That's what it always seems to take to make it in these parts. Once again, spirits and confidence are up on **Cloud Nine**. Roger is out on the wheel right now. He is a very content man this afternoon.

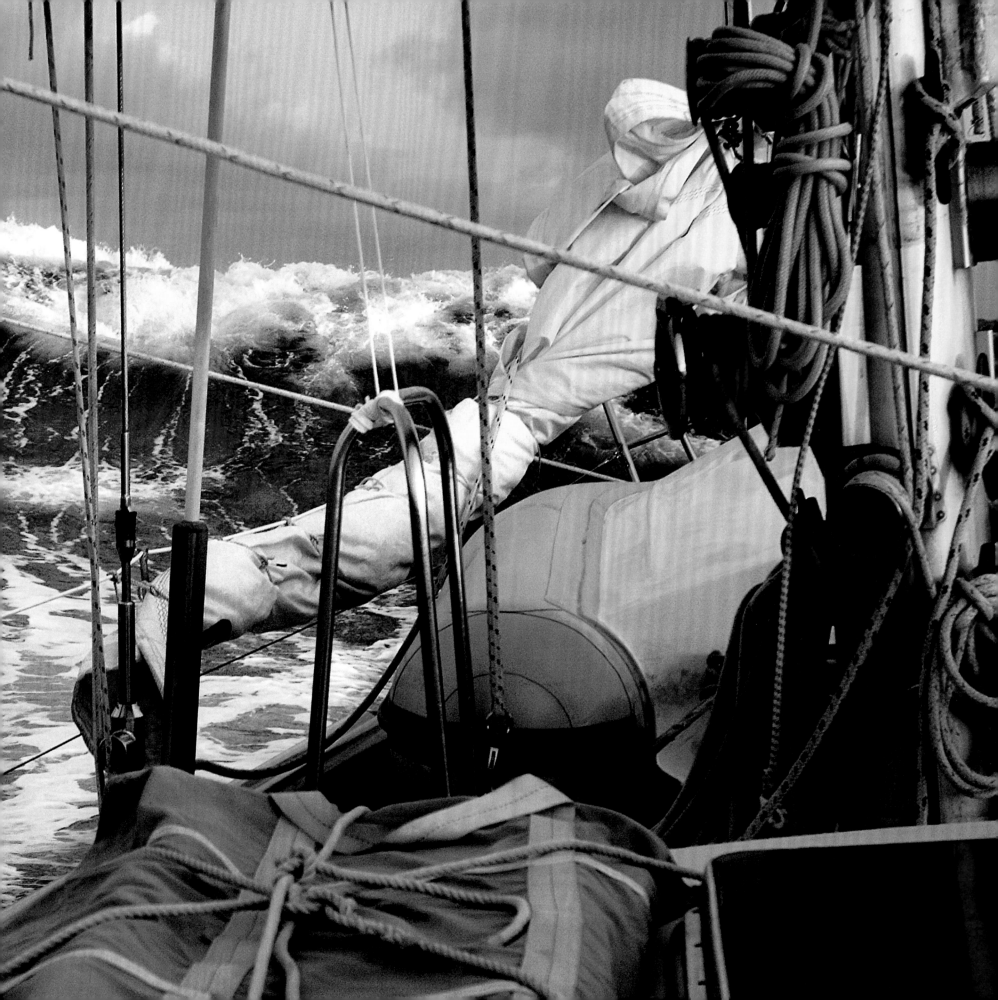

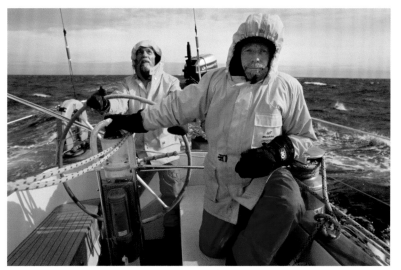

Captain Roger Swanson and Geoff Pope were comfortable and confident on watch while crossing Baffin Bay with very fast sailing conditions. *Cloud Nine* was entering an alien and austere world.

LANCASTER SOUND • NORTHWEST TERRITORIES • CANADA

Talk about dramatic entrances. We probably just crossed Baffin Bay in record time, roaring in tonight doing almost 9 knots in a gale warning. 25 to 40 knots of wind, big seas, you know the rest. And so, this is the Northwest Passage. It has a fairly short, but highly charged history, full of fatal errors and few triumphs. It is a dream world that did not cooperate with the terms imposed by its conquerors. The Arctic and Northwest Passage have their own harsh realities that must be accepted or the consequence is peril. It is on these terms that we will proceed, or turn back, knowing full well our own limitations and frailties as compared with the immensity and power of this most special and sacred place.

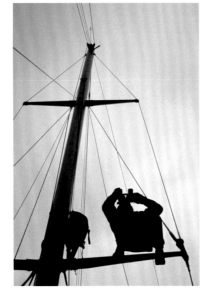

"Ice watch" was part of the daily routine in the Canadian Arctic channels. The spreaders allowed bird's-eye views of the pack ice. *Cloud Nine* had a welcome surprise in Erebus Bay, meeting up with the French boat *Back of the Moon.*

EREBUS BAY • NORTHWEST PASSAGE • CANADA

Returned to Erebus after trying to get west through pack ice. Obviously, it did not work. Found ice edge. Generally headed south and west, which turned out to be impossible to steer in the fog with a useless compass. Took one promising lead to the west but to no avail. We came about in a dead-end basin and said, "Back to the barn." So, here we wait in Erebus Bay for the conditions to change. Weeks since a shower and still in the same clothes. Summer is winding down. Patience is running thin. We need some luck again.

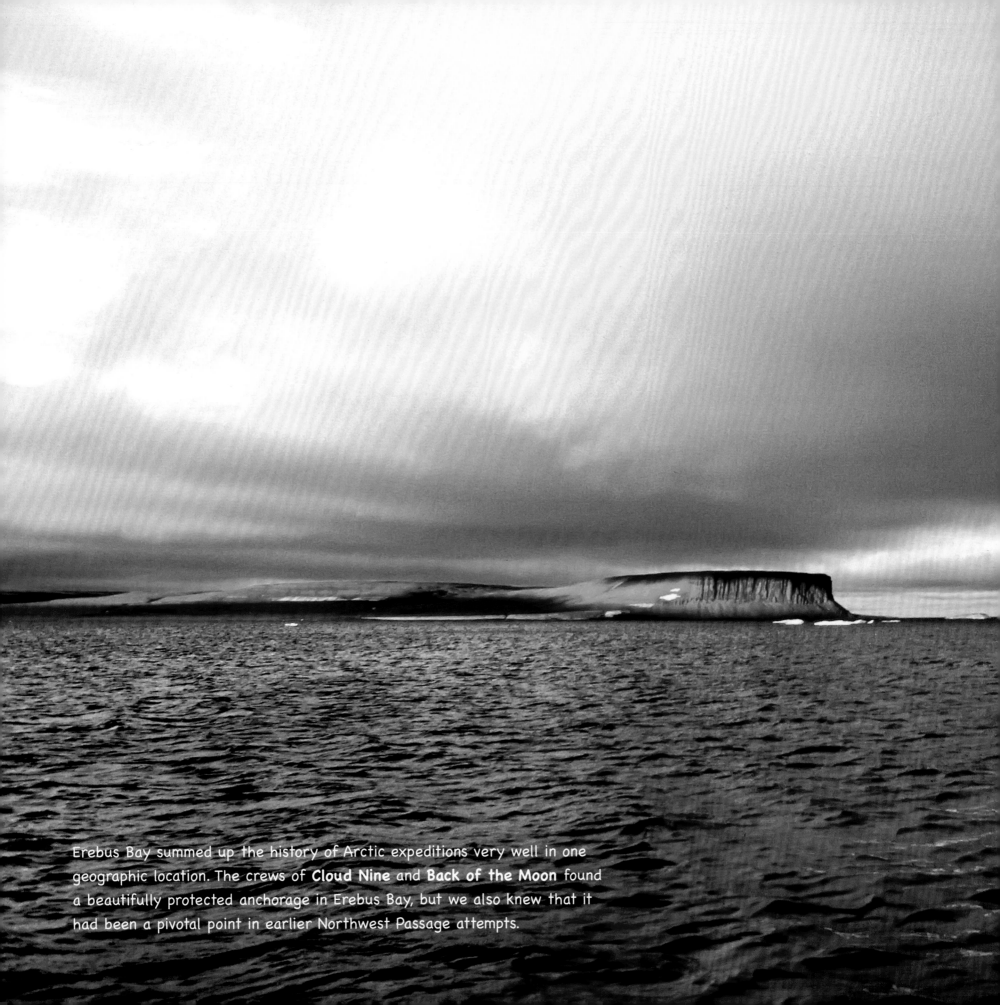

Erebus Bay summed up the history of Arctic expeditions very well in one geographic location. The crews of **Cloud Nine** and **Back of the Moon** found a beautifully protected anchorage in Erebus Bay, but we also knew that it had been a pivotal point in earlier Northwest Passage attempts.

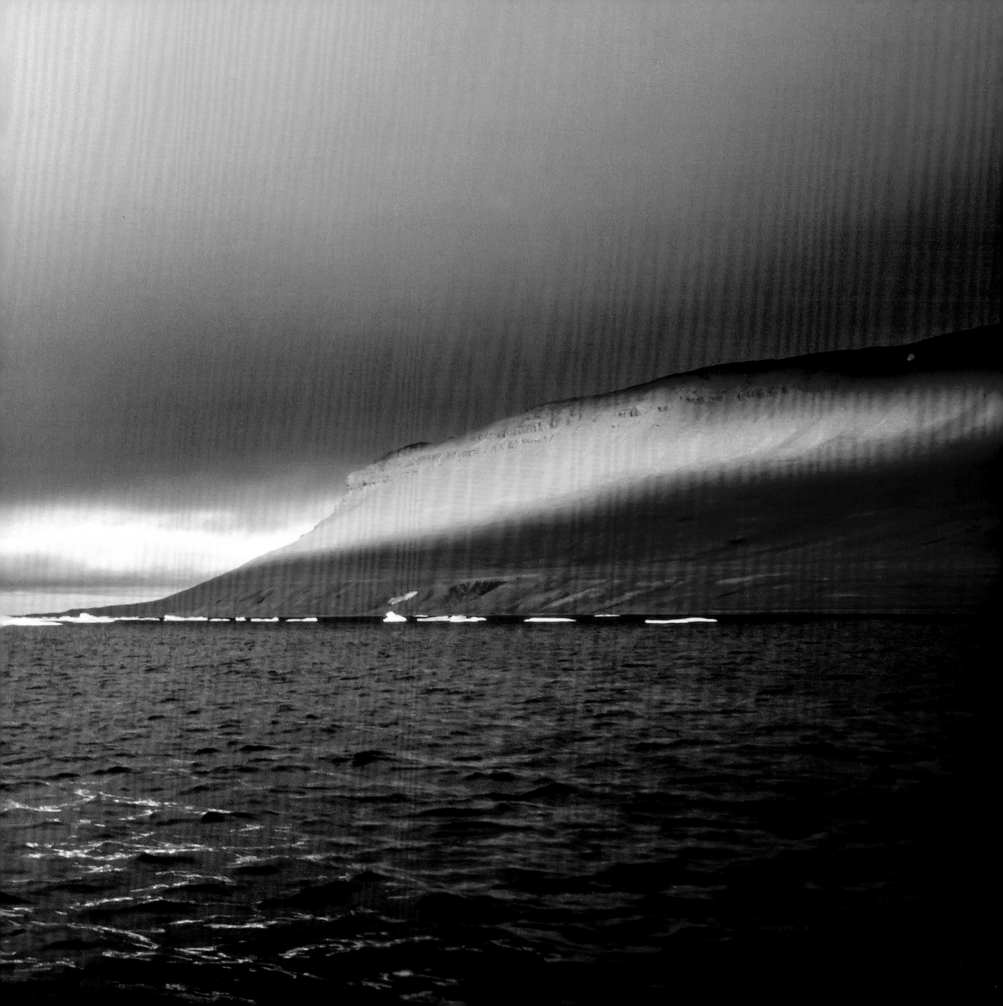

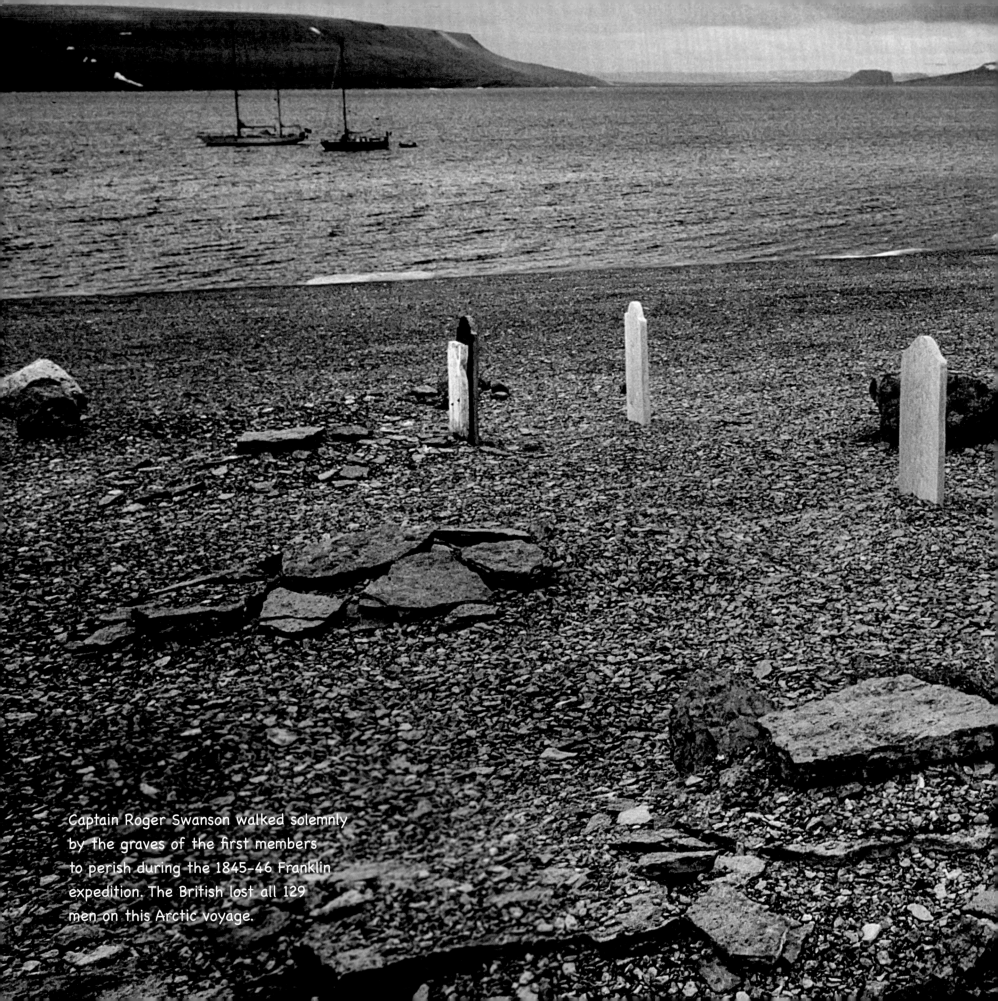

Captain Roger Swanson walked solemnly by the graves of the first members to perish during the 1845-46 Franklin expedition. The British lost all 129 men on this Arctic voyage.

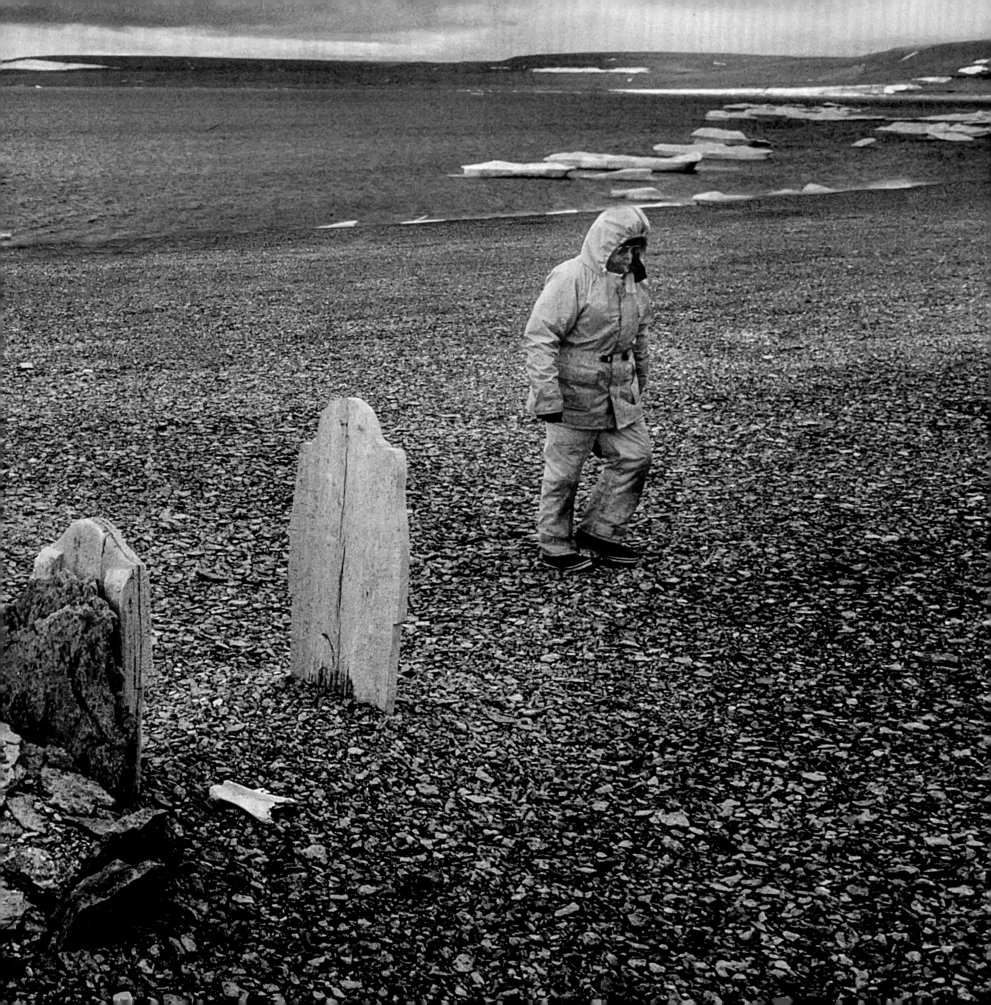

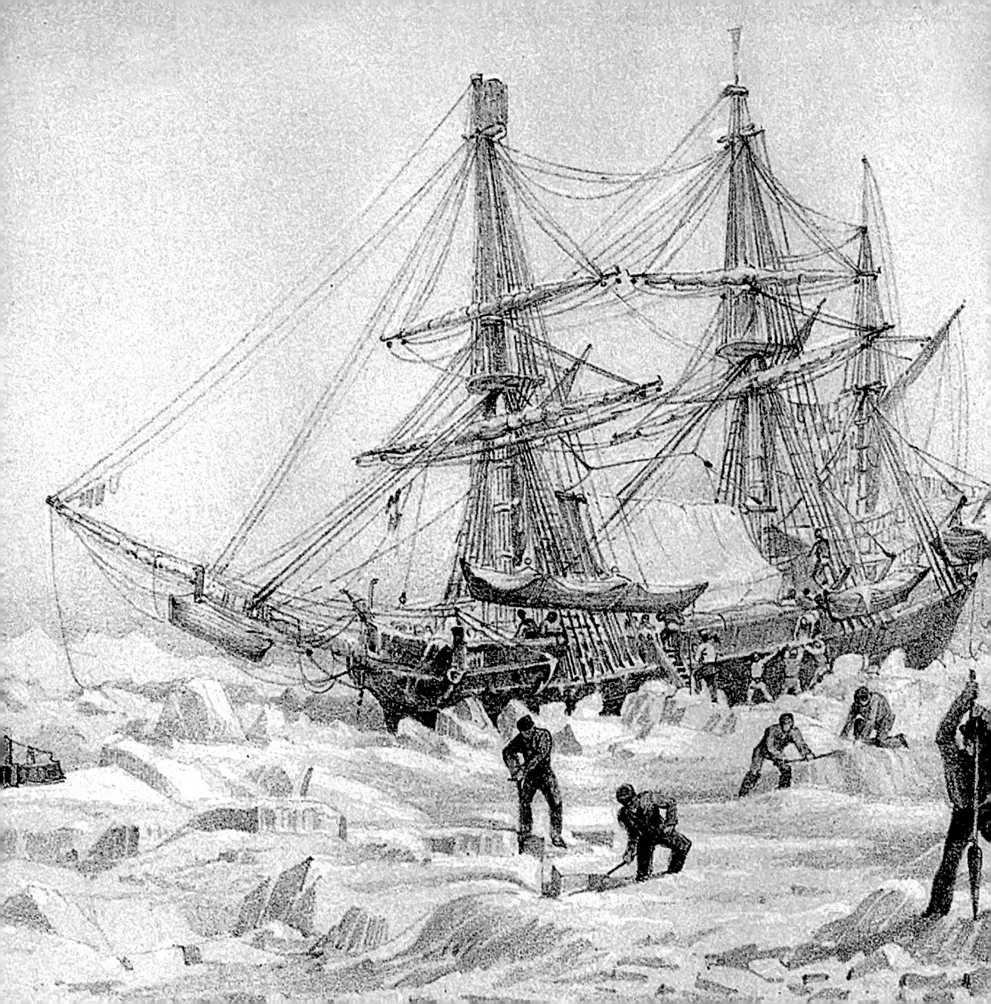

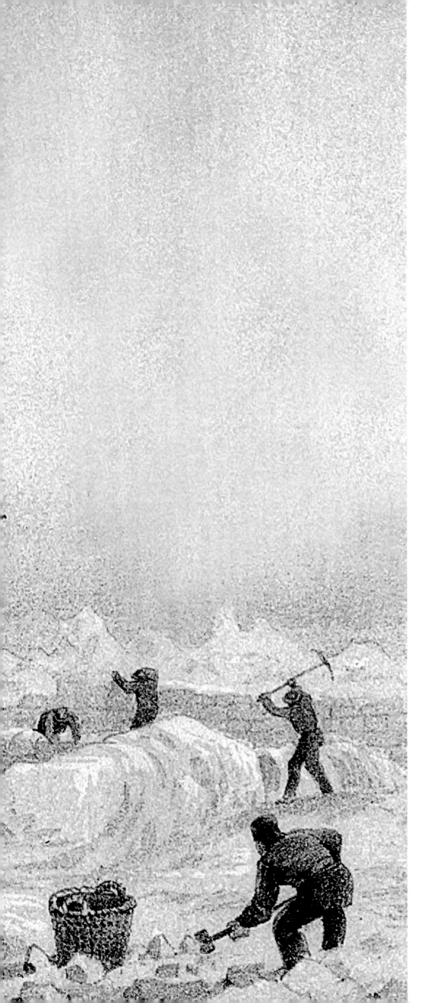

 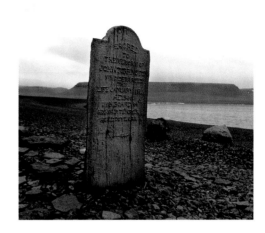

Sir John Franklin was a seasoned Royal Navy officer with three previous Arctic expeditions under his belt. At 59, he led two vessels into the Arctic ice, *Erebus* and *Terror*, both retired military vessels, large and unmaneuverable in the unforgiving conditions. Three crew members died in the first winter of 1845-46 and were buried on Beechy Island in Erebus Bay.

JOURNAL • AUGUST 15 • 1994

EREBUS BAY • NORTHWEST PASSAGE

Today's history lesson, and why we are here, is the Sir John Franklin British expedition to the Northwest Passage. The 129-man crew intentionally froze their vessels, **Erebus** and **Terror**, into the winter pack ice in 1845-46. They opted to stay at Beechy Island, which still holds the remains of their winter cabin and, of course, the graves of the first three crew members to perish. Little did the rest of the crew realize what awaited them as they buried their mates. Once the crew set sail again, their vessels became hopelessly frozen in Victoria Strait, near King William Island. They were low on supplies, but refused help and food offerings from the Inuit people. What food they had was tainted with lead, because the containers were poorly soldered, a new technology at the time. They were getting poisoned without knowing it, but what ultimately led to their demise is still a mystery.

Update: In the summer of 2014, **Erebus** was discovered in Victoria Strait, providing some physical evidence to help solve the puzzle of this failed expedition.

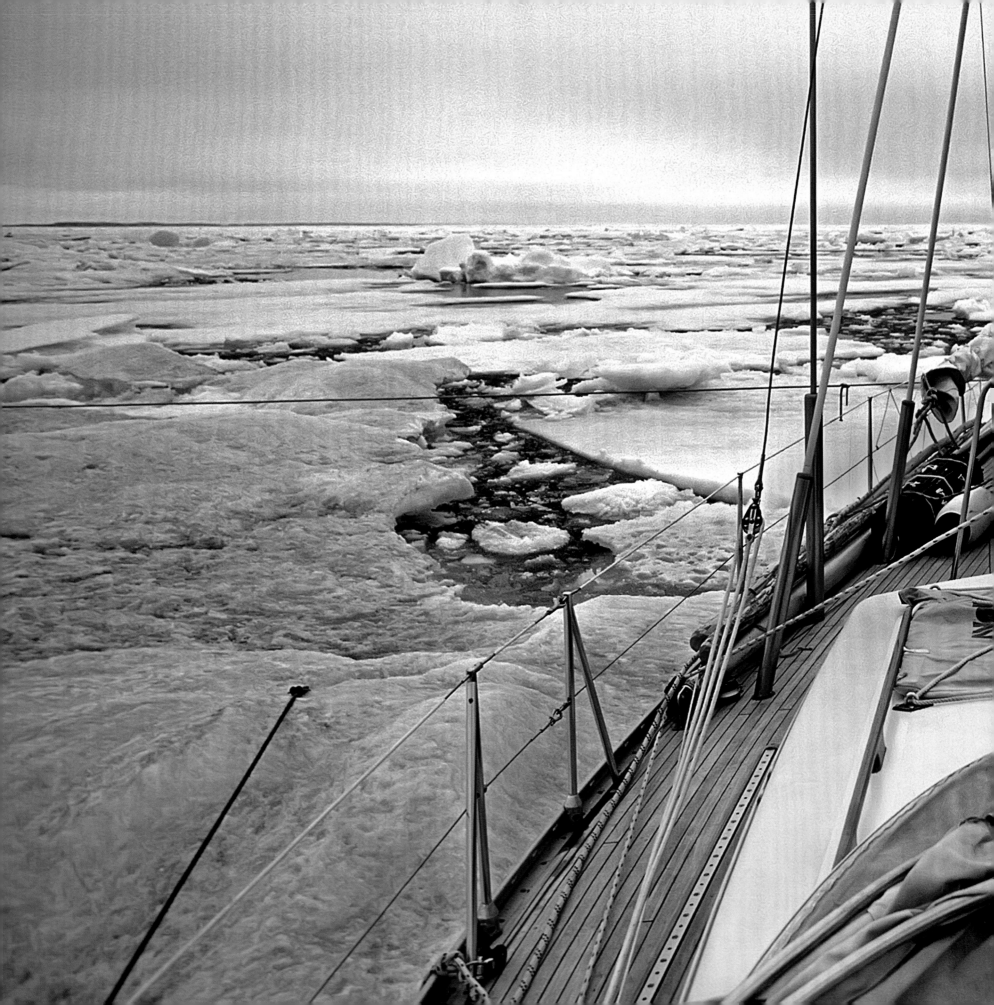

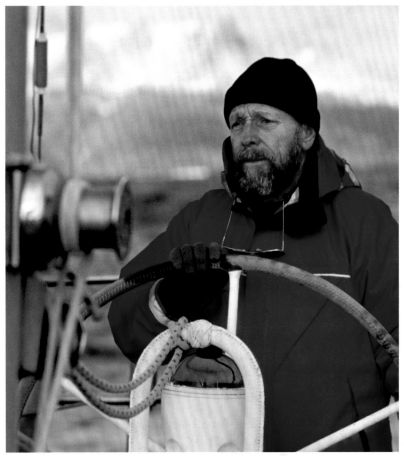

Our crew encountered a tremendous amount of sea ice in the attempt to proceed south into the Canadian archipelago of islands and channels. Dense fog blinded us, our compass was useless, and pack ice blocked us at every turn. We got pinned near the shore of tiny Griffith Island.

BARROW STRAIT NEAR GRIFFITH ISLAND • NORTHWEST PASSAGE

A rat in a maze pretty much sums up the whole ordeal. Now we find ourselves in a most remarkable predicament. We have our grapple anchor and ice screws secured into an old ice floe. We are 15 miles south of Resolute Bay, but we can't get there.

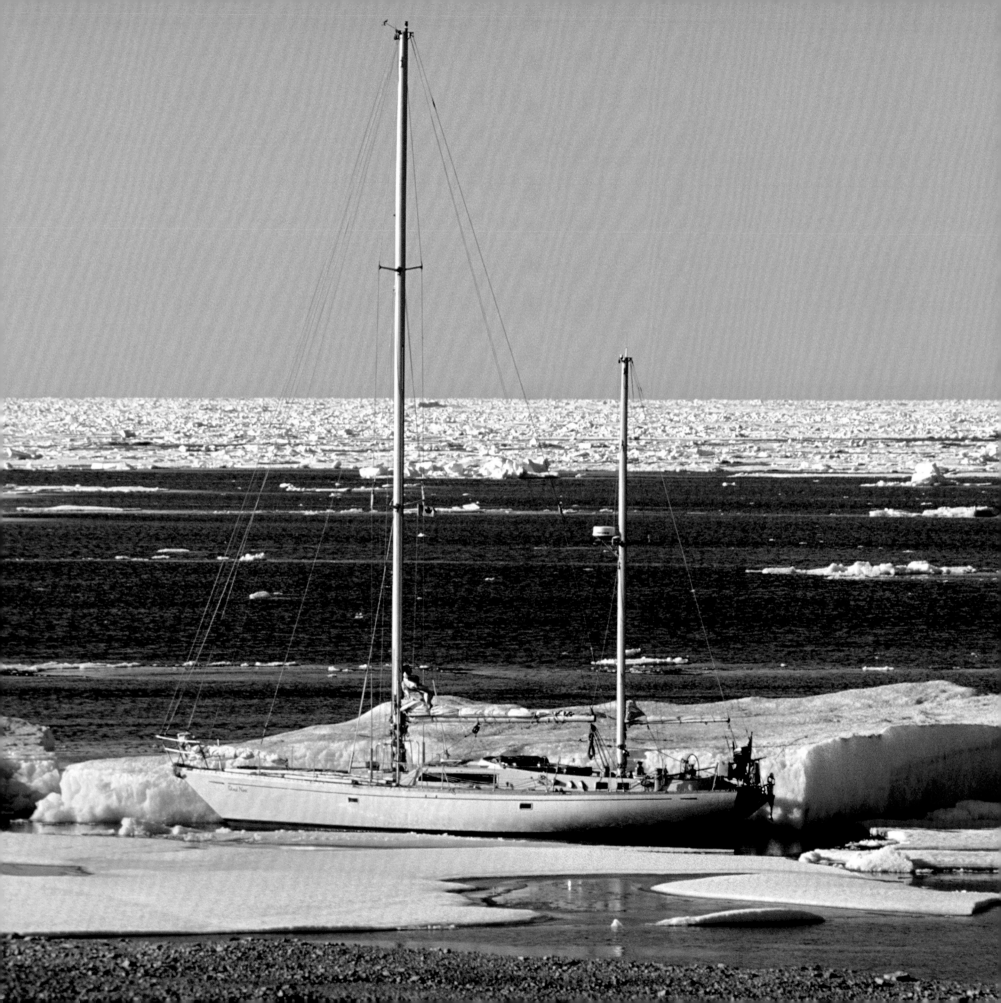

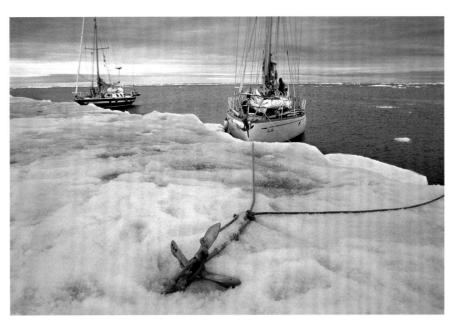

Looks can be deceiving. A sunny day masked the danger to *Cloud Nine* as she sat in what we called "Growler Harbor." Endless pack ice "pressurized" the ice floe and vessel when the tide changed, nearly grounding us on Griffith Island. *Cloud Nine* and *Back of the Moon* were separated by ice and fog but would later reunite.

GROWLER HARBOR

We are currently moored to a large ice floe 300 feet from shore on Griffith Island. It is an absolutely breathtaking morning, sunny and calm. If you did not know the dangers, it would just be another nice summer day in the Arctic.

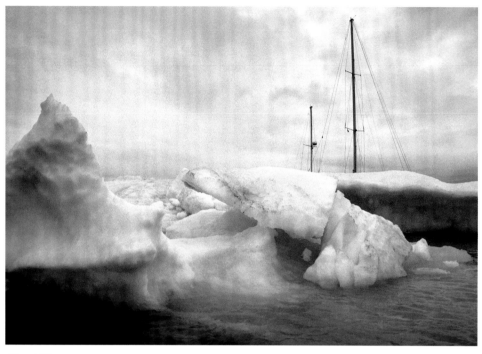

Cloud Nine was stuck in the ice for more than a week and could find no way to further advance south across Barrow Strait and into Peel Sound or Prince Regent Inlet. We had to abandon the Northwest Passage attempt.

GROWLER HARBOR 3 · GRIFFITH ISLAND

Precarious would be a good choice of words. When I came on watch, we noticed our large floe was moving, and could hear it scraping across the bottom. There was a pressure wave and a tremendous amount of ice coming down on us right out of nowhere. It was like nothing we had seen. We called for the rest of the crew and Roger. Within minutes, we had started the engine and had lines off the ice. Just missed being pinned. As we pulled out and turned away, I saw the incoming pack ice collide with our growler harbor. It was no contest: Our mooring was shoved off its perch, spun around, and pushed well up onto shore. This would have been the end of **Cloud Nine.**

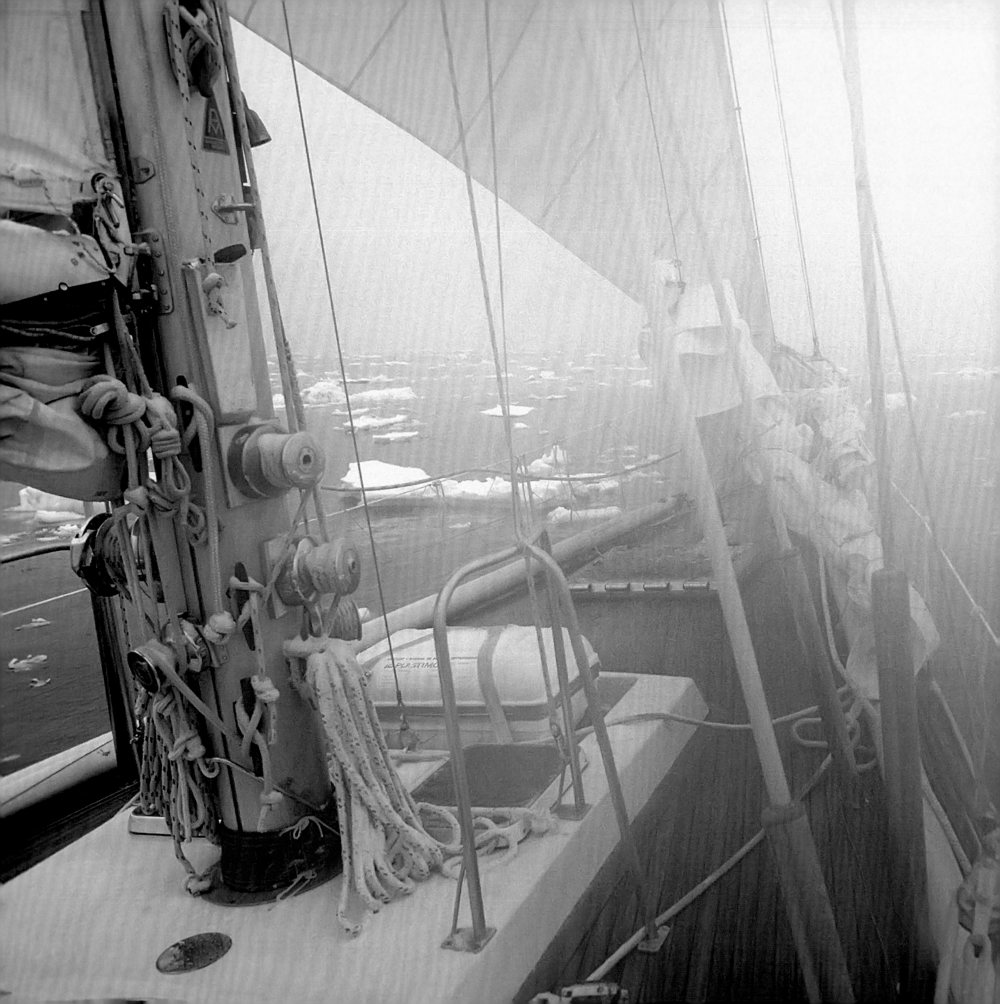

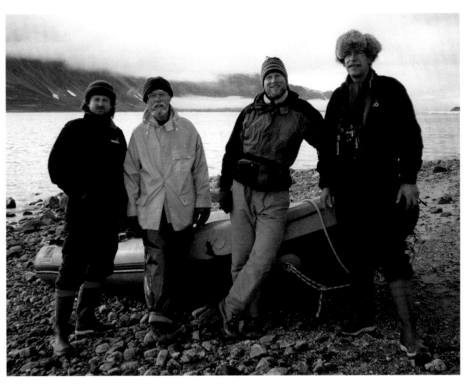

Retreat! The crew of *Cloud Nine* eventually freed the vessel from the dense pack ice, found a northern shore lead and got out of Lancaster Sound. We met up again with our friends from *Back of the Moon* on Baffin Island, near Pond Inlet, and bid them a sad farewell. From left: Johan Falsen, Geoff Pope, me, and Captain Phillip D'Elvee.

JOURNAL • AUGUST 23 • 1994

BAFFIN BAY TO DAVIS STRAIT • NORTHWEST PASSAGE EXIT

We were very lucky to escape the Passage's grip and retreat east to relatively ice-free waters. We were in danger of being frozen in the ice for the winter. Not an option. We haven't seen a dark night in months, but the season is changing. Night and ice do not mix. This has been a long and humbling sail out of the high Arctic. One thing is very clear: The Northwest Passage has won again.

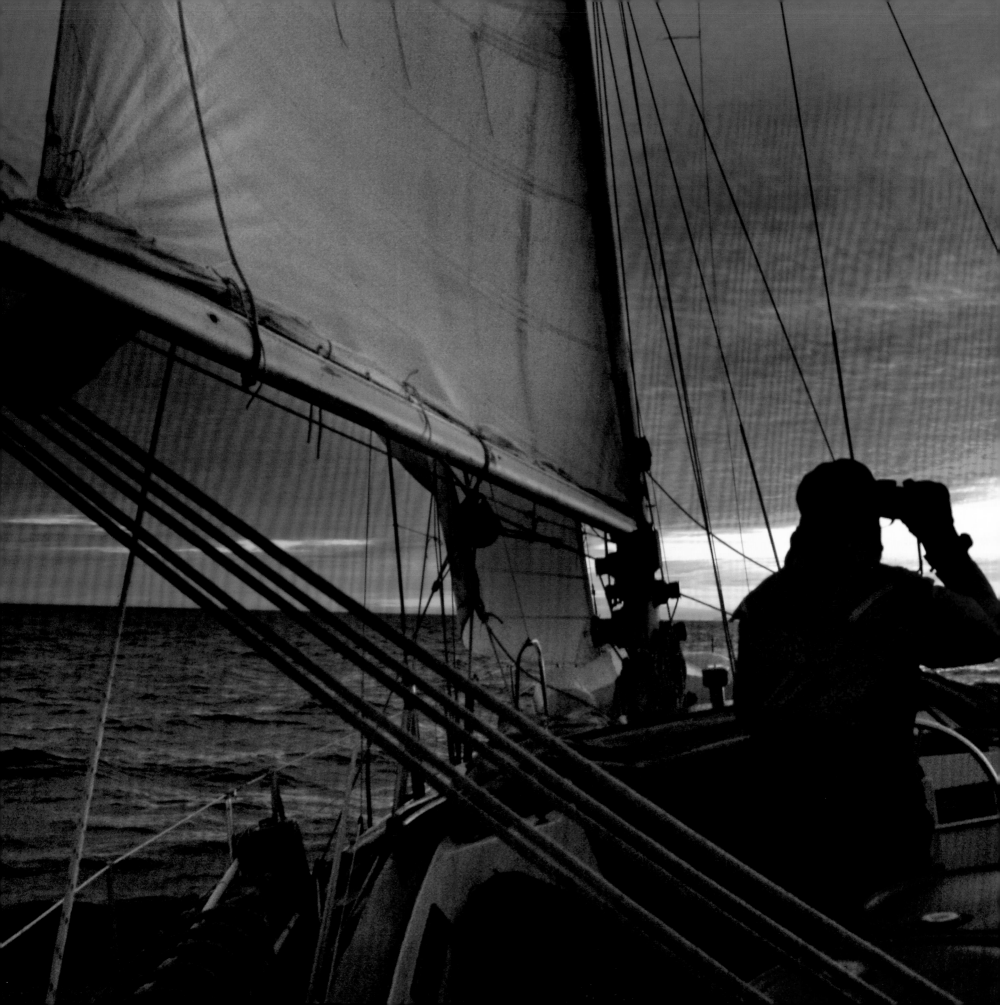

EYEWITNESS TO A CHANGING PLANET

Time passed. Life changed. NASA and other organizations had begun compiling information from satellite images of the North and South Poles in 1979. Scientists studied the data, and the Canadian Coast Guard used it to navigate its ice-breakers. But over a quarter of a century, the proliferation of personal computers and the arrival of the Internet had made this detailed information available to anyone.

At the same time, a new concern had arisen: Weather patterns were becoming more erratic and pointed to something called "climate change." Our little blue planet was getting warmer. The theory made

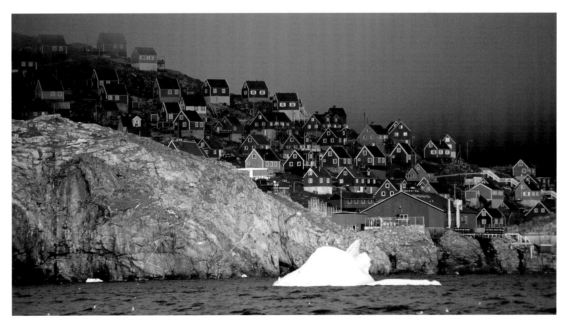

Crew member and watch mate Chris Parkman scanned the horizon for icebergs and "bergy bits" near Davis Strait on *Cloud Nine's* northward passage to the Greenland coast in 2007. Colorful Upernavik, Greenland, 350 miles north of the Arctic Circle, is the last village where a small vessel can fuel up and get provisions for the westward passage to the Canadian Arctic.

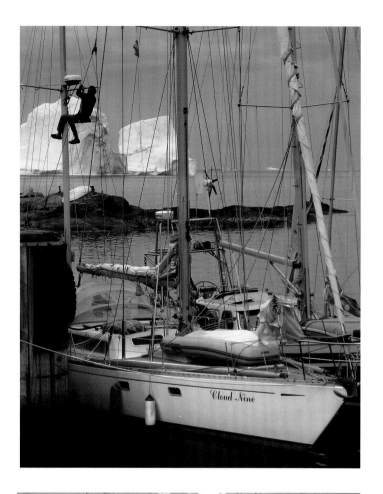

The spectacular beauty of the Greenland landscape can be seen in the fjords of Prince Christian Sound, where a small berg can glow blue on a gray day. Crew member Chris Parkman, top, worked on *Cloud Nine's* temperamental radar unit in Upernavik. The crew assembled and readied the vessel in Nova Scotia.

sense to me, but the details, in countless models and feedback loops, were confusing. The theory needed to be tested in the field.

By 2006, Captain Roger Swanson had *Cloud Nine* in position to make another attempt at the Northwest Passage. I signed on as a crew member and photographer for a 2007 voyage. Roger was 76 and knew this would be his last opportunity to tackle a feat that had so confounded him. No U.S. vessel had succeeded yet at making an east-to-west passage. Roger warned: "This will not be a sightseeing cruise." We all knew what that meant: This would be a 6,000-mile push.

It also would be the perfect opportunity for me to gauge climate change in person. Were satellite photos really showing a dramatic loss of summer sea ice coverage in the Arctic regions? The images revealed patterns in the breakup and melt of the ice, letting us know exactly when to make our run for the Northwest Passage. Very unusual and warm weather dominated the Upper Midwest during the winter of 2006-07. Iowa's little glacial lake, blue Okoboji, did not freeze completely, nor did many northern lakes, even in Canada.

Eastern Canada's Maritimes region is a perfect staging area for North Atlantic access to the Far North. The crew of *Cloud Nine* sailed from Halifax, Nova Scotia, to St. Anthony, Newfoundland, and then from Newfoundland to the west coast of Greenland.

We were passage-making, not sightseeing, so we sailed right past Jakobshavn Glacier, which had changed and receded dramatically since our 1994 visit. The fastest-moving glacier in the world, it had increased speed threefold or more, and its calving face had

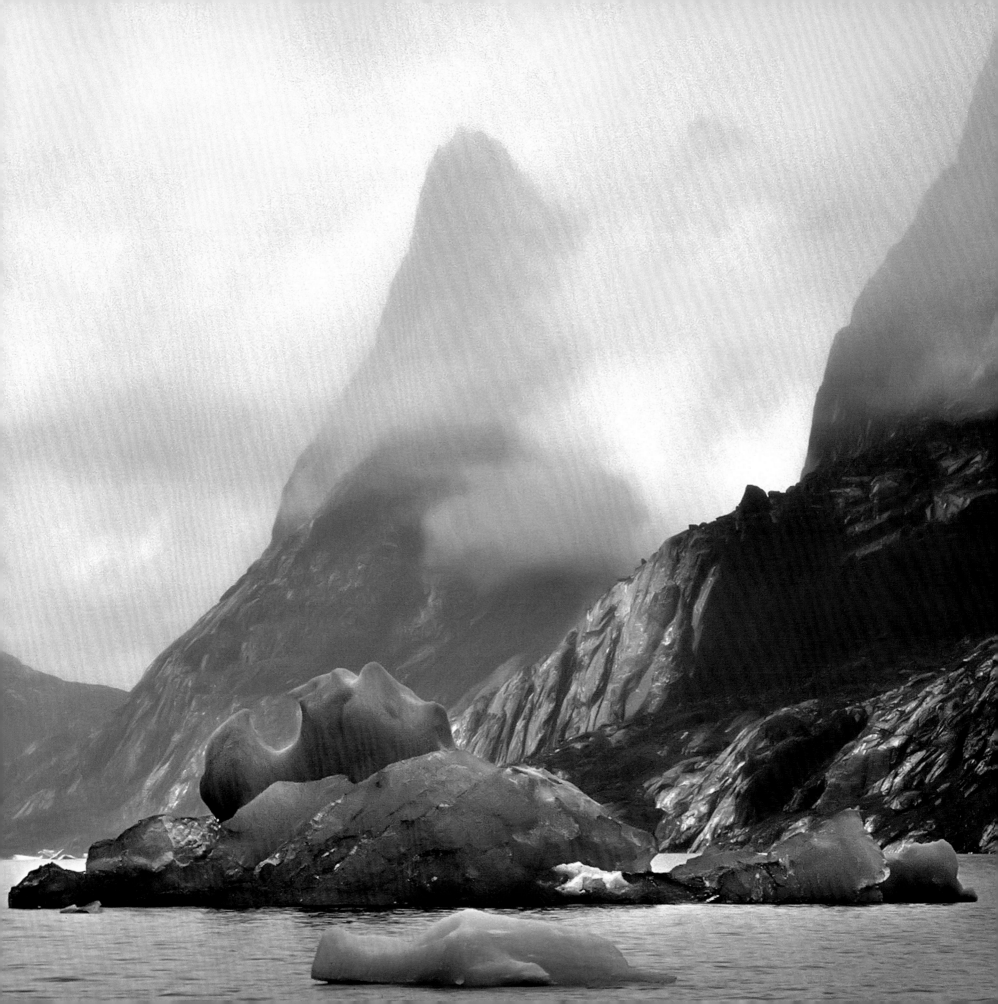

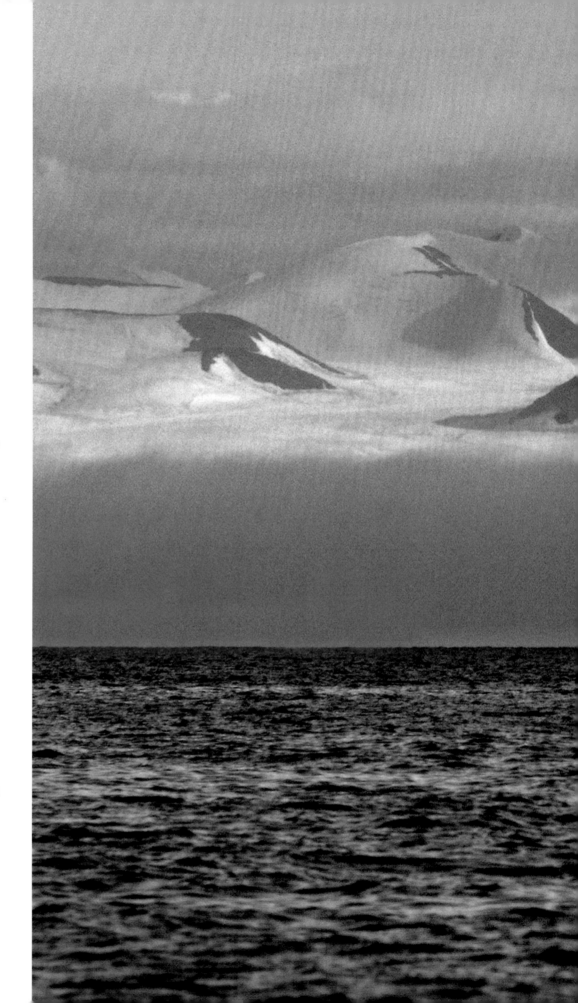

receded by some 20 kilometers. Incredible. I wanted to be there to see it and document it, but we were on a mission.

We stopped quickly for provisions and fuel in Sisimiut, bringing bittersweet memories of my former mate, Geoff Pope, who on our 1994 voyage had reconnected with a sail- or who helped rescue him during an earlier outing. *Cloud Nine* made a fast passage to Upernavik, West Greenland, which would be our last opportunity to ready the vessel and get provisions. We moored next to *Jotun Arctic,* a Norwegian sailing and research team sponsored by Nansen Institute. The captain, Knut Espen, a friend of Roger's, was very much like a young Roald Amundsen. *Jotun Arctic* was one of dozens of vessels studying climate and cultural changes along Greenland's coast.

Problems with our radar were making it impossible to detect icebergs hidden by the fog that is prevalent in these latitudes. But our shoreside discussions and study of ice charts revealed that our chances of making it through the passage were excellent. *Cloud Nine* set sail across Baffin Bay on August 8, 2007.

Cloud Nine entered the Northwest Passage and Lancaster Sound. It was the same beautiful and austere landscape I remembered from the 1994 voyage, but this time there was no sea ice.

90

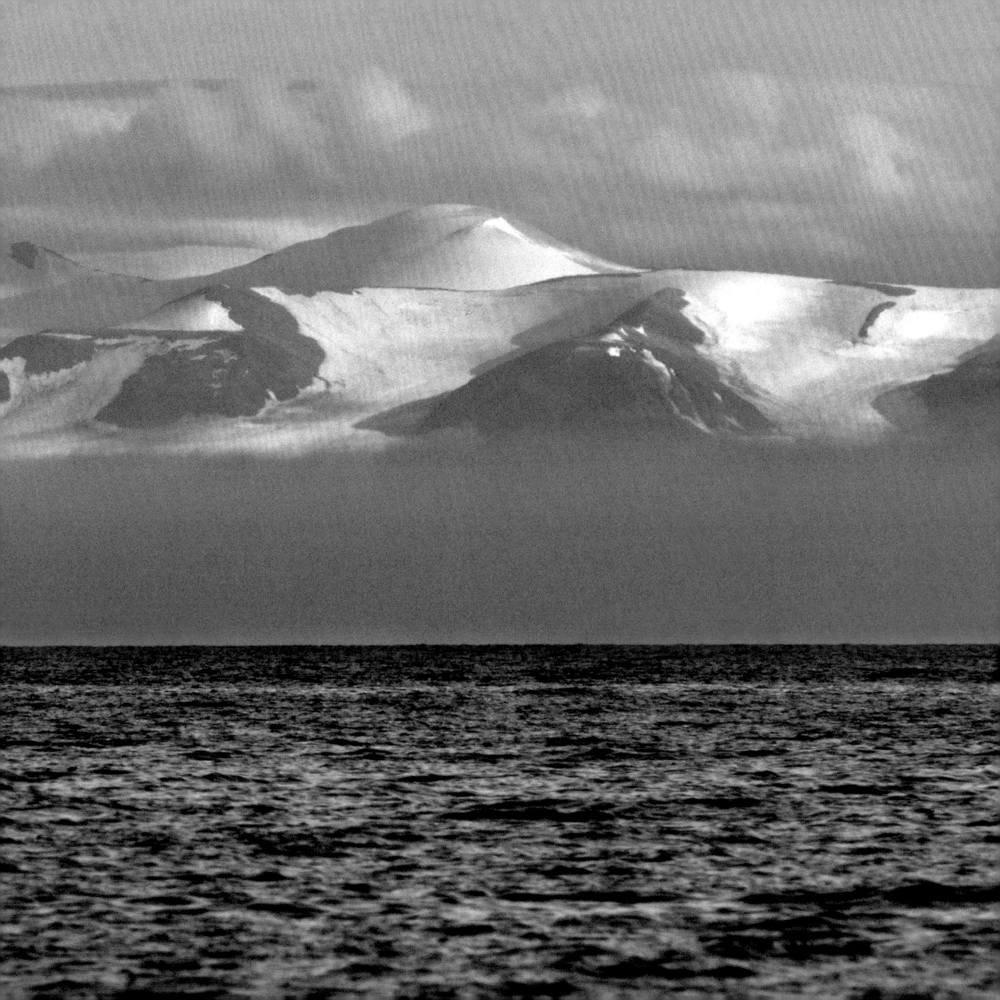

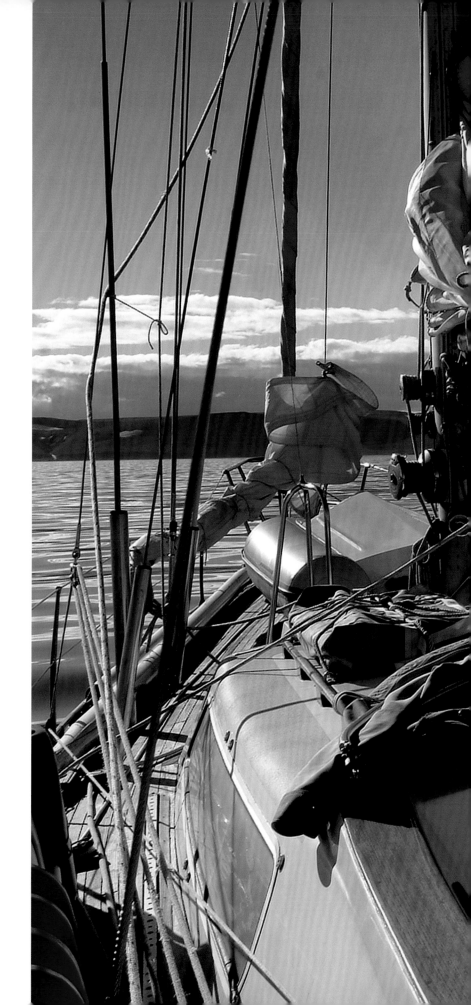

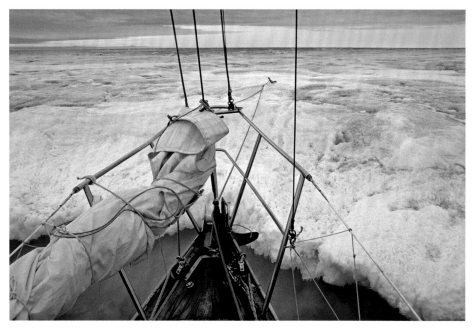

Above: On August 13, 1994, dense pack ice in Barrow Strait thwarted *Cloud Nine's* Northwest Passage attempt, forcing our retreat. Right: Exactly 13 years later, an ice-free Barrow Strait greeted the crew of *Cloud Nine,* clearly demonstrating what the satellites and scientists had predicted about ice loss.

JOURNAL • AUGUST 13 • 2007

BARROW STRAIT

Pack ice, or frozen sea ice, permeated Barrow Strait in 1994, blocking our attempt to continue the Northwest Passage. What a contrast we discovered in 2007. **Cloud Nine** arrived at Port Leopold on the northeast corner of Somerset Island, where the crew enjoyed a rest with sunny skies and warm temperatures. We proceeded west, coming very near to where we were trapped in the ice in 1994. There was absolutely no ice. We were utterly shocked. We continued into the North-west Passage in 2007, 13 years to the day from when we retreated in 1994.

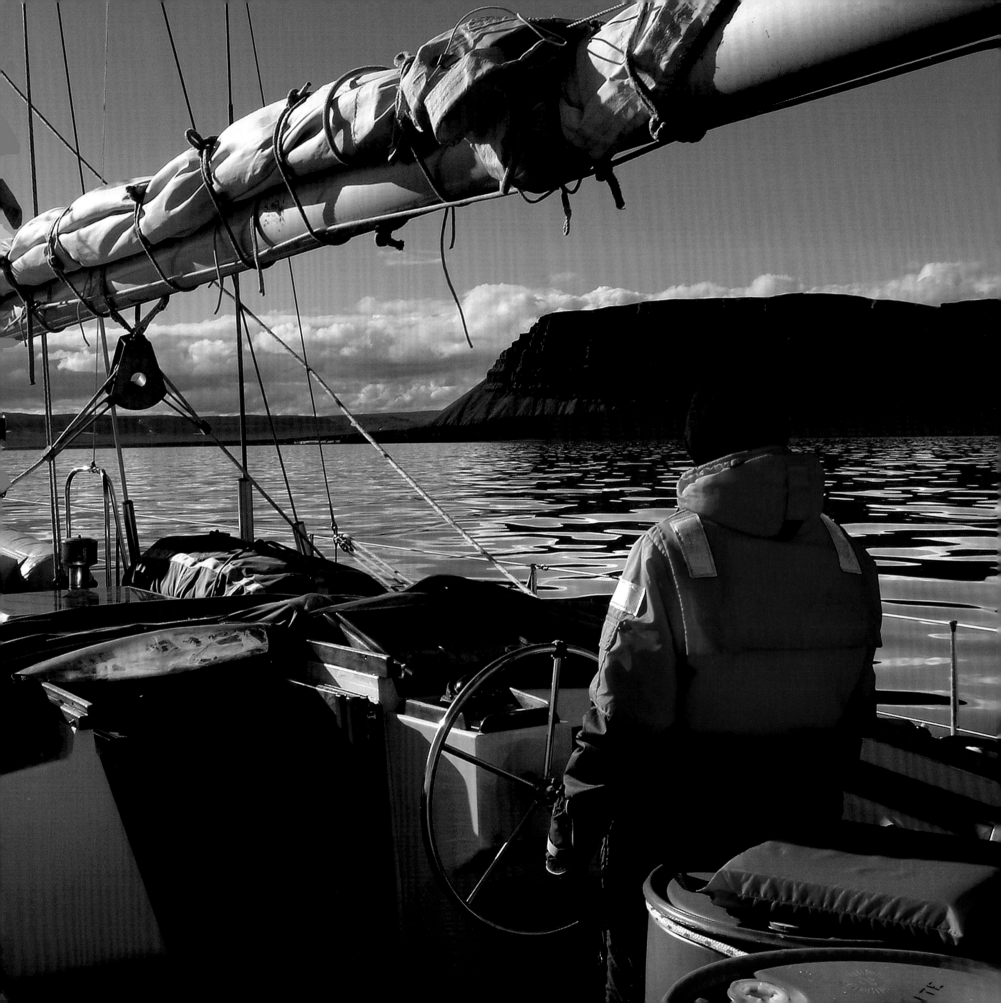

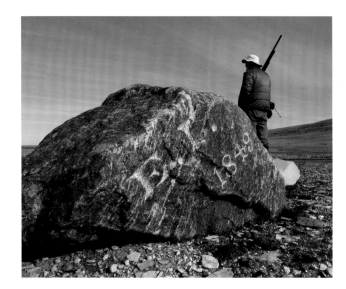

Two polar bears, mother and cub, strolled across the barren, ice-free land-scape. They seemed lost in an utterly new environment with their food supply now far off on the receding ice edge. Near right: Doug Finley, a sailor from San Francisco, kept polar bear watch near Ross Rock in Port Leopold, near Nunavut, Canada, where the British vessels *Examiner* and *Investigator* overwintered in 1848-49.

PORT LEOPOLD • SOMERSET ISLAND • NUNAVUT

A lifetime in 24 hours since I last wrote. This is a great stop to get recharged. Took the dinghy in this morning to where the polar bears were hanging out. Mother and cub. Incredible. Also spotted the big male over on the beach near the expedition shack. We angled in past the Beluga whales and beached the Zodiac. The whales were coming by in waves, literally. The male polar bear did not want much to do with us and lumbered off over the ridge. Huge, powerful creature. Only word is awe.

On to the lonely island shack. Outside is a huge whale vertebrae and a rock with the engraving "E. I. 1849." The initials stand for the British vessels **Examiner** and **Investigator**. They had set out to find the Sir John Franklin expedition, which had set sail in 1845. We call this Ross Rock for James Clark Ross, who led this fact-seeking expedition. The north end of Somerset Island is very arid, desert-like terrain. Very rugged. Mars expeditions have trained around here. On the way out we saw a great mirage, which appeared to be a ship in the distance. I thought maybe it was Franklin out haunting the waters that took him and his crew to their icy graves.

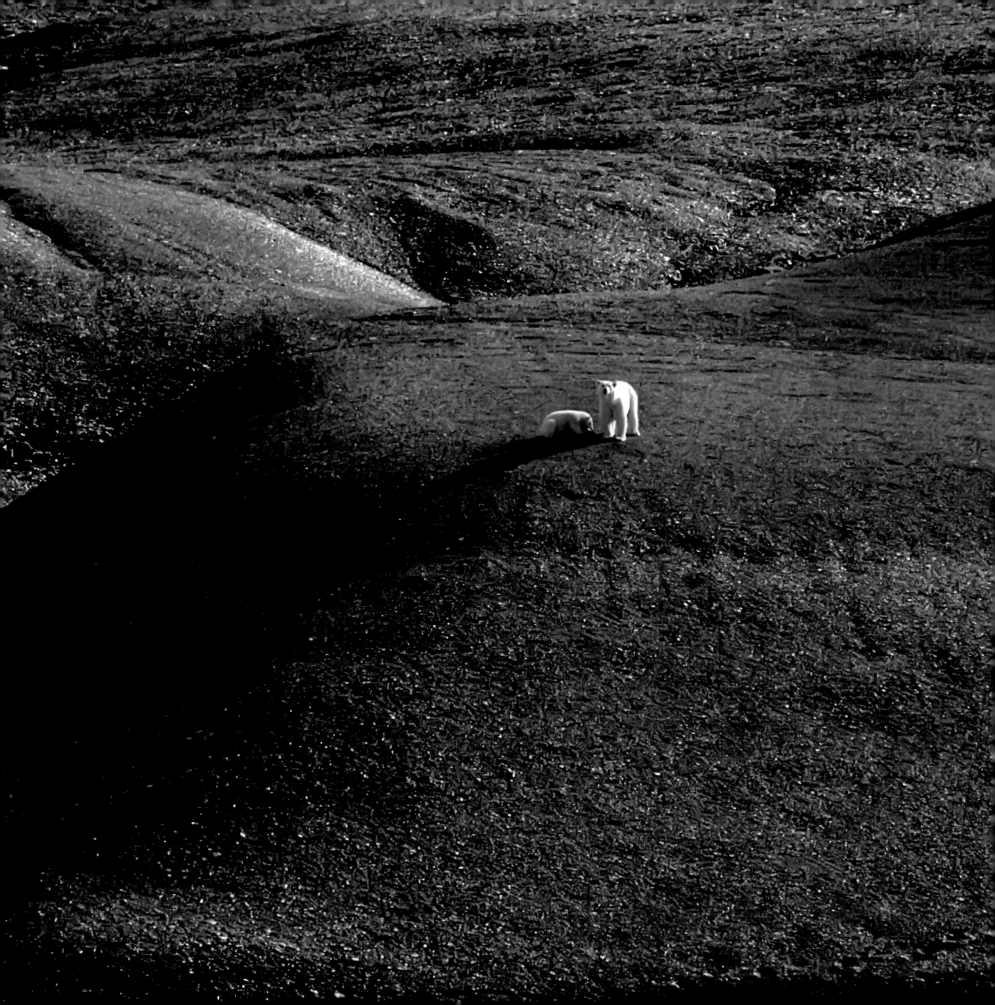

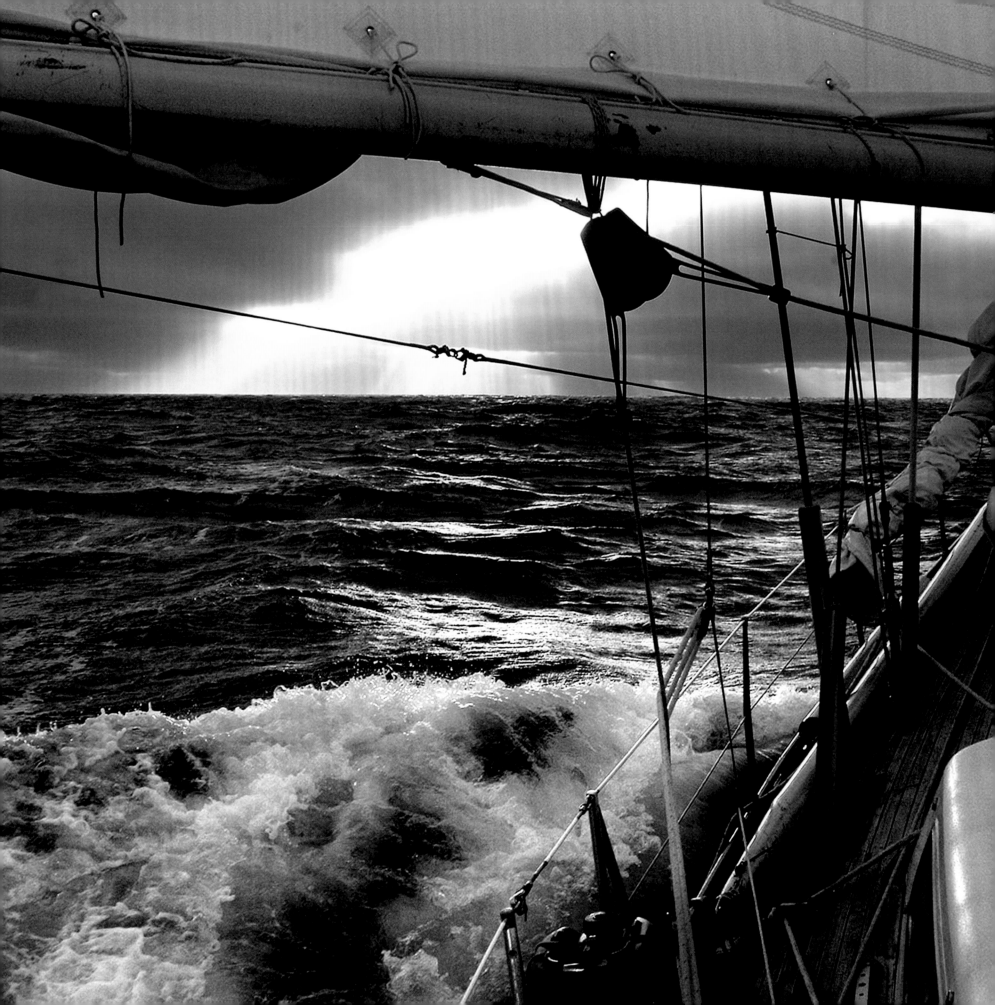

Cloud Nine sailed into the southern channel of Peel Sound. There was absolutely no ice to block us from proceeding deeper into the Northwest Passage. We hoped for equally clear passage to the Canadian hamlets of Gjoa Haven and Cambridge Bay. Above, hunters left behind caribou remains.

JOURNAL • AUGUST 15 • 2007

PEEL SOUND • NUNAVUT • CANADA

The next 300 miles will tell the tale of **Cloud Nine**'s 2007 Northwest Passage attempt. It's foggy, with a north breeze, biting cold. 1740 hours. New ice report. Open lead south into Larsen Sound. Looks good for a wide open run down the shoreline. The remaining ice is completely disintegrating. This is good for us, but not so good for the planet.

It seems to prove without a doubt that climate change is taking place and possibly at an accelerated pace. We are literally a small piece of evidence in the test tube. The Northwest Passage is ice-free, and we are witnessing history, planetary history.

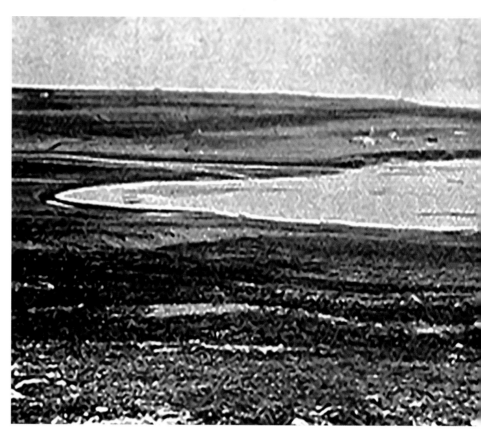

GJOA HAVEN • NUNAVUT • CANADA

We navigated the treacherous Franklin Strait, whose many dangerous shoals nearly ended Roald Amundsen's voyage, and dropped anchor in what he described as the "finest little harbor in the world." We were in awe. Amundsen spent two winters in this perfect harbor and was trapped and frozen in again near the Yukon whaling village of Herschel Island for a third winter (1905-06). All told, Amundsen's historic voyage spanned four summers, with three winters frozen in and waiting for the ice to break. Gjoa Haven represents a milestone for us on **Cloud Nine**. The Peel Sound and Franklin Strait areas blocked our previous attempts. Success looks very good at this point; we expect to make it, and spirits are high. We are utterly shocked by the lack of overall ice coverage this year. Climate change is undeniable, and the people of these high latitudes are feeling the changes first, and rapidly.

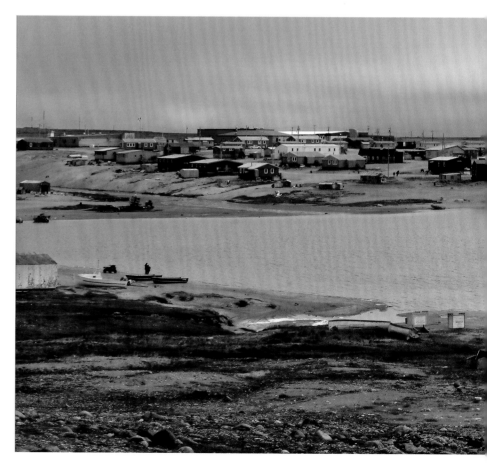

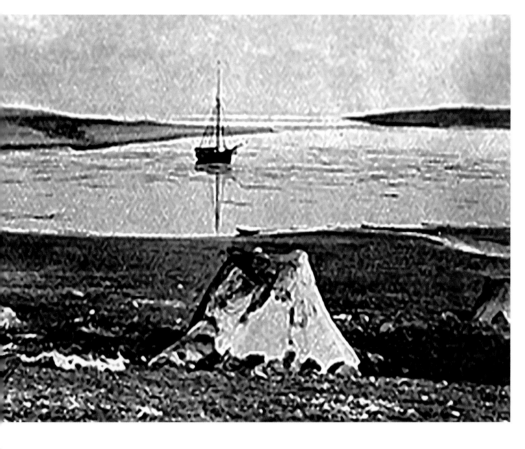

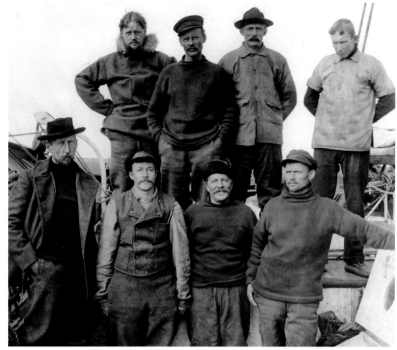

Above: Roald Amundsen (bottom left) is arguably the greatest polar explorer of any era. He succeeded because his adventures were rooted in science and in what he learned from those who lived in extreme climates. At left, his vessel, *Gjoa*, was frozen into this protected harbor for two winters, 1903-05.

Cloud Nine anchored in near the same spot as Amundsen's *Gjoa* in this small Canadian village of 1,300. The crew of *Cloud Nine*, clockwise from top left: Chris Parkman, Matthew Drillio, me, Doug Finley, Gaynelle Templin (Captain Roger Swanson's wife), and our captain.

The archaeological record shows that people have been hunting and fishing at Cambridge Bay for 4,000 years. On a calm day, an Inuit woman cleaned out a ringed seal. Today's Inuit hunters, just like the generations before them, use every part of a seal.

CAMBRIDGE BAY · NUNAVUT · CANADA

We have passed the last great danger of pack ice that could block us from the Northwest Passage, and now we "only" have about 3,000 miles of high-latitude sailing in the Beaufort Sea, Chuckchi Sea, Bering Strait, and Bering Sea to get to Dutch Harbor, Alaska. Daunting, but it looks like we are going to make it this time.

The Inuit people are fascinating. They are heading out now on long fishing and hunting expeditions to gather food and materials from the bush for their winter survival. Although they use new technologies, there is a big push to retain traditional ways. They also seek to maintain control over their lands as the warming climate unlocks huge potential energy and mineral resources. They believe they have rights to this land. Who could argue? But many people question whether control of the Northwest Passage even rests with Canada.

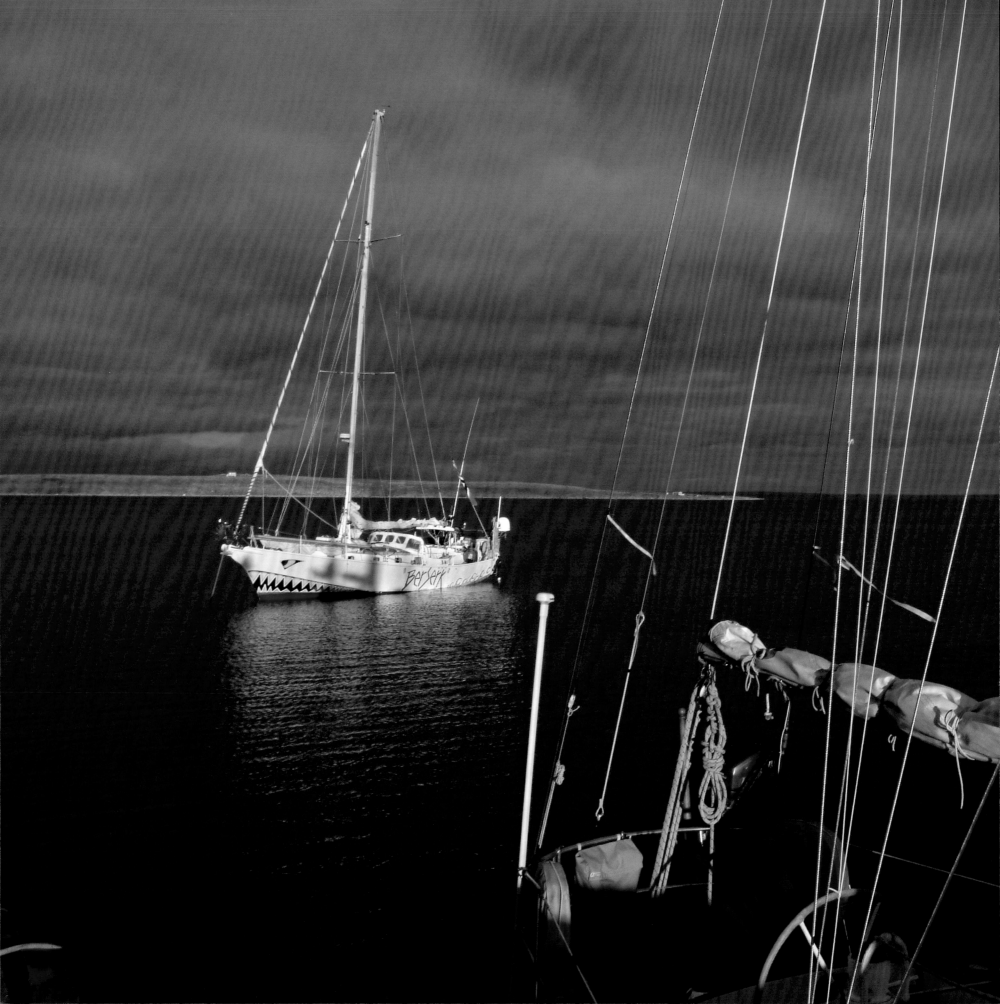

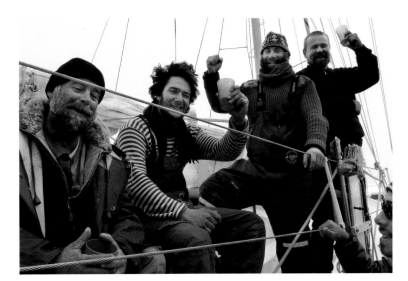

Berserk was a terrific sailing vessel built for polar waters. She was the second vessel of that name for her young captain, Jarle Andhoy, whose friends had said he was "berserk" when at age 19 he first sailed from Norway to Antarctica. That trip ended with a lost boat. Andhoy, second from left, led his so-called Wild Vikings in a 2007 attempt to cross the Northwest Passage.

THE WILD VIKINGS INVADE

More than half of all successful voyages through the Northwest Passage have taken place since 2007. In 1994, when we first attempted it, ours was one of two sailboats to try and fail, although four ice-breaking vessels succeeded. In 2007, there were five successful attempts, including two ice-breaking vessels. In the years since, hundreds of new adventurers have flocked to the Northwest Passage.

Not all of them have been respectful of the Canadian government's sovereignty, the native population, the harsh environment, or the legacy of earlier explorers.

The Norwegian sailboat *Berserk* was one such vessel in 2007. Under Captain Jarle Andhoy, they called themselves the "Wild Vikings" and went from village to village, flouting local drug and alcohol laws, claiming sovereignty, and basically causing trouble everywhere in Canada's Arctic. The Mounties finally arrested them, seized their boat, and sent them back to Norway. The sailboat later departed Canadian waters with a new crew.

In 2011, Andhoy was back in the news. He had sailed *Berserk* to Antarctica, where she and three crew members were lost in a ferocious storm. The captain was ashore at the time, driving toward the South Pole on an ATV. He was fined for sailing without permits or insurance.

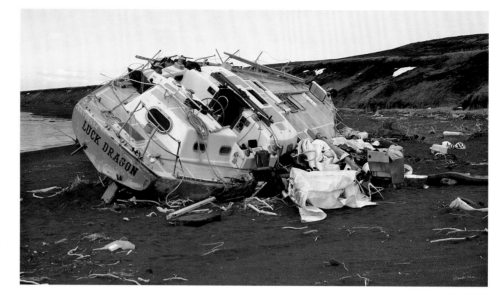

"I feel like a fraud," British sailor Jeffrey Allison told a Wall Street Journal reporter, referring to his voyage through an ice-free Northwest Passage. An accomplished climber and sailor, Allison made his attempt with his son, James. His vessel, *Luck Dragon*, eventually ran out of luck and was found on an Alaskan beach in the spring of 2008.

'EASY' PASSAGE TURNS TREACHEROUS FOR JEFFREY ALLISON OF ENGLAND

I met skipper Jeffrey Allison and his son, James, in Sisimiut, Greenland, in August 2007. They were a crew of three from England preparing to attempt the Northwest Passage east to west, just as we were. Jeffrey was sailing a smaller sister boat to *Cloud Nine*, a Bowman 49 named *Luck Dragon*.

We left Sisimiut ahead of them and met up again in Cambridge Bay, Nunavut, Canada. The Wall Street Journal interviewed us there about our voyage, climate issues, and geopolitics. As *Cloud Nine* was about to depart, I was talking with James, who exclaimed, "I have read all the accounts of history and of the difficulties in the ice, the treachery of the Northwest Passage. I feel like we cheated; it's been so easy." Later, the Journal quoted his father saying he "felt like a fraud" as there had been no ice to battle through.

The Northwest Passage, however, holds many surprises, and we still had to sail 3,000 miles west and south through the Beaufort, Chuckchi, and Bering seas. *Luck Dragon's* luck ran out in the Bering Sea on October 14, 2007. A distress call was sent to the U.S. Coast Guard.

Luck Dragon had a split mainsail, dead engine, and no power. A gale was building, and she was in grave danger. A fishing boat in the area arrived before the Coast Guard, pulling the crew of three from the freezing 15-foot seas. *Luck Dragon* had been beaten by the Bering Sea, not the pack ice of the Northwest Passage.

More sailors than ever are planning to attempt the Northwest Passage. As the Arctic icecap melts, they, too, might think it will be "easy." The story of *Luck Dragon* is a somber reminder of all the sailors who have lost their vessels, and even their lives, in the inhospitable open waters of the Far North.

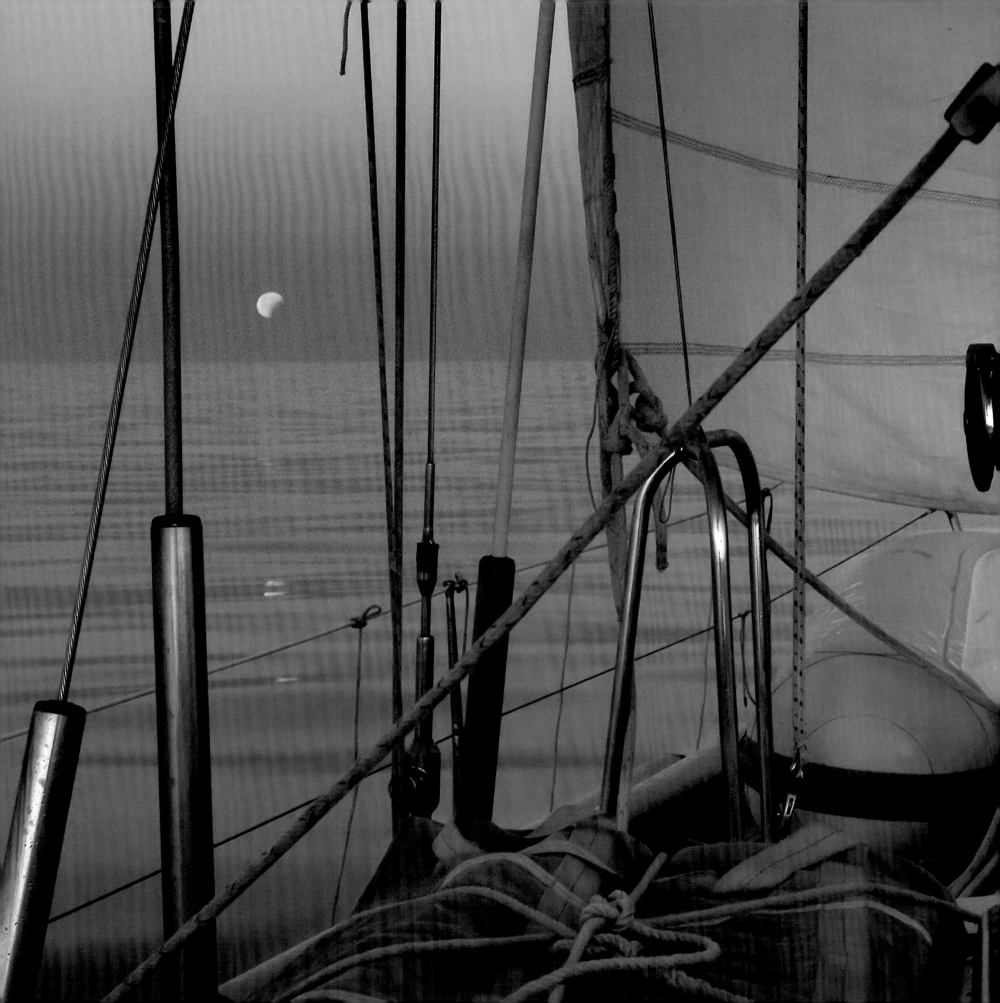

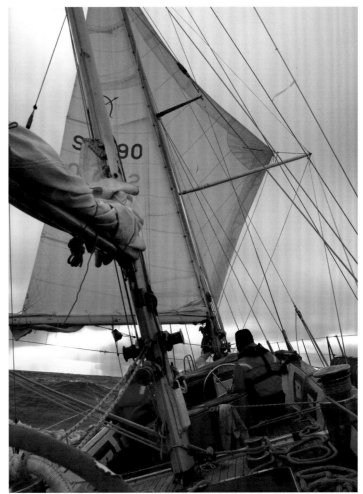

Cloud Nine had calm, serene and ice-free days in the Beaufort Sea, followed by gales, small-craft advisories and fast sailing near Point Barrow, Alaska. We were about to tack south toward home.

TUKTOYAKTUK • CANADA

Days are getting shorter and we now have a night, which is spectacular when you can see the sky. Mind you, we have not seen the moon for a month and wondered if there was some Arctic effect going on. Well, we discovered last night it was not only full, but we had a full five-hour lunar eclipse going on with a few northern lights thrown in for dessert. I have never witnessed such a sight.

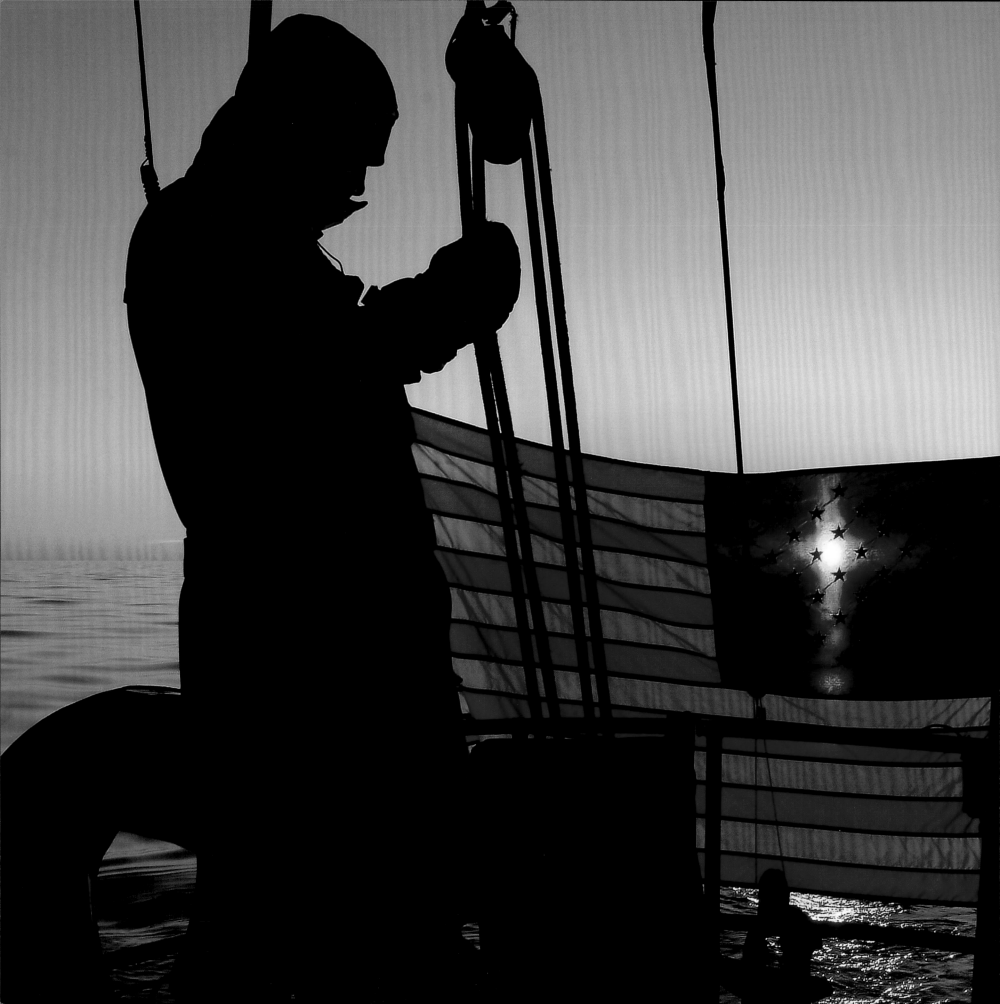

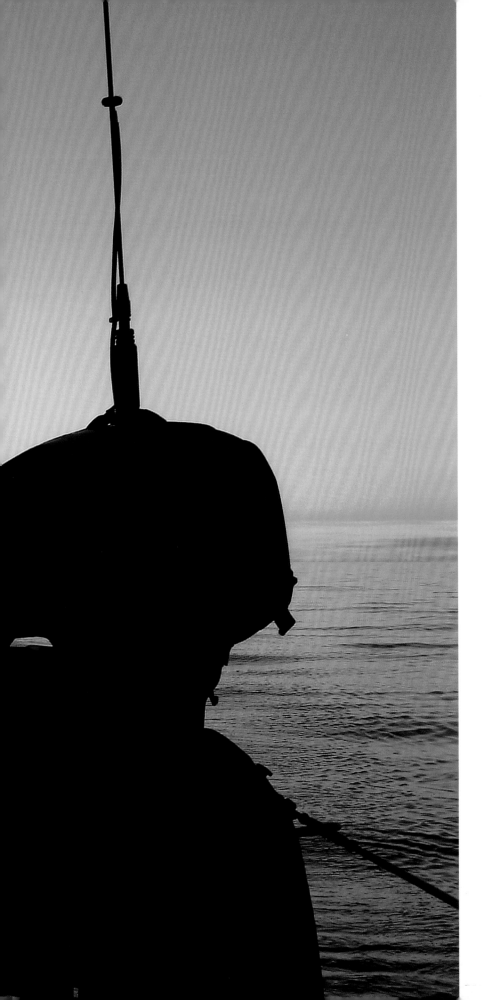

ARCTIC SEA ICE: A DOWNWARD TREND
(Minimum coverage in millions of square kilometers)

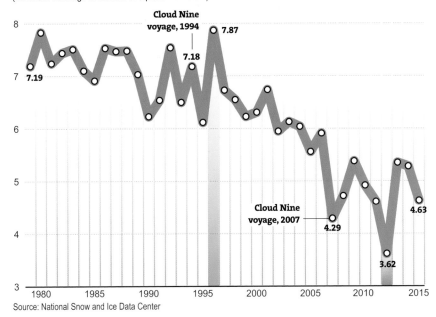

Source: National Snow and Ice Data Center

Satellite data showed sea ice coverage falling precipitously, according to ice levels recorded before the annual freeze season begins in late September. The record loss of ice afforded us a very fast traverse of the Northwest Passage in 2007.

CHUKCHI SEA NEAR BERING STRAIT

At 0544 Hours, **Cloud Nine** and crew crossed the Arctic Circle, heading south to officially accomplish the transit of the Northwest Passage. We had a small party to celebrate (hard to party at 6 a.m.), recounted a few stories, and were on our way toward Nome, Alaska. We are the first Americans to complete Roald Amundsen's route, making one of the fastest transits ever — in a single year. Roger also thinks he may be the oldest skipper to accomplish the feat, at age 76. The golden age of exploration, Amundsen's, has come to a close, and a changing climate will be the focus of a new era of exploration. We on **Cloud Nine** have bridged the two eras. We were solidly stuck in the Arctic's vast pack ice in 1994. And now we have sailed through the same route, witnessing an ice-free Northwest Passage.

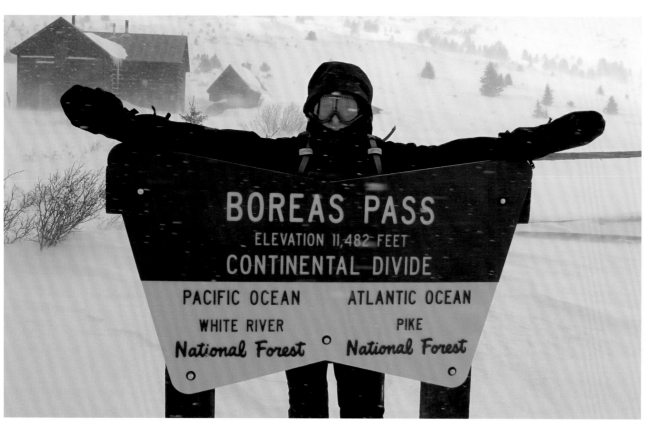

My Arctic experiences brought me to the first-ever World Science Festival in New York City in 2008, right, where I spoke on the changes in pack ice in the Northwest Passage. Land masses and oceans are connected through vast natural systems, a fact brought home when viewing the Continental Divide at Boreas Pass, Colo., above. Waters to the west of this divide flow toward the Pacific, those on the east go toward the Atlantic.

ADVENTURE CONNECTS WITH ENVIRONMENTAL ACTIVISM

I felt privileged to sail and explore the new Arctic regime and be a part of Northwest Passage history. But these experiences profoundly changed my life. I felt an urgent call to action, a larger responsibility to share my "boots on the ground" climate story with others. It was clear that our collective human actions have begun altering the biosphere, our intricate, but delicate, life support system on Earth. I wanted to explore this interconnectedness.

I was looking for a new group of committed individuals: explorers for a new age on an adventure with purpose.

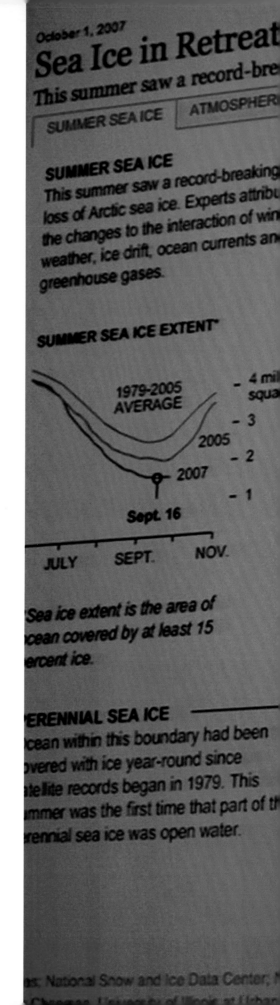

October 1, 2007

Sea Ice in Retreat

This summer saw a record-bre

SUMMER SEA ICE | ATMOSPHERI

SUMMER SEA ICE
This summer saw a record-breaking loss of Arctic sea ice. Experts attribu the changes to the interaction of win weather, ice drift, ocean currents an greenhouse gases.

SUMMER SEA ICE EXTENT*

1979-2005 AVERAGE

2005

2007

Sept. 16

– 4 mi squa

– 3

– 2

– 1

JULY SEPT. NOV.

Sea ice extent is the area of cean covered by at least 15 ercent ice.

PERENNIAL SEA ICE
cean within this boundary had been vered with ice year-round since atellite records began in 1979. This ummer was the first time that part of th erennial sea ice was open water.

as: National Snow and Ice Data Center

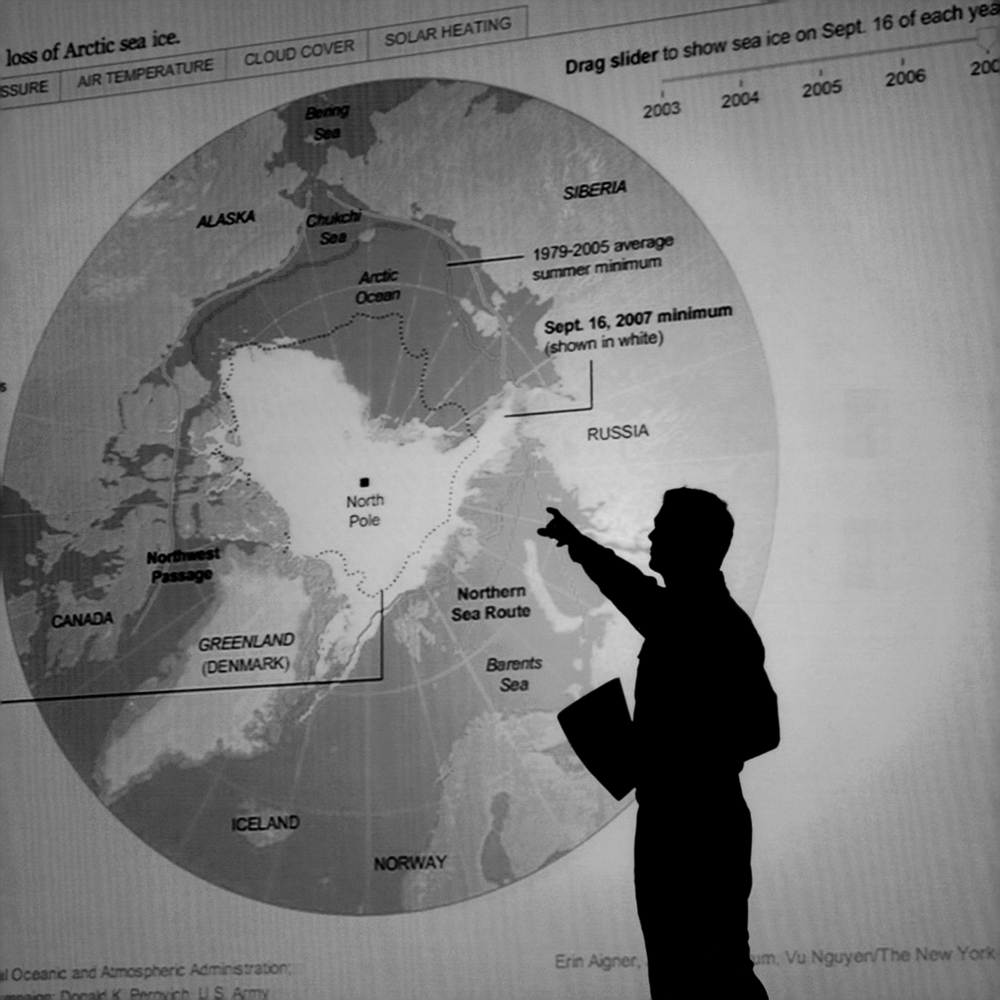

AROUND THE AMERICAS

AN ISLAND CRUISE WITH A PURPOSE

In 2008, Seattle's Pacific Science Center teamed with David Rockefeller Jr.'s newly formed Sailors for the Sea for an ambitious project, Around the Americas. I was invited to join the team of sailors and conservationists who made a clockwise circumnavigation of North and South America in 2009-10. We began and ended the voyage in Seattle, treating the two continents as one gigantic island. Along the route, our mission was to gather and share information about the health of our oceans.

Our vessel, appropriately named *Ocean Watch*, was a Bruce Roberts-designed 64-foot, cutter-rigged steel sailboat, with an efficient 135-horsepower Lugger engine. It had been

From left, the people behind the Around the Americas project: David Rockefeller Jr., Captain Mark Schrader, David Treadway, and Ned Cabot. Cabot was tragically swept from his sailing vessel and lost at sea in 2012.

owned by two oceanographers and was an ideal platform for tasks such as launching Arctic buoys, sampling jellyfish, researching the atmosphere in partnership with NASA, and serving as a NOAA weather station. The vessel also had a camera taking 360-degree views of the surrounding waters and a water-pumping system with 24/7 water sampling sensors, the first of its kind to be installed on a sailboat.

Ocean Watch made 50 port stops in 13 countries during her 13-month circumnavigation of the Americas. In each port of call, the crew, with an educator and scientist, met with locals to build awareness about the precipitous changes occurring in our oceans and to understand regional threats to the marine environment.

Ocean Watch also served as a floating classroom. The Pacific Science Center developed a K-8 oceanography curriculum, and its rotating team of three educators made the program freely available to school systems and educators at stops along the way.

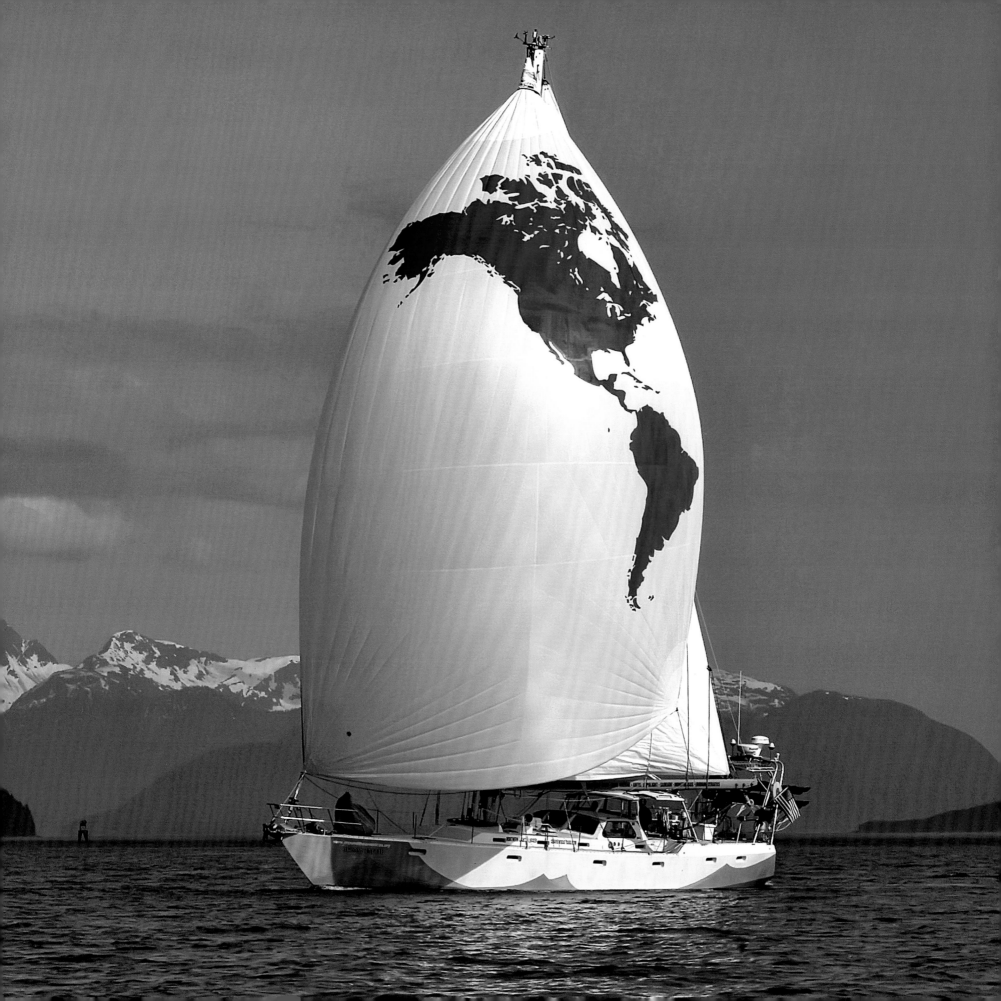

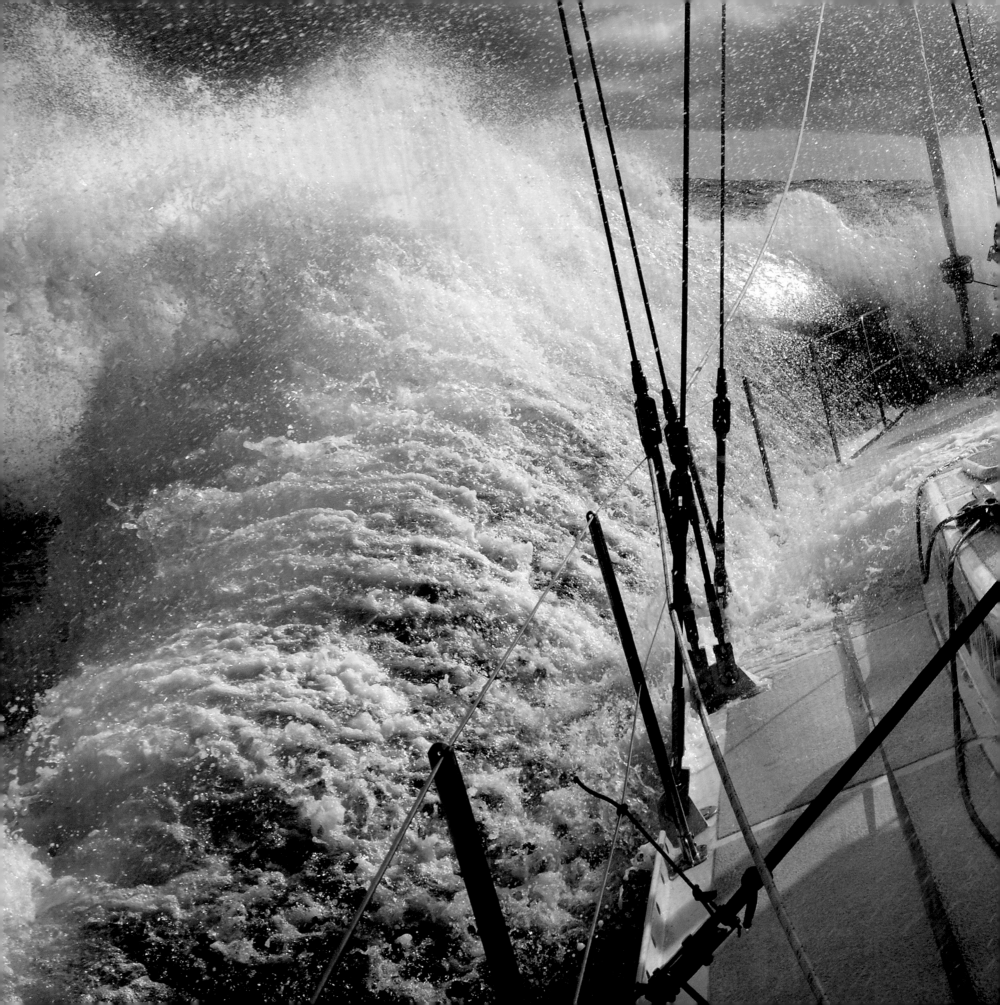

The *Ocean Watch* crew experimented with systems and motor and sail combinations in the Gulf of Alaska. Onboard instrumentation provided a way to monitor qualities like pH levels of water, which was intentionally pumped through the hull as we sailed.

GULF OF ALASKA

0105 hours. It had to happen. The Gulf is kicked up, wind in our face. Just took the second reef and it was messy. Real story, though, is we are sailing through a "carbon sink" and our instruments are grinding data. The oceans have an average pH of 8.1, or slightly "basic." An overabundance of carbon dioxide in the ocean creates carbonic acid, lowers the pH and drives the mechanism behind ocean acidification. The seas and oceans simply cannot absorb all of our excess CO_2. Ocean ecosystems have a very low tolerance to a lower pH, and the world's coral reef systems, with their calcium-based structures, are being ravaged by these changes.

"The fact that life on Earth is dependent upon healthy ocean ecosystems seems to be lost on those who should care the most. Humans have completely, and arrogantly, ignored the importance of what is keeping us alive. Any farmer knows that without healthy soil, a farm and all it supports will not survive. We need to understand that without a healthy ocean, neither will we. The stakes are that high."

– Mark Schrader

MARK SCHRADER: SOLO SAILOR TO CRUSADER

Mark Schrader was the captain of *Ocean Watch* and project director of the Around the Americas voyage. Schrader, a two-time solo circumnavigator, was the first American to solo the world's Southern Capes, first in 1982-83 and then again in 1986-87.

On his first circumnavigation, Schrader took pledges for a yacht race that was a fundraiser for Resource Foundation, a residential treatment facility dedicated to helping youth with mental disorders near his home in Stanwood, Washington. While aboard his vessel, *Resourceful*, he started to understand the vulnerability of the world's oceans. His work there became an early model for *Ocean Watch*.

Schrader admits his concern for the world's waters is a bit selfish as he has spent so much time alone on them, but his experiences have given him a unique perspective and respect for ocean ecology that he truly enjoys sharing. He and his friend David Rockefeller Jr., a sailor and ocean health advocate from New York City, developed the Around the Americas concept in 2006.

Schrader said he got the idea of undertaking an unusual circumnavigation via the Northwest Passage some 30 years earlier when he spent time in the cold Southern oceans. The seeds were also planted in his early years, growing up in a small town in Nebraska. "The Far North is similar in some ways to the cold winters spent outdoors on the plains of the Midwest," explained Schrader. "I grew up building igloos on the farm and imagining grand adventures."

Captain Mark Schrader used a bosun's chair, top left, to inspect instruments and rigging at Juneau, Alaska. Below, he eyeballed the sail set at Staten Island, southern Argentina. A consummate solo sailor, Schrader brought many skill sets to the *Ocean Watch* team.

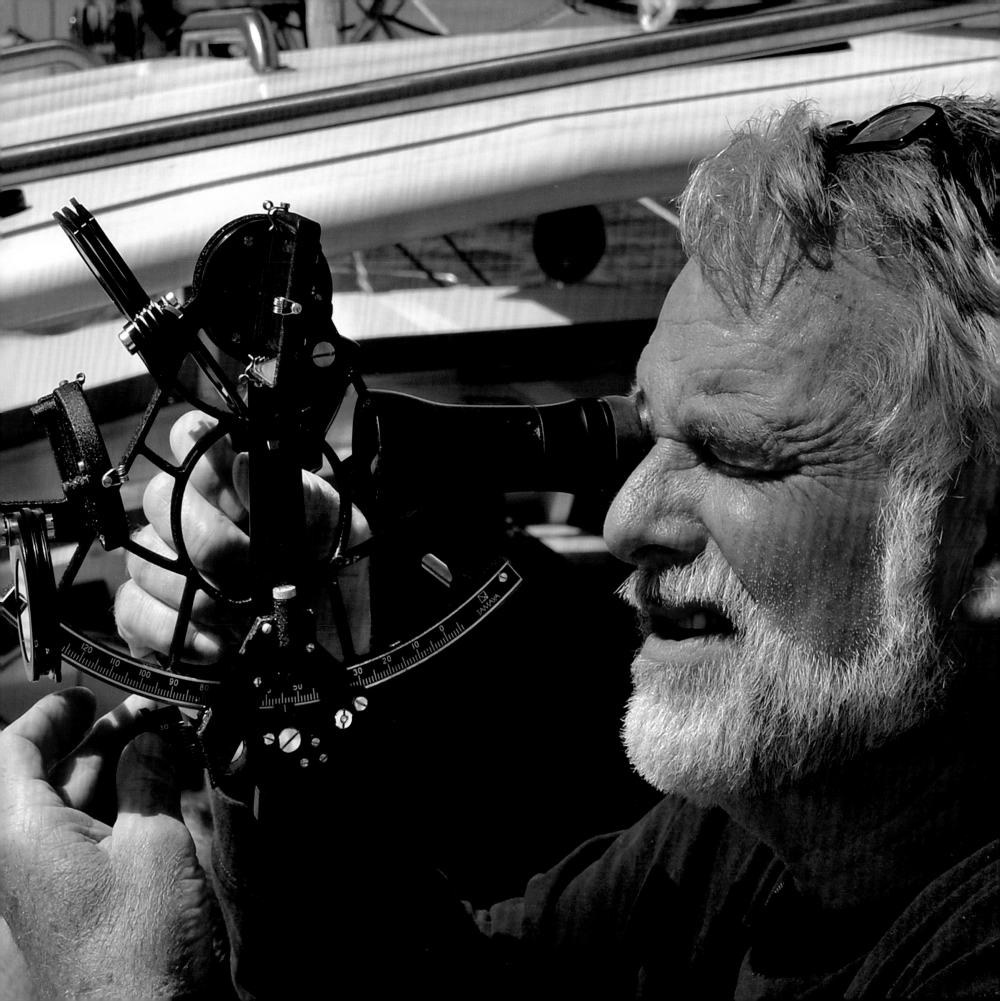

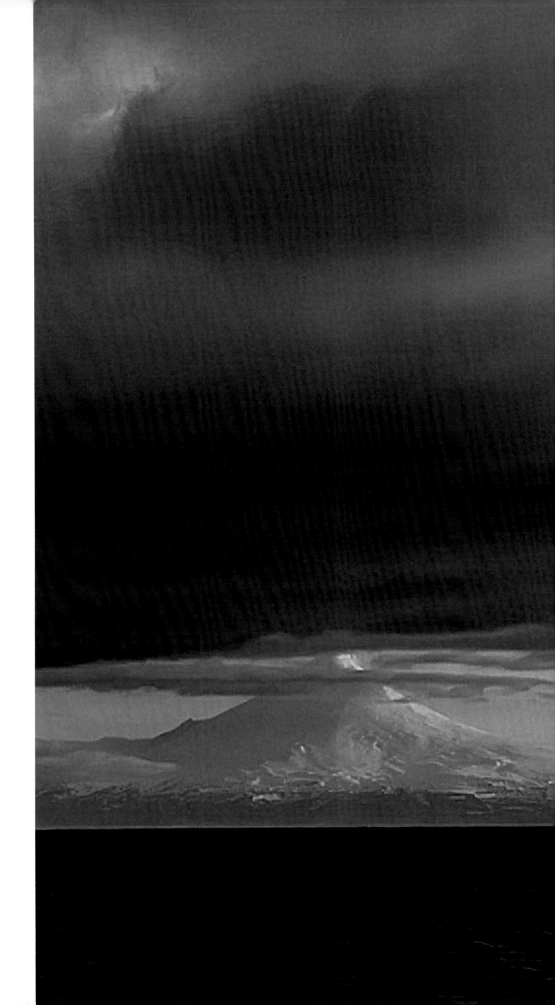

The gold rush of 2009 was very real in Nome, Alaska. Prices have since dropped and many of the dredges operating in Nome have been idled. Right: Mount Shishaldin, left, is an active volcano and the highest peak in the Aleutian Islands chain.

NORTON SOUND · ALASKA

Last leg and we are into Nome tonight. Fantastic passage from the twin volcanoes of Shishaldin and Isanotski, Dutch Harbor, and the dangerous Bering Sea. Translated this means quiet, safe, and free of big moments. This is so different from two years ago on **Cloud Nine**, when we experienced continuous gales. Looking forward to our open house and presentations in Nome. I am interested to see how the Nome gold rush is going. Gold fever has gripped this town again, and entrepreneurs are moving up here building gold dredges that look like something out of "Mad Max."

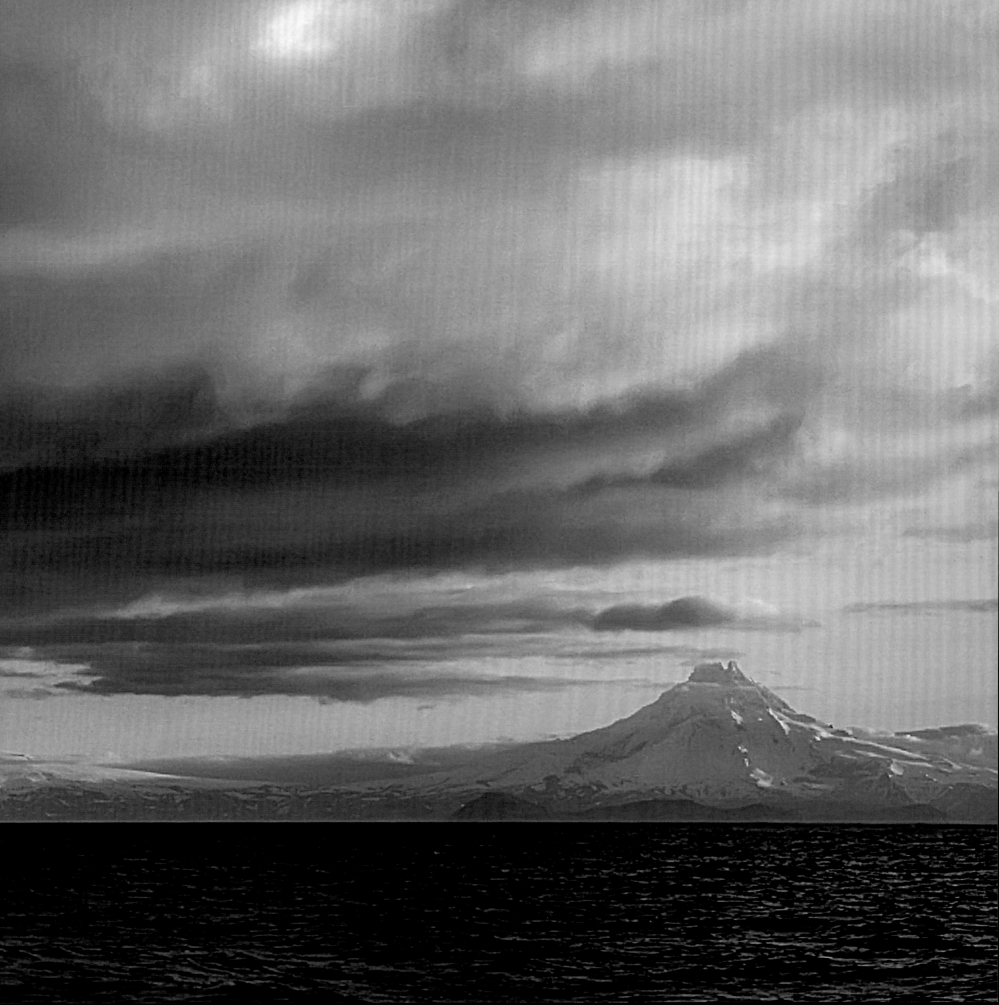

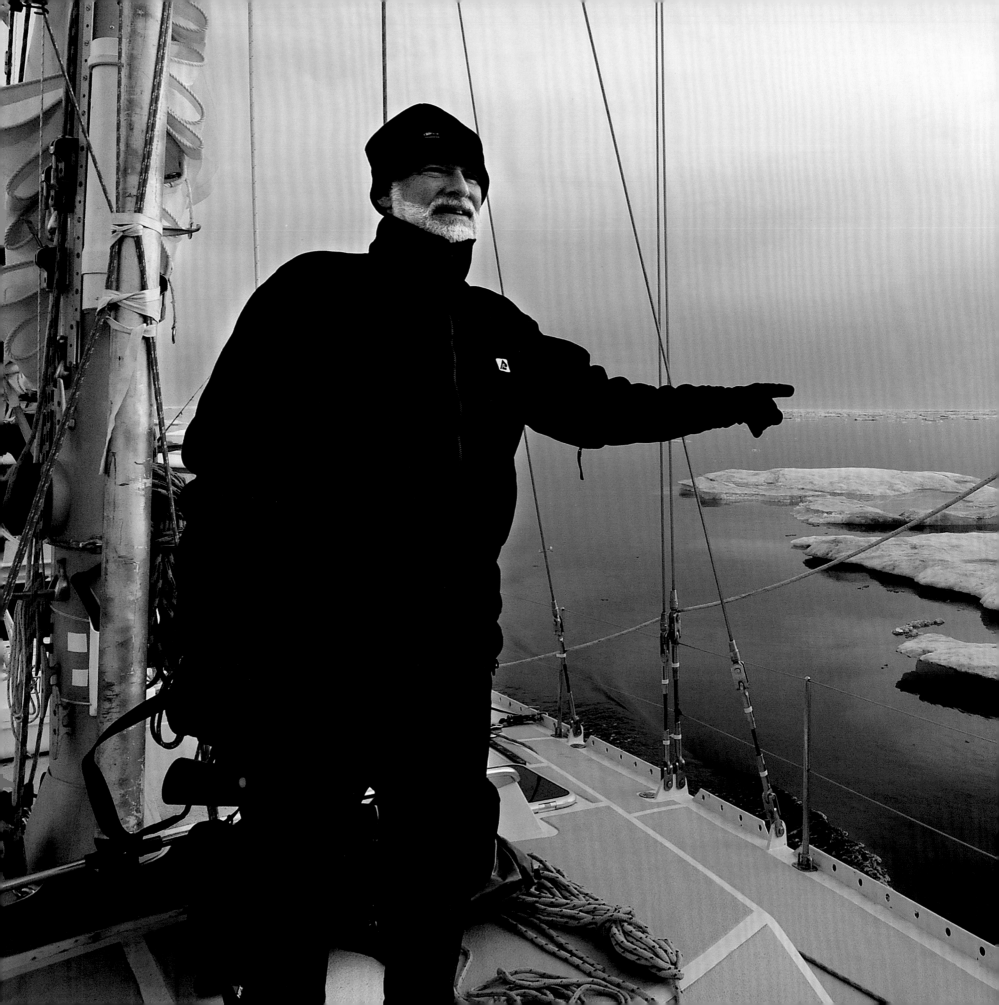

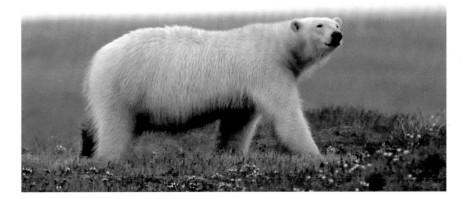

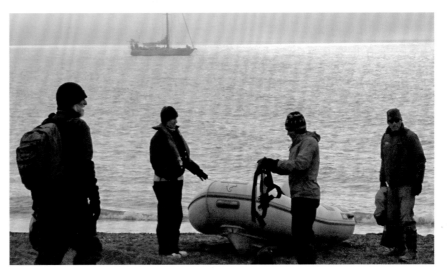

Left: Captain Mark Schrader signaled to helmsman Dave Logan as *Ocean Watch* negotiated a long shore lead to escape a field of pack ice near Barrow, Alaska. Above: A hungry polar bear caused alarm in the Arctic village. With no deepwater port available, *Ocean Watch* was forced to anchor in the open Chukchi Sea.

JOURNAL • JULY 18 • 2009

BARROW • ALASKA

We have been meeting with NOAA scientists and whale experts, including Eskimo whale captains. We played soccer with locals and heard stories of houses in Barrow becoming unstable because the pilings weren't deep enough into the now unfrozen "permafrost." Traditional deep food storage is jeopardized as ice caves need to be 25 feet deep rather than 12 to 15. Hunters and fishermen are falling through the ice even in winter as warmer, fast-moving currents are melting the ice from beneath.

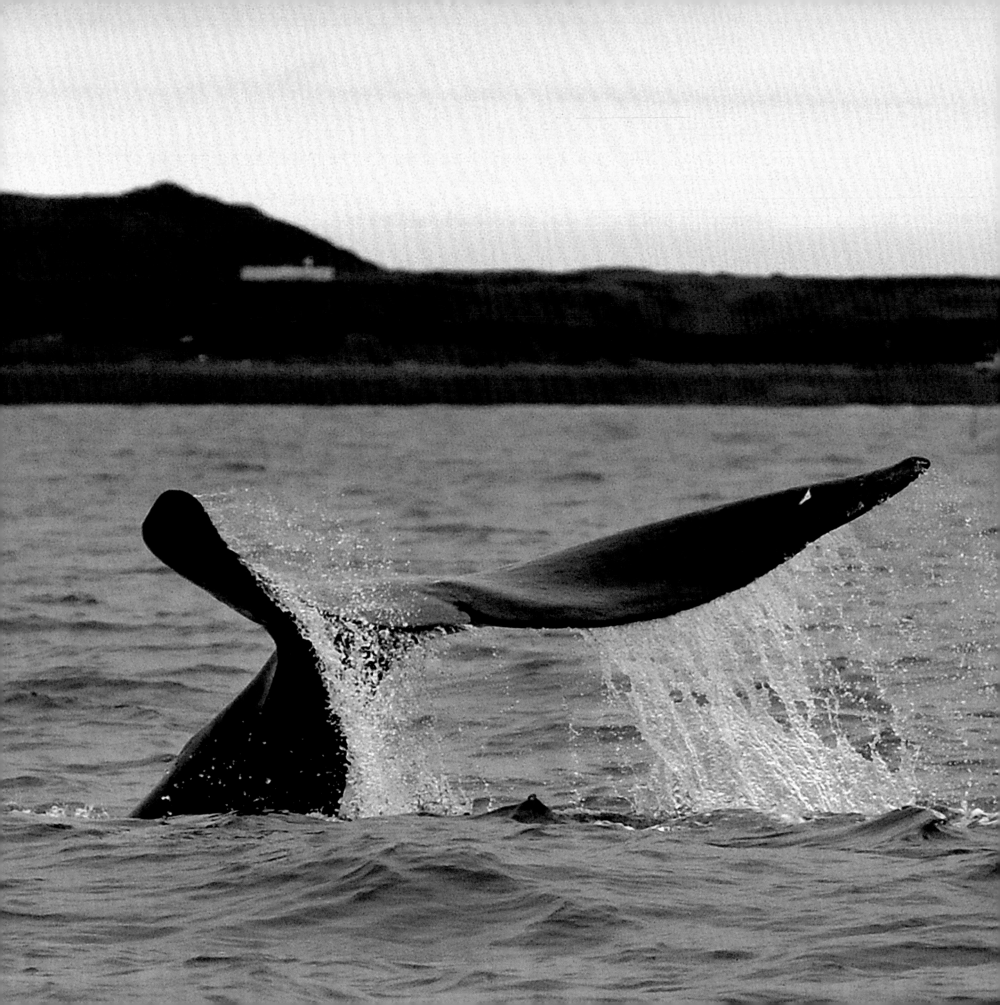

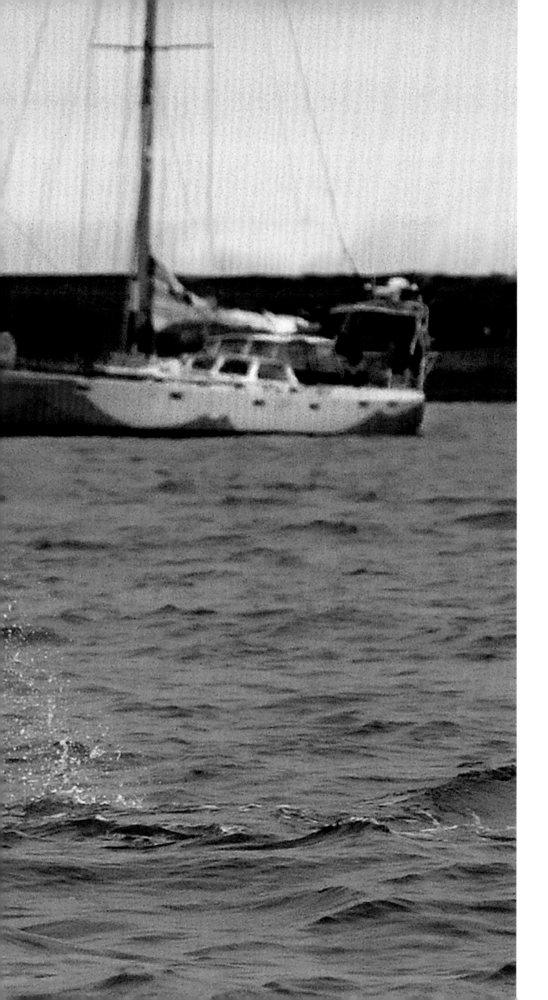

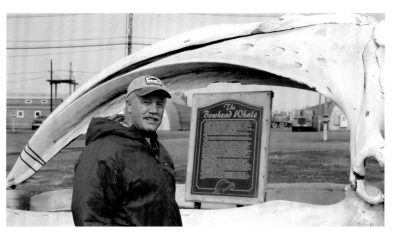

We relished a rare sighting of a bowhead whale in shallow water near an anchored *Ocean Watch*. Whale hunter Harry Brower, top, helped Craig George figure out how to bring bowheads back from the brink of extinction.

BARROW · ALASKA

Thirty years ago, bowhead whales were under threat, and a hunting moratorium was affecting local communities. Longtime Eskimo whaling captain Harry Brower Sr. passed to his son, Harry, the key to bringing the whales back. A young scientist, Craig George, was there at the time to take note. Together they have developed a conservation model — based on subsistence hunting and collaboration between hunters and scientists — that is unique in the world.

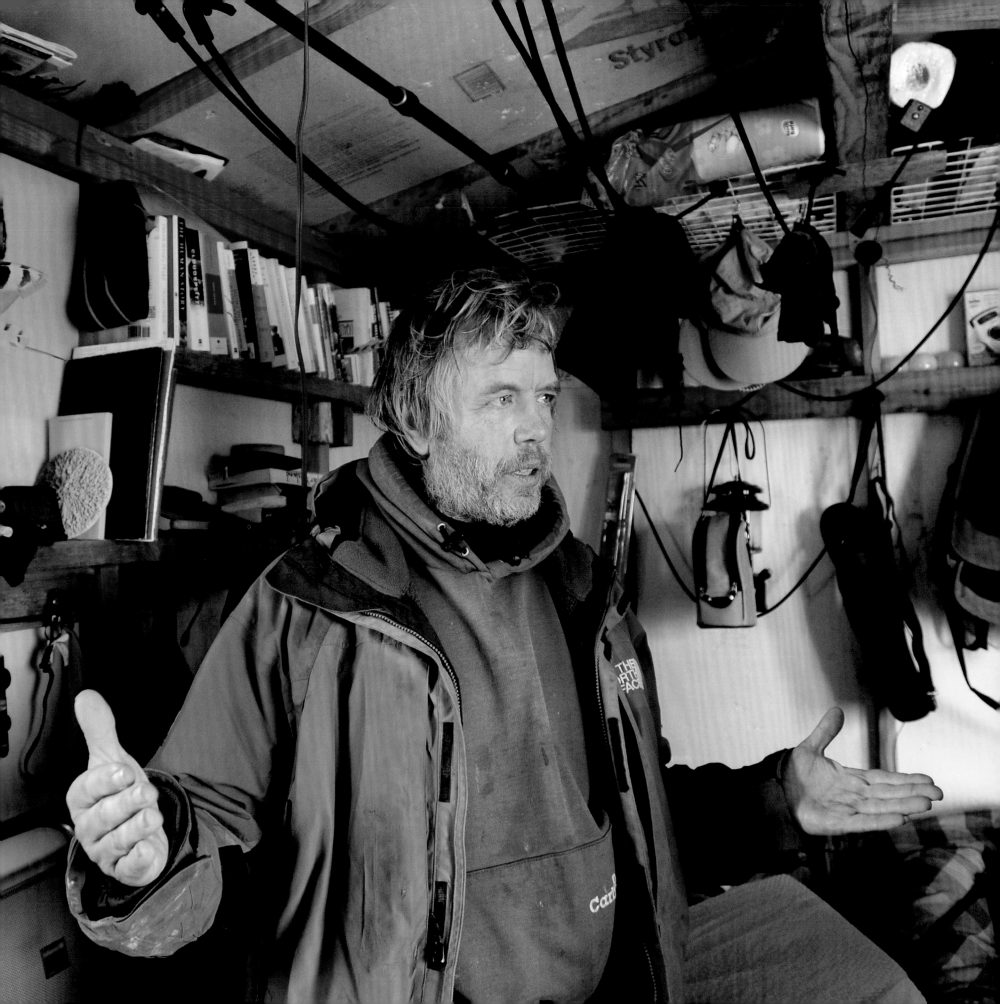

CLOSE ENCOUNTERS WITH BIRDS AND BEARS

By G.J. DIVOKY, Friends of Cooper Island

When I started a study of black guillemots on Cooper Island in the early 1970s, the last thing I thought my work would lead to was documenting the response of an Arctic seabird to dramatic decreases in and the possible disappearance of Arctic pack ice. My initial objective was to study the life history of a seabird off northern Alaska, where offshore oil development was likely to occur. I also wanted to take advantage of the unique colony of nesting black guillemots on Cooper Island with eggs and chicks easily accessible under wooden debris, very unlike the typical nest cavities hidden deep in rock cliffs and rubble.

When government funding for the study ended in early 1981, I decided to return to the island on my own. Having banded most of the breeding birds and all of the fledglings since 1975, I had a personal relationship with many individual birds and wanted to continue to monitor their mate choices, survival, and breeding success. Just as important was my relationship with the island and the Arctic summer. After six years of

Ornithologist George Divoky explained changes to the Arctic environment from his bear-proof cabin. He has noted the lengthening breeding cycle of the black guillemot, which clearly demonstrates a warming Arctic. *Ocean Watch* crew members arrived on Cooper Island, left, a barrier island 30 miles offshore of Barrow, Alaska. Measuring 1-by-3 miles, its high point is 3 feet.

walking the low sand and gravel bar while enjoying the unique 24 hours of daylight, I had developed a deep appreciation for the landscape and a sense of place I had not experienced since my youth.

My long-term connection with both the guillemots and the island made my experiences in the early 21st century all the more disconcerting as I observed the effects of rapid warming on the sea ice adjacent to the island. While the 1990s had brought minor and gradual signs that the Arctic was melting, sudden and dramatic shifts in the environment occurred in 2002 and 2003 that informed me in unexpected ways.

From 1975 to 2001, most guillemot chicks survived their five weeks in the nest to fledge into near-shore waters with extensive sea ice cover. Things changed in 2002 when, in mid-August while measuring birds in the colony, I looked up to see a large polar bear flipping guillemot nest sites and eating nestlings before it walked over to explore my campsite. An unprecedented sudden sea ice retreat had forced a large number of bears to swim to shore on Alaska's

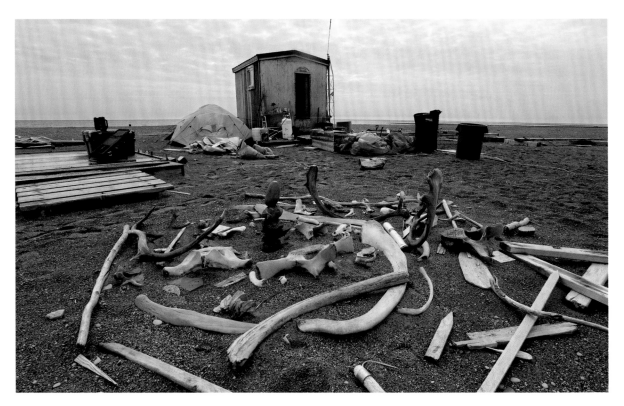

George Divoky has assembled an odd assortment of Arctic gems at his research station on Cooper Island.

northern coast. Polar bears continued to appear over the next two days, eating guillemot nestlings as they moved through the colony. After one bear tore a hole in my tent, I radioed search and rescue for a helicopter — abandoning the guillemot colony for the first time in 28 years.

In 2003, polar bears did not visit the island, but decreased sea ice again caused major nestling mortality, as breeding guillemots were unable to find their preferred ice-associated prey of Arctic cod as the now ice-free waters warmed. Guillemot parents had to turn to less abundant, lower

quality prey, with the result that many chicks were dying of starvation.

The sudden and catastrophic nature of these changes had an immediate and deep emotional impact on me that brought home the realities of climate change in a way that is not possible through long-term monitoring of variables responding to a melting Arctic. A place where both the guillemots and I were relatively undisturbed for decades was suddenly inhospitable. They were dying from predation and starvation, and I was having to deal with the world's largest terrestrial

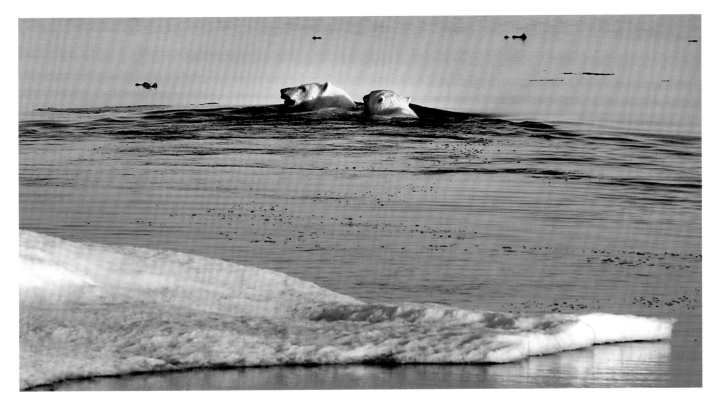

The receding ice edge has forced polar bears to swim greater distances for food.

"After 28 years of annually digging a shallow hole in the island's permafrost to serve as a cooler for my perishables, in 2003 I dug through 4 feet of unfrozen sand and gravel before hitting water."
– G.J. Divoky

predator threatening me and my shelter. While my four decades of research on the island have found a range of climate change impacts, such as date of egg laying now being two weeks earlier than in the 1970s and the breeding population dropping by half in the past 25 years, those findings fail to have the emotional impact of the sudden paradigm shifts I observed and experienced when polar bears first decimated the guillemot colony in 2002 and an unprecedented lack of prey had nestlings starving in all the nests in 2003.

Almost as unsettling as those first experiences with cataclysmic climate change signals is how I have had to accept the "new normal." Polar bears are now a regular and expected part of the late summer field season, although they no longer eat large numbers of chicks since the wooden nest sites were replaced with "bear-proof" plastic cases in 2011. Wide-scale starvation of nestlings has become a regular, though still disturbing, occurrence, and I now often return to my camp with pockets full of dead nestlings.

My experiences with climate change have been unique and required living on a cold and remote island long enough to document the decades before and after the Arctic began its ongoing rapid melt — predicted to result in the complete loss of summer sea ice in this century. Since the current effects of anthropogenic warming at lower latitudes and on the general public are only beginning, it is important to understand just how major the changes have been in the Arctic in recent decades and that they are a precursor of changes that soon may be global in scope.

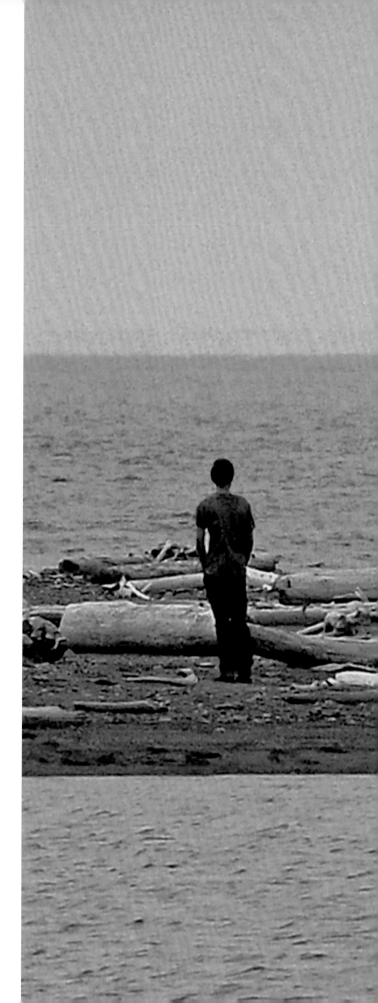

We had been operating in 24/7 daylight mode for weeks. When the sunset finally arrived, it was a startling sight. Right: Caribou strolled across a sand spit at Herschel Island, where energy companies are exploring and developing new Arctic oil and gas fields.

HERSCHEL ISLAND · NORTHWEST PASSAGE

The sunset tonight quite literally seemed to set the Arctic icescape on fire. Talk about global warming! It looked as if the Apocalypse was upon us. Meanwhile, silhouetted ice floes and be rgy bits quietly eased by **Ocean Watch**. This is the Arctic dream that I pursue. It's a powerful evening in the Far North. Finally saw our first planet in the sky again, a sure sign that night will eventually come and the season will change.

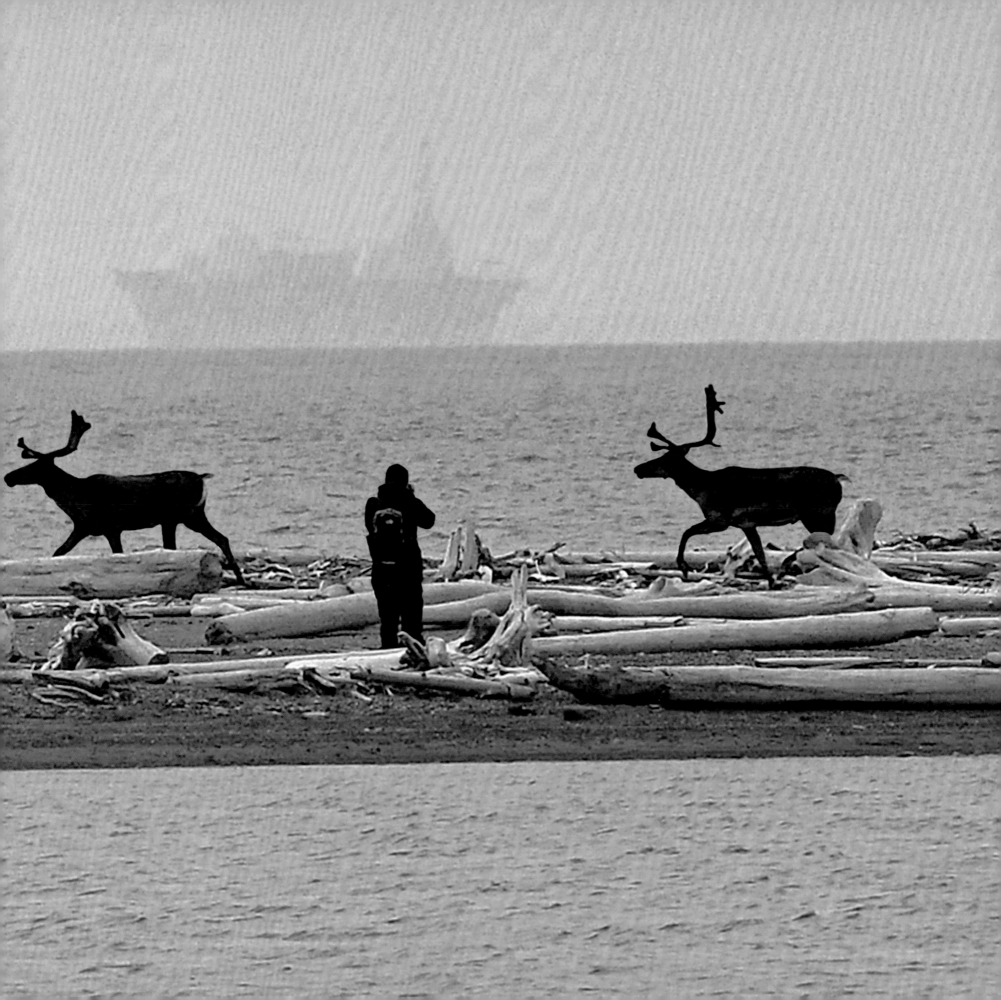

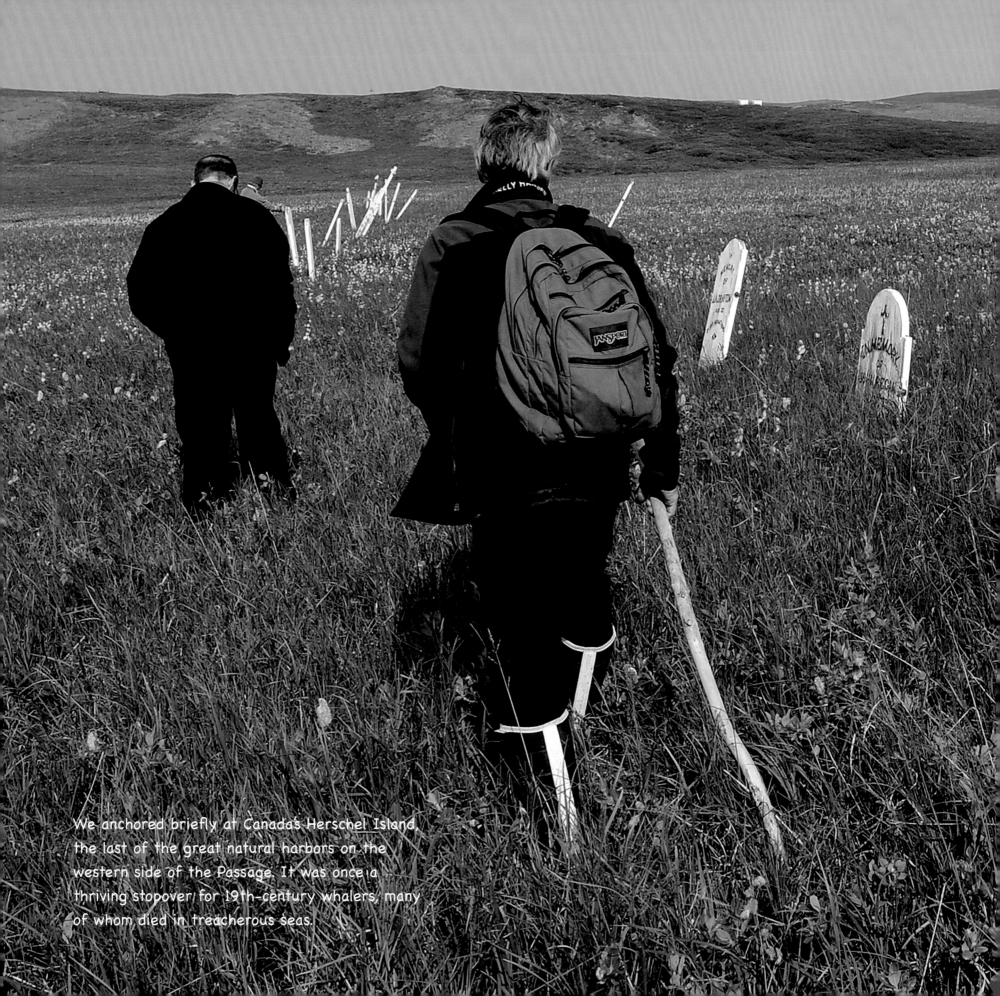

We anchored briefly at Canada's Herschel Island, the last of the great natural harbors on the western side of the Passage. It was once a thriving stopover for 19th-century whalers, many of whom died in treacherous seas.

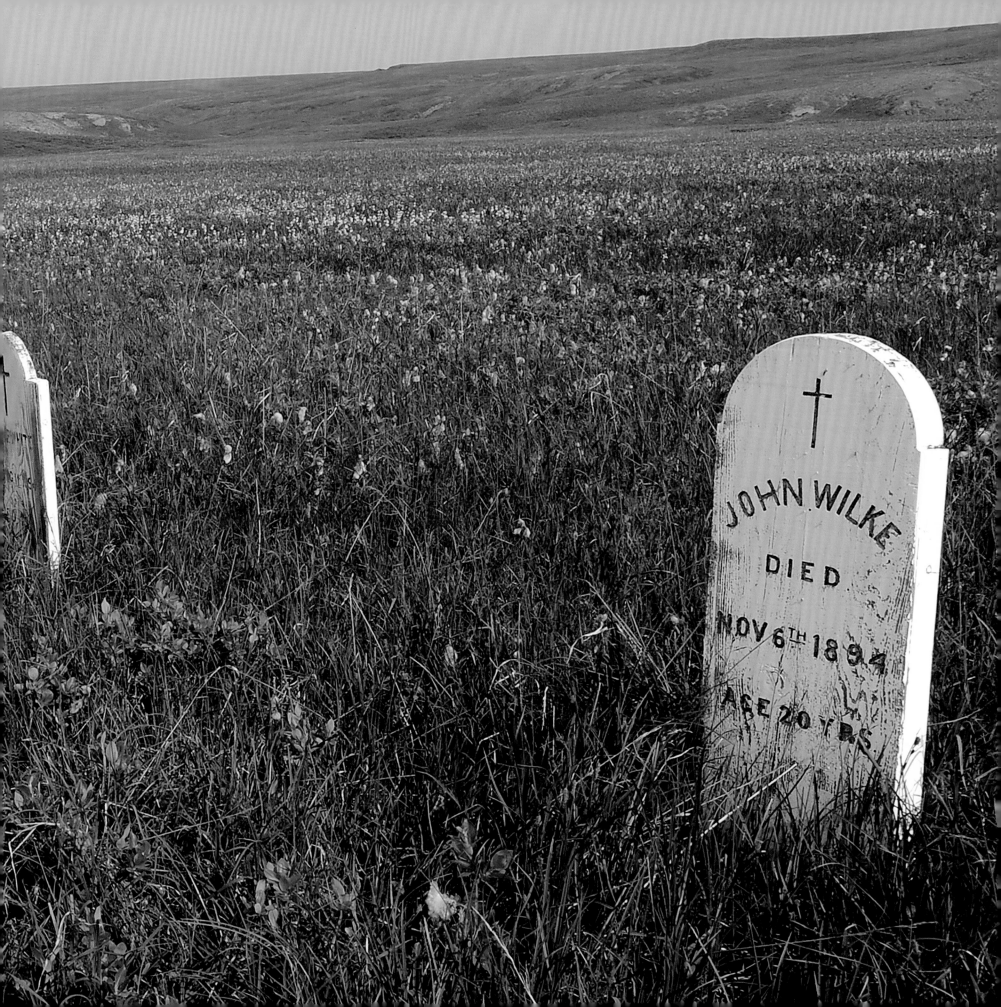

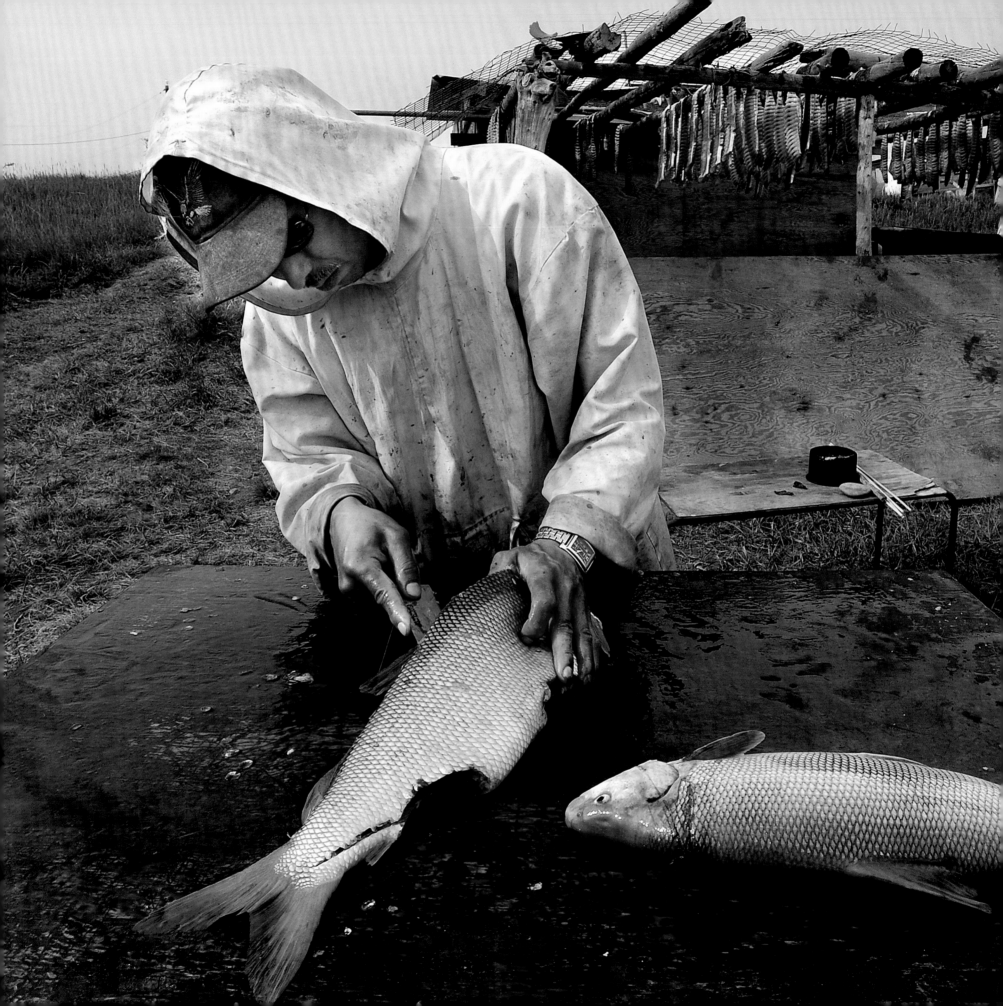

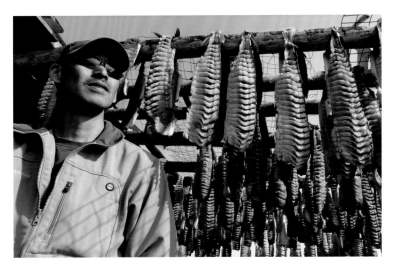

Inuit hunter and fisherman Wayne Thrasher filleted a whitefish to dry in his summer smokehouse. He is worried about threats to the Arctic environment as well as the viability of his traditional way of life and of his community.

A VANISHING WAY OF LIFE IN THE ARCTIC REGIONS

Tuktoyaktuk (Tuk) is a small town with summer fishing camps set up all along the shore, including on the small islands dotting the Mackenzie River delta. Two years earlier, I had stopped to photograph one camp in particular. It had beautiful drying racks heavy with whitefish, a radio tuned in to CBC/Radio-Canada, a fire going, and a thermos of coffee, but no one was there. I took many images, but the owner of the camp never emerged.

Soon after *Ocean Watch* arrived in Tuk, I scanned the horizon and noticed fish-drying racks at about the same spot. A short walk brought me to the camp, which I immediately recognized. Not only were the racks full of whitefish, but the nearby radio was tuned in to the same station. This time, however, a compact, fit figure emerged from the smokehouse. It was Inuit hunter and fisherman Wayne Thrasher.

I happily spent the next three days observing, listening, and getting hands-on lessons as Wayne went about managing the summer gill-netting operation. This gentle and insightful man moves and speaks at a pace equal to that of the Arctic: slow, methodical, and calculated, with absolutely no mistakes.

Wonderful stories emerged of his great grandfather, a whaling captain on a boat in the 1930s, and Wayne's own work helping to clear bears from the distant early

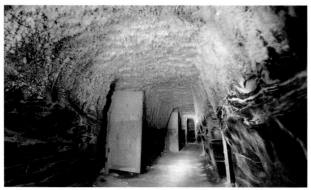

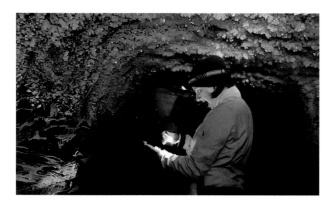

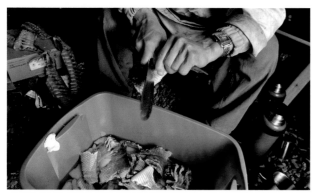

A 30-foot climb down a frozen ladder leads to the community icehouse. *Ocean Watch* educator Zeta Strickland marveled at the ice crystals. "Bipsi" is a mix of beluga whale and whitefish.

warning (DEW) radar stations. Wayne told of using caribou skin to make his mukluks for the upcoming hunting season and then showed how to use a musk ox horn as armor against a bear's deadly jaws. He also shared some tragic stories, including one about a recent boating accident that had killed a couple of his longtime friends.

In keeping with the oral tradition of native people, Wayne's father passed on a story about a family that had been mistreated in the area in the "old days" and kept migrating east until they eventually reached Greenland.

"People from Tuk founded parts of Greenland and will tell you the same story there," said Wayne as we snacked on "bipsi," a mix of whitefish and raw beluga. Indeed, several Greenlanders had come to Tuk for an Inuit Circumpolar Conference in the 1990s and had repeated the tale.

Wayne was busy, however, as in 12 days' time he had caught and smoked more than 300 whitefish and cleaned out a Beluga whale. He was nearly done with the process and asked us to help him move his winter food stores to the underground community icehouse.

Ocean Watch educator Zeta Strickland and Dave Logan met us at the door, and down the 30-foot ladder we went into the frozen world of the permafrost. Wayne told us that it had taken 20 men a year, using pick axes and shovels, to build the storage area in 1964. It has 19 rooms, although only five or so are being used now, as more residents turn to modern refrigeration methods. Wayne continues to lay up food for his extended family and the community, even though it requires tremendous work.

Back at the camp, we jumped into his little aluminum rowboat and hand-pulled our way along nets that he had suspended over used plastic motor oil containers. Wayne demonstrated how to quickly determine the size of the fish, using the net itself. We brought in another half-dozen whitefish to clean while freeing the

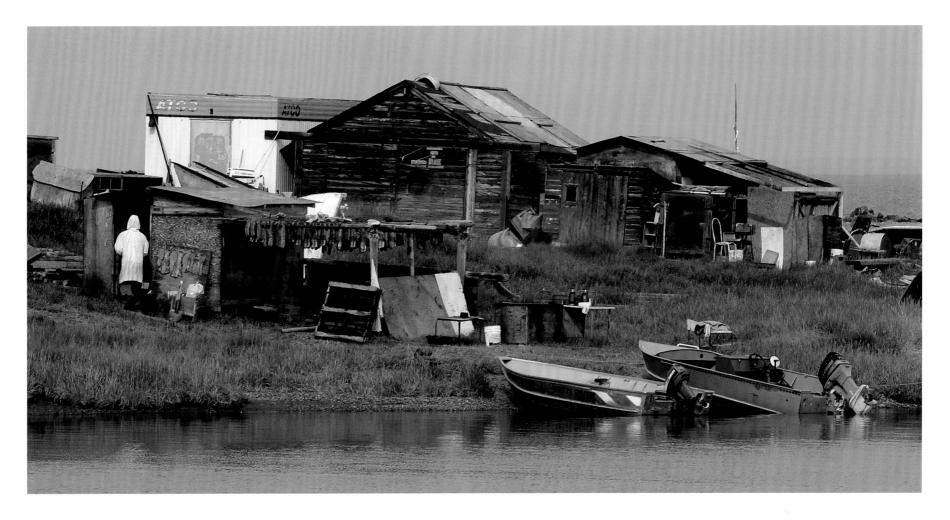

same amount of smaller fish. I was impressed by his efficiency. Everything in his possession was recycled in some way, down to the old desks being used as cleaning tables.

Like most native people throughout the North, Wayne worries about the future of his village. He sees a new highway working its way through, water quality changing in the Mackenzie River delta, an increase in seismic testing in the area, and erosion tearing away at the shorelines. As I said goodbye, I marveled at his great experiences but wondered about the future for him and others like him who are clinging to age-old traditions in the emerging new Arctic environment.

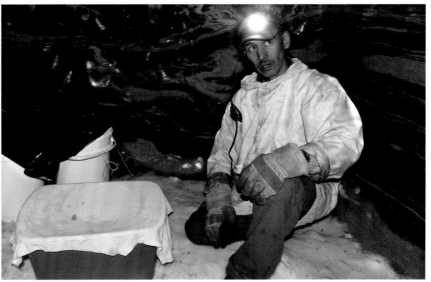

Wayne Thrasher operates a fish camp in Tuktoyaktuk in the Inuvik Region of Canada's Northwest Territories. An ice cave, carved deep into the permafrost, provides communal storage for freshly caught fish, whale or wild game. Thrasher and others have separate family storage rooms within the icehouse.

A cairn built by earlier explorers marks the shoreline of Pearce Point Harbour in Amundsen Gulf. *Ocean Watch* stopped in the remote outpost, waiting for ice to clear.

PEARCE POINT HARBOUR • NORTHWEST TERRITORIES • CANADA

Took refuge. The ice edge is now 20 miles east of here. It is snowing outside, and all is well. What a great harbor; looks like the U.S. Southwest. Canyons, layers, big towers, very arid looking. Interesting landscape. We heard there was a small British boat here, and we barely missed them. The two men left a message in the little hunting cabin we visited. Great views, cairns are all about, bear tracks, caribou bones, ice on the shores. Having a fresh sea ice cocktail tonight. Really excellent day.

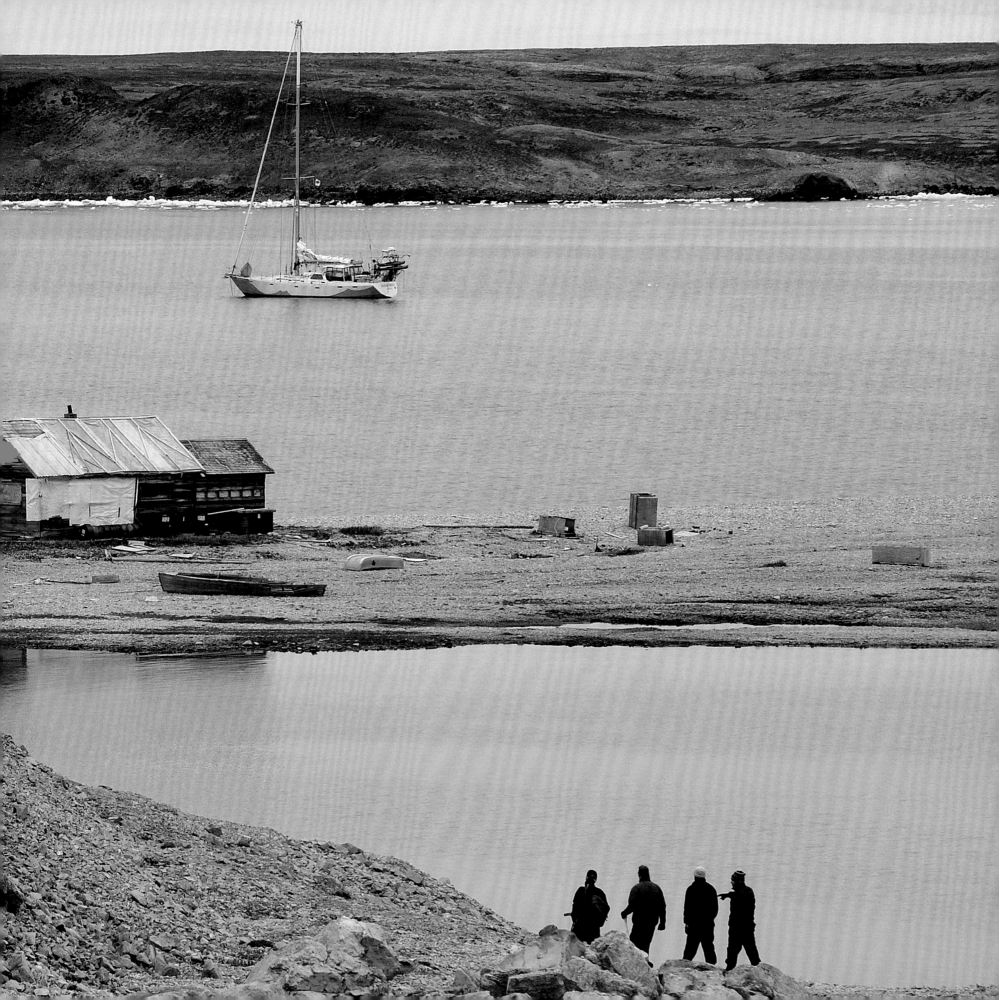

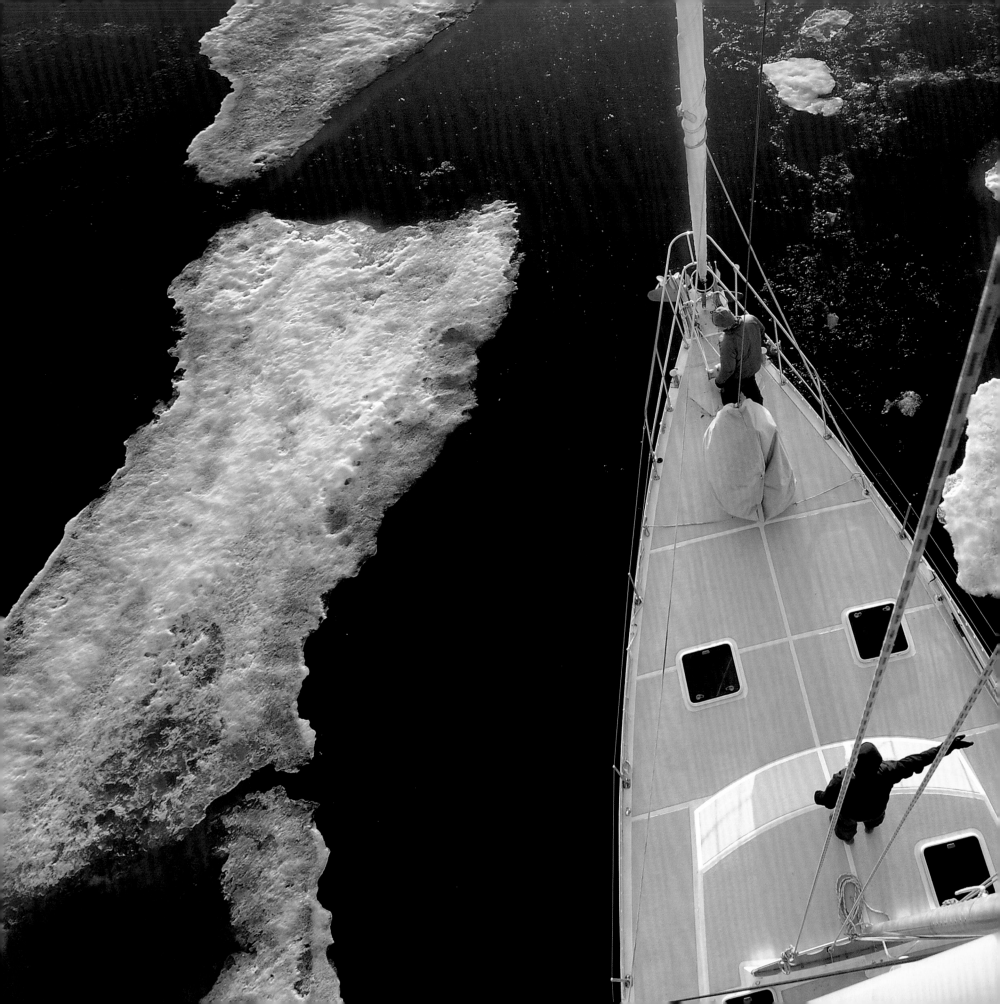

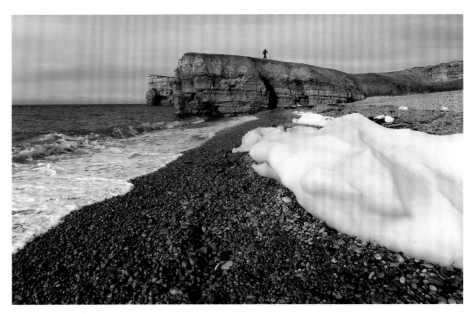

The delicate balance between summer sea ice and an open Arctic Ocean is well illustrated near Pearce Point, above, in the Canadian Arctic. Left: *Ocean Watch* and crew picked their way through dangerous ice floes en route to Cambridge Bay, halfway through the Northwest Passage.

JOURNAL • AUGUST 13 • 2009

AMUNDSEN GULF • CANADIAN ARCTIC

I feel like Spock aboard the USS Enterprise, communicating with Captain Kirk: "Captain, we have arrived at the ice edge." Tough going today. I was up the mast four times, beginning at 0530 hours, as we headed into the ice in first light. Established the lead and stayed in close within 1 mile along Victoria Island as we picked our way through heavy concentrations of ice all day. Unbelievable challenge for everyone aboard and great teamwork.

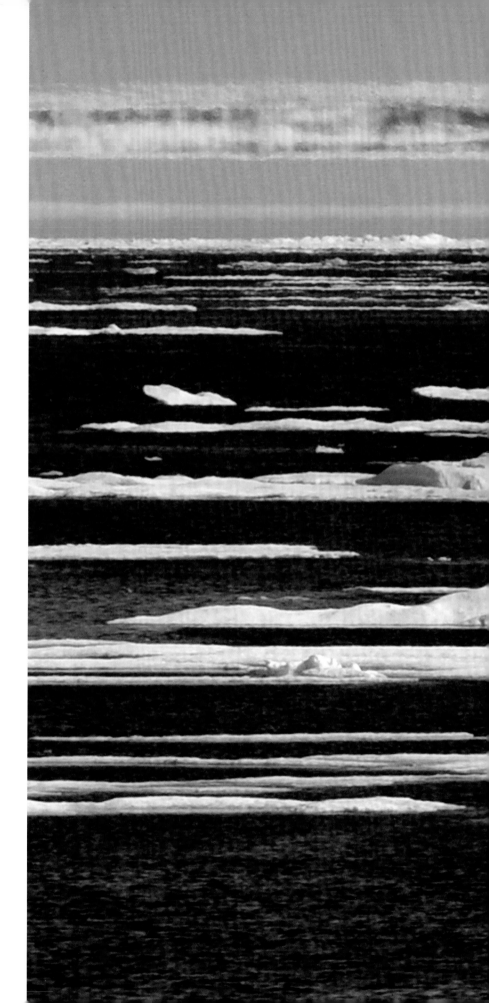

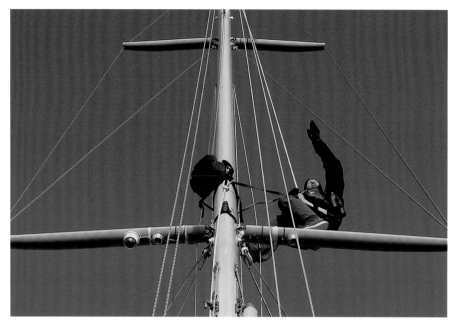

I was often high in the spreaders, looking for open "leads" and trying to solve the riddle of the pack ice in Amundsen Gulf, which was a very real threat in the summer of 2009. Right: Refracted light created a mirage, hovering just above the horizon.

AMUNDSEN GULF · CANADIAN ARCTIC

Perfect conditions all afternoon and evening. Witnessed some beautiful mirages. Walls of "ice blink" looked like huge layered cities of white and crystal, shimmering on the horizon. At one point we got completely bottled up in the middle of the wide bay. We were in a maze, nothing open in our preferred direction. We backtracked out and then in closer to shore where we found a lead and worked it. We got into open water and stayed on that lead. Dave Logan did a great job at the helm.

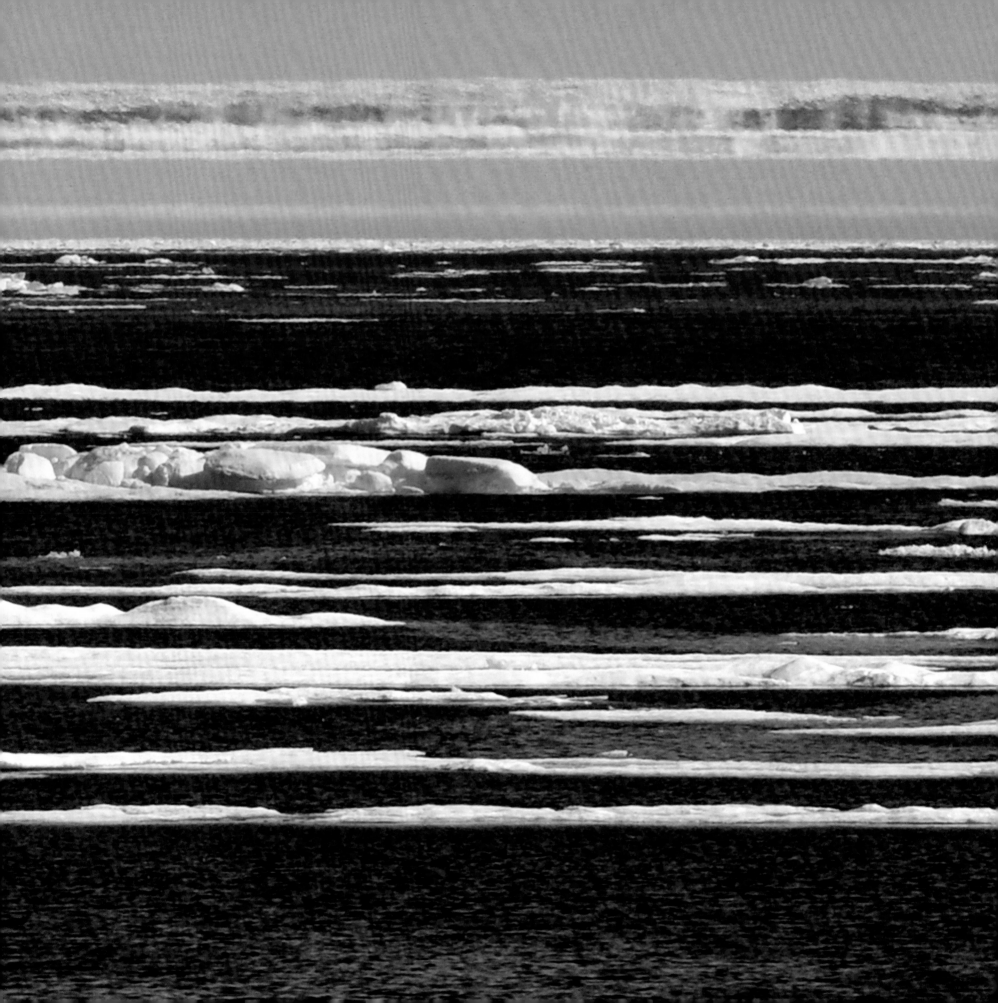

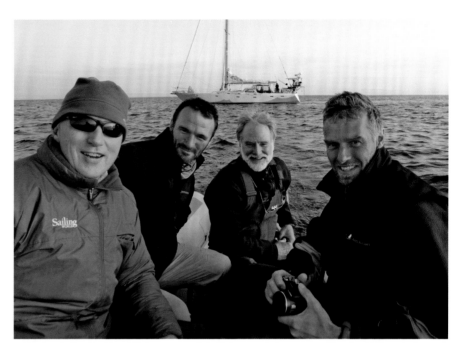

At left: Two Royal British Marines on holiday, Kevin Oliver, left, and Tony Lancashire, were attempting the guts of the Northwest Passage in a 17-foot open boat. Above: The crew of *Ocean Watch* welcomed Tony and Kevin aboard with a whiskey toast and some much needed supplies.

JOURNAL • AUGUST 15 • 2009

CORONATION GULF • CANADA

Right in the middle of this icy mess, we got a radio call from two British sailors on the vessel **Arctic Mariner**. We looked for them to no avail. They spotted the larger **Ocean Watch**, so we throttled back and launched the dinghy to meet them. There they were, Tony and Kevin, on leave from the war in Afghanistan for a little "summer vacation," attempting the Northwest Passage in a 17-foot open boat. They wore sandals in the 34-degree weather and had a grapple hook in an ice floe just offshore to stay away from a bear that had been annoying them. We shared stories and information and gave them a few supplies. Herb McCormick later wrote on our blog: "If these two had been in charge of the British Empire, there would still be one." Well said, and well done, men.

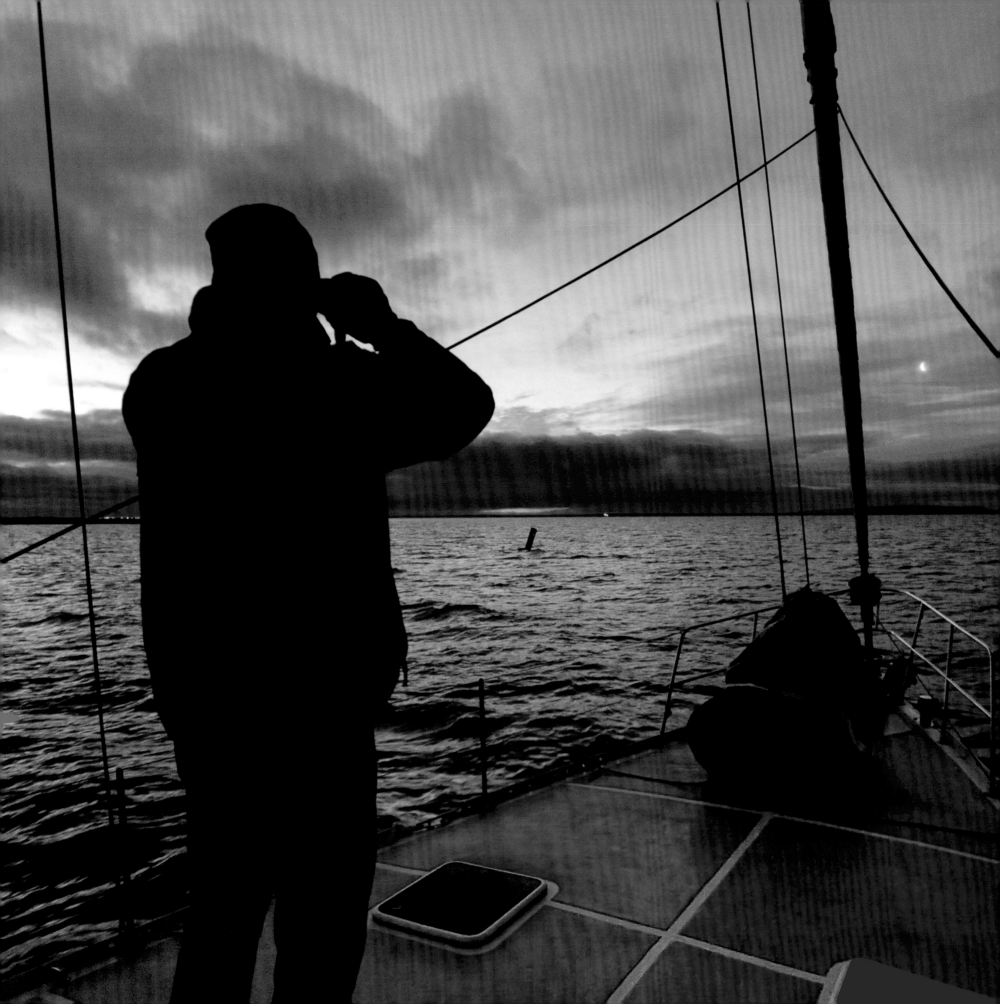

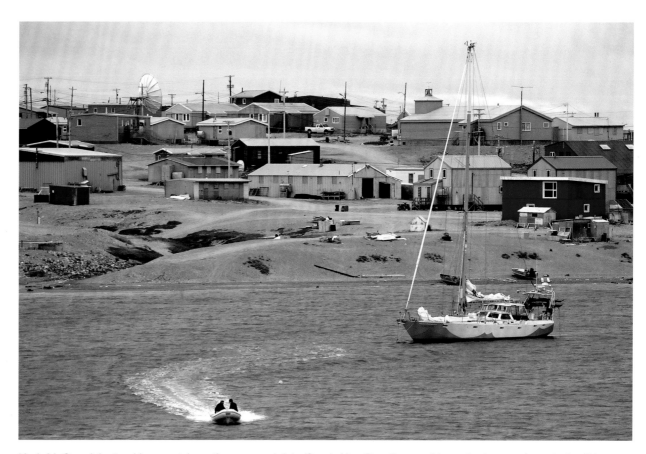

Herb McCormick stood bow watch on the approach into Cambridge Bay, the most important resupply port of call in the Northwest Passage. Above: Back in the footsteps of Amundsen, the crew dropped anchor in Gjoa Haven, with a favorable ice report in hand. Small villages like Gjoa could soon be overrun by tourists on large cruise ships.

JOURNAL • AUGUST 15 • 2009

CORONATION GULF • CANADIAN ARCTIC

2200 Hours — Cambridge Bay approach is now close at hand. Something about this August 15 date is very strange and coincidental. Two years ago the Passage opened up and we went through the open lead in Peel Sound and into Gjoa Haven. Last year the Passage opened the same day. Now we are proceeding in ice-free water and have a new ice report. Guess what? The Northwest Passage is officially open for business today. Once again, the ice is disintegrating quickly. The odds are going our way. As I stated two years ago, and is still true today, "What's good for **Ocean Watch** and completing the Northwest Passage is probably not such good news for the planet."

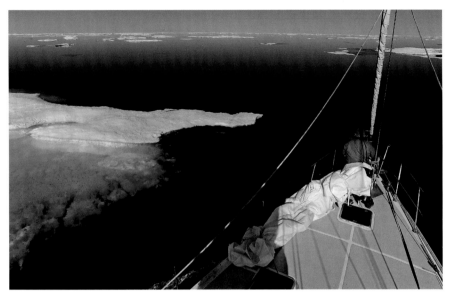

With Herb McCormick on bow watch, *Ocean Watch* followed a perfect shore lead along the Boothia Peninsula, going north to Bellot Strait. Right: Ice floes in the Northwest Passage take on many sizes, shapes and colors, forming natural sculptures that are a rewarding challenge for a photographer.

FRANKLIN STRAIT · CANADA

Ocean Watch departed Gjoa Haven, heading north to Bellot Strait. Those 300 miles are the most treacherous and difficult to navigate, with ice and shoals all about. A shore lead developed and mirror-like waters allowed us to proceed at full throttle with no wind. Perfect weather window. Seals on ice floes were all about, and then two beautiful polar bears were spotted, a female and her cub. This was the most wonderful sight of the voyage: Healthy polar bears in the wild on their ice floes.

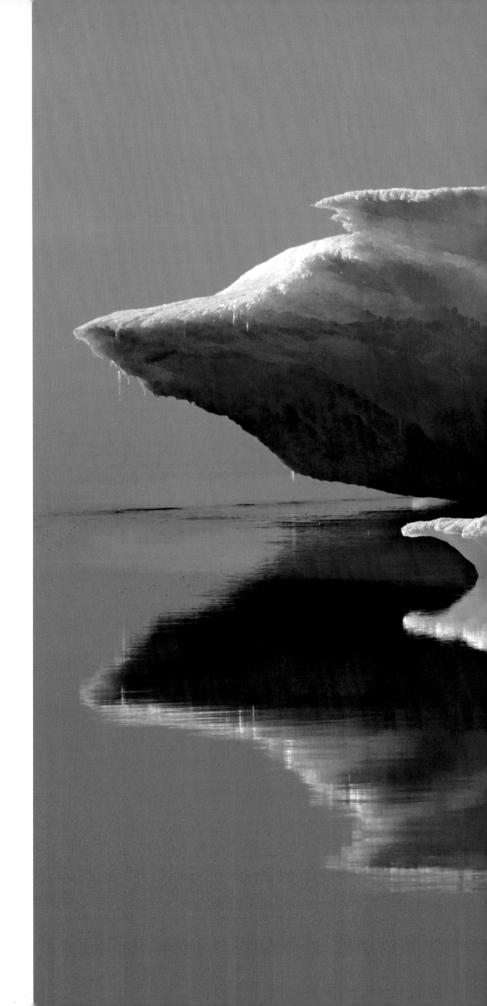

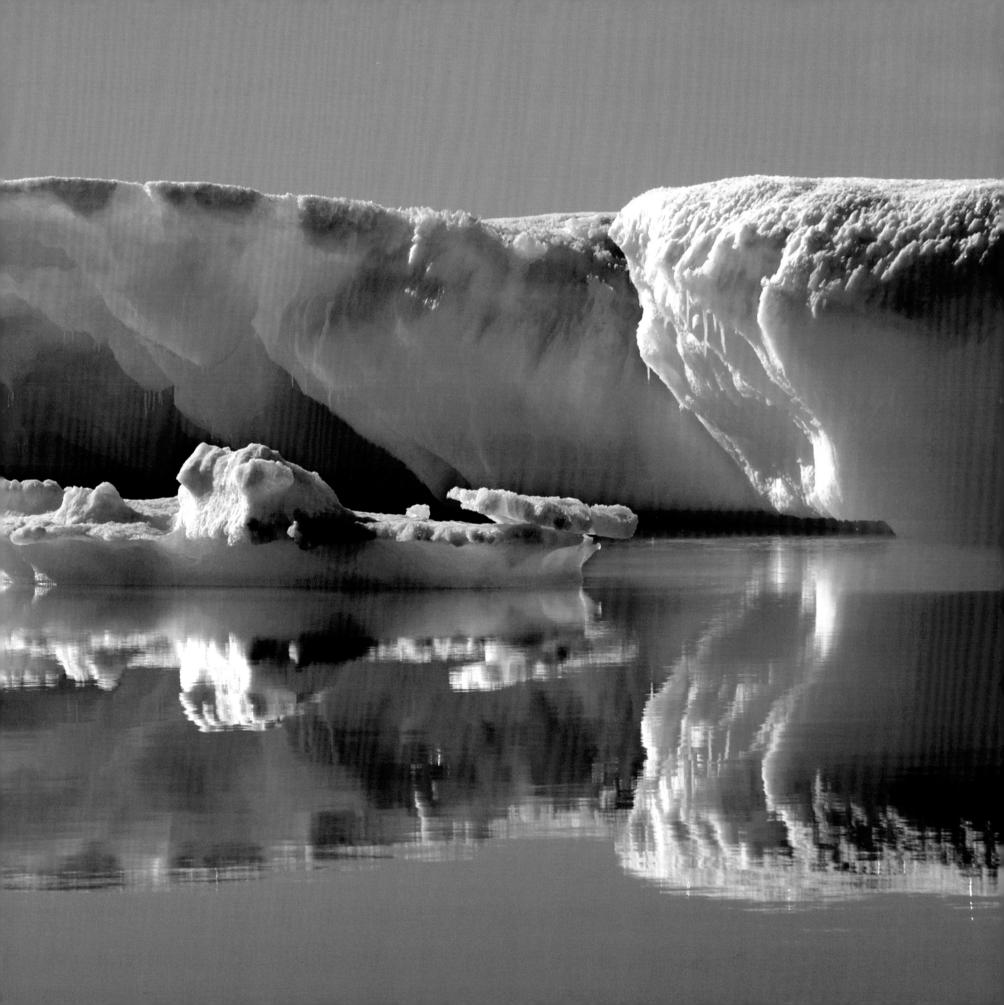

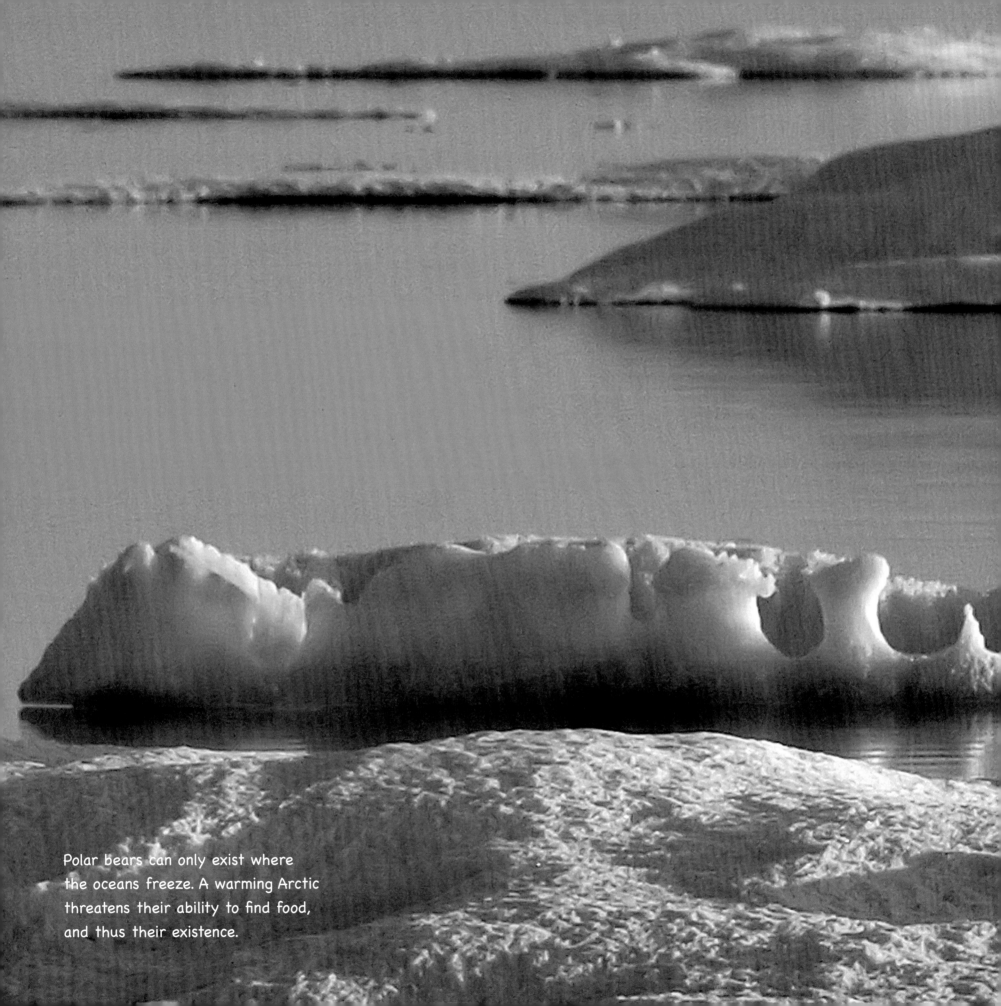

Polar bears can only exist where
the oceans freeze. A warming Arctic
threatens their ability to find food,
and thus their existence.

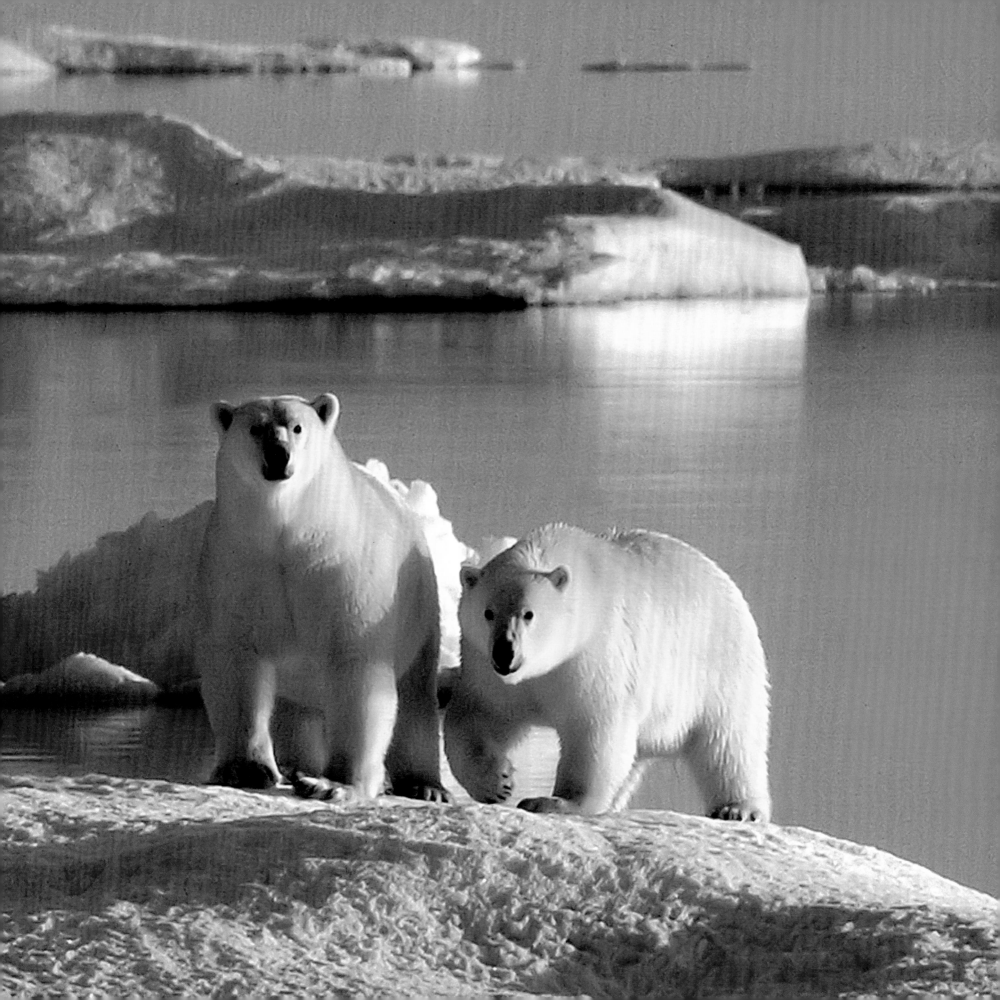

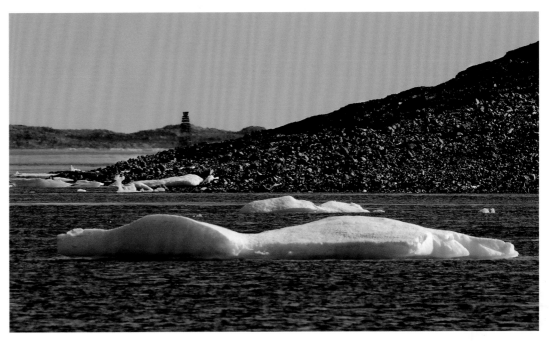

Ocean Watch cleared Bellot Strait and entered ice-free waters, a sign that we would be able to complete the Northwest Passage. Zenith Point on Boothia Peninsula's Murchison Promontory, above, is the northernmost tip of North America.

JOURNAL • AUGUST 26 • 2009

BELLOT STRAIT · CANADIAN ARCTIC

Followed our shore lead north in Franklin Strait. At Bellot Strait, the decision was made to enter, even though we heard there was still some pack ice in the dog-legged blind channel, coupled with a 7-knot current. The interior of the strait hides the northernmost tip of the North American continent, Zenith Point. The **Ocean Watch** crew decided, if possible, we must pass by that particular point. It was a daunting feeling to know our next extreme location would be Cape Horn, at the tip of South America. We exited Bellot Strait at 14 knots with the current and entered waters free of sea ice. We were out.

MAPPING THE SEA CHANGE IN ICE LEVELS AT THE POLAR CAPS

By **HARRY STERN, Polar Science Center, University of Washington**

On August 11, 1778, Captain James Cook, the preeminent explorer of his age, sailed north through the Bering Strait in search of the Northwest Passage. Working his way along the coast of Alaska on August 17, he wrote: "Some time before Noon we perceived a brightness in the Northern horizon like that reflected from ice, commonly called the blink; it was little noticed from a supposition that it was improbable we should meet with ice so soon." But sure enough, the next day he encountered "ice which was as compact as a Wall and seemed to be ten or twelve feet high at least." Cook had literally received a signal from over the horizon, warning him of the ice. It formed an impenetrable barrier, thwarting his bid to discover the Northwest Passage at 70°44' N, his farthest north.

Fast-forward 200 years. On October 24, 1978, NASA launched its Nimbus 7 satellite, carrying an instrument that mapped the entire Arctic sea-ice cover every 48 hours, regardless of clouds or darkness. Nimbus 7 lasted for nine years, and follow-on satellites have continued to provide complete coverage of Arctic sea ice every day of every year since then. These satellites have been sending us signals from over the horizon, but lately their message has been the opposite of what Cook received: The ice is

Aboard *Ocean Watch*, Harry Stern noted the enormous icebergs in Lancaster Sound and Baffin Bay. Icebergs in both polar regions have broken off from glaciers and pose a great risk to coastal lands as they melt and raise sea levels worldwide.

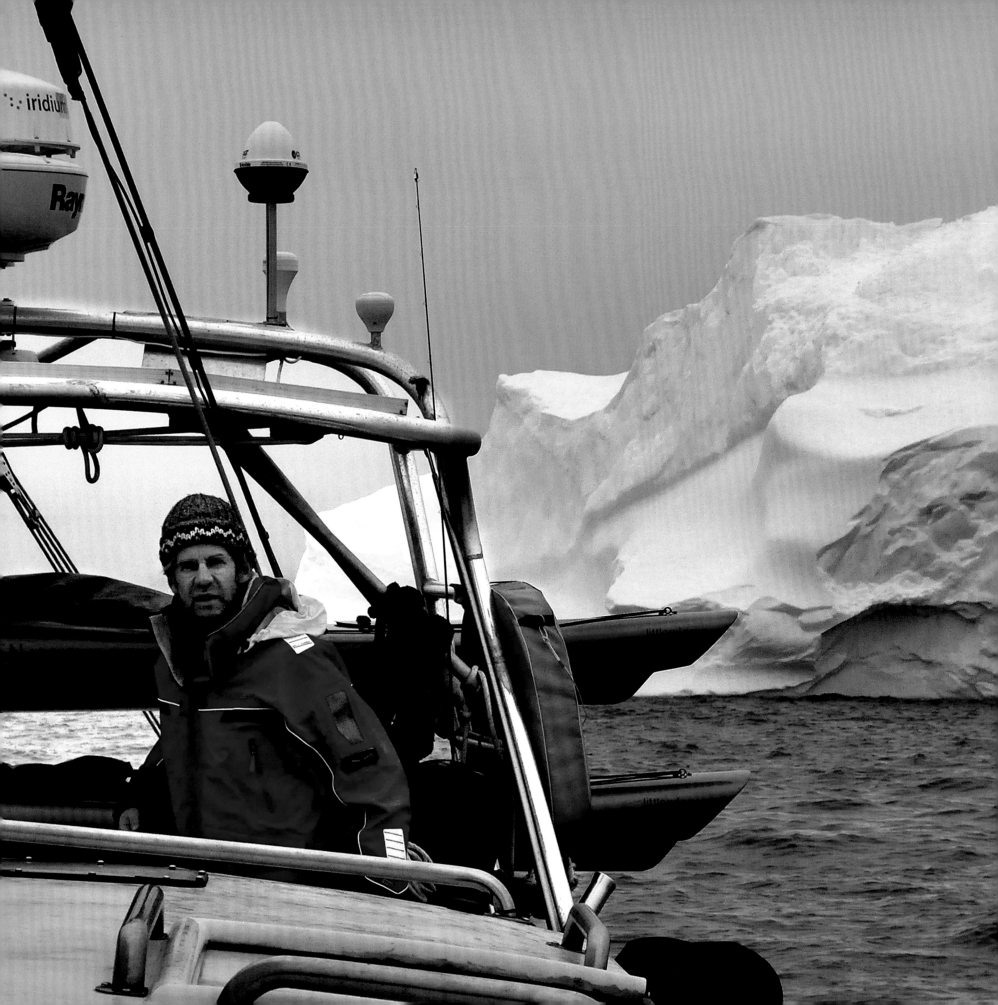

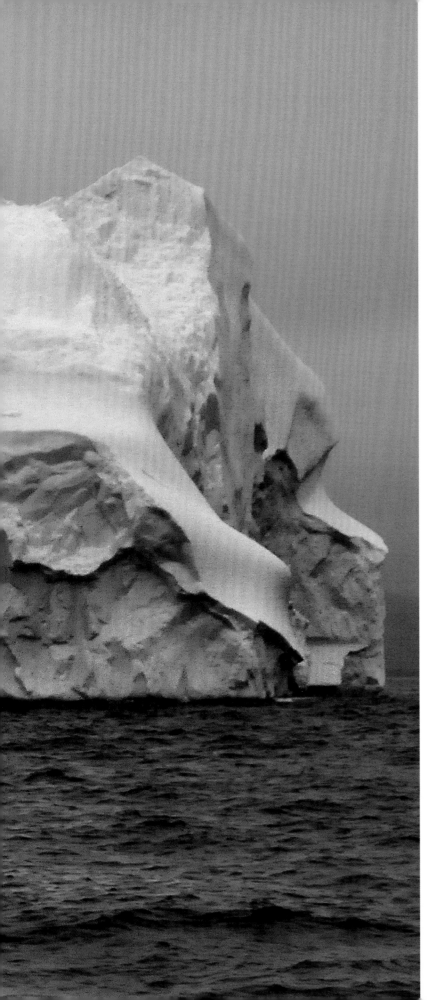

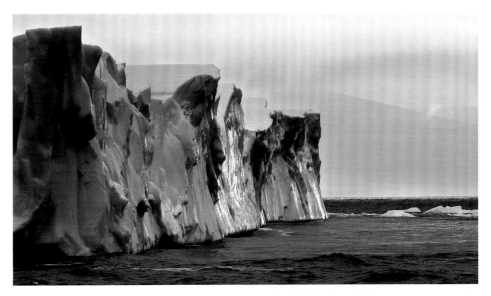

An astute polar historian, Harry Stern noted that only 111 Northwest Passages were made in the 100 years after Amundsen (1906). However, since 2006, 127 transits have been completed, many by small private boats. As we entered Baffin Bay, icebergs became more prevalent and would be our companions for the next 2,000 miles.

not there, where we expect it should be.

In the 1990s, the sea-ice edge north of Bering Strait began retreating farther north each summer, opening up more ice-free ocean during the navigation season. In the 1980s, the August sea-ice edge was typically at 70° to 72° N, not so different from what Cook experienced. But since 2007, the August sea-ice edge has been about 75° N, roughly 400 kilometers farther north than in the 1980s. There is no doubt that this is the result of human-induced global warming caused by the burning of fossil fuels that pump greenhouse gases into the atmosphere.

I joined *Ocean Watch* in Cambridge Bay, roughly halfway through her west-to-east transit of the Northwest Passage, and two months into her yearlong circumnavigation of North and South America. David Thoreson and I shared the forward cabin and stood the same watch during my four weeks onboard. As a sea-ice researcher with the University of Washington's Polar Science Center, my job was to make the daily science

measurements that were part of the Around the Americas mission. We left Cambridge Bay on August 18, the same day of the year that Cook had been blocked by a wall of ice along the coast of Alaska. There was now no ice in sight, and we encountered only scattered floes on the way to Gjoa Haven.

From Gjoa Haven we picked our way through loose sea ice toward Bellot Strait. After passing through Bellot Strait on August 26, we didn't encounter any more sea ice, but before long we sighted massive icebergs in Lancaster Sound.

The icebergs were a stark reminder of the global sea level rise that's in store due to increasing ice loss from glaciers and ice sheets. Sea level is expected to rise by 1 to 4 feet by the end of the century, but those estimates don't include any contribution from the possible speed-up of glaciers that drain the Greenland and Antarctic ice sheets, because our understanding of glacier dynamics is still rudimentary. Some estimates run as high as 10 feet of sea level rise by the year 2100 if the ice sheets continue to pump icebergs into the ocean at a faster and faster rate. If all the ice in Greenland drained into the ocean, sea level would rise by 20 feet. Antarctica? 200 feet. That's a danger that Cook couldn't even have imagined.

We rocketed down the coast of Labrador under a vigorous gale, finally passing through the Narrows into the well-protected harbor of St John's on September 11. I bade farewell to David and *Ocean Watch* on September 15. Racing to the highest perch overlooking the sea, I watched them sail over the horizon from atop Signal Hill.

Massive icebergs rose 250 feet above the waterline, with potentially 2,000 feet below. With our 24/7 daylight at an end, icebergs replaced sea ice as the greatest hazard.

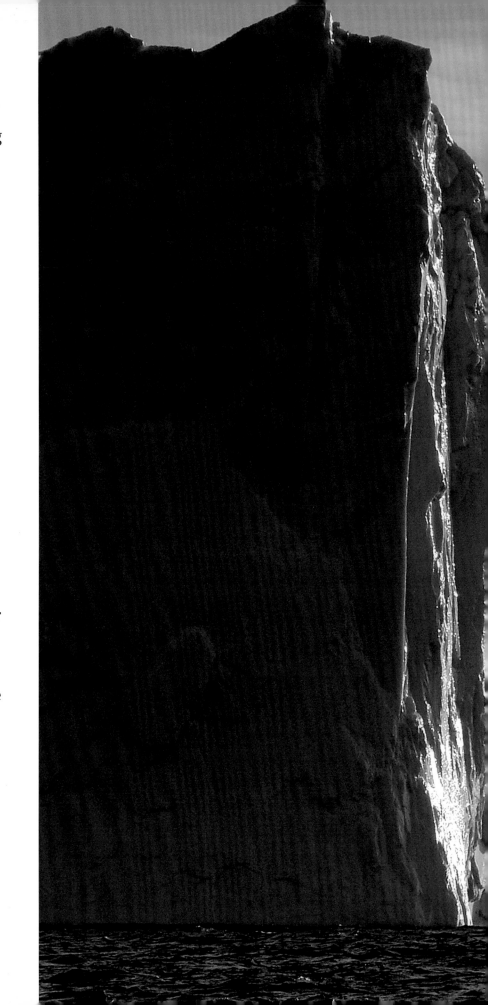

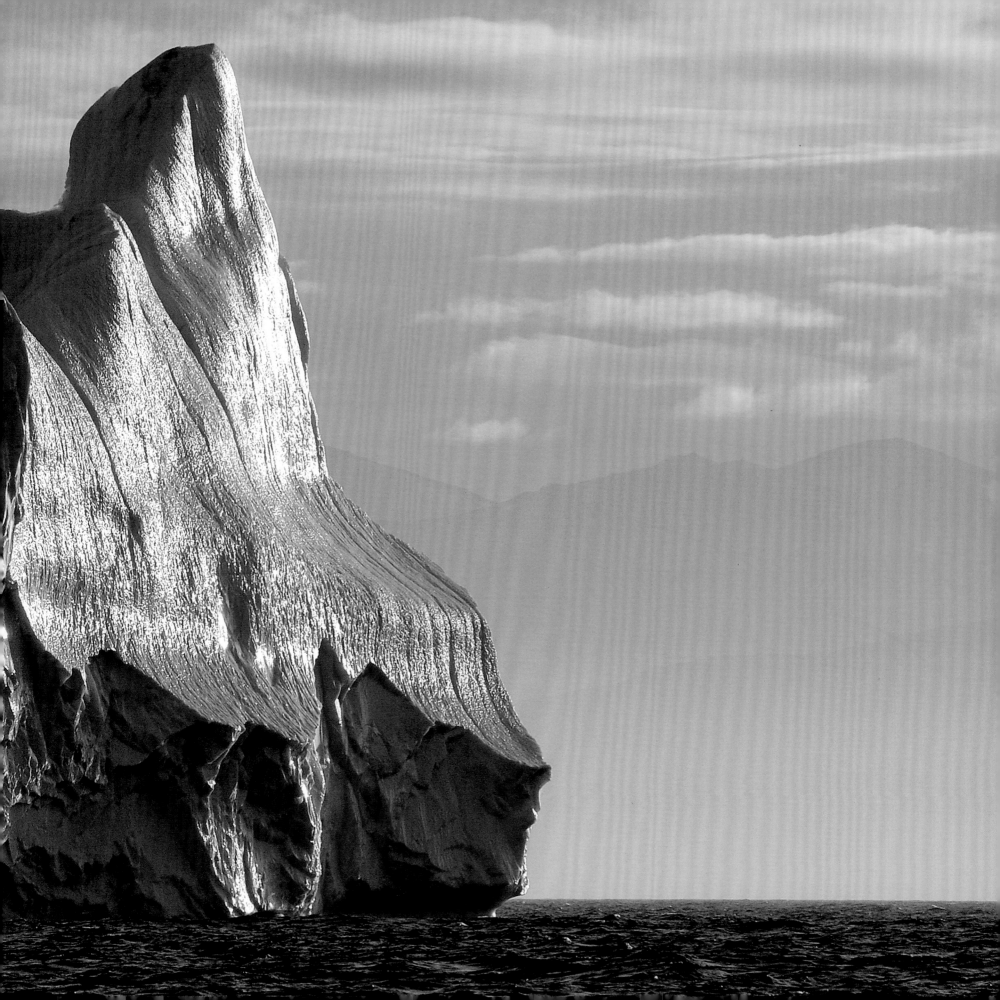

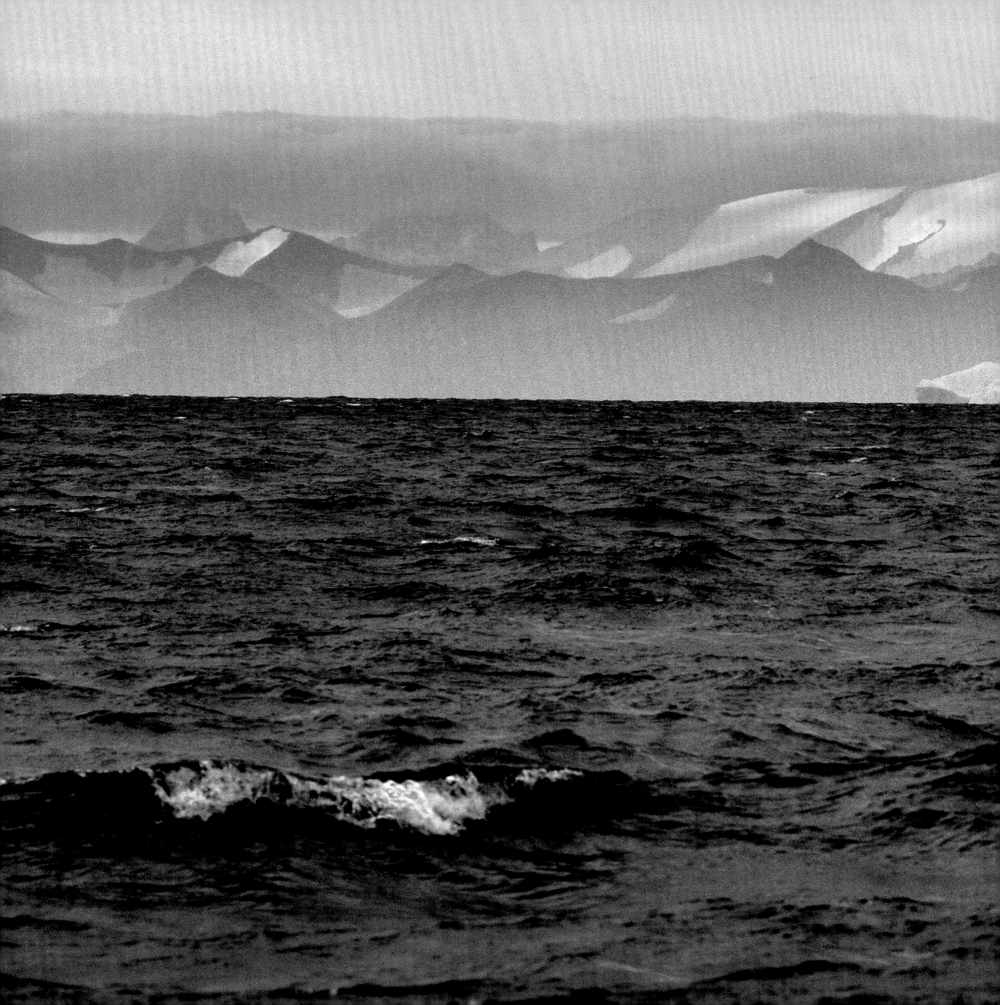

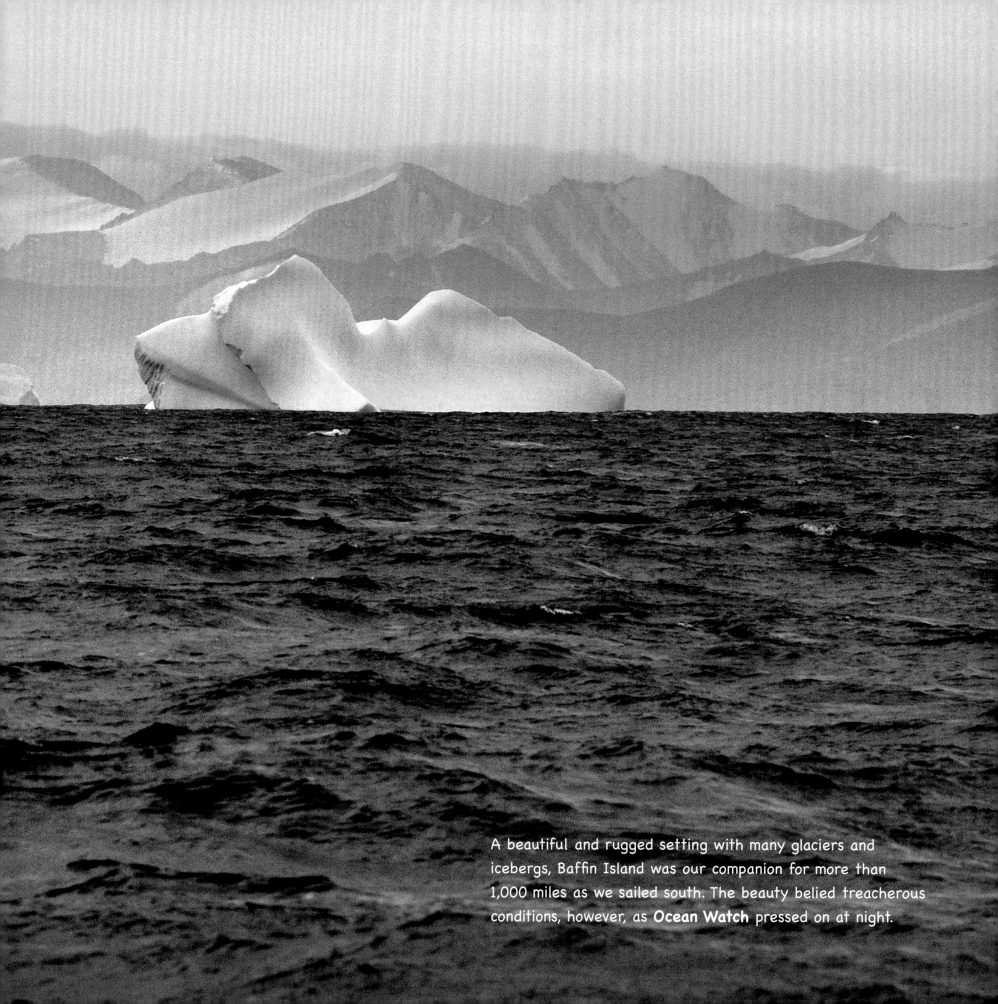

A beautiful and rugged setting with many glaciers and icebergs, Baffin Island was our companion for more than 1,000 miles as we sailed south. The beauty belied treacherous conditions, however, as **Ocean Watch** pressed on at night.

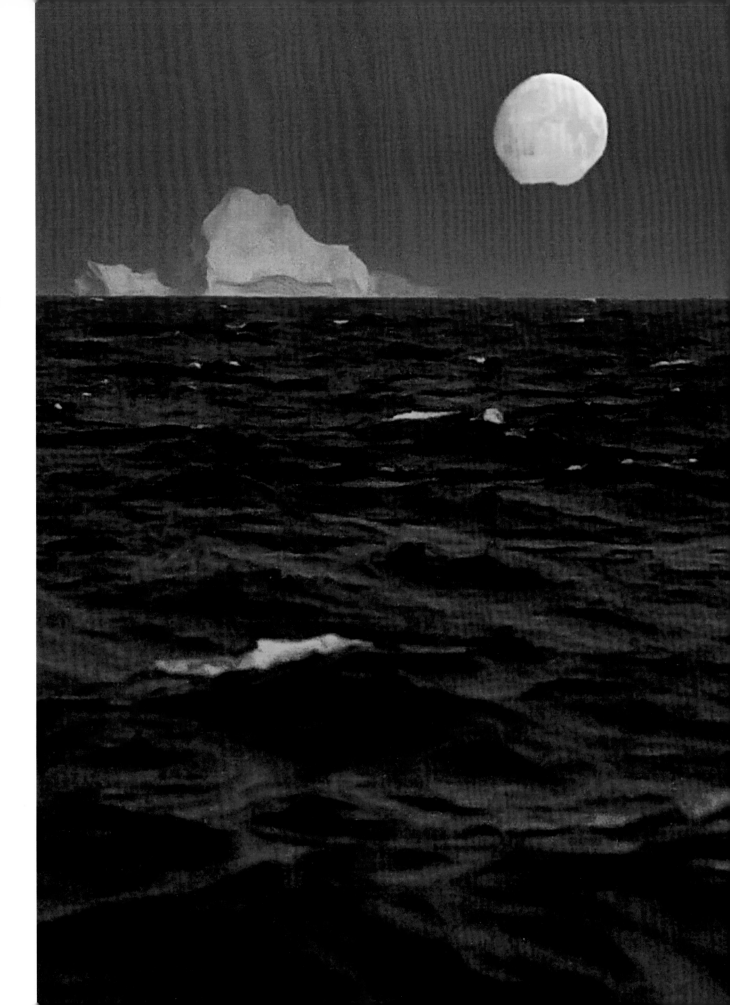

BAFFIN BAY TO DAVIS STRAIT

Our last night in Baffin Bay. Good riddance. What a long day it has been. Squalls, gales, and confused, awful seas. But through it all, I witnessed the northern lights, full moon, Summer Triangle (formed by Altair, Deneb and Vega), and finally Polaris over my shoulder. There are still many icebergs to contend with as hazards, along with big swells and low pressure. I have a pit in my stomach. We are just absolutely clawing our way out of the Arctic. 2100 Hours. **Ocean Watch** crossed the Arctic Circle and officially completed the Northwest Passage. This is my sixth time crossing the Arctic Circle and fourth on the eastern side. We made it! The Around the Americas voyage will continue to completion, and I am the first American sailor in history to complete the Northwest Passage in both directions.

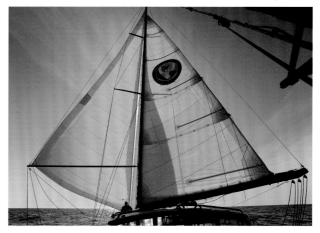

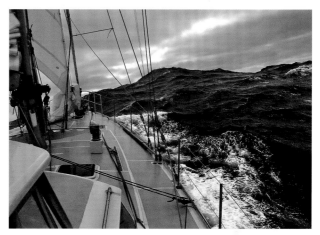

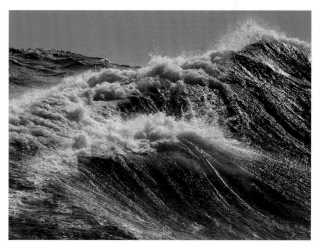

A full moon lifted our spirits, providing spectacular, and rare, views of nature. Above, from top: With a wing-and-wing sail set, *Ocean Watch* gained precious southward miles. The winds and seas picked up as the crew sailed into Davis Strait and the Labrador Sea.

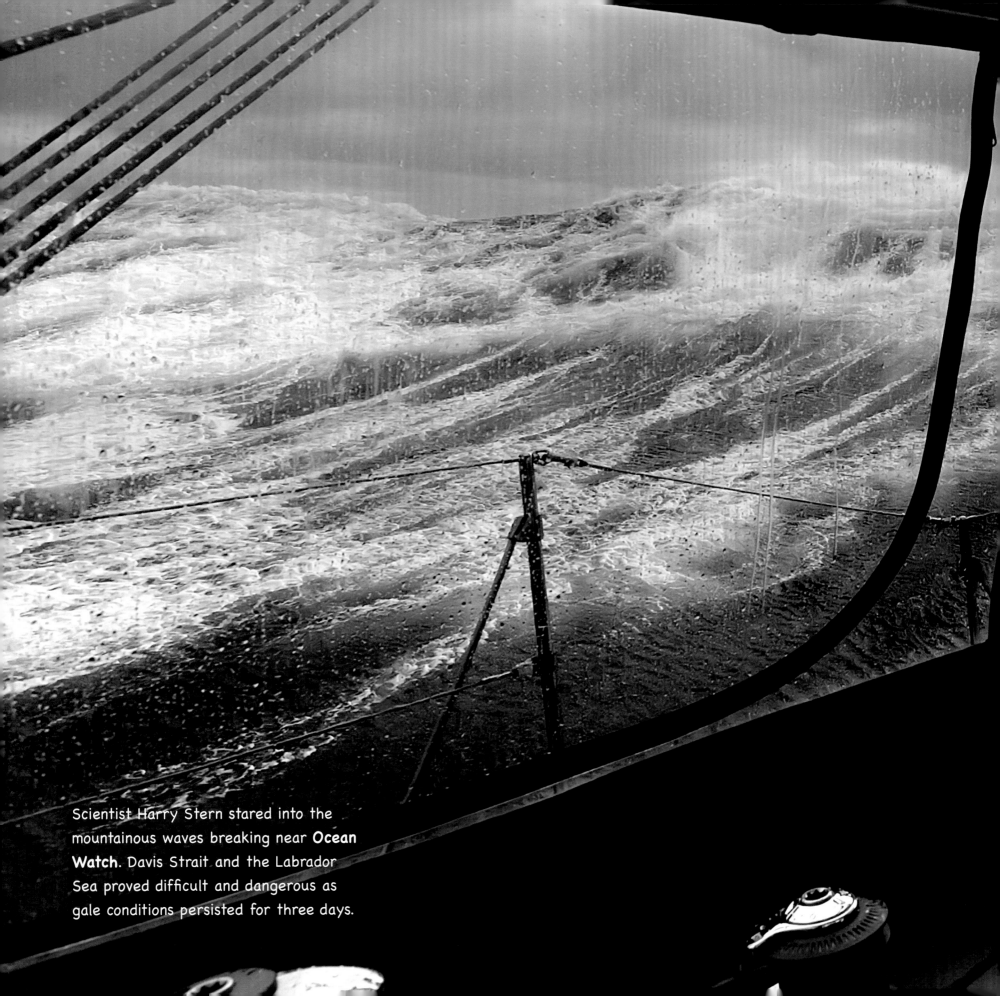

Scientist Harry Stern stared into the mountainous waves breaking near **Ocean Watch**. Davis Strait and the Labrador Sea proved difficult and dangerous as gale conditions persisted for three days.

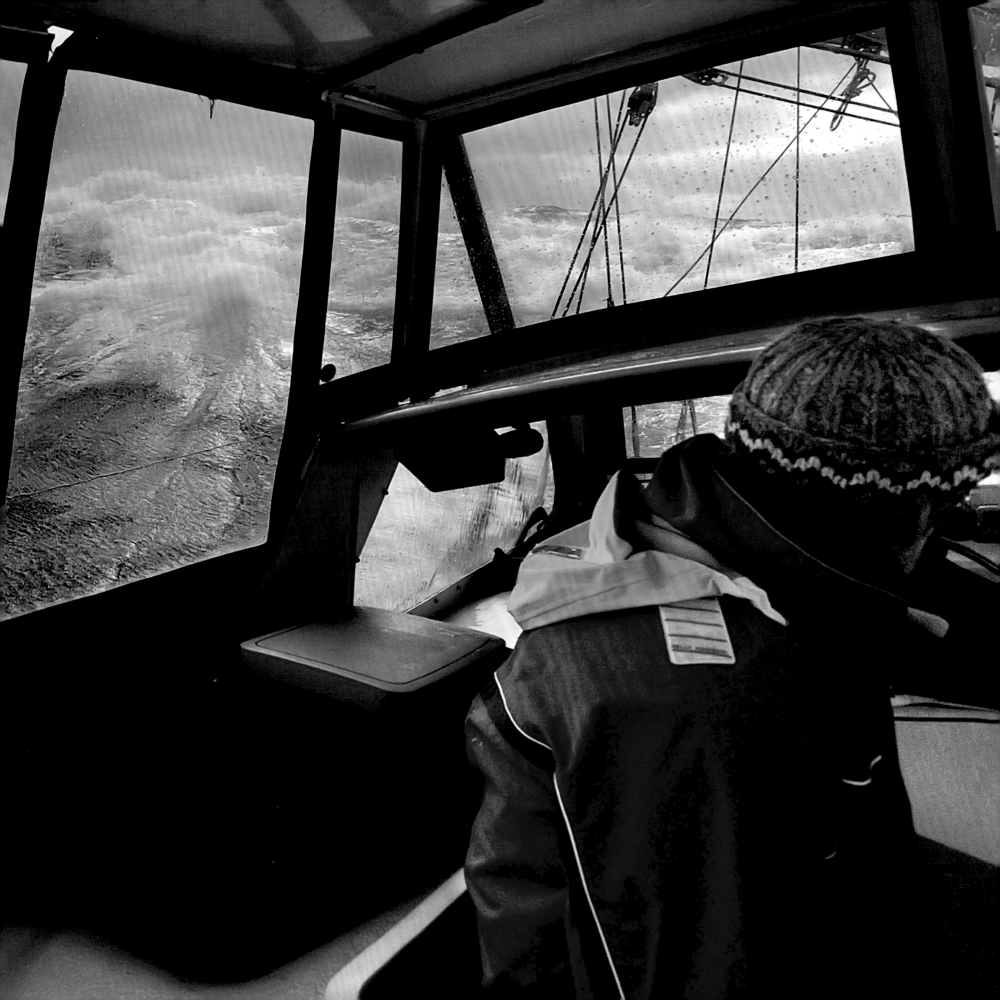

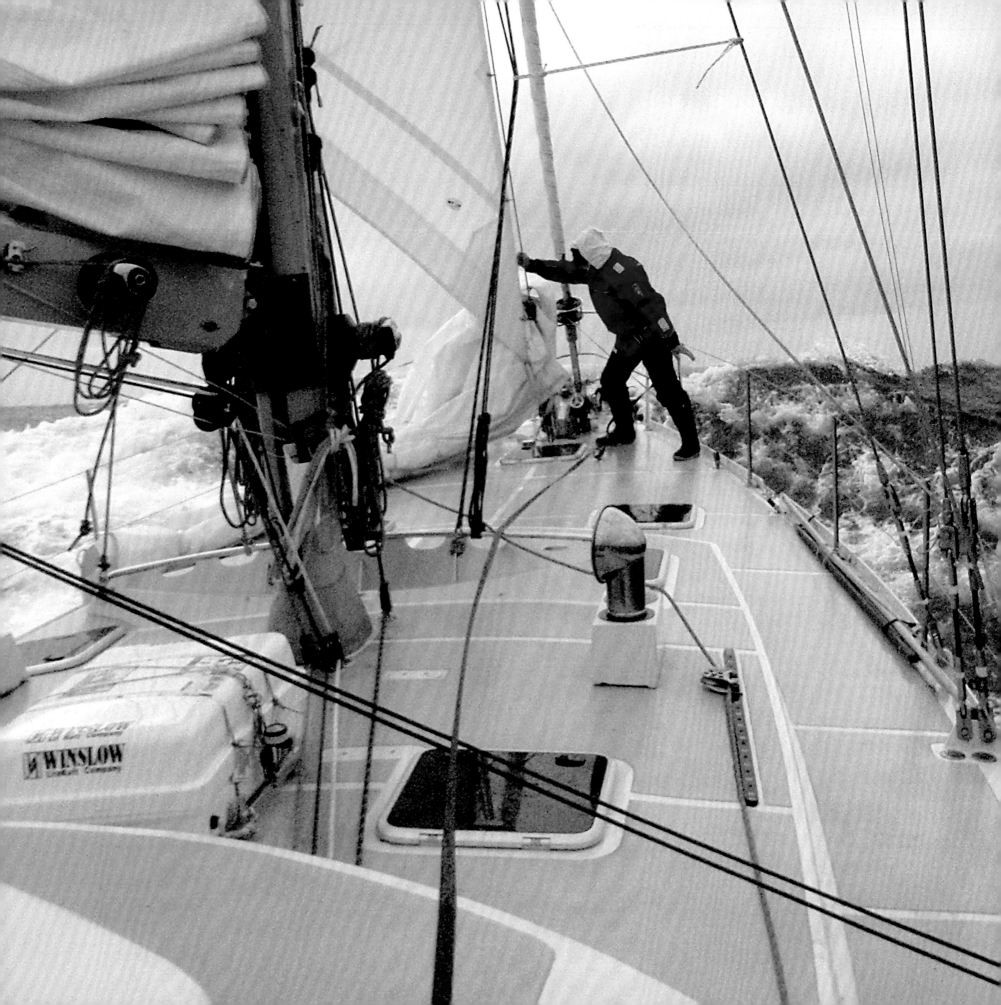

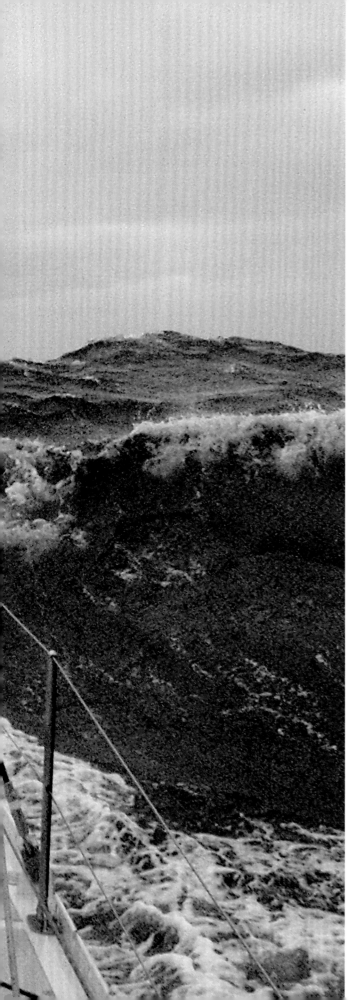

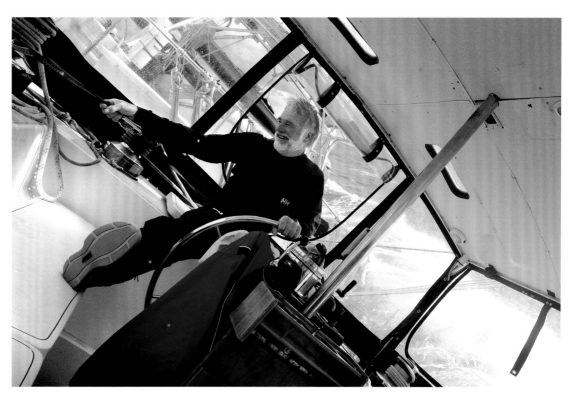

With a following gale and seas, Captain Mark Schrader, left, was tethered in on the bow as he secured a headsail. Above: Schrader manned the helm in what Herb McCormick described as "sporty" conditions for the crew of *Ocean Watch*. We continued sailing south to St. John's, Newfoundland.

JOURNAL • SEPTEMBER 8 • 2009

LABRADOR SEA

Gale! 45 knots and 20-foot seas. Extremely nasty on deck, but beautiful images. Finally off watch. Into bunk and exhausted. **Ocean Watch** is performing well through it all. Amazing photographs from earlier. Big and powerful mountains of sea running with us. Herb McCormick was describing them as "liquid Himalayas," and I agree. Water was dumping into the cockpit. Dangerous sail changes. Must try to get sleep. It's a lonely place out here in the Labrador Sea.

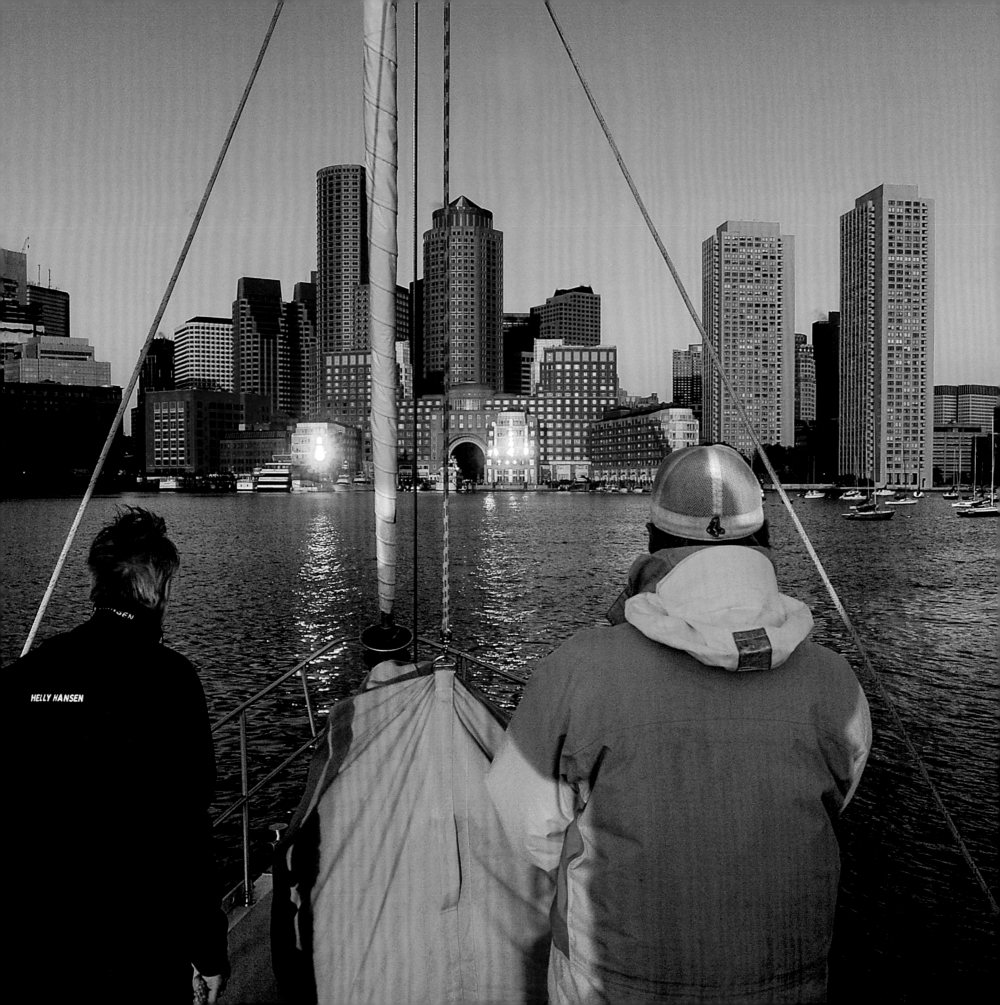

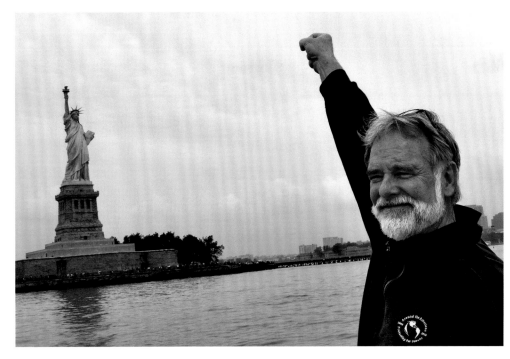

After the Arctic, the gleaming city of Boston was a welcome stop. Above: We resumed our educational efforts along the U.S. Atlantic seaboard with stops in New York City, sailing against the Gulf Stream current to Charleston, S.C., and eventually into Miami.

BOSTON • MASSACHUSETTS

Boston looked like a shimmering city of gold on our approach, but it hovers right at sea level. Having just witnessed the rapidly warming and melting North, I cannot help but wonder about all our coastal cities and the impact of sea-level rise. But for now, we are back in the USA. It was not easy. Gales again laying us over pretty good. Built to 40 knots in the afternoon. Things finally settled down, but now we are in shipping lanes again, big-city stuff. We have another gale in our weather window. It will be good to get in and stop.

Ocean Watch Captain Mark Schrader and I addressed students visiting the Intrepid Sea, Air, and Space Museum in New York City. The museum's Power of One program aims to inspire young people with personal stories of discovery. We told them about our young lives and how we became involved in ocean and sea advocacy.

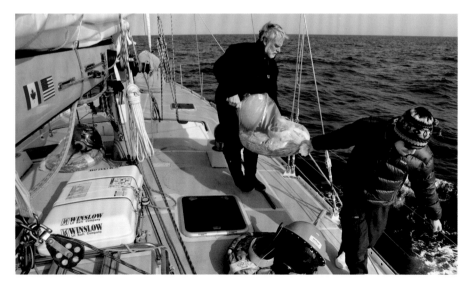

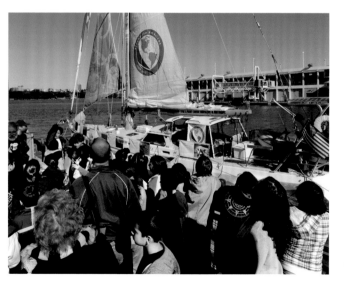

At each port, *Ocean Watch* members discussed the Around the Americas mission, such as our part in an international program using buoys in the Arctic to monitor sea ice coverage and forecast the weather. We also welcomed visitors aboard the vessel and brought in others like sailor Harry Horgan, of Miami, who discussed disability and defying limits.

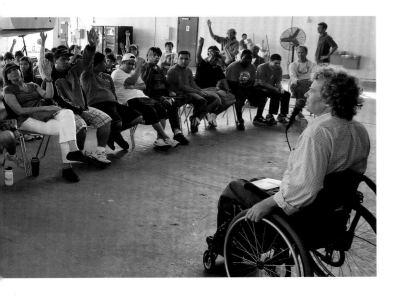

BRINGING THE OCEANS' LESSONS TO LAND

As *Ocean Watch* returned to the U.S. East Coast, her crew was looking forward to a break from sailing and an opportunity to work with Around the Americas educational teams in each of four major ports.

Armed with new stories, science and information about the oceans, ice pack, wildlife, and people of the Arctic North, we were especially eager to share our tales with children, because basic oceanography is rarely included in K-8 schools' science curriculum. Seattle's Pacific Science Center developed our curriculum so that the lessons, aimed at grades 6 through 8, could easily be adapted for younger children. Exercises on atmospheric aerosols, underwater sound, and sea ice were directly related to research projects on board *Ocean Watch*.

A scientist at Hollings Marine Laboratory in Charleston, S.C., explained how the world's increasingly distressed coral reef systems are indicators of how human activity is affecting the health of coastal environments.

This educational outreach was as big a part of our Around the Americas mission as the physical exploration. Many of the fundamental properties of the ocean are changing: Seawater pH is decreasing, endangering coral reefs; warming waters are causing sea levels to rise, imperiling low-lying areas; and Arctic sea ice is shrinking, threatening local wildlife. Changes in the marine environment affect not only inhabitants of the sea, but also have great ramifications for both coastal communities and inland populations. All of these changes are heavily influenced by human activity. Consequently, individuals on land can play an important role in protecting and improving the health of our oceans.

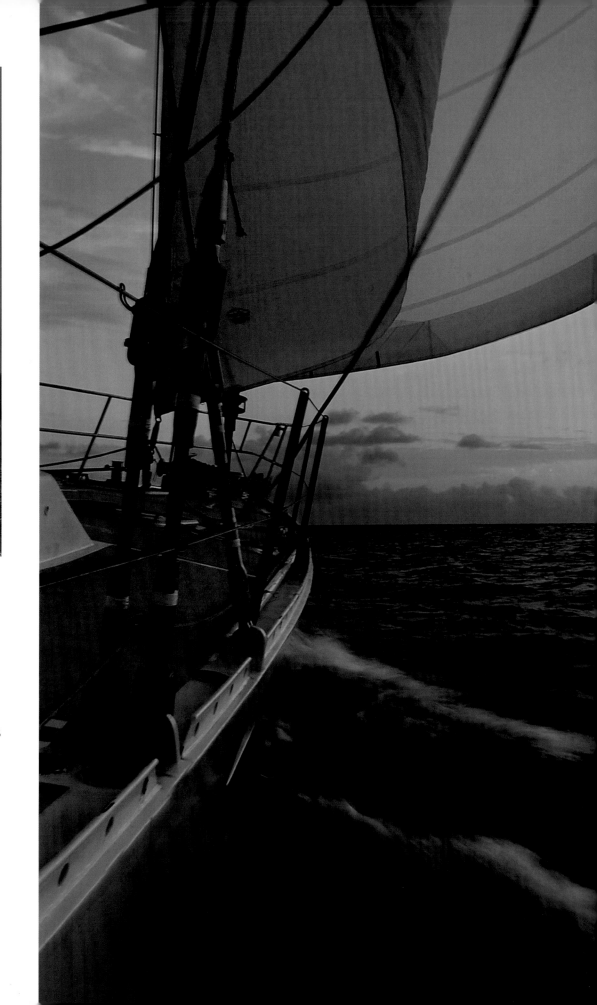

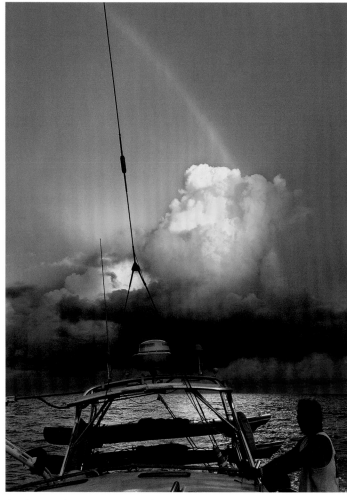

As the crew entered the tropics, the evening sky came alive with towering cumulous clouds and relentless heat. At right: From Miami, *Ocean Watch* sailed southeast against prevailing currents and winds, traveling some 3,000 miles to the Horn of Brazil.

CARIBBEAN SEA

Magical, calm evening with single star reflections on the sea. A half-moon is rising from behind lightning-singed clouds. It's the kind of evening you would completely disregard at home while busy doing mundane tasks. Here there is nothing to interfere with the experience of the natural elements. This is the beauty of passage-making. It is a very simple existence, where subtlety is a powerful and renewed force of nature.

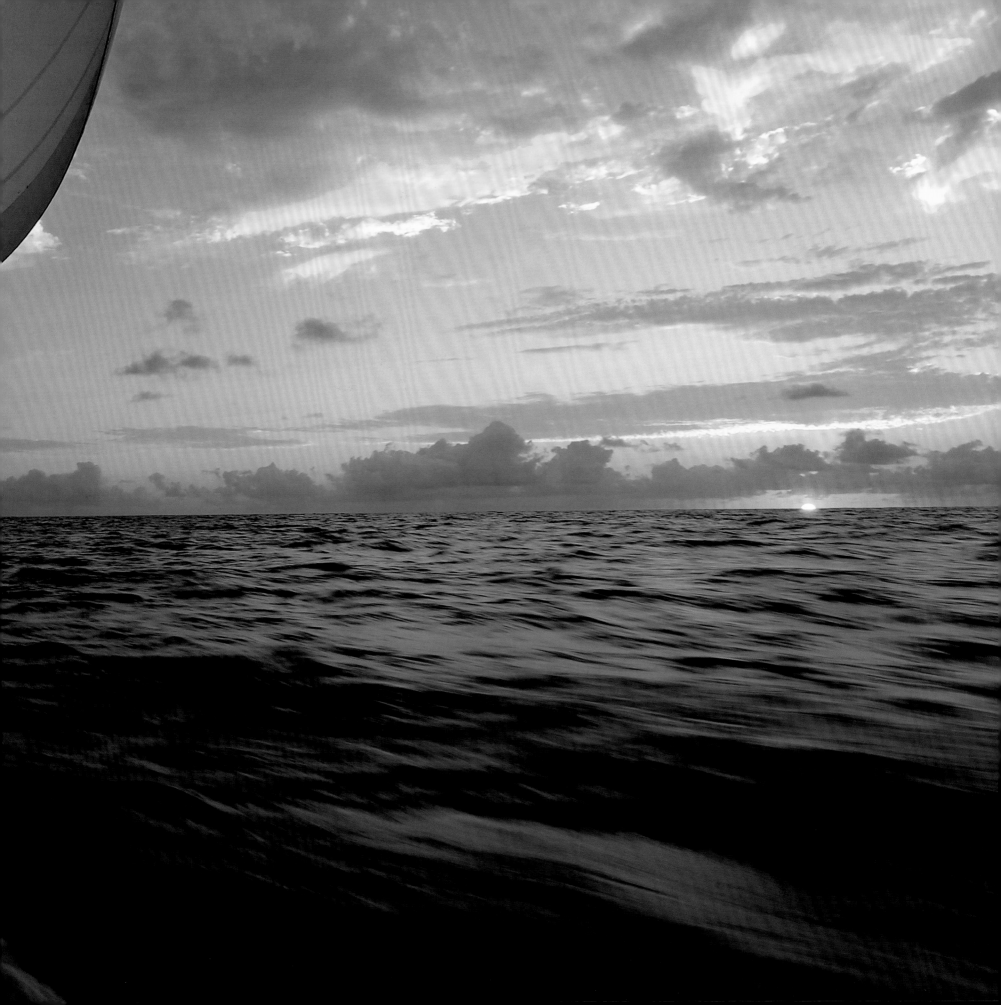

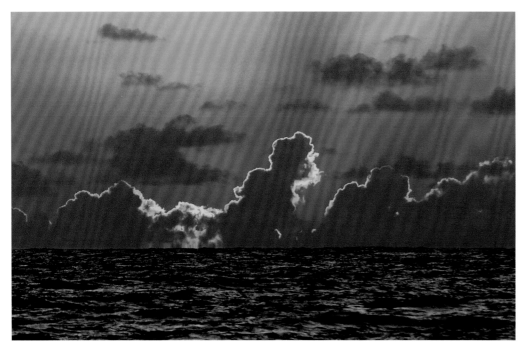

Oceanographer and Texas blues aficionado Michael Reynolds, right, was a tireless documentarian during our voyage. He explained how towering cumulus clouds form near the Equator, all fueled by the sun.

SAILING TO THE EQUATOR

Michael Reynolds, a physical oceanographer aboard **Ocean Watch**, was particularly excited to sail through the Intertropical Convergence Zone (ITCZ) today. Reynolds explained that this fascinating area encircling the Earth along the Equator is where winds originating in the Northern and Southern Hemispheres come together. He explained: "This is fun for me: We are sailing through a very important section of the Earth's engine that runs the rest of the atmosphere. My colleagues like to say the Equator is the driving force between all atmospheric circulation, weather, and climate that we know. The sole purpose of the Equator is to gather all the heat, and redistribute this heat to the poles."

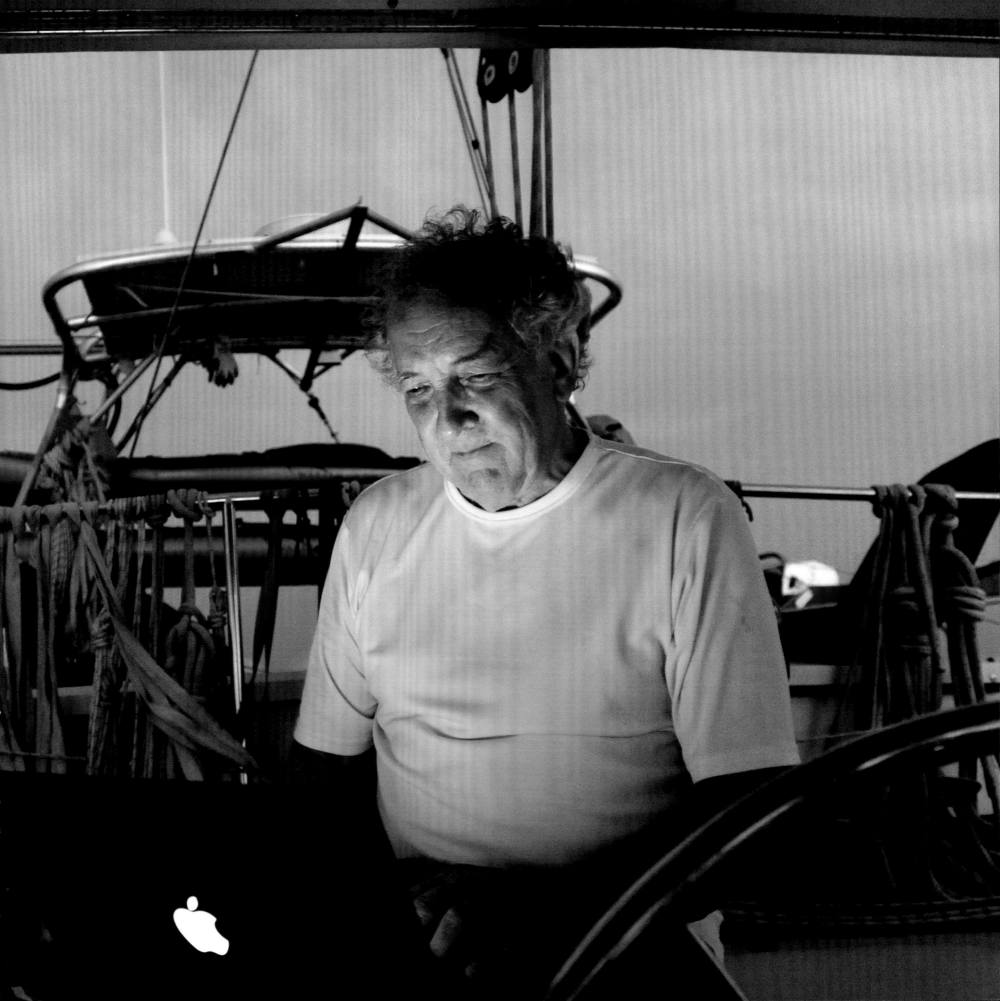

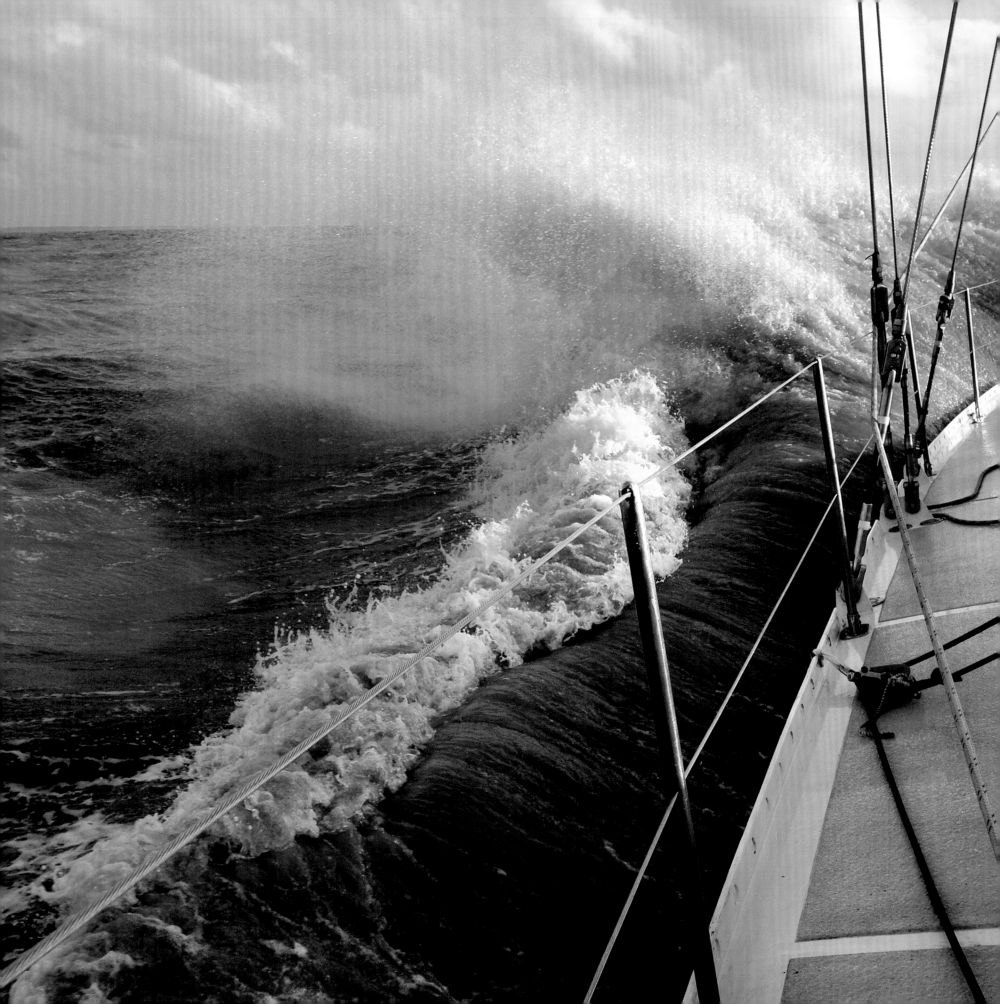

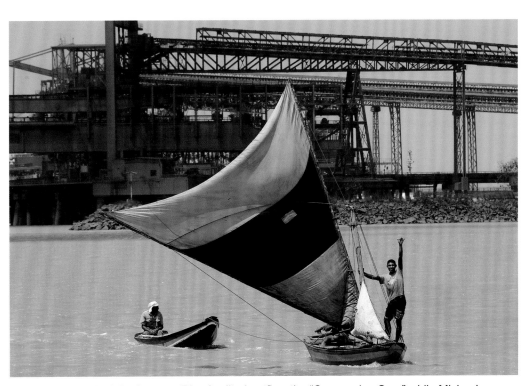

As sailors, we called the Amazon River's silted outflow the "Cappuccino Sea," while Michael Reynolds called it a nutrient-rich and important "carbon sink." Above: We saw Brazilians sailing small homemade boats far out at sea and in tough working ports along the northern coast.

FRENCH GUIANA TO NORTHERN BRAZIL

Ocean Watch is now sailing through the outflow of the Amazon River against a 3-knot current. Wondering if we will ever make it to Rio. Got an email today stating that the early Spanish explorers saw no potential along this coast because it was too hot for civilization. We concur. So we motor-sail into the heat and the unknown. If we envisioned Cape Horn to be one of the greatest landmarks of the entire voyage, then the Horn of Brazil has been underestimated. We are in a battle with adverse conditions, sailing a 3,000-mile passage from Miami. It would have been easier to sail to Africa and back to Rio, utilizing prevailing winds and currents. But we are coastal sailing on a serious schedule and now two weeks behind.

More than 5 billion people, or 70 percent of the Earth's population, live within 100 miles of the ocean, as illustrated in Mar del Plata, Argentina, at right, and above in Valparaiso, Chile. They will be the first affected by rising seas.

SOUTH ATLANTIC OCEAN

Happy Birthdays, Happy Holidays, Merry Christmas, Happy New Year. They are all behind us, and we are sailing in the South Atlantic en route to the Falkland Islands. It was fascinating to visit some remote cities and ports like Cayenne in French Guiana and São Luis and Natal in northeast Brazil. The crew navigated through steamy, yellow fever country; silted-in harbors; clearing French, EU, and Brazilian visas; pirates; and the rusting industrial port of São Luis. **Ocean Watch** finally rounded the Brazilian Horn and sailed south and down the east coast of South America with planned stops in Rio de Janeiro, Brazil; Punta del Este, Uruguay; and Mar del Plata, Argentina. With shorter than planned visits in each city, we are back on schedule, recharged and happy to be back at sea.

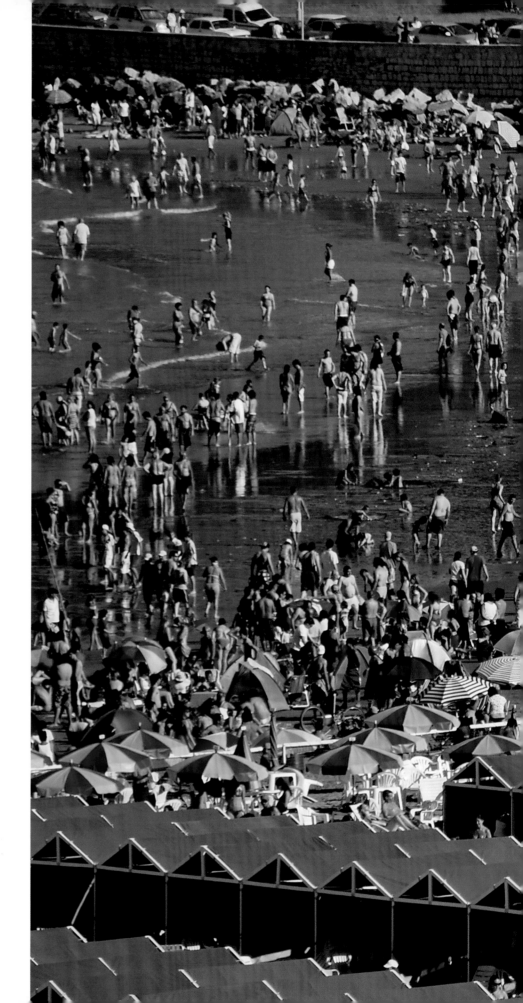

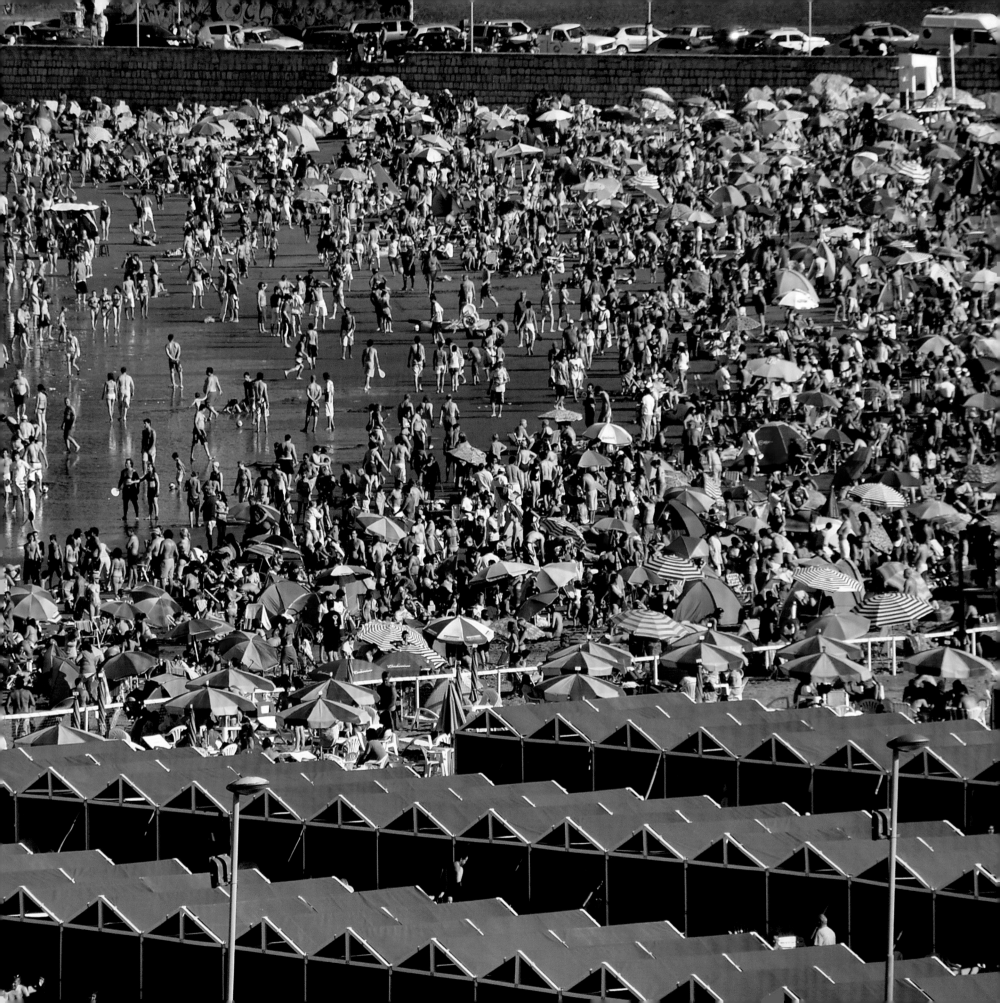

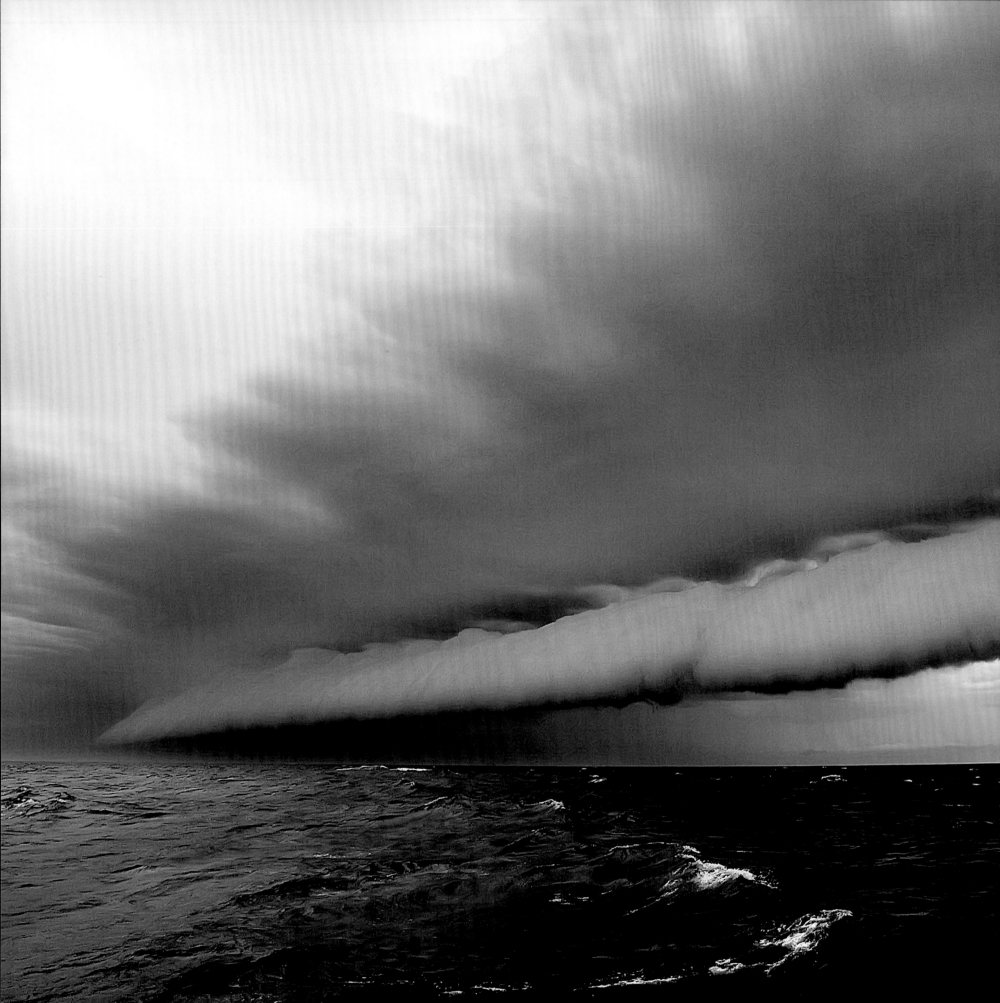

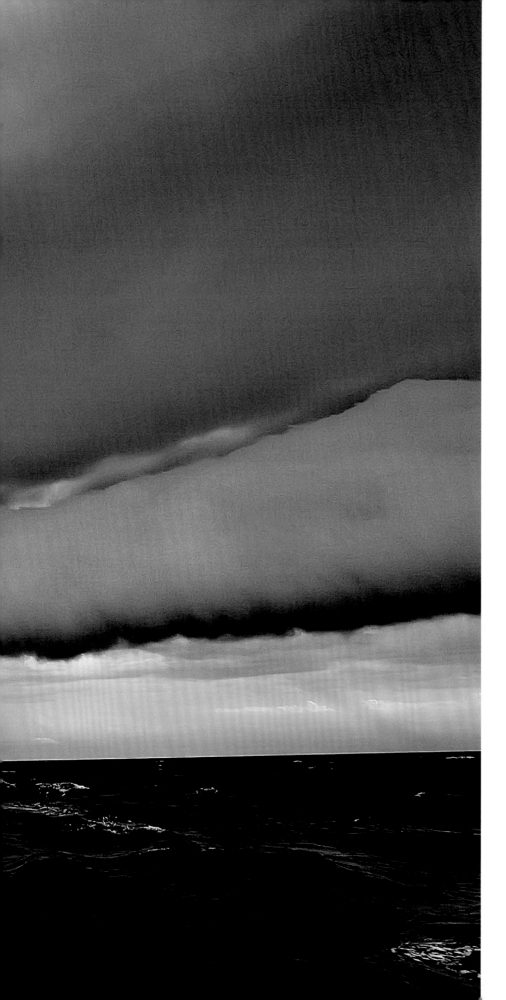

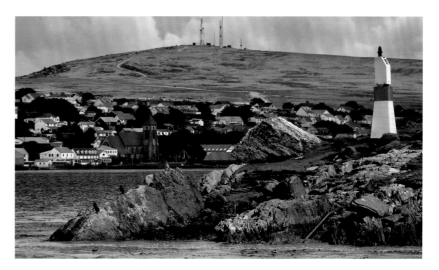

An intimidating weather front signaled an abrupt change in weather and ushered us into the cold South Atlantic. Above: Stanley is the capital of the Falkland Islands, 300 miles east of the Beagle Channel and Cape Horn.

SOUTH ATLANTIC OCEAN TO THE FALKLAND ISLANDS

Of the things we really enjoy witnessing, the change of weather has to be high on the list. Near the Falkland Islands, a great tubular wall cloud rolled quickly toward us, and we thought it was the end of the world. This was our welcome into the "Roaring Forties," a windy band of westerlies experienced between 40 and 50 degrees south latitude, where we would sail for the next two months. We are all excited to arrive in the Falkland Islands. They contain very diverse populations of flora and fauna and are sparsely populated with just over 3,000 people. There are numerous young scientists stationed here, doing species counts and surveys. Some have said they feel like Darwin because this scale of sampling has never been undertaken before and they are discovering new species.

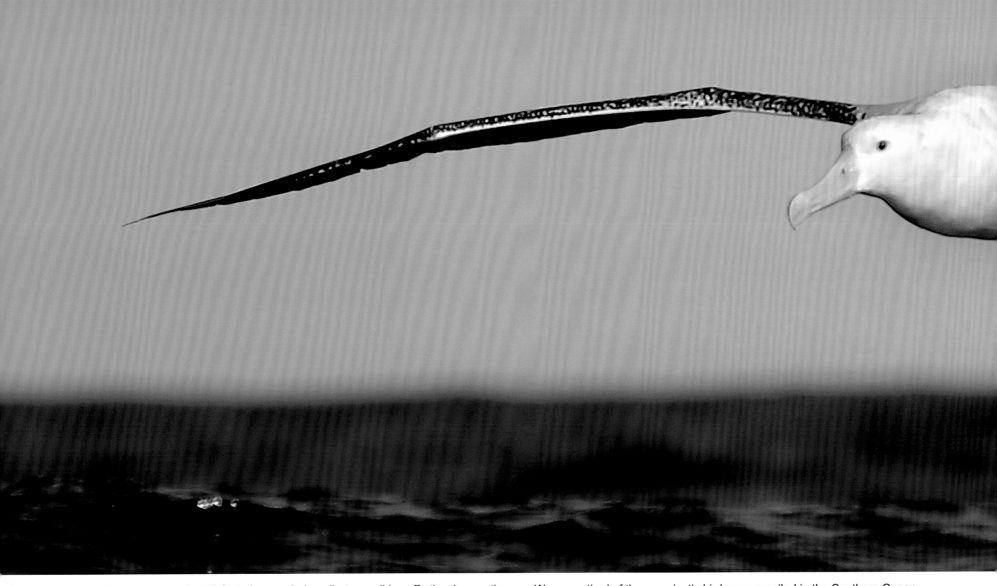

With a wingspan averaging 10 feet, the wandering albatross glides effortlessly over the sea. We never tired of these majestic birds as we sailed in the Southern Ocean.

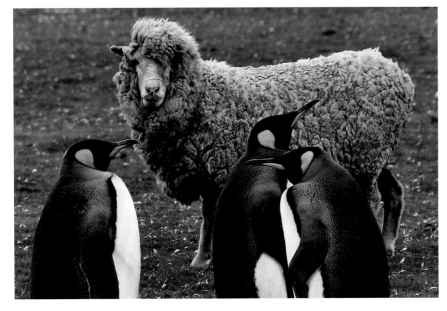

King penguins share their Falkland Island colony with grazing sheep.

Magellanic penguins are only found in the Falkland Islands, Argentina and Chile.

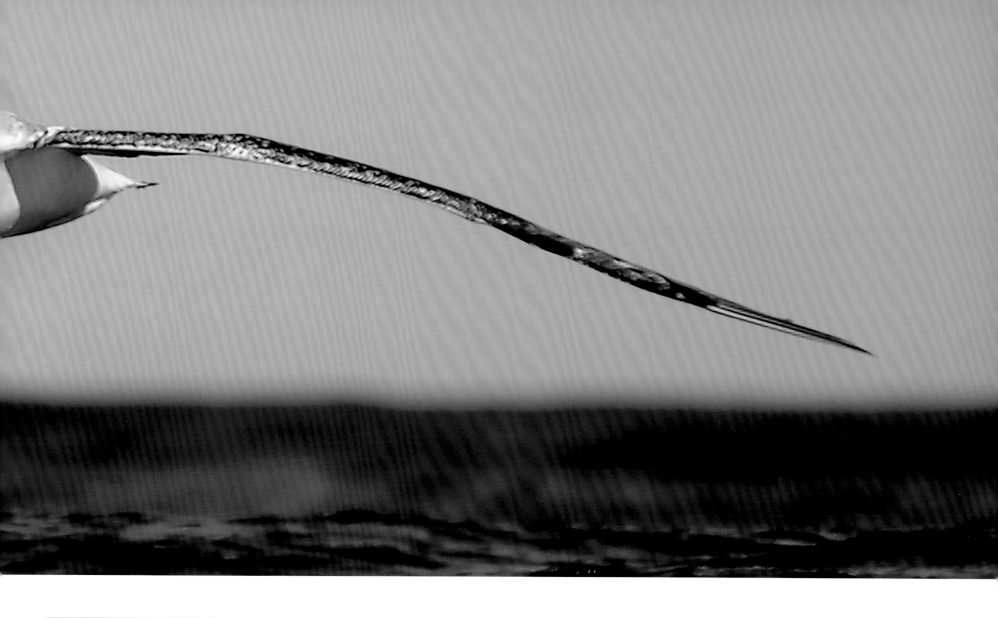

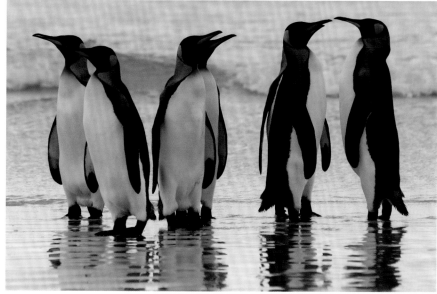

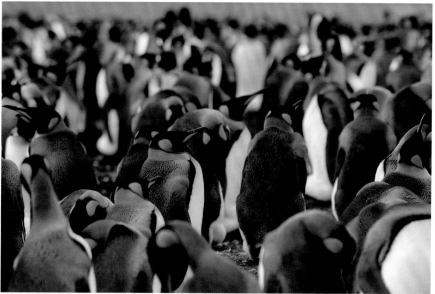

Since the 18th century, King penguins have also been called Patagonian penguins.

The northernmost King penguin colony is at Volunteer Point on the Falklands.

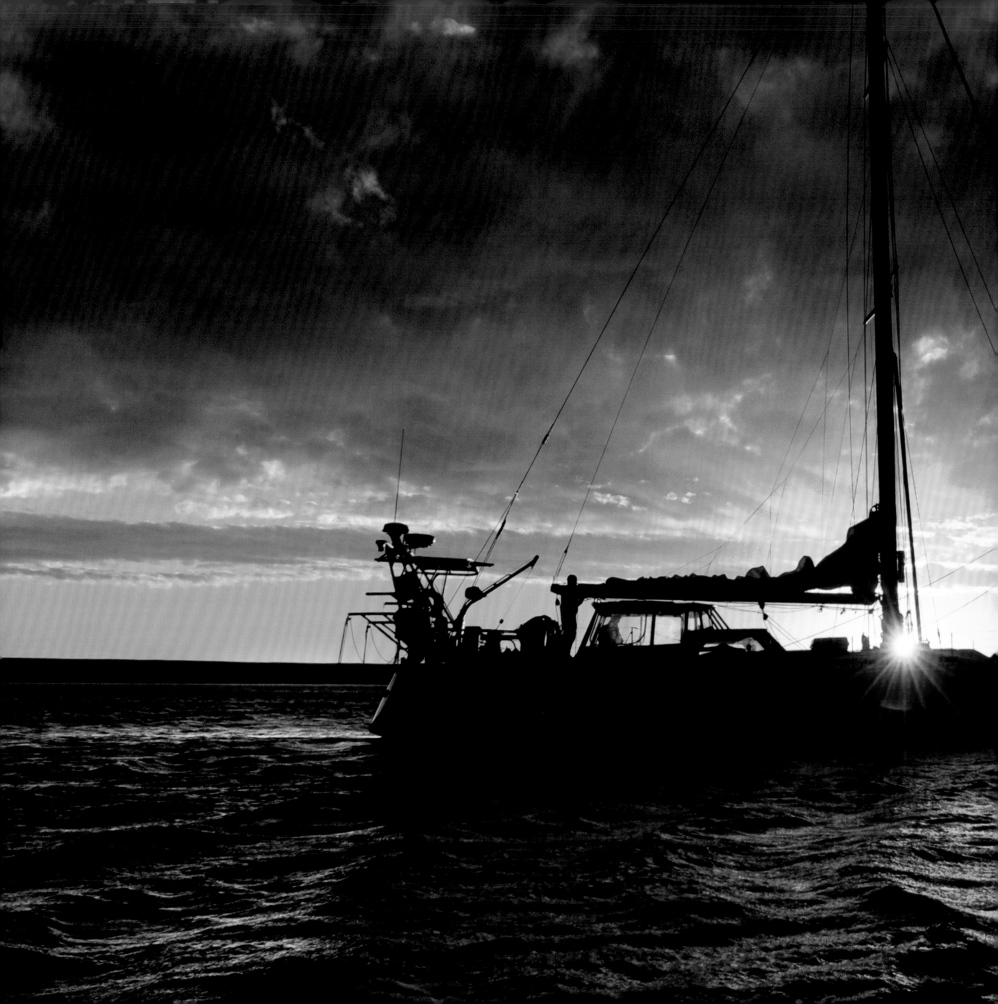

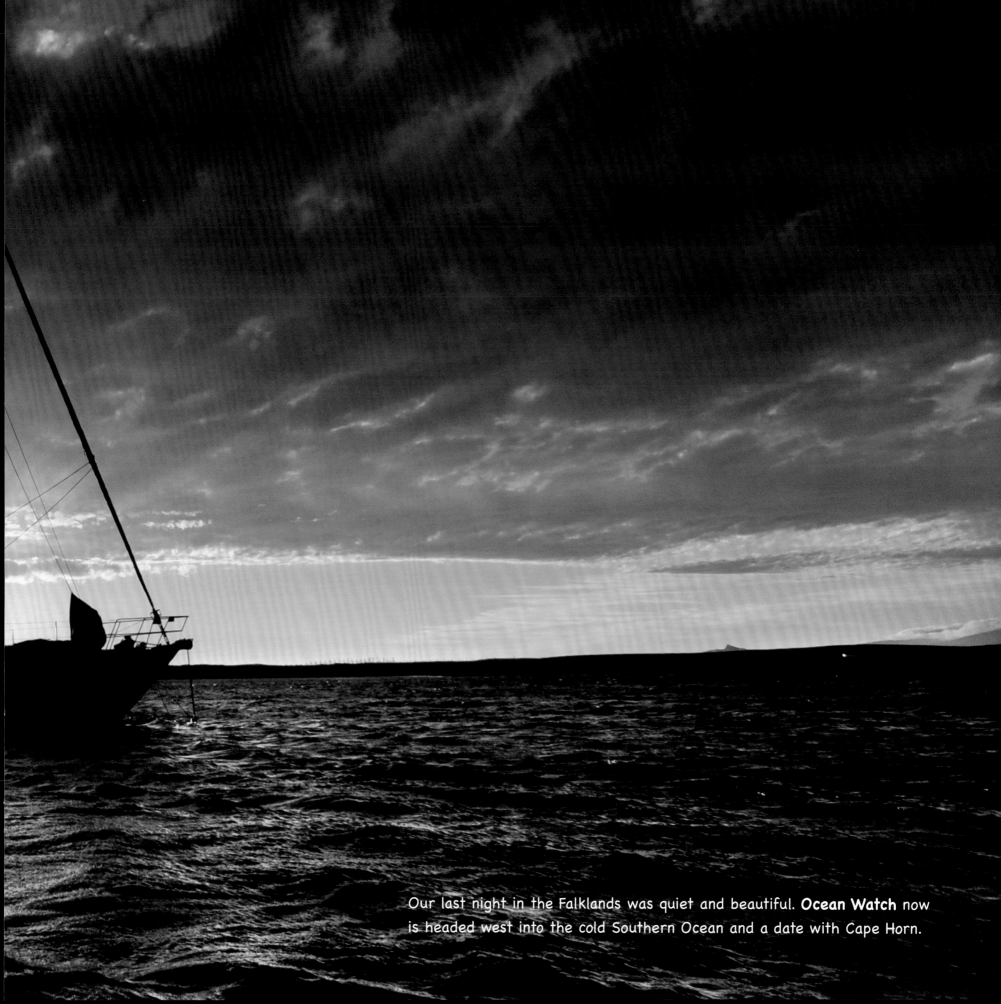

Our last night in the Falklands was quiet and beautiful. **Ocean Watch** now
is headed west into the cold Southern Ocean and a date with Cape Horn.

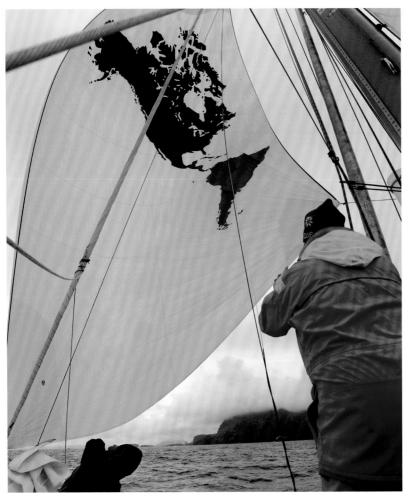

Drawing on a rare easterly breeze, *Ocean Watch* rounded Cape Horn from the east. Right: We had sailed 90 miles south from Puerto Williams, Chile, to a small bay within 10 miles of Cape Horn. The lighthouse keeper reported 105 knots of wind, but we positioned ourselves for success.

JOURNAL • JANUARY 24 • 2010

CAPE HORN · SOUTH AMERICA

We looked for a weather window for over a week. Finally, an easterly airflow was forecast. Captain Mark Schrader decided to go for it. **Ocean Watch** sailed very fast through the islands to the back side of Cape Horn and into the open sea. ... The crew raised the big spinnaker with the two continents flying, literally, over the end of the southern continent. Very emotional moment. **Ocean Watch** had crossed her most southern point and a huge landmark. Time to go north, go home.

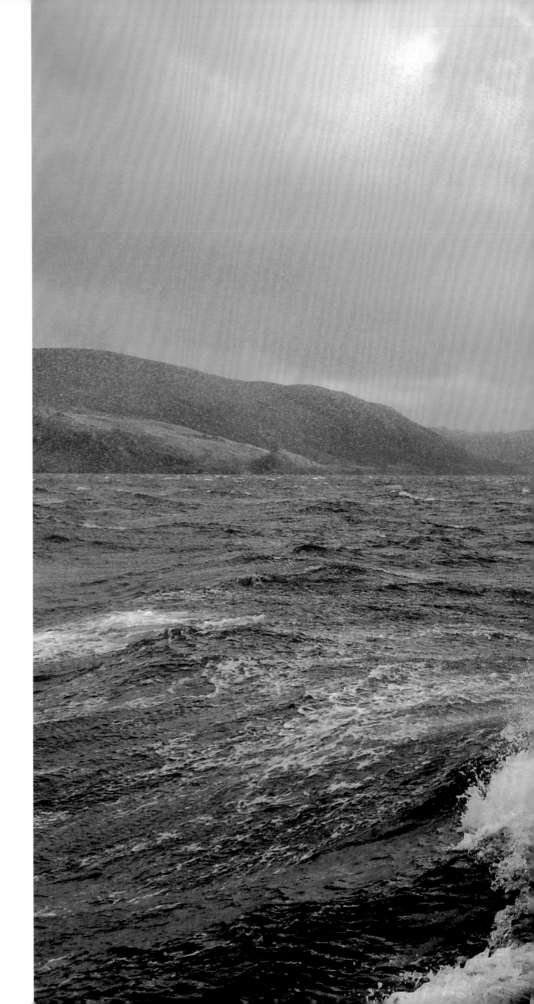

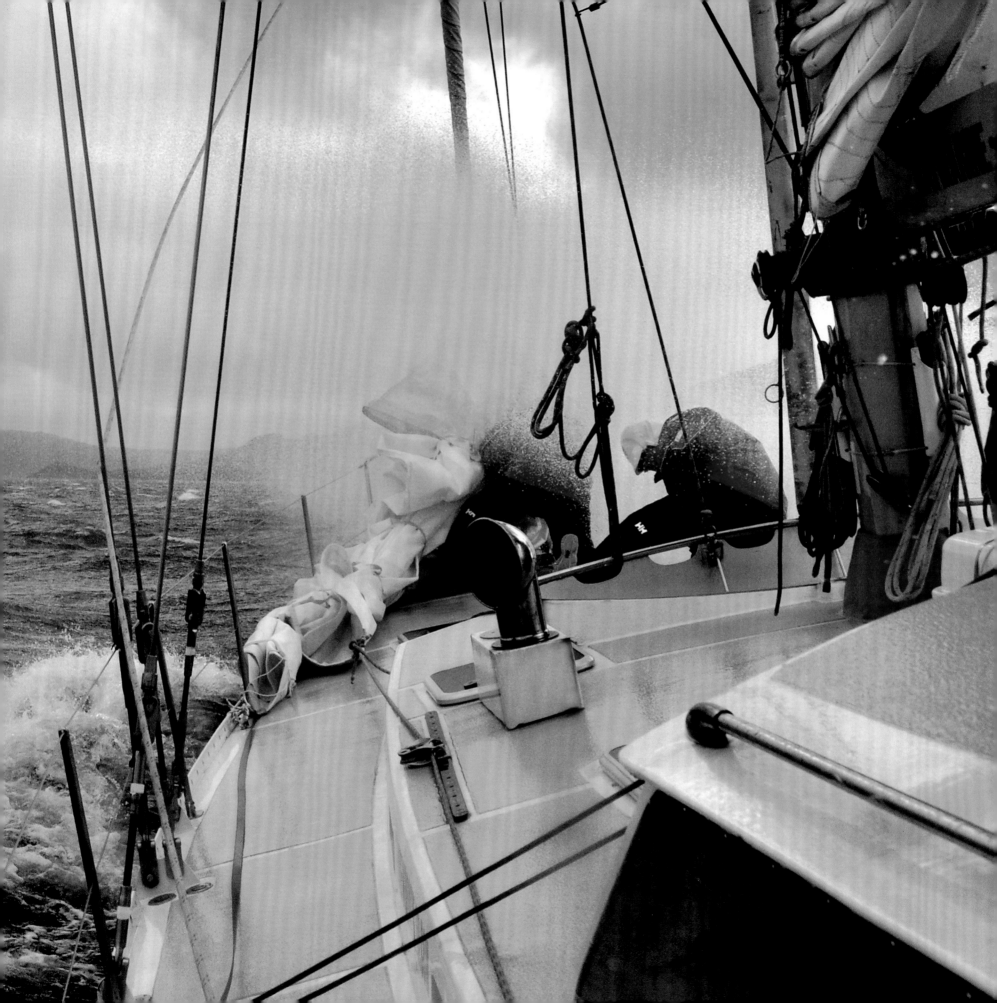

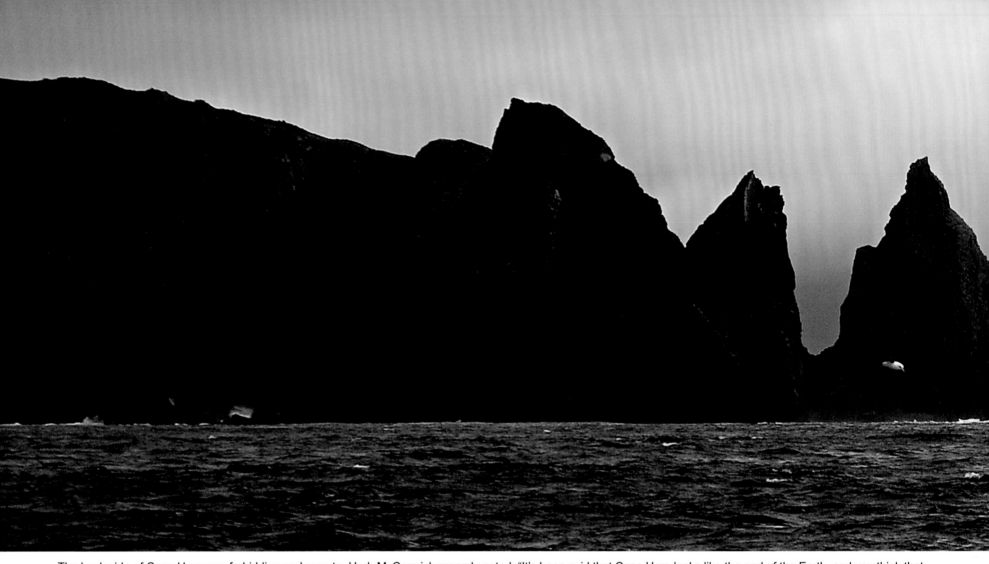

The back side of Cape Horn was forbidding and remote. Herb McCormick properly noted: "It's been said that Cape Horn looks like the end of the Earth, and you think that seems a bit trite. But, in fact, it really did look like the absolute, final, nonnegotiable end of the Earth."

Intense weather systems roamed the Southern Ocean, creating short weather windows for safe travel between anchorages.

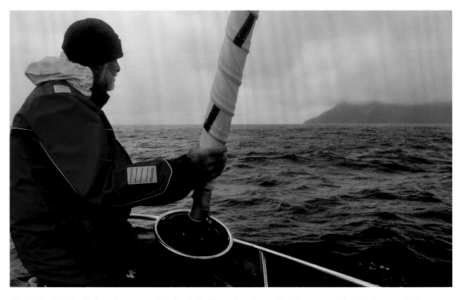

Captain Mark Schrader was the first U.S. sailor to solo-circumnavigate the world's great Southern Capes. He took a moment to reflect near Cape Horn.

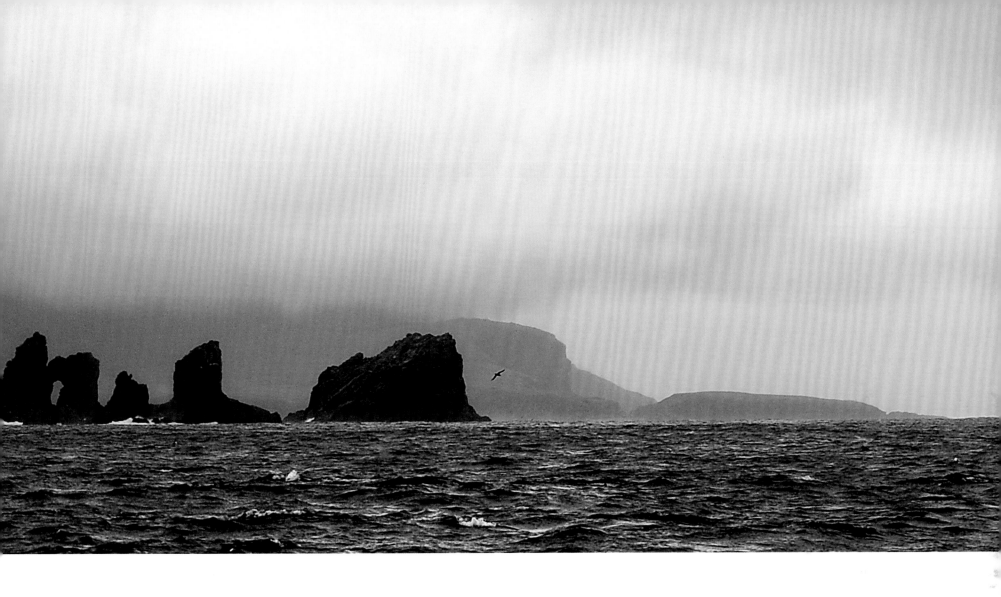

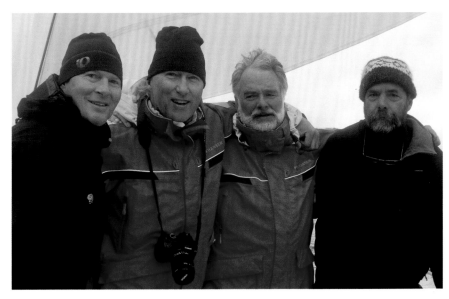

The core crew of *Ocean Watch* as we rounded Cape Horn. From left: me, Herb McCormick, Captain Mark Schrader and Dave Logan.

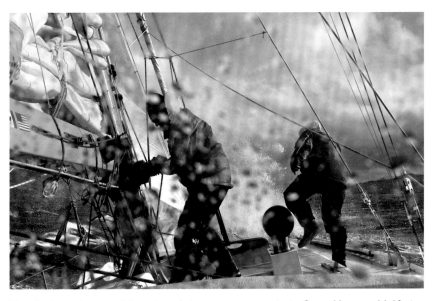

Foredeck work was wild, wet, and dangerous en route to Cape Horn amid 40- to 60-knot winds that occasionally gusted past 100, or about 115 miles per hour.

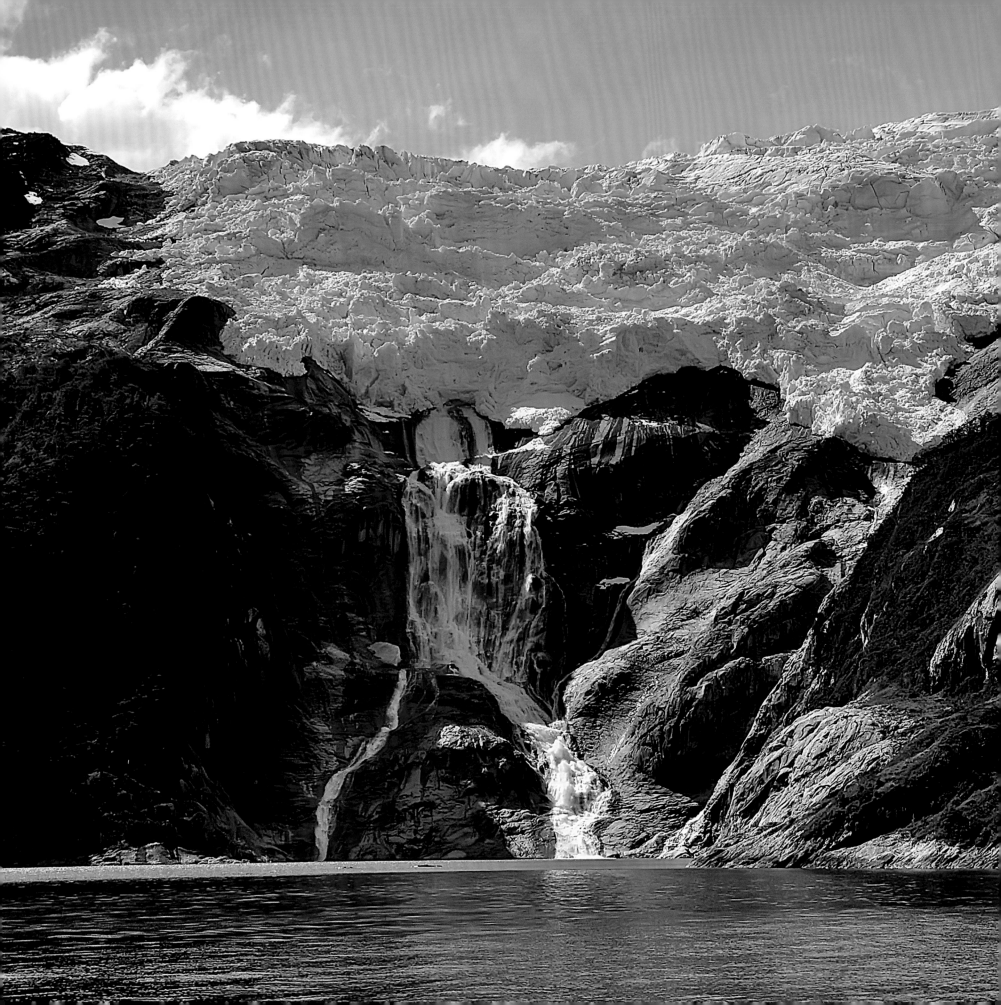

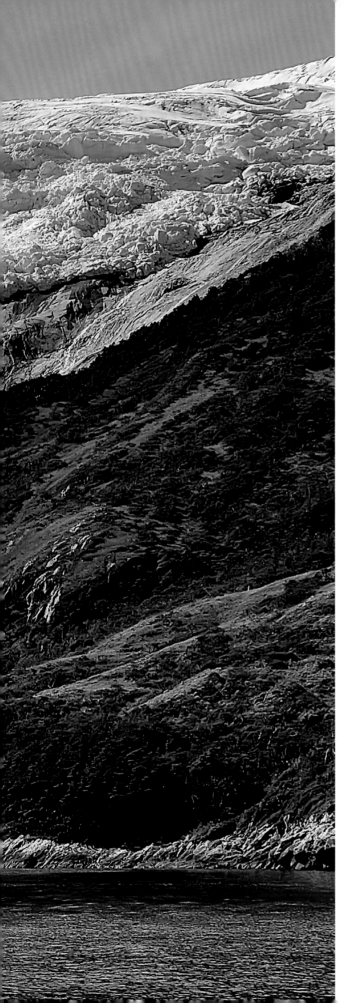

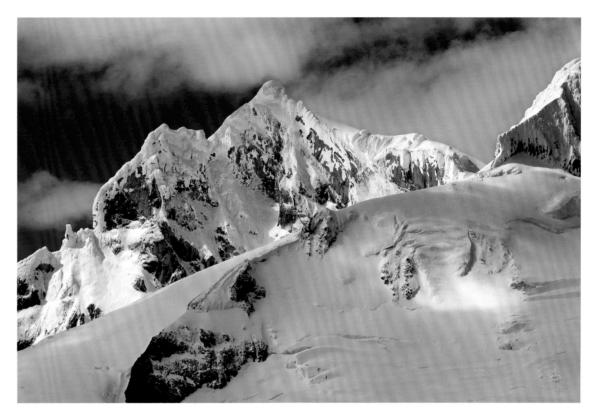

We voyaged west through the spectacular Beagle Channel, left, where numerous mountain peaks and glaciers extend to the sea. Patagonia has the largest mass of ice in the Southern Hemisphere, outside of Antarctica. Of the 48 glaciers in the Southern Patagonia Ice Field, 46 are retreating. They are part of a larger worldwide trend of retreating and thinning glaciers and ice sheets.

BEAGLE CHANNEL · MAGELLAN STRAIT

Both Alaska and southern Chile have an "inside passage." If Alaska's is better known, it is only because of its proximity to population centers and access from the Pacific Northwest. Southern Chile's is extremely remote and well-protected, going through the Beagle Channel, the Strait of Magellan, and a series of smaller south-to-north passageways. We are using this route north through beautiful mountain fjords and icy landscapes while avoiding the ferocious Southern Ocean gateway into the Pacific. We've had gale force winds, as well as numerous snow and hail showers sandwiched between beautiful sun and rainbows. The weather changes more quickly here than any place I have ever experienced.

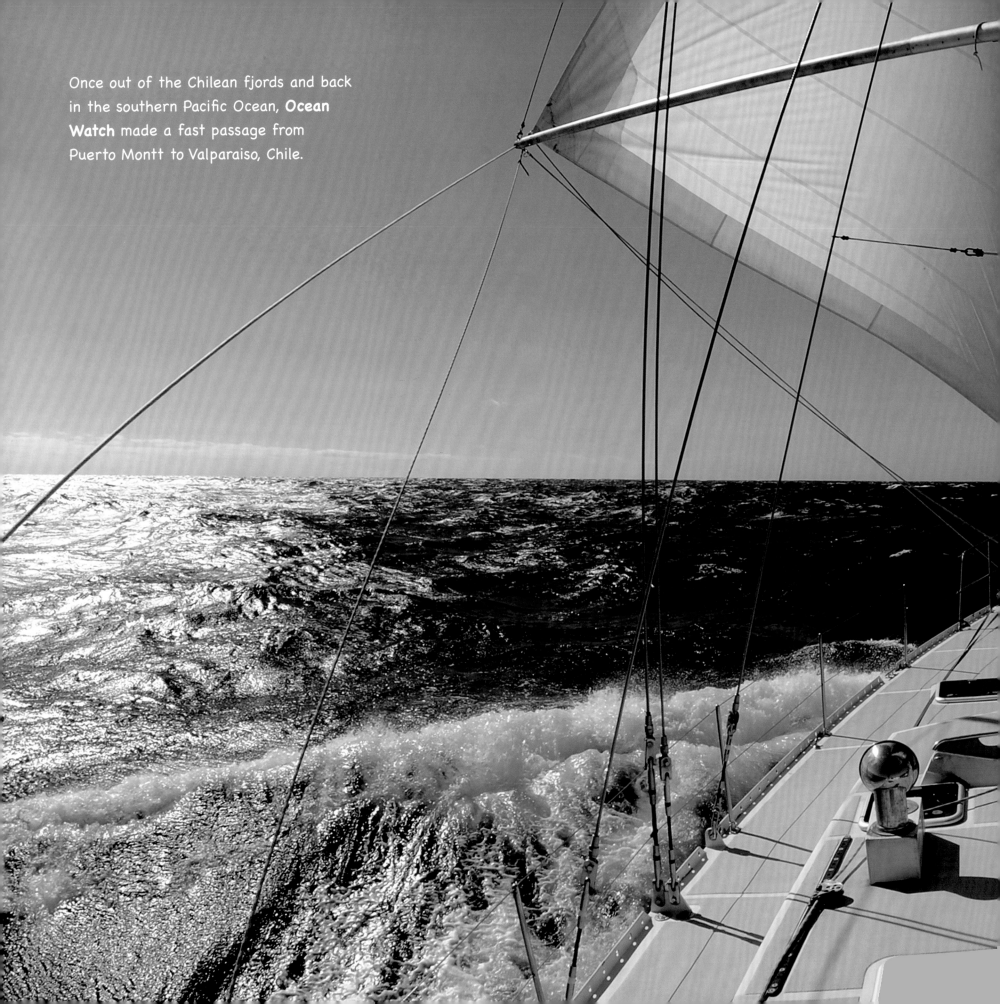

Once out of the Chilean fjords and back in the southern Pacific Ocean, **Ocean Watch** made a fast passage from Puerto Montt to Valparaiso, Chile.

The beaches of Lima, Peru, are among the most polluted in the Pacific. Ships dump trash offshore, and currents carry debris from faraway places. Plastic waste harms or even kills many marine animals by getting into their food supply or physically trapping them. Right: Framed by the dunes of San Lorenzo Island, Peruvian pelicans, with a wingspan of 8 feet, hoped for a free meal from local fishermen.

JOURNAL · MARCH 5 · 2010

LIMA · PERU

Ocean Watch was making another great passage to the north, and then the wind stopped. Our days grew hotter, as did the Pacific's surface waters. The cooler upwelling of the Pacific Ocean never happened. The Peruvian coastal waters typically provide one of the planet's richest fisheries, but not this year. With a strong El Niño in place and the absence of southeast winds, the nutrients are not surfacing from the depths, and the fish are absent. The Peruvian fishing fleet is now completely idled. It's easy to see that El Niño has global implications.

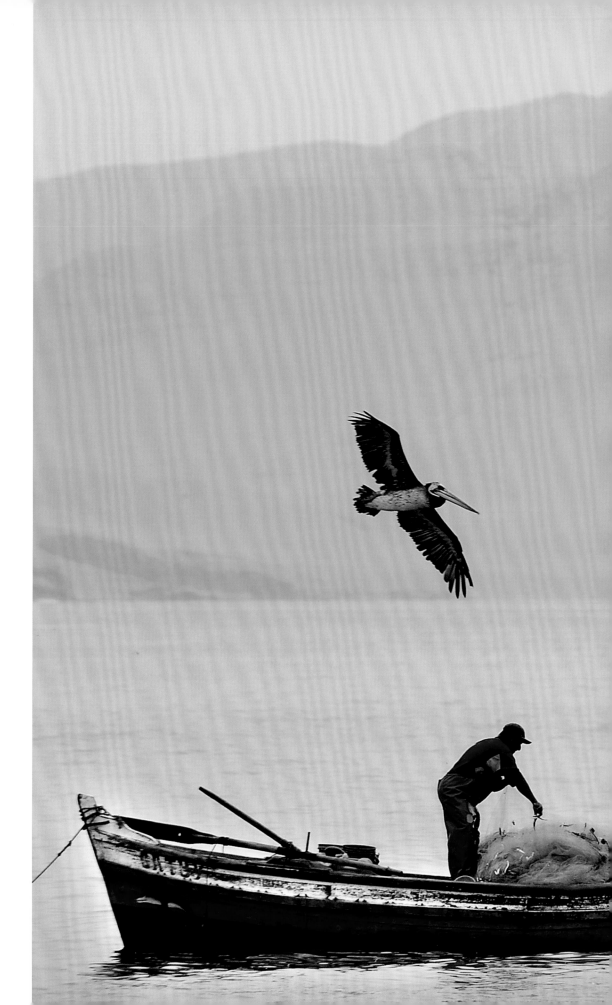

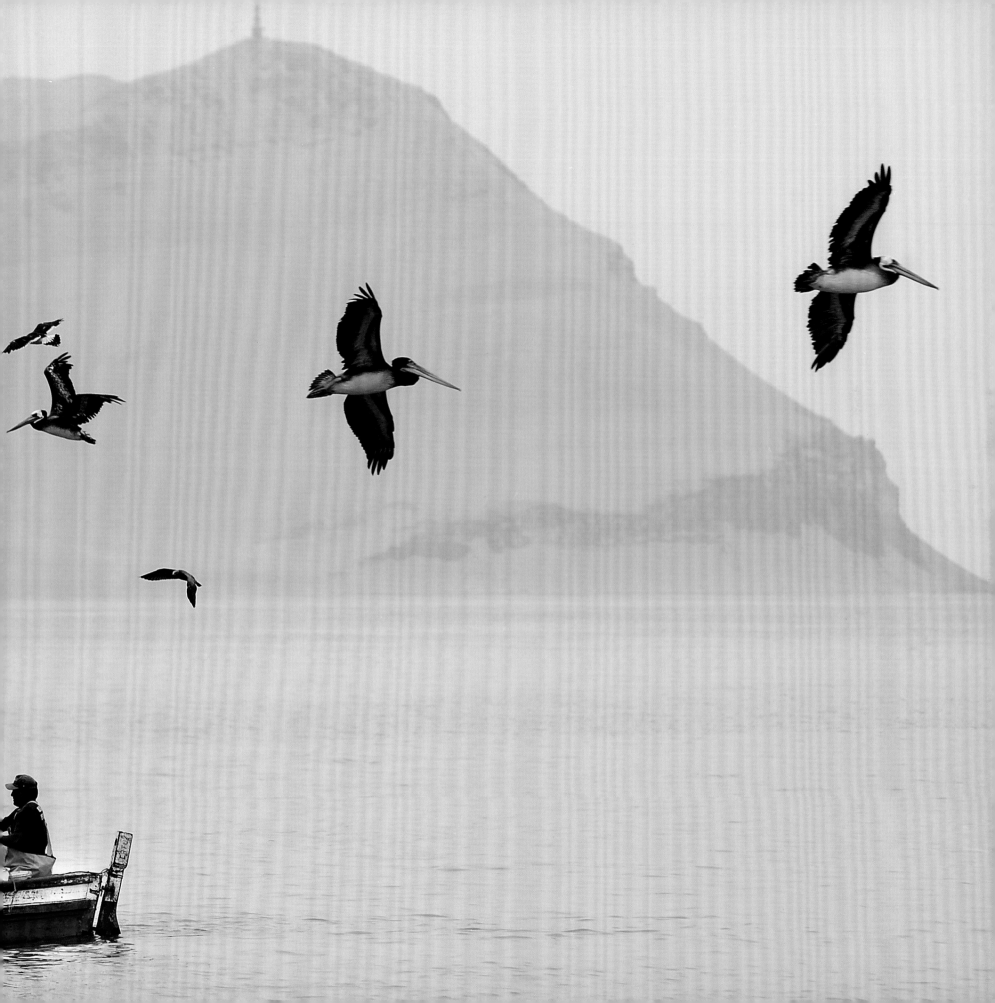

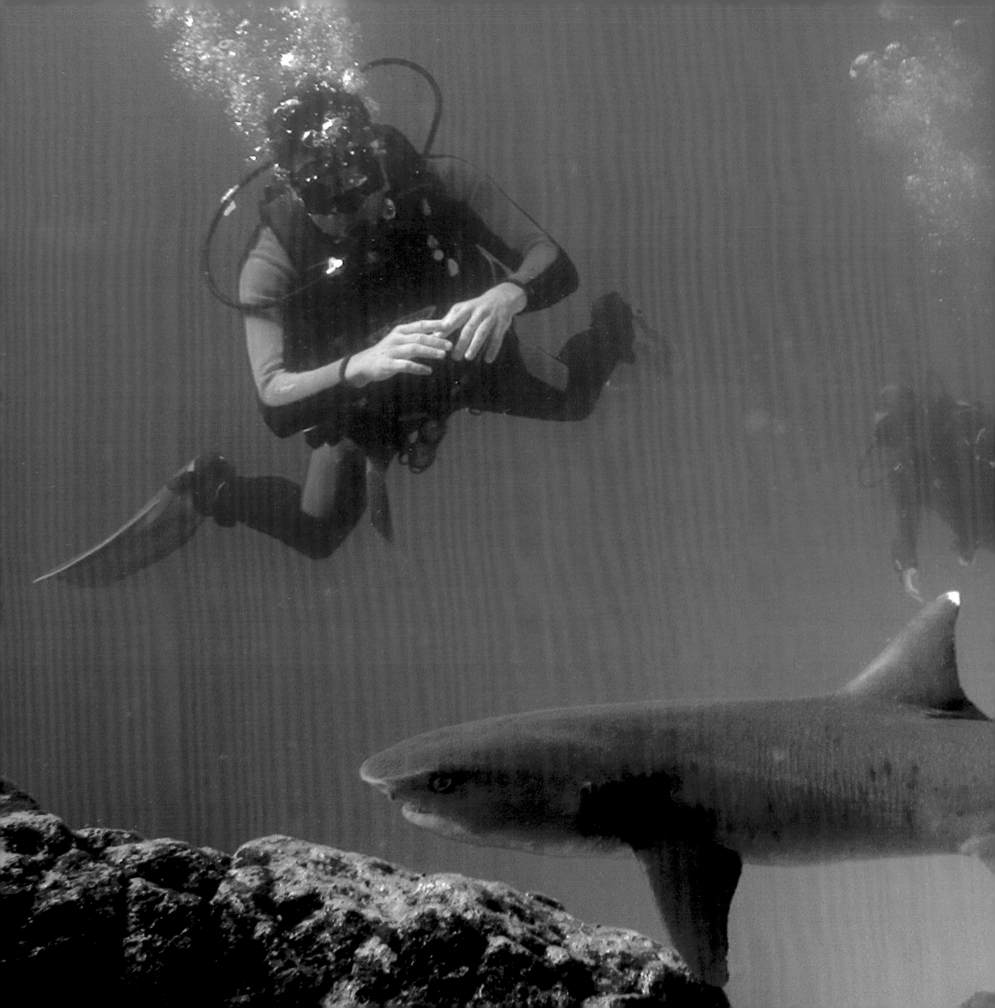

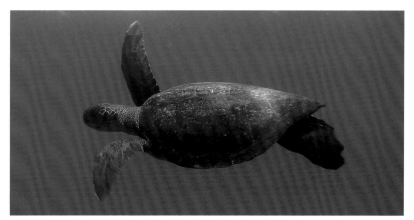

Left: A white-tipped reef shark glided by divers near the Galapagos Islands.
Above: Green turtles navigated the strong ocean currents, and eagle rays
"flew" effortlessly past us.

GALAPAGOS ISLANDS

It's hot again with almost no air circulation aboard
Ocean Watch. Under the strong El Niño, we motored
almost all 900 miles from Lima, Peru, to the Galapagos
Islands. Unlike Charles Darwin on the **HMS Beagle**, we
experienced a harbor teeming with vessels and 40,000
residents. This Galapagos faces many threats and pos-
sibly some "unnatural selection." But diving the colorful
reefs and bountiful waters reminded me of our bigger
mission, to witness not only the negatives, but also to
record the harmony and beauty of nature at her finest.

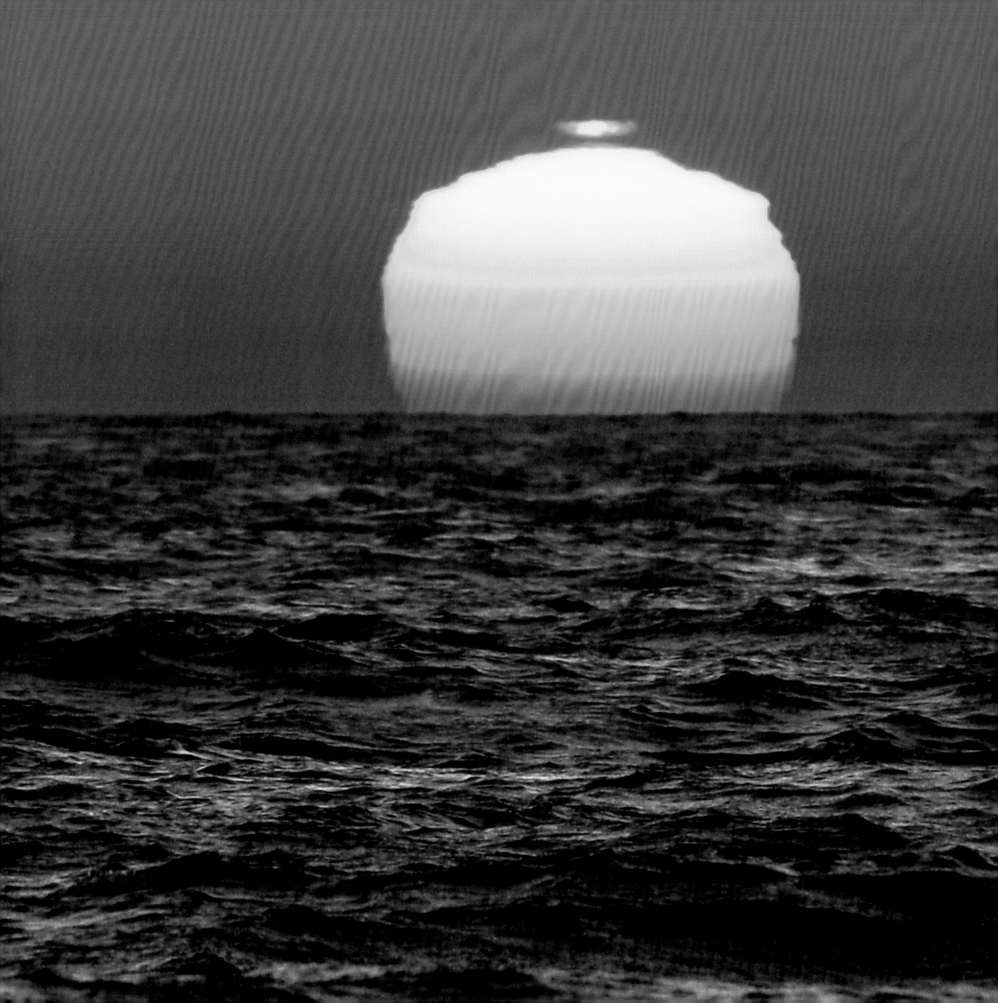

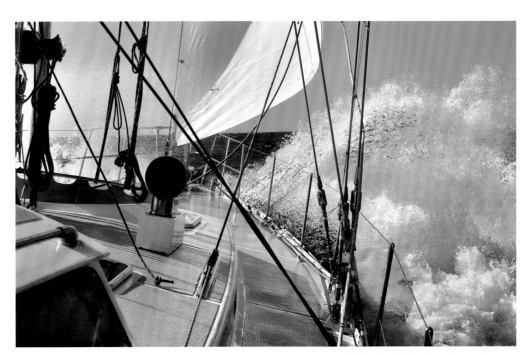

A green flash, left, is an optical phenomenon when a green spot is briefly visible just above the sun. It occurs shortly after sunset or before sunrise. Above: Near the Baja Peninsula, the wind changed direction and increased out of the northwest, the direction we needed to travel.

PACIFIC OCEAN · BAJA PENINSULA

We have now left Costa Rica and the Mexican ports of Acapulco, Puerto Vallarta, and Cabo San Lucas in our northward wake. The push is on to get back to the USA. We once again have schools, people, and schedules to meet. Every night the crew of **Ocean Watch** looks for the ephemeral "green flash" at sunset. I was lucky to shoot a few of them on this voyage, but believe this is the best. The "Baja bash" has now officially begun. The prevailing northerlies make it difficult to sail from the Baja Peninsula to San Diego. Sailors often travel all the way to the Hawaiian Islands and loop back northeast to the U.S. coast rather than attempt the bash. But we're committed to our route because, you know, why would we ever do anything easy on **Ocean Watch**?

ON A MISSION TO EXPAND SCIENTIFIC KNOWLEDGE

Science, education and outreach formed the mission of the Around the Americas sailing expedition. That meant *Ocean Watch* needed to participate in real scientific inquiry, with a real scientist on board. Properly equipping a small sailboat for such work was very difficult, but first mate Dave Logan and scientist Michael Reynolds rose to the challenge, incorporating small, efficient systems into *Ocean Watch*.

For example, they built in and carried instruments to collect "data sets of opportunity" throughout the expedition. Various scientists joined the expedition and participated in port-based education and outreach activities alongside educators.

The expedition's science program was very ambitious, considering the size of the vessel and crew and that we were constantly sailing through different oceanic regions. There were many scientific partners, but none more important than the University of Washington's Applied Physics Laboratory, which assembled the meteorological studies package.

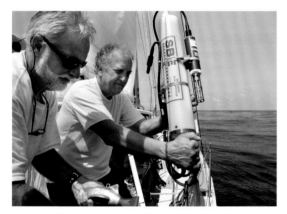

Captain Mark Schrader, left, and Michael Reynolds measured water temperature, salinity and pH as *Ocean Watch* sailed the North Pacific. The sensor helps to determine whether and how bodies of water are changing.

Scientists use computer models to understand global climate change, but to make accurate predictions, they must start with precise data. Satellites provide a grid of measurements from space, while research vessels like *Ocean Watch* provide measurements from the Earth's surface.

Our goal was to help define the exchange of heat and water vapor between the ocean and atmosphere. Our instruments allowed for very precise measurement of winds, humidity, air pressure, solar and infrared radiation, and air and sea temperatures.

Other science-related tasks conducted during the voyage included: observing clouds for NASA satellite overpasses, surveying jellyfish populations, deploying buoys in the Arctic Ocean, studying solar reflection, measuring seawater properties, and recording sounds occurring underwater.

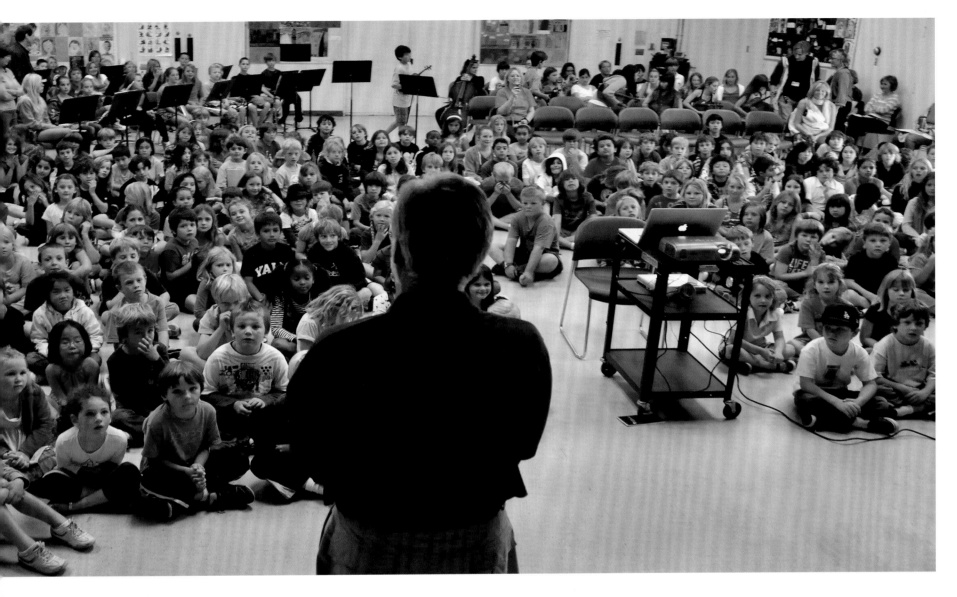

Captain Mark Schrader spoke to students at Point Dume Marine Science School in California, another educational stop for *Ocean Watch* on the Around the Americas expedition. At far left, *Ocean Watch* crew members studied jellyfish at the Birch Aquarium at Scripps Institute of Oceanography at the University of California, San Diego. Scientists hope to learn more about jellyfish because they have proved remarkably adaptable to climate change. Center, Michael Reynolds prepared to take a tissue sample of a jellyfish to send to a marine lab. Schoolgirls from Los Angeles' Watts neighborhood enjoyed a chance to learn about oceanography aboard *Ocean Watch* as it docked at Marina del Rey.

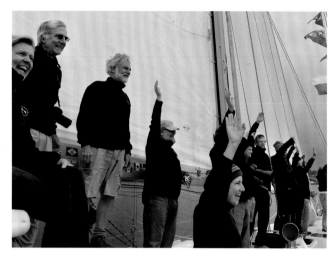

Many scientists and supporters joined the crew for the celebratory final leg into Seattle. With one last fireboat escort, *Ocean Watch* slowly made her way into her final port of call. The photo at right is by Casey Woodrum.

PORT TOWNSEND · WASHINGTON · USA

We made it! There is really nothing better than coming home after a very long and exhausting expedition. What an unbelievable run. The Strait of Juan de Fuca was the most welcome sight of our voyage. The great circle is now complete. After 382 days, 50 port stops and 27,524 nautical miles, we are sailing to Seattle, where it all began. The physical Around the Americas voyage is coming to a close. Now the challenging journey of telling stories, instilling awareness, and stimulating curiosity really begins.

Map of the Around the Americas Sailing Expedition

In 2009, *Ocean Watch* left Seattle on a 28,000-mile sail around the Western Hemisphere, making 50 stops in 13 countries.

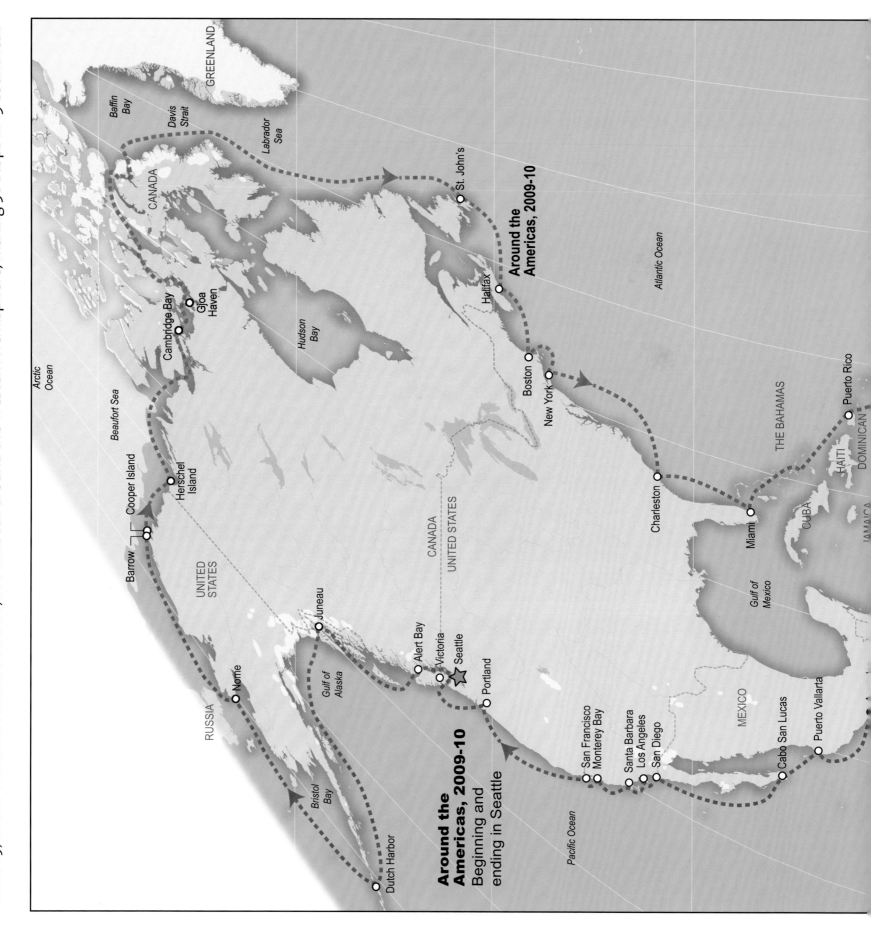

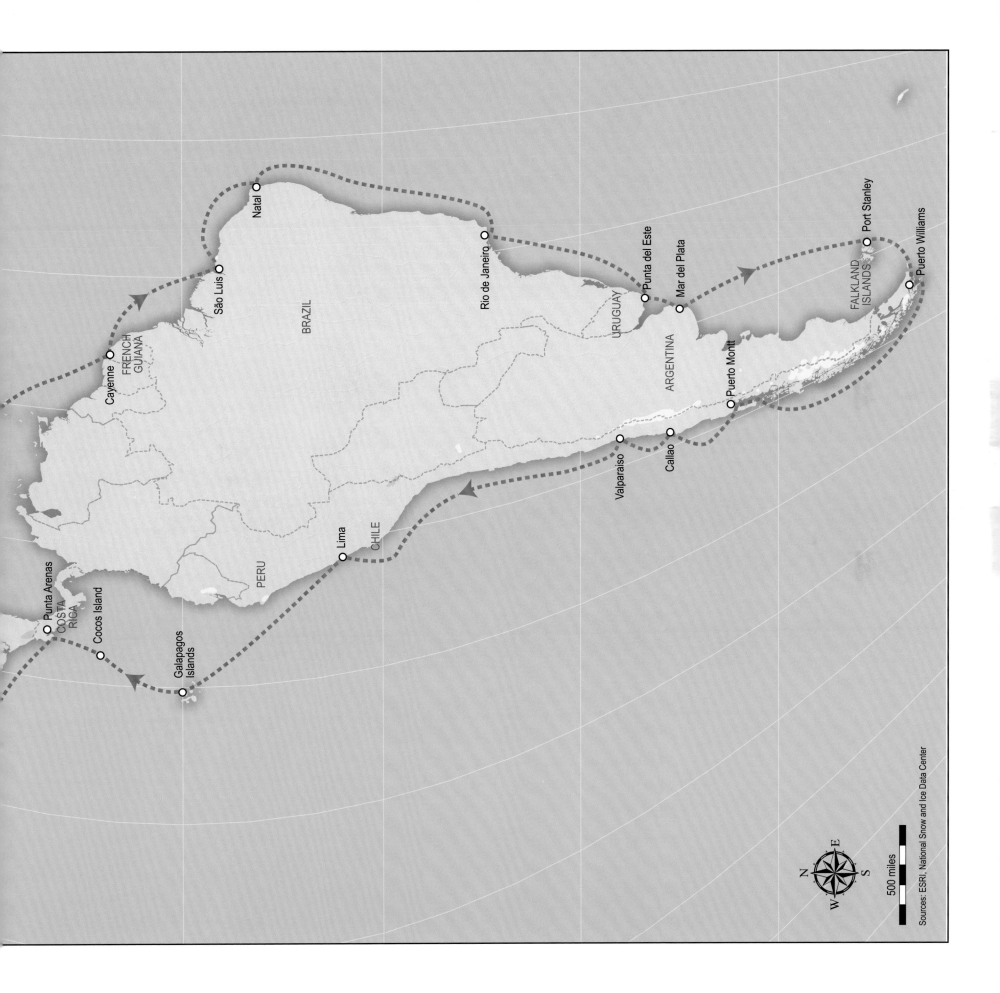

Natal

Rio de Janeiro

São Luis

BRAZIL

Cayenne

FRENCH
GUIANA

Punta del Este

Mar del Plata

URUGUAY

ARGENTINA

Puerto Montt

Port Stanley

FALKLAND
ISLANDS

Puerto Williams

Valparaiso

Callao

Lima

CHILE

PERU

Punta Arenas

COSTA
RICA

Cocos Island

Galapagos
Islands

N
W E
S

500 miles

Sources: ESRI, National Snow and Ice Data Center

A NEW ERA OF EXPLORATION

As I struggle with the thoughts to sum up a lifetime of outdoor observations and photography, April 2016 has just gone down as the world's warmest April since humans began recording in 1880. In fact, each of the last seven months in a row has shattered the previous world record. 2015 was the warmest year ever recorded, and 2016 looks to be breaking that record. On top of that, the northern polar ice pack just set the record for the lowest amount of winter ice. Northern sea routes are opening. A cruise ship is preparing to make its way through the Northwest Passage this summer.

Pack ice prevented us from completing the Passage 22 years ago. Nine years have passed since we made it through on *Cloud Nine*. While that accomplishment was exhilarating, it was also alarming. I did not expect a rapid change into a world using only renewable energy, but I am deeply troubled by the recent coordinated campaign to discredit climate science and the scientists themselves.

Like many baby boomers, I grew up witnessing the great race for space, to put the first human on the moon.

We have ended a classic era of exploration founded on many "first-time" accomplishments and entered a new era. Explorers now travel the world in search of data and knowledge to understand our Earth's life support systems.

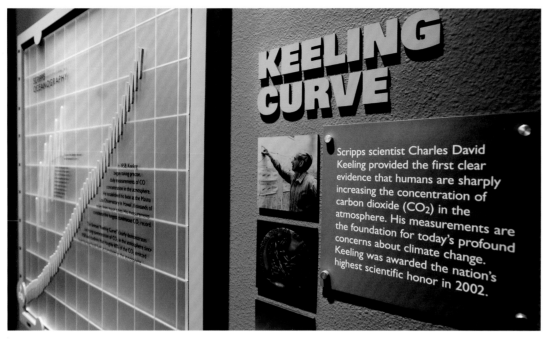

The Keeling Curve documents the increase of carbon dioxide emissions from human activity since 1958. Charles David Keeling, a scientist at the Scripps Institution of Oceanography, began taking measurements at Mauna Loa, Hawaii, and the South Pole and was the first to bring the world's attention to the consequences of our collective actions. At right, a power plant in western Mexico spews carbon emissions into the atmosphere.

Not only did we make that giant leap, but we also started to explore the deepest reaches of the oceans. Science was a noble, even cool, pursuit. Scientists were trusted, and we trusted that with their help we, as a team, a country, a world, could accomplish anything.

The first images of our little blue planet taken from space, though, gave us a new perspective. It suddenly seemed fragile, vulnerable. That realization planted a seed in my life and more broadly spawned an environmental movement that rippled around the world.

Many scientists are stating we have entered a new "human-influenced" epoch, the Anthropocene, when human activities are starting to have a significant impact on Earth's geology and ecosystems. This seems the time for humans to reflect upon how we have organized ourselves socially, politically, and economically. We need to tap into that "space shot" mentality again to solve the climate crisis and move forward with a new model of sustainability.

And we can do it. We have the energy technology available now.

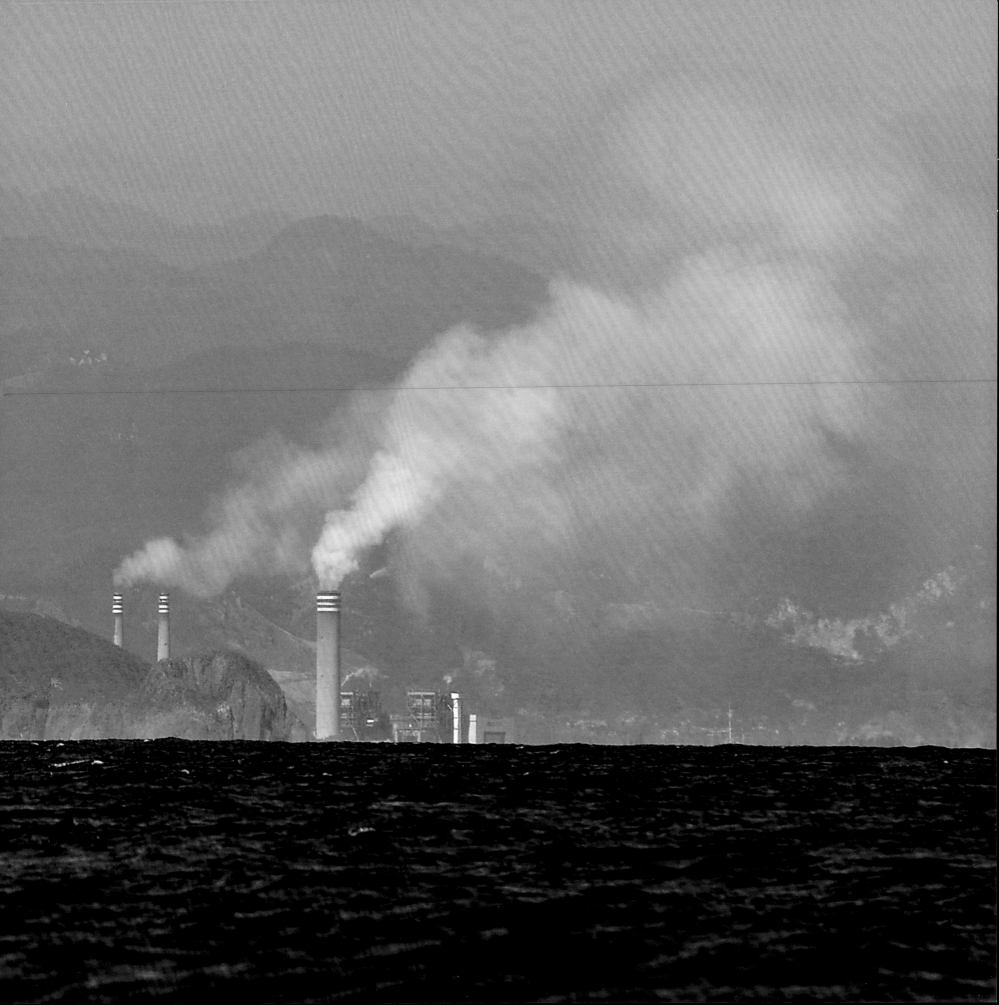

Just look at the stunning results of the Rosetta space probe for inspiration.

In 2004, the European Space Agency, assisted by NASA and led by planetary scientists and comet experts, launched a rocket from a steamy spaceport in French Guiana. They had theorized that they could land a spacecraft on a passing comet. The comet wasn't coming for another 10 years, but based on applied physics and computer models, they reckoned they could predict the paths of the two objects and make this science-fiction tale reality.

The launch of the Rosetta space probe on March 2, 2004, from the Guiana Space Centre was successful. For the next 10 years, and 4 billion miles, Rosetta chased the comet around our solar system, even using planets as slingshots to align orbits. On November 12, 2014, as Rosetta aligned with its target, scientists successfully landed a robotic craft named Philae on the comet. Wow. Who wouldn't want to be an explorer in this new era?

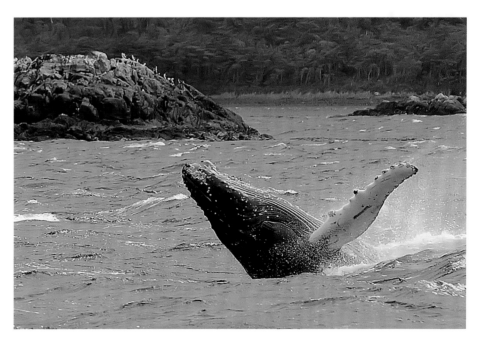

The U.S. space program has had spectacular results, but it has also made us more aware of how vulnerable our planet is. We've made strides in protecting wilderness areas and wildlife on land, but our oceans and their inhabitants, like this humpback whale in southern Chile, need sanctuaries, too.

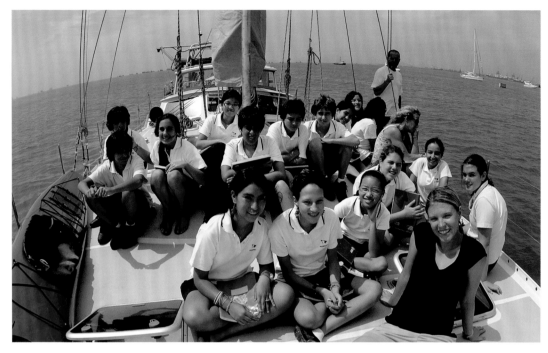

Students like these I met in Peru during the Around the Americas expedition have convinced me that a new generation of explorers and scientists will be able to address the environmental challenges we face and lead us to a more sustainable future.

There's beauty in that type of accomplishment. What often gets lost in climate change discussions, though, is the sheer beauty of our planet itself. That is what lured me to — and over — the horizon. In addition to promoting sustainability, I want to make sure that precious wilderness and ocean areas are protected for future generations. I want them to be able to enjoy the outdoors and explore a healthy environment just as I did. Such positive experiences were what led me to keep expanding my focus, from adventure to advocacy.

My generation is leaving a natural world in need of attention, but I am encouraged to see a new generation channeling the spirit of explorers like Roald Amundsen and Ernest Shackleton, combining science, creativity, and appreciation of nature to tackle the challenges of this new era.

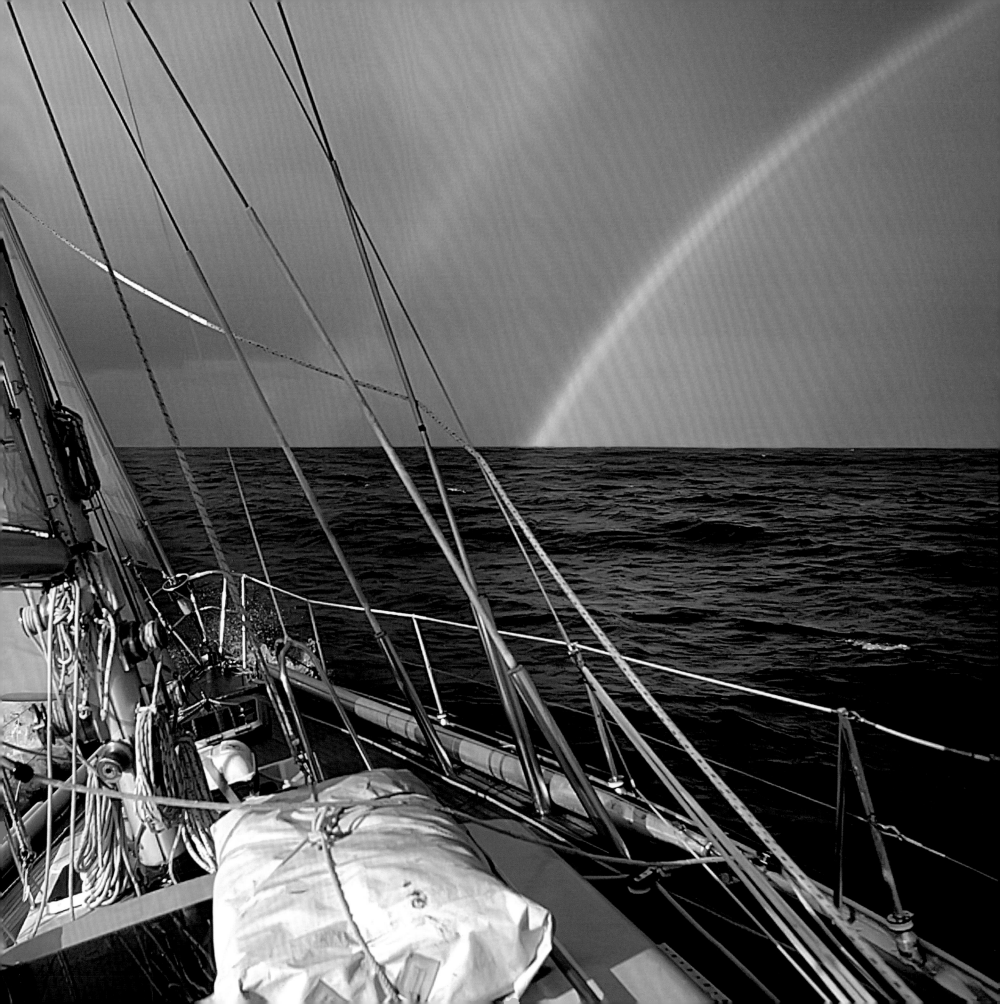

After being whisked off to an undisclosed location outside of Puerto Williams, Chile, the crew of *Ocean Watch* was inducted into a top secret band of South American pirates.

First mate Dave Logan was a little camera-shy for about the first 15,000 miles of our voyage, but finally warmed up to the lens by the end.

Looks can be deceiving. I was in a serious bit of trouble and could have lost an ear if I had given a wrong answer during my Chilean interrogation.

Extremely entertaining Rick Fleishman and his lovely wife, Jennifer (no, that's not her), joined us for the hottest stretch of sailing along the north coast of Brazil.

Bryce Seidl, former CEO of the Pacific Science Center, showed off his big catch for dinner, a flying fish he landed in the Pacific near the Equator.

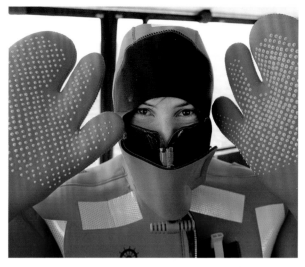

Educator Zeta Strickland, from the Pacific Science Center, fashioned the latest "gumby" survival suit in an emergency drill at Barrow, Alaska.

Captain Mark Schrader got a little hot under the collar when he discovered he was being served up for dinner at a beach cookout in the Canadian Arctic.

Crossing the Equator necessitated a skit to honor King Neptune from first-timers (Pollywogs), from left, Herb McCormick, Jennifer Price, and Dave Logan.

Resident writer McCormick read a novel set in the Arctic ice to keep cool as temperatures soared to 95 degrees near the Equator.

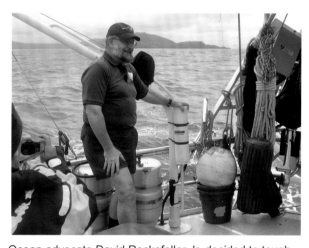

Ocean advocate David Rockefeller Jr. decided to tough it out by forgoing foul weather gear as we sailed around Cape Horn.

Young scientist Bryan Reeves, left, seemed a little unsure about McCormick's offer to protect him from possible polar bear attacks.

Needing libations to satisfy King Neptune, McCormick, right, and I mixed up a fresh batch of Dark 'n' Stormies for the Equatorial celebration.

Former NBA champion Bill Walton, an ocean advocate, closely followed the *Ocean Watch* voyage. He and David Rockefeller Jr. met us in San Diego.

ACKNOWLEDGMENTS

Thank you first and foremost to my friend and mentor, Roger Swanson. I miss you tremendously, Roger, and will always remember your willingness to take greenhorns like me to sea. Your spirit of adventure was tremendous, and you made me feel that anything was possible. Thank you also to the Swanson family, including Roger's First Mate and wife, Gaynelle Templin, sons Steven and Philip, and daughter, Lynne.

I wish to acknowledge many of my mates on Roger's *Cloud Nine*, especially those on the voyages mentioned in this book. We had fun together and as a team accomplished so much. Our crew south to Antarctica included Cherie Ruppe, Dick Clarke, Bill Gilges, and John TePaske. The 1994 crew to the Northwest Passage was Sue McNabb, Rona House, Geoff Pope, and Jim Hanegan. The 2007 crew to the Northwest Passage was Gaynelle, Chris Parkman, Doug Finley, and Matthew Drillio.

There are too many others to mention all of the tremendous people I met and sailed with on *Cloud Nine,* but I particularly want to thank longtime friends Helmut and Jane Mauer for their help on and off the water.

• • •

Captain Roger Swanson taught countless people to love sailing and the ocean. I will always be grateful that he encouraged me to embrace whatever is over the horizon.

The Around the Americas experience was, literally, off the charts. We left as mates and came back as brothers. Thank you, Mark Schrader, for executing a flawless mission; Herb McCormick, for all your great writing and creativity; Dave Logan, for refitting and running a beautiful vessel; and Michael Reynolds, for demonstrating to us all how hard a dedicated scientist works in the field.

It would take another entire book to fully recognize everyone involved with that expedition. And, in fact, we did just that with the publication of "One Island One Ocean" in 2011, a great book that is unfortunately out of publication. There was an amazing group of businesses, institutions, family members, and friends who made the Around the Americas expedition possible, but there are a few to whom I would like to give a very special shout out.

Our principal partners were Sailors for the Sea and Pacific Science Center, and I especially wish to thank David Rockefeller Jr., David Treadway, and the late Ned Cabot at Sailors for the Sea; and Bryce Seidl, Zeta Strickland, and Roxanne Nanninga at Pacific Science Center. Thanks also to our shoreside teams, especially Dawn Curtis-Hanley and Bryan Reeves; the refit team, especially Paul LaRussa and Andy Gregory, with whom I enjoyed sea-testing *Ocean Watch*; and sailmaker Carol Hasse and her talented team at Port Townsend Sails.

There were many underwriters of the Around the Americas voyage, but I would especially like to thank the Rockefeller family and the gracious John and Gloria Osberg, whom I can only aspire to be like when I grow up, as well as our major supporters and equipment sponsors.

Ocean Watch's scientific mission was a vast collaboration made possible by a wide range of institutions, scientists, and companies, including the University of Washington's Applied Physics Lab, the Joint Institute for the Study of the Atmosphere and Oceans, the MIT Sea

Grant Program, the National Oceanographic and Atmospheric Association, NASA's S'COOL Project, the Office of Naval Research, the SeaKeepers Society, and Sea-Bird Inc.

Thank you to Cruising World magazine for great support and coverage of our voyage and to Eric Johnson and Eric Jensen of Seattle's KOMO-TV for resurrecting your documentary division and producing a great film of the voyage.

There were scores of people who supported our endeavors in many ways. Thank you to Lon and Susan Woodrum, Casey and Marnye Woodrum, Horacio Rosell, Kelly Meyer, Rick Fleischman, Jennifer Price, Tom Hoymer, Dale Chihuly, John Bocstoce, Craig George, Geoff Carroll, Harry Brower Jr., Wayne Thrasher, Peter Semotiuk, Harry Horgan, Bill Walton, and Fabien Cousteau. I know I am missing so many; thank you all.

• • •

Thank you to some of my new friends and partners in the climate and wilderness protection movements: Joseph Robertson, a true climate explorer and policy strategist with the bipartisan Citizens' Climate Lobby, and Cindy

The core crew of *Ocean Watch* as we neared Puget Sound. From left: me, Dave Logan, Herb McCormick, Captain Mark Schrader, and Michael Reynolds.

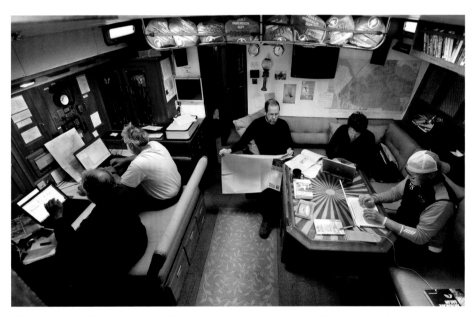

The seafarer's life is similar to that of an astronaut. Outside, there's seemingly limitless space. Inside, however, you're confined to tiny bunks and small communal areas.

Shogan and her entire staff at the Alaska Wilderness League for their tremendous efforts to protect our last great wilderness areas, especially the Arctic National Wildlife Refuge.

And I'd like to give a big thank you to Iowa Public Television and especially producer Chris Gourley for your help with my documentaries.

• • •

"Over the Horizon" had a great and patient creative team. Doing a book about a lifetime of work was a huge challenge. Big thank yous go to Tom Wallace, a kind and dear friend and terrific photo editor and book designer; my publisher, Mark Hirsch, who blazed the trail with his book, "That Tree"; my "slice and dice" copy editor, Kathe Connair; mapmaker Ray Grumney; and website designer Linda Creagh.

Thank you, also, David Rockefeller Jr. for your beautiful Foreword, Herb McCormick for the terrific Introduction, George Divoky for sharing your important work at Cooper Island, and Harry Stern for your keen historical and scientific context.

• • •

And finally, special thank yous to my wife, Kirsty, who supports me in every way, met us in ports, and sailed with the *Ocean Watch* team even when seasick, and to my mother, Judy, and siblings Becky, Wendy, and Michael for all your help and for putting up with your crazy son and brother.